Graphic Designer's
ULTIMATE
Resource Directory

POPPY EVANS

NORTH LIGHT BOOKS
CINCINNATI, OHIO

Other fine North Light Books are available from your local bookstore, art supply store or direct from the publisher.

Visit our Web site at www.howdesign.com for information on more resources for graphic designers.

03 02 01 00 99 5 4 3 2 1

Library of Congress Cataloging-in-Publication Data

Evans, Poppy.
 The graphic designer's ultimate resource directory / Poppy Evans.—1st ed.
 p. cm.
 Includes index.
 ISBN 0-89134-912-X (alk. paper)
 1. Commercial art—United States—Directories. 2. Graphic arts—United States—Directories. 3. Graphic arts equipment industry—United States—Directories. I. Title.
NC999.E825 1999
741.6′029′473–dc21
 98-32411
 CIP

Edited by Dawn Korth
Production edited by Michelle Kramer and Amy J. Wolgemuth
Designed by Cindy Beckmeyer
Production coordinated by Erin Boggs

Credits

About the AUTHOR

Poppy Evans is a freelance graphic designer and writer for the design industry who resides in Park Hills, Kentucky. She is the former managing editor for *HOW* magazine and former art director of *Screen Printing* and *American Music Teacher* magazines. She has authored many books for the graphic design industry, including *The Complete Guide to Eco-Friendly Design*, and written articles that have appeared in *PRINT*, *HOW*, *Step-By-Step Graphics*, *Publish* and other graphic arts magazines. She also lectures on eco-friendly design and production techniques. Evans currently teaches graphic design and production at the Art Academy of Cincinnati and serves as contributing editor for *Publish* magazine.

Dedication

This book is dedicated to my son, Evan, who is a constant reminder to me of what's truly important in life.

Acknowledgments

I would like to thank Greg Albert and Lynn Haller at North Light Books for coming up with the idea for this book and assigning it to me, and to Dawn Korth for her input and help in editing it. I would also like to thank Michelle Kramer and Amy Wolgemuth for steering this book through production, and Cindy Beckmeyer for her striking design and layout.

Others who helped me in locating and qualifying products and services are Dutch Draley, Screenprinting and Graphic Imaging Association (SGIA); Steve Duccilli, *Screen Printing*; Kurt McQuiston, Art Academy of Cincinnati; Duane Neher, Johnston Paper; and Debra Sexton, *Impressions*.

Finally, I would like to thank everyone who contributed a visual or a project idea. All of these individuals took time from their schedules to furnish me with information as well as art or photography. To everyone who helped with advice and ideas, my heartfelt thanks.

Table *of* CONTENTS

Introduction

Have you ever tried to locate a product or service and found yourself thumbing through countless directories and trade magazines, only to ultimately fall short of finding what you need? Exasperated, you pick up the phone and start calling colleagues in an attempt to find answers, and after several hours of playing phone tag, you still haven't been able to locate what you want.

Sound familiar? There's nothing more frustrating than not knowing where to find something you need to complete the job on hand, especially when you're trying hard to meet a deadline and time is precious. That's why the *Graphic Designer's Ultimate Resource Directory* was created. The categorized listings of products and services in this book were created specifically to satisfy designers who need to tap into a dependable list of resources as quickly as possible.

Within this book you'll find contact information and Web sites for every major national competition for graphic design and related disciplines; listings of stock illustration and photo agencies and what they specialize in; sources for unusual papers, envelopes, pocket folders and other paper products you may not have even known existed; plus a countless variety of items and services that designers of packaging, signage, other printed materials and multimedia will want to have access to. You'll also find production tips and ideas on where to look for more resources specific to a particular area, as well as design projects that make innovative use of products or services. You'll even find a chapter devoted to free products and services.

Compiling this directory was no easy task. In the course of locating and qualifying resources, I encountered many endlessly ringing phones, busy signals, snippy operators and hundreds of voice mail messages. Companies with unattended phone lines and those with rude sales help didn't make the cut for this book. Those firms that did make the cut are well-established businesses with helpful and knowledgeable sales people. You can be assured that when you dial any of the numbers in this book, your call will be greeted by a representative of a company with a desire to do business with graphic designers.

As the *Whole Earth Catalog* of the industry, you'll find the *Graphic Designer's Ultimate Resource Directory* will function as your single source for all areas of graphic design, replacing many other directories that focus only on specific areas of design. In fact, it will probably be the directory that you'll reach for next, whenever your Rolodex doesn't provide a solution to your quest for a product or service. I know it has already helped me. As I accumulated information for this book, I found myself pulling up completed chapters on my computer on more than one occasion to locate something I needed.

Every effort has been made to give the readers of this book up-to-date information, but in the ever-changing area of digital design it's likely that some information may be out-of-date by the time you read this. To stay current, check my Web site at www.poppyevans.com for updates on information that appears in this book.

If you have suggestions for additional listings for this book or are aware of a product or service you would like to share with other graphic designers, you can E-mail them to me at the Web site above or let my publisher know so these additions can be included in the next edition of the *Graphic Designer's Ultimate Resource Directory*. Please forward your ideas to

Graphic Designer's Ultimate Resource Directory
North Light Books
1507 Dana Ave.
Cincinnati, OH 45207
Fax: (513) 531-7107

Illustration

Sources for Illustrators,

Including Royalty-Free and

Stock Illustration

Creative Directories

When searching for location photographers or stock agencies, don't overlook local talent directories. In additition to the local directories that many cities offer, there are national talent books, huge directories regarded as the "Who's Who" of U.S. photography, illustration and design. Because they feature full-page, full-color ads of illustrators' work, each directory is a virtual catalog of samples, offering pages and pages of styles and looks from which to choose. These directories are distributed free of charge to recognized advertising agencies, design studios and magazine publishers. They can also be purchased at art supply stores.

The Alternative Pick/Storm Entertainment

1133 Broadway, Ste. 1408
New York, NY 10010
(212) 675-4176
Fax: (212) 675-4936
Features illustrators, designers, photographers and multimedia artists. Audience is primarily music and entertainment industry professionals.

American Showcase Illustration

915 Broadway, 14th Fl.
New York, NY 10010
(800) 894-7469, (212) 673-6600
Fax: (212) 673-9795, (212) 358-9491
www.showcase.com
Consists of two volumes: One features illustrators' reps; the other features independent freelancers. Includes more than 4,500 images.

Also publishes *Creative Options for Business and Annual Reports*, a directory that contains more than 150 images representing illustrators who do business-oriented work, and Virtual Portfolio, a directory of illustrators on CD-ROM.

The Creative Illustration Book

10 Astor Pl., 6th Fl.
New York, NY 10003
(212) 539-9800
Fax: (212) 539-9801
www.blackbook.com
Huge volume of over five hundred pages features the work of over four hundred illustrators.

Graphic Artists Guild Directory of Illustration

Serbin Communications
511 Olive St.
Santa Barbara, CA 93101
(800) 876-6425, (805) 963-0439
Fax: (805) 965-0496
www.gag.org
Currently in its fifteenth edition. Qualified art buyers can receive a free copy.

RSVP

P.O. Box 314
Brooklyn, NY 11205
(718) 857-9267
Fax: (718) 783-2376
www.rsvpdirectory.com
Directory that consists of one book divided into two sections: one each for illustration and design. Printed annually. Web site features on-line gallery.

The Workbook

940 N. Highland Ave.
Los Angeles, CA 90038
(800) 547-2688, (213) 856-0008
Fax: (213) 856-4368
New York Sales Office: (212) 674-1919
Chicago Sales Office: (312) 944-7925
www.workbook.com
Lists thousands of illustrators in the *Illustration Portfolio*, one of four volumes of *The Workbook*. In addition to alphabetical listings of studios by region, it includes four-color section with visual representations. Directory volume also lists artists' reps. Web site offers on-line portfolios.

Stock Illustration Agencies

The following agencies offer copyright-free illustrative or nonphotographic images that are paid for on a per-usage basis. If you're looking for an illustration and don't have time to commission one, call one of these agencies, describe what subject matter, medium and style you want, and the agency will call, fax or send you a description or preview of the images it has that meet your requirements. Work is usually furnished in transparency format or as digital art. Most of these agencies also offer a catalog or description of available images.

Anatomy Works

232 Madison Ave.
New York, NY 10016
(212) 679-8480
Fax: (212) 532-1934
Specializes in medical subject matter, including anatomy.

C.S.A. Archives

30 N. 1st St., 4th Fl.
Minneapolis, MN 55401
(612) 339-5181
Fax: (612) 339-3283
www.csa-archive.com
Compiled by designer Charles Spencer Anderson, this collection primarily consists of 7,777 line art images from the 1920s to the 1960s. The images have accumulated over ten years by Anderson and his staff in the course of developing their own projects. Collection also includes original images from the firm. Five-hundred-page catalog of nonreproducible images is $49.95.

Culver Pictures

150 W. 22nd St., Ste. 300
New York, NY 10011
(212) 645-1672
Fax: (212) 627-9112
Specializes in historical images, predating the 1950s. Also offers vintage photographs.

Custom Medical Stock Photo

3660 W. Irving Park Rd.
Chicago, IL 60618
(800) 373-2677
www.cmsp.com
Stocks millions of illustrations dealing with scientific subject matter, particularly medicine, psychology and chemistry. Offers an electronic bulletin board where images can be previewed on-line. Also will supply images on CD-ROM.

The Image Bank

2777 Stemmons Frwy., Ste. 600
Dallas, TX 75206
(214) 863-4900
Fax: (214) 863-4860
or
111 5th Ave.
New York, NY 10003
(212) 539-8300
Fax: (212) 539-8391
www.theimagebank.com
Extensive image library offers thousands of illustrations in a variety of mediums and styles, many from nationally known artists. Also sells stock photography.

Refer to image on page 19.

Laughing Stock

192 Southville Rd.
Southborough, MA 01772
(508) 460-6058
Fax: (508) 480-9221
www.laughing-stock.com
Specializes in lighthearted subject matter. Catalog and

Web site feature black-and-white and color illustrations by Tim Lewis, Timothy Cook, Linda Black and many other artists. Does research and assignments.

Refer to image on page 20.

The Stock Illustration Source
5 E. 16th St., 11th Fl.
New York, NY 10003
(212) 691-6400
Fax: (212) 691-6609
www.sisstock.com
Offers illustrations covering a broad range of subject matter and styles. Stocks both color and black-and-white from hundreds of illustrators, many of whom are nationally recognized artists. Collection includes over seven thousand images.

The Stock Market
360 Park Ave. S., 16th Fl.
New York, NY 10010
(800) 999-0800, (212) 684-7878
Fax: (800) 283-0808
Thousands of black-and-white and color images covering all types of subject matter and mediums.

Stockworks
11936 W. Jefferson Blvd., Ste. C
Culver City, CA 90230
(310) 390-9744
Fax: (310) 390-3161
Offers contemporary images covering all types of subject matter in color and in black and white.

SuperStock International
7660 Centurion Pkwy.
Jacksonville, FL 32256
(800) 828-4545, (904) 565-0066,
(800) 246-3378 (for catalog and CD-ROM browser)
Fax: (904) 641-4480
Best known for its collection of close to four million photos, SuperStock also stocks illustrations.

Artists' Reps

These companies represent a variety of illustrators. Call them for catalogs of artists' samples.

American Artists
353 W. 53rd St., Ste. 1W
New York, NY 10019
(212) 682-2462
Fax: (212) 582-0090

Carolyn Potts & Associates
4 E. Ohio, Ste. 11
Chicago, IL 60611
(312) 944-1130
Fax: (312) 988-4236

Famous Frames
5183 Overland Ave., #A
Culver City, CA 90230
(310) 558-3325
Fax: (310) 642-2728
www.famousframes.com

France Aline, Inc.
1076 S. Ogden Dr.
Los Angeles, CA 90019
(213) 933-2500
Fax: (213) 933-2081

James Conrad
2149 Lyn, #5
San Francisco, CA 94115
(415) 921-7140
Fax: (415) 921-3939

Jerry Leff Associates
420 Lexington Ave.
New York, NY 10170
(212) 697-8525
Fax: (212) 949-1843

Joel Harlib & Associates
405 N. Wabash Ave.
Chicago, IL 60611
(312) 329-1370
Fax: (312) 573-1445

Mendola, Ltd.
420 Lexington Ave.
New York, NY 10170
(212) 986-5680
Fax: (212) 818-1246
www.mendolaart.com

Pat Hackett
101 Yesler, #502
Seattle, WA 98104
(206) 447-1600
Fax: (206) 447-0739
www.pathackett.com

Rita Marie Represents
1464 Linden Ave.
Highland Park, IL 60035
(312) 222-0337
Fax: (773) 883-0375

Scott Hull Associates
68 E. Franklin St.
Dayton, OH 45459
(937) 433-8383
Fax: (937) 433-0434
New York Office: (212) 966-3604
San Francisco Office: (415) 285-3808
www.scotthull.com

Tip!

In addition to the clip art books, stock houses and other resources within this chapter, copyright-free illustration can come from other sources. If you're looking for art at a pittance, any work that has been in the public domain for over fifty years qualifies.

Illustrations you find in old magazines, encyclopedias, textbooks, almanacs and other literature can be used in your work as freely as you would use clip art. When browsing yard sales, flea markets and places where you can buy dated publications, think of the possibilities for using nostalgic images. The only restriction on what you select is an image's reproducibility; it must be clean and damage-free. The larger the image, the better the reproduction possibilities.

In addition to clip "finds," you can also purchase usage rights to art that has been in the public domain. Archival sources such as government agencies, universities and educational organizations may require much lower fees for their images than would clip or stock resources.

Sharon Dodge & Associates
3033 13th Ave. W.
Seattle, WA 98119
(206) 284-4701
Fax: (206) 622-7041

Woody Coleman Presents
490 Rockside Rd.
Cleveland, OH 44131
(216) 661-4222
Fax: (216) 661-2879
www.portsort.com

Clip Art Books and Services

Clip art houses commission illustrations that they sell as royalty and copyright-free art. You can use these images traditionally, sizing and reproducing "as is," or as a starting point, scanning them into your computer and altering them in any way you wish.

The following is a list of firms that specialize in hard-copy clip art. Also referred to as "slicks" or "camera-ready originals," they are reproduced in books, sheets or other tangible means, as opposed to digital clip art, which is supplied electronically. You'll find sources for digital clip art later in this chapter.

Clipper
Dynamic Graphics
6000 N. Forest Park Dr.
P.O. Box 1901
Peoria, IL 61656-9941
(800) 255-8800, (309) 688-8800
Fax: (309) 688-5873

Offers yearly or monthly subscription service to *Clipper*, a monthly book of clip art. Provides file binders, layout ideas and timely seasonal art. Cost is $38.85 monthly.

Dover Publications, Inc.
31 E. 2nd St.
Mineola, NY 11501
(516) 294-7000
Offers over one hundred books depicting anything and everything—silhouettes, vintage art, Victorian cuts, reproductions of old Montgomery Ward and Sears Roebuck catalogs, clip art alphabets, trademarks and symbols. Dover books can be purchased in many art supply shops and bookstores. Doesn't take fax or phone orders.

Graphic Source Clip Art Library
Graphic Products Corp.
1480 S. Wolf Rd.
Wheeling, IL 60090-6514
(847) 537-9300
Fax: (847) 215-0111
More than sixty books in many styles on a variety of subjects. Each book contains at least one hundred illustrations. The company sells most of its books through art supply stores, but orders of $25 or more are accepted.

North Light Books
1507 Dana Ave.
Cincinnati, OH 45207
(800) 289-0963, (513) 531-2222
Fax: (513) 531-4744
Offers six books covering the following subject areas: holidays, animals, food and drink, sports, men and women. Also publishes *Pictograms and Typefaces of the World* and *Trademarks and Symbols of the World*.

Digital Clip Art

Companies offering digital clip art commission illustrations that are then scanned or otherwise reproduced and sold as copyright- and royalty-free art. These images are already in digital format, meaning they can be brought into your computer, sized, altered and manipulated to your heart's content, or used as is.

If you constantly work on the computer and you don't own a scanner, digital clip art will give you prescanned artwork. If you have a scanner, prescanned images will save you scanning time and supply you with a professional-quality image, usually exceeding the quality level attainable on most studio flatbed scanners.

All listings offer images that are both Mac- and PC-compatible unless otherwise noted. Check individual listings for image resolution as well as compatibility with your computer and software configuration.

Adobe Image Library/Image Club Graphics, Inc.

1525 Greenview Dr.
Grand Prairie, TX 75050
(800) 661-9410 (orders), (800) 387-9193 (catalog requests)
Fax: (800) 814-7783
www.imageclub.com
Image library is made up of three four-color collections: Health and Wellness, Business Bots and Office Perspectives. Each collection consists of forty drum-scanned illustrations. Illustrations are provided in four formats: CMYK, RGB and high- and low-resolution versions. Illustrations are rendered in contemporary style and colored with washes. The neutral-toned illustrations in the Office Perspectives collection are rendered in ink and charcoal by artist Norman Schureman. Image collections are supplied on CD-ROM.

Agfa Direct

Agfa Division, Bayer Corp.
90 Industrial Way
Wilmington, MA 01887
(800) 424-TYPE, (508) 658-5600
Fax: (508) 657-5328
www.agfahome.com/agfatype
Offers a Master series illustration library of four-color, high-resolution images, organized into volumes of sixty images by subject matter. Topics include People and Lifestyles, Business and Finance, Outdoor Recreation and Design Metaphors. Illustrations are rendered in a variety of contemporary styles and mediums. Images are delivered on CD-ROM. Also sells royalty-free photography on CD-ROM.

Art Parts

℅ FontHaus, Inc.
15 Perry Ave., A7
Norwalk, CT 06850
(800) 942-9110, (203) 367-1993,
Fax: (203) 367-7112
www.fonthaus.com
Original black-and-white and color illustrations with contemporary flair, a variety of subject matter rendered in woodcut style. Offers sixty-four sets of 50-plus illustrations organized by subject matter for $169 each plus a Cheap Parts collection of 550-plus illustrations for $99. Topics include holidays, sports, health/medical, animals, food and more. One collection consists of face parts so users can create unique faces. Each CD-ROM collection contains thirteen sets of over 850 illustrations.

Refer to image on page 21.

Tip!

There are a lot of companies offering digital clip art collections. Because so many are on the market, it's hard to determine which collections offer images that will work best for your publication needs. When checking out the image collections offered in this section, keep these considerations in mind:

- **Compatibility**—*In addition to PC vs. Mac platforms, be sure images will work with the software you're using.*

- **Format**—*Formats include EPS, TIFF, PICT, GIFF, JPEG, GCM, WMF. Determine whether the image formats in a given collection will offer the versatility you need for your design applications. If they don't, be sure you have a program that can convert images to a variety of file formats.*

- **Vector vs. PostScript**—*Vector-based images can be enlarged without losing clarity or developing a pixelated look.*

Artville

2310 Darwin Rd.
Madison, WI 53704-3108
(800) 631-7808, (608) 243-1215
www.artville.com
Library offers thousands of illustrations and photographs in collections ranging from $60 to $290 with fifty to one hundred images per volume. Images are furnished as CDR, EPS, JPEG and TIFF files. Subject matter ranges from painterly backgrounds and impressionistic landscapes to more realistic rendering styles. Web site offers search engine that lets browsers search CD-ROM collections by general subject matter or by keying in a specific subject. Web site also lets browsers view images in each collection. However, browsing capability doesn't differentiate between illustration and photography. Orders can be placed by fax, mail or phone.

Artworks

Dynamic Graphics
6000 N. Forest Park Dr.
Peoria, IL 61614
(800) 255-8800, (309) 688-8800
Fax: (309) 688-5873
Library of thousands of black-and-white images is offered in various volumes, organized by illustration style and subject matter. Inografs collection consists of one hundred black-and-white images rendered in a bold, rough-hewn style. Other black-and-white collections include silhouettes, scratchboard renderings and pen-and-ink styles that range from simple to highly detailed. Theme volumes include a variety of illustration styles. Subjects include business, health care, sports, education, food, dining, symbols and seasons. Other collections offer borders and backgrounds. Images are supplied on diskette and CD-ROM.

ClickArt EPS Illustrations

Broderbund Software
T/Maker Co.
1390 Villa St.
Mountain View, CA 94041
(800) 986-2537, (415) 962-0195
Fax: (415) 962-0201
www.broderbund.com
Offers many different collections of line art on floppy disk and CD-ROM. Individual collections focus on cartoons, church bulletin and newsletter images, holidays, business, real estate and Christian holidays. Number of images varies per collection. Prices range from $29.95 to $49.95.

Corel Galleria

1600 Carling Ave.
Ottawa, Ontario K1Z 8R7
Canada
(800) 772-6735, (613) 728-3733
Fax: (613) 761-9176
www.corel.com or www.corel.com/corelweb (images specifically for Web use)
Offers ten thousand PICT format clip art images on CD-ROM. Collection includes over fifty image categories, including business, maps, food, transporation and celebrities. Cost is $59.

Designer's Club

Dynamic Graphics
6000 N. Forest Park Dr.
Peoria, IL 61614
(800) 255-8800, (309) 688-8800
Fax: (309) 688-5873
Monthly clip subscription service on CD-ROM. Provides a different disc every month with over fifty-five black-and-white and color illustrations of all kinds, including borders, symbols and timely seasonal art. Cost is $49.50 per month.

Digital Stock Corp.

400 S. Sierra Ave., Ste. 100
Solana Beach, CA 92075
(800) 545-4514, (760) 634-6500
www.digitalstock.com
Offers two painted backgrounds of hand-rendered abstract shapes in heavily layered paint. Urban Graffiti collection consists of graffiti-like images, including faces. Conceptual Backgrounds collection is comprised of painted symbols, landscapes and people. Each collection consists of one hundred color illustrations on CD-ROM. Also sells photos on CD-ROM.

Digital Wisdom

P.O. Box 2070
Tappahannock, VA 22560-2070
(800) 800-8560, (804) 443-9000
Fax: (804) 758-4512
www.digiwis.com
Offers maps of the world, the United States, all fifty states, flags of the world and more. Collections are PC- and Mac-compatible and are delivered on CD-ROM. Prices range from $49 to $495. Also sells world photos on CD-ROM.

Graphics Express

Tiger Software
P.O. Box 569005
Miami, FL 33256-9005
(800) 335-4054
Fax: (305) 443-8212
Offers bargain-priced packages of art from other suppliers, such as a collection of two thousand black-and-white images from Metro ImageBase and a one thousand image collection (for Mac only) from Task-Force Clip Art. Another collection consists of U.S. government art. All collections are delivered on CD-ROM.

Image Ideas

105 W. Beaver Creek Rd., Ste. 5
Richmond Hills, Ontario L4B 1C6
Canada
(888) 238-1600, (905) 709-1600
Fax: (905) 709-1625
Library includes ten Mac-compatible contemporary collections of 7″ × 5″ or 10″ × 6½″ mostly color images scanned at a resolution of 300 dpi as well as a Mac- and PC-compatible Master series consisting of several volumes. Other collections include vintage black-and-white and color images plus engravings and famous works of art. Offers CD-ROM browser of low-resolution versions of its library. Also offers photo library.

Letraset USA

40 Eisenhower Dr.
Paramus, NJ 07653
(800) 526-9073
Fax: (201) 909-2451
www.letraset.com
Offers decorative borders, initials, advertising motifs and other images and symbols from Letraset's dry transfer library. Consists of four collections of 150 images each, organized by subject on floppy disk or CD-ROM. Available off the shelf at retailers of art and design supplies.

Pro 3000 and Euro 5000

Tiger Software
P.O. Box 569005
Miami, FL 33256-9005
(800) 335-4054
Fax: (305) 443-8212

Features a collection of images from European artists. Images consist of black-and-white and color line art of embellishments, maps, universal symbols, holiday motifs and more. Each collection consists of approximately four thousand images on CD-ROM. Cost is $59.90 each or $89.90 for both.

Softedge

37 Plaistow Rd., Unit 7, Ste. 121
Plaistow, NH 03865
(800) 363-7709, (603) 382-4389
Fax: (603) 382-9353

Offers a variety of collections on CD-ROM ranging from black-and-white humorous illustrations to a four-color Master series. Also offers collections of textures, borders and ornaments and edge-effect plug-ins. Prices start at $29.95 and vary, depending on collection. Also sells royalty-free photos and fonts (Cool Fonts).

Squigglies

5600 S. Greenwood Plaza Blvd., #315
Englewood, CO 80111
(800) 887-5158
Fax: (303) 694-0823

Promoted as "too hip to be clip," this illustration library is full of lighthearted, four-color illustrations rendered in a contemporary, cartoonlike style. Offers eight collections, organized by subject matter, of one hundred images each for $89.95.

Time Tunnel

31316 42nd Pl. SW
Federal Way, WA 98023
(888) 650-6050, (253) 838-3377
Fax: (253) 838-8866
www.timetunnel.com

Offers a collection of one hundred royalty-free vintage science fiction images in three sizes. Images are scans from pulp science fiction magazine covers from the 1930s–1950s and are furnished as JPEG files. Comes on CD-ROM for $99.95.

Refer to image on page 22.

Totem Graphics, Inc.

6200 Capitol Blvd., Ste. F
Tumwater, WA 98501
(360) 352-1851
Fax: (360) 352-2554
www.gototem.com

Offers thirty-three different subject titles on diskette. Each diskette contains ninety-six images. Price for each is $39.95. Larger collections on CD-ROM range from $59.95 to $495. Also sells royalty-free photo collections.

Williams & Wilkins

351 W. Camden St.
Baltimore, MD 21201-2436
(800) 527-5597
Fax: (800) 447-8438

Sells professionally rendered medical art, including human anatomy, medical equipment, medical symbols, veterinary anatomy and emergency situations. Collections of mostly color images are delivered on CD-ROM and range from 460 images for $260 to 1,850 images for $499.

Youth Specialties

P.O. Box 668
Holmes, PA 19043
(800) 776-8008
Fax: (610) 586-3232

Offers six volumes of line art images at $49.95 each. Collection of illustrations is organized into the following subject areas: borders and symbols, phrases and verses, spiritual matter, general images and sports.

Digital Map Art

These suppliers address the complex needs of designers and publishers needing map art. In addition to offering a range of locales, each company varies in the way the art is delivered. To aid purchasers in applying their own colors and other custom treatments, it's important to note how each company supplies its art and with which programs the art is compatible. All manufacturers listed below sell map art that is both PC- and Mac-compatible.

Cartesia Software

80 Lambert Ln., Ste. 100
Lambertville, NJ 08530
(800) 334-4291, (609) 397-1611
www.map-art.com

Offers two Designers series consisting of flat map art in Adobe Illustrator format. The World collection includes world maps, thirty country maps and thirty-four regional maps as well as maps of oceans and seas.

The USA collection includes four-color maps of the United States and the individual states. Also offers more detailed maps in Illustrator format that include maps of the fifty states and individual country maps. The maps that comprise the Data Bank series have multiple layers broken down into roads, rivers, lakes, boundaries, major, intermediate and minor cities and

much more. A Terrain Images/USA collection includes relief maps in black and white and four color as Adobe Photoshop TIFF files. Also offers an inexpensive Clip Art Pack—a collection of three hundred images that includes world, country, Canadian province and U.S. state maps.

Chalk Butte

137 Steele Ln.
Boulder, WY 82923
(307) 537-5261
Specializes in world and U.S. relief maps. Images are scanned at 72 dpi and come in two collections: U.S. Digital Topography and eleven Large Digital Maps. Both are available in Mac and PC versions. The Mac package comes with PICT images and the PC package comes with TIFF images.

Digital Wisdom

P.O. Box 2070
Tappahannock, VA 22560-2070
(800) 800-8560, (804) 443-9000
Fax: (804) 758-4512
www.digiwis.com
Offers maps of the world, the United States and all fifty states, flags of the world and more. Many images are furnished in gray scale so designers can apply color as they wish. Images are supplied as TIFF, PICT and BMP format in 300 and 72 dpi. Mask files in Illustrator and Macromedia FreeHand allow the user to isolate ocean floor relief, coastlines, borders, cities and other details. Also sells world photos and globe shots on CD-ROM.

Magellan Geographix

6464 Hollister Ave.
Santa Barbara, CA 93117
(800) 929-4627, (805) 685-3100
www.maps.com
Offers several collections. Its MGDigital Atlas volume includes over seven hundred flat maps, each with ten to fifty layers of information, including text layers for city names, railways, roads and so forth, plus layers for graphic elements. Company also offers a subscription service for an annual fee as well as satellite photographs of the earth and map art suitable for multimedia. Art is available in FreeHand and Illustrator formats.

The Perfect Image Computer Graphics

1241 Elm St., Ste. A-1
West Springfield, MA 01189-1839
(413) 732-4959
Collection of almost 130 full-color flat maps comes with layers for each piece of land and ocean. Maps are available in CorelDRAW format.

Picture Fonts

If you're familiar with Zapf Dingbats, you know how easy it is to access symbols from your computer keyboard. Beyond scanned illustrations, a wide range of clip art possibilities are now being marketed as picture fonts—images that are accessible as keystrokes.

Picture fonts offer as many line art reproduction possiblities as clip images. They can also ensure clarity on a larger scale because they are scaled by changing their point size, as you would when sizing any font on your computer. If you need a lot of one-color image applications, the small amount of computer memory they require and their low cost makes more sense than illustrations furnished as EPS files on CD-ROM.

The following companies offer keyboard-accessible black-and-white line art illustrations on diskette.

Emigre Graphics

4475 D St.
Sacramento, CA 95819
(800) 944-9021, (916) 451-4344
Fax: (916) 451-4351
www.emigre.com
Offers original illustrations by avant-garde designers. Includes a variety of styles and subject matter, including borders and graphic ornaments.

Image Club Graphics

A Division of Adobe Systems, Inc.
1525 Greenview Dr.
Grand Prairie, TX 75050
(800) 661-9410 (orders), (800) 387-9193 (catalog requests)
Fax: (800) 814-7783
www.imageclub.com
Distributes several dingbats and ornaments collections, including a Mini Pics series of illustrations organized into subject-related collections of about one hundred images.

International Typeface Corp. (ITC)

866 2nd Ave.
New York, NY 10017
(800) 634-9325, (212) 949-8072
Fax: (212) 949-8485
www.itcfonts.com
ITC now owns the Fontek library of picture fonts that was formerly distributed through Letraset. The Fontek line of illustration fonts has been augmented by ITC's efforts to add to its library by commissioning even more picture font collections from illustrators offering a range of styles and subject matter.

Nimx Foundry

3878 Oak Lawn Ave., Ste. 100B-177
Dallas, TX 75219
(214) 340-1645
Fax: (214) 340-6399
www.nimx.com

Offers a collection of thirty-eight funky display fonts, dingbats and picture fonts. Firm also makes a picture font called Faces, which allows for mixing and matching facial parts to create unusual creatures. Mac- and PC-compatible fonts come on diskette or CD-ROM.

Picture Fonts

℅ FontHaus, Inc.
15 Perry Ave., A7
Norwalk, CT 06850
(800) 942-9110, (203) 367-1993
Fax: (203) 367-7112
www.fonthaus.com

Collection consists of a wide range of images, organized by style and subject matter. Illustration styles vary considerably and include primitive, contemporary and vintage looks.

Precision Type

47 Mall Dr.
Commack, NY 11725-5703
(800) 248-3668, (516) 864-0167
Fax: (516) 543-5721
www.precisiontype.com

This font distributor offers a variety of symbol and picture fonts from every foundry imaginable. Subject areas include wood type ornaments, astrological signs, embellishments, warning symbols, card faces, company logos and much more.

UTF

℅ Hybrid Communications
185 South Rd.
Marlborough, CT 06447
(800) 945-3648, (860) 295-9135
http://gs1.com/UTF/UTF.html

Foundry specializes in novelty and picture fonts. Web site makes finding picture fonts easy by organizing content into four areas: retail, industry, hotel and cuisine, and art and antiques. Over thirty Mac- and PC-compatible fonts available on diskette and on-line.

Rubber Stamps

To the uninitiated, rubber stamp enthusiasts are a unique breed; they have their own association, trade magazines and conventions. So what's all the excitement about? For one thing, if you browse through any of the catalogs from the manufacturers listed below, you'll be impressed with the novelty of the images available. Layering, borders and pattern creation are easy with stamps. The creative possibilities are limitless!

The companies listed here stock rubber stamps of all kinds of images as well as stamp pads and other rubber stamp supplies. In addition to mounted stamps, many of these manufacturers also offer unmounted stamps at a discount. Call or write to each for a catalog of images.

Ala Art

37500 N. Industrial Pkwy.
Willoughby, OH 44094
(800) 831-4427
Fax: (800) 831-0029
Original hand-drawn images. Cost of catalog is $2.

Bizarro

P.O. Box 292
Greenville, RI 02828
(401) 231-8777
Fax: (401) 231-4770
Alphabet sets and a variety of novelty stamps. Will produce custom stamps from customer-furnished artwork. Also offers embossing powders, rainbow stamp pads and a user's guide. Will send catalog at no charge.

Graphic Rubber Stamp Co.

11250 Magnolia Blvd.
North Hollywood, CA 91601
(818) 762-9443
Fax: (818) 762-4251

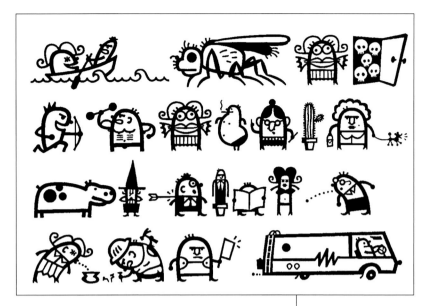

FontHaus offers many picture fonts, covering a broad range of illustration styles and subject matter. Shown is a sampling from a font called Dick & Jane Revisited.

If you want to locate more outlets for rubber stamps and stamp supplies, check out Rubberstampmadness, a magazine for rubber stamp enthusiasts, available from many of the outlets listed above.

Gumbo Graphics offers thousands of rubber stamps, many of them nostalgic images, such as this sampling from its railroad collection.

A wide range of images plus embossing powders, stamp pads, techniques videos and paper items. Offers three different catalogs of stamp images at $2 per catalog.

Gumbo Graphics
P.O. Box 11801
Eugene, OR 95440
(503) 226-9895
Fax: (503) 223-2824
Over two thousand images, including unusual items, reproductions and more. Will send catalog for $2.

Hippo Heart
28 2nd Ave.
San Mateo, CA 94401
(650) 347-4477
Fax: (650) 347-4751
A variety of images, including borders and corners. Will send catalog for $2, refundable at the time of purchase.

Jam Paper & Envelope
111 3rd Ave.
New York, NY 10003
(800) 8010-JAM, (212) 473-6666
Fax: (212) 473-7300
Rubber stamps made from supplied artwork. Also novelty stamps. Will furnish free catalog.

L.A. Stampworks
P.O. Box 2329
North Hollywood, CA 91610
(818) 761-8757
Fax: (818) 761-0973
Over one thousand images include cartoon characters in action, balloon quotes, vintage images, borders and more. Offers catalog for $5.

Leavenworth Jackson
P.O. Box 9988
Berkeley, CA 94709
Offers over four hundred beautiful and useful designs. Doesn't handle fax or phone orders. Catalog available for $2.

Name Brand
P.O. Box 34245
Potomac, MD 20827
(301) 299-3062
Fax: (301) 299-3063
Custom stamps as well as standard slogans: "We've Moved," "Thank-You" and more.

100 Proof Press
R.R. 1, Box 136
Eaton, NY 13334
(315) 684-3547
Close to three thousand images, including ethnic and vintage images, make-a-face parts and more. Cost of catalog is $4.

Posh Impressions
30100 Town Center Dr., Ste. V
Laguna Real, CA 92621
(800) 421-POSH, (714) 651-1735
Offers over forty thousand images, plus videos, a newsletter and other learning aids. Offers catalog for $3.

Rubber Stamp Zone
777 Bridgeway, Ste. 203
Sausalito, CA 94965
(800) 993-9119, (415) 331-9601
Fax: (800) 993-9119
Offers thousands of images. Will send catalog for $2.

Stamp-a-Barbara
505 Paseo Nuevo
Santa Barbara, CA 93101
(805) 962-4077
Fax: (805) 568-0330
Manufactures stamps and carries stamps from a variety of companies.

A Stamp in the Hand Co.
20630 S. Leapwood Ave., Ste. B
Carson, CA 90746
(310) 329-8555
Fax: (310) 329-8985

Stamps with a hand-carved eraser look in a variety of designs. Also offers custom stamps. Send $3.75 for catalog.

Stamp Your Art Out

9725 Kenwood Rd.
Cincinnati, OH 45242-6130
(513) 793-4558
Fax: (513) 563-9620
Distribution center for stamps from a variety of manufacturers.

Manufacturers of Dry Transfer Graphics and Symbols

These companies manufacture rubdown transfers of graphic elements such as patterns, textures, bursts, and architectural and transportation symbols sold through art supply stores. Contact them directly to locate a retailer in your area.

Graphic Products Corp.

1480 S. Wolf Rd.
Wheeling, IL 60090-6514
(847) 537-9300
Fax: (847) 215-0111

Letraset USA

40 Eisenhower Dr.
Paramus, NJ 07653
(800) 526-9073
Fax: (201) 909-2451
www.letraset.com

Manufacturers of 2-D Illustration Software

These vector-based drawing programs can render black-and-white and four-color line drawings, logos and symbols. The programs also make patterns, gradations and produce type. Many can also be used with digital tablets to produce rendering techniques that simulate brushstrokes.

Adobe Systems

411 1st Ave. S.
Seattle, WA 98104-2871
(800) 833-6677, (206) 628-2749
www.adobe.com
Manufactures:
 Illustrator (Mac, PC)—Drawing program interfaces well with Photoshop's photoediting tools.

Corel Corp.

1600 Carling Ave.
Ottawa, Ontario K1Z 8R7
Canada
(800) 772-6735, (613) 728-3733
www.corel.com

Manufactures:
 CorelDRAW (PC)—Drawing program for Windows users includes clip art.
 Corel Draw Suite (Mac)—Drawing program is Corel's answer to professional Mac drawing programs, such as Illustrator and FreeHand.
 Corel Xara (PC)—Drawing program is useful for producing Web and print graphics.

Deneba Software

7400 SW 87th Ave.
Miami, FL 33173
(800) 622-6827, (305) 596-5644
Fax: (305) 273-9069
www.deneba.com
Manufactures:
 Canvas (Mac, PC)—Budget-priced program offers basic drawing capabilities.

Lari Software

207 S. Elliott Rd., Ste. 207
Chapel Hill, NC 27514
(800) 933-7303, (919) 968-0701
Fax: (919) 968-0801
www.larisoftware.com and www.electrifier.com
Manufactures:
 LightningDraw Pro (Mac)—Vector-based drawing program includes transparency effects similar to Photoshop's.

The Image Bank offers thousands of illustrations in a variety of styles—many from nationally known artists. See their listing on page 10.

One of many contemporary images offered by Laughing Stock. The agency's collection consists of many illustrations by well-known artists, such as this one by Timothy Cook. For more information, see their listing on page 10.

Macromedia
600 Townsend
San Francisco, CA 94103
(800) 457-1774, (415) 252-2000
www.macromedia.com
Manufactures:

FreeHand (Mac, PC)—Drawing program offers superior application integration with Web software.

Manufacturers of 3-D Rendering and Painting Programs

The programs listed below can render 3-D drawings or painterly techniques that replicate the look of fine arts media.

Asymetrix Corp.
110 110th Ave. NE
Bellevue, WA 98004
(800) 448-6543, (425) 462-0501
www.asymetrix.com
Manufactures:

Asymetrix 3D F/X (PC)—An excellent interface makes this budget-priced program easy to learn.

Caligari Corp.
1955 Landing Dr.
Mountain View, CA 95043
(800) 351-7620, (716) 871-5041
Fax: (415) 390-9755
www.caligari.com

Manufactures:

TrueSpace (PC)—Professional-quality 3-D modeling and animation program.

MetaCreations Corp.
P.O. Box 724
Pleasant Grove, UT 84062-9914
(800) 846-0111, (800) 472-9025, (805) 566-6200
Fax: (888) 501-6382
www.metacreations.com
Manufactures:

Bryce (Mac)—Offers basic 3-D modeling capabilities.

Detailer (Mac, PC)—3-D paint program creates simple 3-D models and surface maps. Users can also paint directly onto 3-D objects.

Infini-D (Mac)—Midrange-priced 3-D modeling program.

Painter (Mac, PC)—Long regarded as the premiere program for rendering images that replicate the look of fine arts mediums, such as oil paints on canvas, charcoal, pastel and marker on a variety of paper surfaces.

Ray Dream Studio (Mac, PC)—High-end 3-D illustration package also offers advanced animation features.

Strata, Inc.
2 W. St. George Blvd., Ste. 2100
St. George, UT 84770
(800) 869-6855, (801) 628-5218
www.strata3d.com
Manufactures:

StudioPro (Mac)—3-D drawing program offers professional-quality rendering tools.

Vision 3D (Mac)—Lower-priced version of StudioPro.

3D-Eye, Inc.
700 Galleria Pkwy., Ste. 400
Atlanta, GA 30339
(800) 946-9533, (770) 937-9000
www.eye.com
Manufactures:

TriSpectives (PC)—3-D program includes modeler and features that aid in the production of technical renderings. Comes with Vivid Details, a collection of royalty-free seamless tiles and textures plus other images.

TriWizard (PC)—Creates 3-D text, objects and animations. Comes with Vivid Details (see TriSpectives).

Manufacturers of Illustration, Painting and 3-D Plug-ins and Accessory Software

In addition to the plug-ins and accessories listed in this section, many of the products

listed in the plug-in section at the end of chapter two, "Photography," have the potential to work with some of the drawing, painting and 3-D rendering programs in this chapter. Review chapter two's plug-in section, and contact individual manufacturers for more information on program compatibility.

Adobe Systems

411 1st Ave. S.
Seattle, WA 98104-2871
(800) 833-6677, (206) 628-2749
www.adobe.com
Manufactures:

CADtools (Mac, PC)—Converts Illustrator into a drafting and precision drawing tool.

Alien Skin Software

1100 Wake Forest Rd., Ste. 101
Raleigh, NC 27604
(888) 921-7546, (919) 832-4124
Fax: (919) 832-4065
www.alienskin.com
Manufactures:

Stylist (Mac)—Illustrator plug-in helps create and manage style sheets and styled objects.

Avenza

3385 Harvester Rd., Ste. 205
Burlington, Ontario L7N 3N2
Canada
(800) 884-2555, (905) 639-3330
Fax: (905) 639-7057
www.avenza.com
Manufactures:

MAPublisher (Mac)—Illustrator plug-in bridges the gap between GIS data files and PostScript output. Aids in mapmaking.

MAPublisher LT (Mac, PC)—Easy way to import geographic desktop mapping and CAD files into Illustrator. Imports dedicated mapping formats such as SDTS and AutoCAD DXF.

DS Design, Inc.

1157 Executive Cir., Ste. D
Cary, NC 27511
(800) 745-4037, (919) 319-1770
www.dsdesign.com
Manufactures:

Colorize (Mac)—Lets user add color to black-and-white scans of line art.

Extensis

1800 SW 1st Ave., Ste. 500
Portland, OR 97201
(800) 796-9798, (503) 274-2020
Fax: (503) 274-0530
www.extensis.com

Art Parts offers digital clip art in black and white and color with a contemporary, woodcut look. The company offers CD-ROM collections covering a variety of subjects. See their listing on page 13.

Manufactures:

Vector Tools (Mac)—Successor to DrawTools lets Illustrator and FreeHand users work more efficiently by providing important missing functions.

ILLOM Development

Box 838, Strandgatan 21
S-891 18 Örnsköldsvik
Sweden
(+46) 660-786-57
Fax: (+46) 660-786-58
www.illom.com
Manufactures:

Toolbox (Mac)—Illustrator plug-in adds utility tools to program, such as a search and replace function, typestyle library and enhanced selection tools.

On-line Plug-in Source for Adobe Illustrator Users

www.pluginsource.com

Many of the programs listed that are Illustrator plug-ins can be accessed through the Adobe Plug-in Source Web site. The site gives descriptions and visual demos of each program's capabilities and system requirements. The plug-in source will also let you order and download many programs online. Programs that can't be downloaded from the Web site may be ordered by calling (800) 685-3547, sending a fax to (800) 648-8512 or E-mailing plugin@imageclub.com. In addition to Illustrator plug-ins, the site also offers Adobe Acrobat, PageMaker, Photoshop Premiere and After Effects plug-ins.

Time Tunnel's image library is comprised of direct scans of illustrations from collector's editions of old magazines. For more information, see their listing on page 15.

Macromedia

600 Townsend
San Francisco, CA 94103
(800) 457-1774, (415) 252-2000
www.macromedia.com
Manufactures:

XRes (Mac)—High-resolution image editor.

MetaCreations Corp.

P.O. Box 724
Pleasant Grove, UT 84062-9914
(800) 846-0111, (800) 472-9025, (805) 566-6200
Fax: (888) 501-6382
www.metacreations.com
Manufactures:

Bodacious Backgrounds, Dynamic Duet, Sensational Surfaces, Wild Bundle (Mac, PC)—Four collections, each consisting of about one hundred full-color TIFF images of surface textures and patterns that can be applied to images created in Painter, Ray Dream Studio and Detailer.

Micrografx Software, ABC Graphics Suite

1303 E. Arapaho Rd.
Richardson, TX 75081
(800) 671-0144, (972) 234-1769
Fax: (972) 994-6036
www.micrografx.com
Manufactures:

Designer (PC)—Aids users of Webtricity and Graphics Suite 2 in production of vector-based graphics, such as logos and symbols.

ScanVec, Inc.

155 West St.
Wilmington, MA 01887
(800) 866-6227, (508) 694-9488
Fax: (508) 694-9482
www.scanvec.com
Manufactures:

Tracer (Mac)—Vectorizing tool converts drawings and designs to paths.

Photography

Sources for Photographers

and Copyright-Free

Photography

Creative Directories

When searching for location photographers or stock agencies, don't overlook local talent directories. In additition to the local directories many cities offer, there are national talent books, huge directories regarded as the "Who's Who" of U.S. photography, illustration and design. Because they feature full-page, full-color ads of photographers' and photo agencies' work, each directory is a virtual catalog of photographic samples, offering pages and pages of styles and looks from which to choose.

The Alternative Pick/Storm Entertainment

1133 Broadway, Ste. 1408
New York, NY 10010
(212) 675-4176
Fax: (212) 675-4936
Features illustrators, designers, photographers and multimedia artists. Audience is primarily music and entertainment industry professionals.

The Creative Black Book

10 Astor Pl., 6th Fl.
New York, NY 10003
(212) 539-9800
Fax: (212) 539-9801
www.blackbook.com

Directory includes examples from about three hundred photographers. Also lists stock photography agencies, photo labs and retouchers.

KliK Showcase Photography

915 Broadway, 14th Fl.
New York, NY 10010
(800) 894-7469, (212) 673-6600
Fax: (212) 673-9795
www.showcase.com
Features more than thirteen hundred photos from photographers working in all parts of the United States.

The Workbook

940 N. Highland Ave.
Los Angeles, CA 90038
(800) 547-2688, (213) 856-0008
Fax: (213) 856-4368
New York Sales Office: (212) 674-1919
Chicago Sales Office: (312) 944-7925
www.workbook.com
Photography volume offers four-color representation of thousands of photographers organized alphabetically by region. Directory volume also lists retouchers, stylists, makeup artists and model agencies. *The Workbook*'s Web site also includes the on-line portfolios of many photographers and stock agencies.

Tip

Need to find a model, photo stylist or makeup artist? In addition to photographers, many of the talent directories listed in this chapter offer listings for these and other photography-related services.

A la Carte's specialty is food product photos. Images are shot with consistent lighting so they can easily be assembled in image-editing programs into still lifes.

Royalty-Free Collections on CD-ROM

As opposed to licensing images from stock agencies, images on CD-ROM enable the user to immediately draw from a copyright-free selection of images already on hand. The collections in this section are also royalty-free. Unlike stock images, which charge for each usage, royalty-free images can be used as often as you like. Each of the firms listed offers photo libraries on CD-ROM or diskette.

All collections are Mac- and PC-compatible, unless otherwise noted. Check individual listings for image resolution.

Images specific to Web design and multimedia can be found in chapter ten, "New Media."

Adobe Image Library/Image Club Graphics, Inc.
1525 Greenview Dr.
Grand Prairie, TX 75050
(800) 661-9410 (orders), (800) 387-9193 (catalog requests)
Fax: (800) 814-7783
www.imageclub.com
This division of Adobe offers a wide range of photography in a variety of useful formats. Web art packages deliver animated GIF, JPEG, 3DMF and QTVR images that include buttons, backgrounds, rules and other graphic elements. Photography for print is comprised of TIFF images and organized into volumes by subject matter. Collections such as Photogear offer thirty images of textures in two sizes for $79. The forty collections that comprise the Digital Vision series consist of one hundred related images at three resolution sizes for $250.

Agfa Direct
Agfa Division, Bayer Corp.
90 Industrial Way
Wilmington, MA 01887
(800) 424-TYPE, (508) 658-5600
Fax: (508) 657-5328
www.agfahome.com/agfatype
Offers a wide-ranging series of photo collections from other agencies. Image titles include those from Central Stock, Light Sources Stock, Take Stock and John Foxx Images in collections ranging from silhouettes of nostalgic memorabilia to lifestyle and nature images. Also offers a Digital Textures series, featuring $9'' \times 12''$ scans of metal, coins, corrugated metal and other background textures, as well as the Image Farm collection of background textures and objects (which includes clipping paths). Collections range from $69 to $249. Also sells royalty-free illustrations on CD-ROM.

A la Carte
3117 E. Northridge
Mesa, AZ 85213
(602) 807-6577
Fax: (602) 807-8005
Offers four collections. Each consists of one hundred high-quality photographs of food items, all shot individually against a white background. Individual food items are shot with consistent lighting so they can be assembled in an image-editing program into still lifes. Images are in Photo CD format. Cost is $250 for each collection.

Arc Media, Inc.

5330 Main St., #210
Buffalo, NY 14221
(716) 633-2269
or
238 Davenport Rd., #306
Toronto, Ontario M5R 1J6
Canada
(416) 410-4429
www.arcmedia.com
Sells over three hundred collections of about one hundred photos each. Library is constantly expanding and covers a full range of subject matter. Collections are available in either Photo CD, BMP, EPS, HIG, JPEG, PICT or TIFF with TIFF scans at various resolutions.

Artville

2310 Darwin Rd.
Madison, WI 53704-3108
(800) 631-7808, (608) 243-1215
www.artville.com
Over sixty collections of photography based on common themes as well as unique collections, including buttons, shells and close-ups of flowers and food. Images are supplied as CDR, EPS, JPEG and TIFF files with fifty to one hundred images per volume. Prices range from $60 to $290. Also sells royalty-free illustrations.

Aztech New Media

1 Scarsdale Rd.
Don Mills, Ontario M3B 2R2
Canada
(800) 494-4787, (416) 449-4787
Fax: (416) 449-1058
www.comcentral.net
Offers a World Photo collection of three thousand images, sold as a twenty-four-disc set. Also offers theme-based collections of about one hundred images each. All images are uncompressed 1,000 × 1,700-pixel TIFF images at 300 dpi. A sampler that contains all of the library's images at 72 dpi is available for $39.95.

BeachWare

9419 Mt. Israel Rd.
Escondido, CA 92029
(760) 735-8945
www.beachware.com
Offers two collections: a texture series of TIFF images scanned at 288 dpi plus low-resolution PICT images of people in bathing suits, many images vintage. All are available for Mac and PC. Collections are $19.95 each. Also offers images in screen resolutions.

Guide to Usage Rights

Royalty-free images give users unlimited use of the images. These are typically furnished at a single price, as collections on CD-ROM or on diskette.

Licensing arrangements grant the user onetime use of an image. These images are usually more expensive than rotyalty-free, frequently shot by big-name photographers and available through stock agencies that specialize in licensing individual photos. Usage rates vary depending on the size the image will ultimately appear, visibility of where it will appear (cover vs. interior of a publication) and the number of people who will see the image (usually based on circulation). Additionally, stock agencies will generally charge less for nonprofit than for commercial usage.

C&L Digital

Agfa Division, Bayer Corp.
90 Industrial Way
Wilmington, MA 01887
(800) 424-TYPE, (508) 658-5600
Fax: (508) 657-5328
www.agfahome.com/agfatype
High-quality images, created by photographer Bruce Cobb, are available in two collections of one hundred images each. One collection focuses on Western scenes and cowboys. The other is an assortment of elegant lifestyle shots. Images are 5″ × 7″ 300-dpi scans furnished as TIFF and JPEG files. Prices are $169 and $179.

Classic PIO Partners

87 E. Green St., Ste. 309
Pasadena, CA 91105
(800) 370-2746, (626) 564-8106
www.classicpartners.com
Library includes collections of retro objects from 20th Century Props: Telephones, Microphones, Radios, Business Equipment Volume 1, Nostalgic Memorabilia Volume 1, Entertainment Volume 1 and a two-disc set of Classic Fabrics. Each collection has forty images, twenty objects in two resolutions. Collections also include outline masks and clipping paths so that images can be arranged to produce collages. Prices for each collection range from $70 to $99. A sampler disc is also available for $49.

Comstock Klips

30 Irving Pl.
New York, NY 10003
(800) 225-2722, (212) 353-8600
Fax: (212) 353-3383
www.comstock.com
Well known for many years as a premiere stock photo agency, Comstock is now offering an ever-expanding

collection of its images in royalty-free collections. Current offerings number over twenty titles consisting of about 104 images each. Prices range from $79 to $499 per title. Images are reproduced at 300 dpi at 8″ × 12″ as JPEGs.

Copernicus Software

267 A Ave.
Lake Oswego, OR 97034
(800) 368-6231, (503) 636-8164
www.copernicus-software.com
Offers three titles of related subjects—Mountains and Climbers, Catalogs and Brochures, and Business and Industry—containing seventy images in two sizes and two resolutions. Also offers the Copernicus Collection of Multimedia Images, covering a broad range of subjects with 560 72-dpi images at various sizes. Photos are produced by a group of in-house photographers. Images are JPEG and PICT. Collections range from $49 to $100.

Corel Corp.

1600 Carling Ave.
Ottawa, Ontario K1Z 8R7
Canada
(800) 772-6735, (613) 728-3733
Fax: (613) 761-9176
www.corel.com
Offers an extensive library of over eighty thousand photos, available in eight hundred theme-based titles of one hundred images. The collection is also available in volume sets of twenty-five titles each or "Super Ten Packs" of ten titles each. Images are furnished in Photo CD format. Corel also includes a printed catalog and file manager with each of its CD-ROM collections. Windows customers get Corel Photo CD Lab software. Prices range from $25 to $775.

Cyberphoto

P.O. Box 10512
Newport Beach, CA 92658
(800) 990-3472, (714) 515-1300
www.cyberphoto.com
Eclectic library of images contains collections of beach scenes, sunsets and clouds; models in swimsuits; Egyptian art and architecture; and more. Most collections consist of around 125 images scanned in six sizes, for $60. File formats are JPEG and TIFF.

Diamar Interactive

600 University St., Ste. 1701
Seattle, WA 58101
(800) 234-2627, (206) 340-5975
www.diamar.com
Specializes in shots of people, offering ten volumes. Also sells collections of nature subjects plus individual shots of people and objects against white backdrops. Images are furnished as JPEG, Photo CD and

TIFF files. Prices range from $40 to $299 for collections ranging from fifty-four to one hundred images. Single image prices range from $40 to $199.

Digital Impact, Inc.

6506 S. Lewis, Ste. 275
Tulsa, OK 74136-1047
(800) 775-4232, (918) 742-2022
Fax: (918) 742-8176
www.digitalimpact.com
All-encompassing collection of around four hundred general-interest photos in Photo CD format is offered as a four-disc collection for $199. Collection is bundled with Kodak's Access software, which lets you view content in contact-sheet format.

Digital Stock Corp.

400 S. Sierra Ave., Ste. 100
Solana Beach, CA 92075
(800) 545-4514, (760) 634-6500
www.digitalstock.com
Offers an extensive library of digital images that are scanned at a high resolution of 2,048 × 3,072 pixels and color corrected, available on CD-ROM as collections of related subject matter. Each CD-ROM title is $249 and contains one hundred images. Close to one hundred CD-ROM titles are offered, with the collection ever expanding. Also offers a Signature series, which features the work of award-winning photographers. All images are ready for CMYK separations and bundled with Kodak color-management profiles. Also offers an on-line catalog and images for the Web.

Digital Wisdom

P.O. Box 2070
Tappahannock, VA 22560-2070
(800) 800-8560, (804) 443-9000
Fax: (804) 758-4512
www.digiwis.com
Library is divided into two collections. GlobeShots is made up of about 270 images of the earth, including star and cloud effects. Images are offered in 72- and 300-dpi resolutions. BodyShots contains 330 images of people at work, provided as 2,000 × 1,000-pixel images at 300 dpi. Collections range from $49 to $495 and come with image browsers. Also sells maps on CD-ROM.

D'Pix

P.O. Box 572
Columbus, OH 43216-0572
(614) 834-8834
www.dpix-direct.com
Offers cityscapes, textures, food, backgrounds, travel subjects. Lets the customers create their own CD-ROM collections of their own image selections.

Eldar Co.

95 Liberty St., Ste. A-8
Stamford, CT 06902
(800) 573-7753, (203) 323-4363
www.eldarco.com
Selective Ornaments collection includes over forty scanned images of marble architectural ornaments and tile available at 300- and 72-dpi resolutions. CD-ROM also includes vector-art patterns and ornaments and a browser. Price: $69 per title.

Harpy Digital, Inc.

P.O. Box 66023
Los Angeles, CA 90066
(310) 397-7636
Fax: (310) 397-4187
www.harpydigital.com
Offers collections of photography of exotic insects and moths shot against simple backgrounds. Each collection, consisting of about one hundred images, is $25 and comes with printed color thumbnails. Also sells two boudoir collections of duotoned nudes photographed between 1885 and 1920 as well as vintage photos of gargoyles and cathedrals from the same period.

Imaging Ideas

105 W. Beaver Creek Rd., Ste. 5
Richmond Hills, Ontario L4B 1C6
Canada
(888) 238-1600, (905) 709-1600
Fax: (905) 709-1625
Library includes ten contemporary collections of $7'' \times 5''$ or $10'' \times 6\frac{1}{2}''$ images scanned at a resolution of 300 dpi. Other collections include vintage black-and-white photos, printing and engravings of famous works of art and backgrounds, textures and objects—all scanned at resolutions and sizes suitable for print. Also sells A la Carte's collection of food images. Offers CD-ROM browser of low-resolution versions of its library.

Letraset USA

40 Eisenhower Dr.
Paramus, NJ 07653
(800) 526-9073
Fax: (201) 909-2451
www.letraset.com
Offers a Phototone collection of five background textures, including food, paper and textiles, industrial surfaces and natural backgrounds. Price is $199 for each collection. Users of a limited number of images can purchase a low-resolution preview collection on CD-ROM for $39.95. Once a selection is made, your

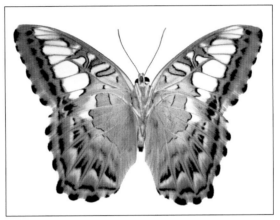

Much of Harpy Digital's image library is made up of collections of exotic insects shot individually against simple backgrounds. The company also sells collections of other subject matter.

first high-resolution version of an image is free. After that, selections are $149.95 each.

Mary and Michael Photography

135 Cowper St.
Palo Alto, CA 94301
(650) 326-9567
Fax: (650) 326-6247
www.commerce.digital.com
Professional photographers Mary Bartinikowski and Michael Price offer their Cloud Gallery collection for $19.95. Collection comes with printed thumbnails. Other images offered are gathered from their personal travels and cover a diverse range of subjects. These images are available at single-image prices ranging from $15 to $70, depending on the resolution.

PhotoDisc, Inc.

2013 4th Ave.
Seattle, WA 98121
(800) 528-3472, (206) 441-9355.
Fax: (206) 441-9379
www.photodisc.com
Extensive collection of over sixty thousand images is organized into over 130 volumes ranging from $149 to $499 each. Each volume comes with image-management

software. Collections include Clement Mok's photographic clip art library of twenty-five thousand images. A starter kit, which allows for viewing the entire collection, is available for $39. Company also offers on-line sales and delivery of its CD collections.

PhotoSphere Images, Ltd.

380 W. 1st Ave., Ste. 310
Vancouver, British Columbia V5Y 3T7
Canada
(800) 655-1496, (604) 876-3206
Fax: (800) 757-5558, (604) 876-1482
www.photosphere.com/photos
Offers an extensive library of people, places, backgrounds and more. Available as single images, which can be downloaded on-line, or in collections of one hundred images on CD-ROM for $195 to $250. A five-hundred-photo sampler is also available for $25. PhotoSphere images are also distributed by Softedge.

PhotoSpin

29916 S. Hawthorne Blvd.
Rolling Hills Estates, CA 90274
(888) 246-1313, (310) 265-1313
Fax: (310) 265-1314
www.photospin.com
Offers fifteen subject volumes of noncompressed, high-resolution images. Number of photos per volume ranges from fifty to one hundred. Prices range from $189 to $389. Subject matter ranges from collections of travel images to medical elements. Sells a browser of one thousand noncompressed low-resolution images from the library for $39.95.

Rubber Ball Productions

44 N. Geneva Rd.
Orem, UT 84057
(888) 224-DISC, (801) 224-6886
www.rubberball.com
Specializes in images of people, offering seven volumes devoted exclusively to different ages and subject matter. Also offers a collection of patterns, details and reflections. Collections contain one hundred JPEG images each and range from $249 to $299. Collection is also available through Agfa Direct.

Seattle Support Group

20420 84th Ave. S.
Kent, WA 98032
(800) 995-9777, (253) 395-1484
www.ssgrp.com
Vast library of over eight thousand images contains thirty-five collections of BMP, JPEG and PICT images organized by subject matter. Collection titles range from one hundred to three hundred images. Image topics run the gamut, ranging from the late Princess Di to vintage. Prices range from $19.95 to $199.95, depending on collection size. For instance, collections

of three hundred images scanned at two resolutions are $124.95. Also offers free images from its Web site.

Softedge

37 Plaistow Rd., Unit 7, Ste. 121
Plaistow, NH 03865
(800) 363-7709, (603) 382-4389
Fax: (603) 382-9353
Serves as a distributor for a variety of photo collections on CD-ROM, including textures and other background effects, and distributes PhotoSphere stock photos. Also offers a series of photographic special effects that work as Photoshop plug-ins. Effects turn continuous-tone images into line art, add edge effects, shadows, textures and other 3-D applications to images. Also sells royalty-free illustrations and fonts (Cool Fonts).

Totem Graphics, Inc.

6200 Capitol Blvd., Ste. F
Tumwater, WA 98501
(360) 352-1851
Fax: (360) 352-2554
www.gototem.com
Features photography of Mearle Gates, who has traveled all over the world to capture a stunning collection of nature photos. Currently offers two collections of 160 images in TIFF format, scanned at 225 dpi resolution for $59.95 each for Mac and PC. Also offers illustrations.

Transmission Digital Publishing

242 W. 30th St., Ste. 3NW
New York, NY 10001
(800) 585-2248, (212) 727-2493
www.transmissiondigital.com
This library of images from photographer Earl Ripling offers a variety of subjects shot with a contemporary, edgy style. Many incorporate blurred motion. Ripling currently offers two collections of thirty-eight TIFF and JPEG images that are a mix of black and white and color, all at 300 dpi and 2,250 × 3,300 pixels. Additional collections will be issued at the rate of one a year. Low-resolution copies of each image are also included. Collections are $129.95 and $149.95 each and are also available through Agfa Direct.

Vivid Details

8228 Sulphur Mountain Rd.
Ojai, CA 93023
(800) 948-4843, (805) 646-0217
www.vivid.com
Offers over six hundred images, mostly textures, backgrounds and other nonpeople or locale subject matter, organized into twelve different volumes, each containing thirty to sixty images. Two volumes are black-and-white versions of popular color volumes. Images are

furnished as 300-dpi, drum-scanned TIFFs. A catalog preview disc, available for $39, shows the complete library as thumbnail images. Volumes are $179 to $229 each.

WeatherStock

P.O. Box 31808
Tucson, AZ 85751
(520) 751-9964, (520) 751-1185
Fax: (520) 751-1185
www.stormchaser.com
Offers one hundred high-resolution images of weather-related photos on CD-ROM for $199. Includes tornadoes, storms, clouds and some geographical shots.

Stock Images on CD-ROM

The following companies offer stock images that are available through CD-ROM browsers. Users of these services purchase a CD-ROM containing low-resolution versions of a stock collection for a nominal fee. Low-resolution versions can be used in comps, but users must pay an additional fee for onetime use of the image when it goes to press. Typically, the agency will supply an unlocking code once the purchase has been made to enable the user to access the high-resolution version of an image.

FPG International

32 Union Square E.
New York, NY 10003
(212) 777-4210
FAX: (212) 995-9652
www.fpg.com
Currently offers low-resolution versions of its image library, available on five CD-ROMs containing 3,500–5,000 images each. CD-ROMs are available free of charge. Images are low-resolution versions of photos from the agency's files that offer unlimited comp usage. Users pay a usage fee if high-resolution originals are furnished.

Letraset USA

40 Eisenhower Dr.
Paramus, NJ 07653
(800) 526-9073
Fax: (201) 909-2451
www.letraset.com
Offers a Phototone collection of background textures, including food, paper and textiles, industrial surfaces and natural backgrounds. A low-resolution preview collection on CD-ROM is available for $39.95. Once a selection is made, your first high-resolution version of an image is free. After that, selections are $149.95 each.

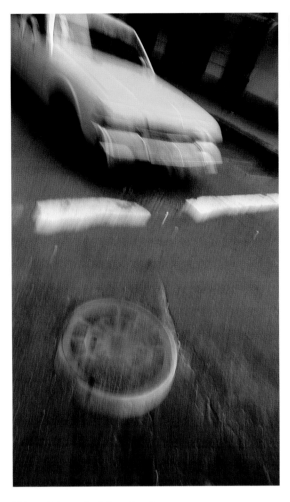

Transmission Digital Publishing specializes in contemporary subject matter. Many images are shot in an edgy, blurred-motion style.

The Stock Market

360 Park Ave. S., 16th Fl.
New York, NY 10010
(800) 999-0800, (212) 684-7878, (800) 283-0808
Fax: (800) 283-0808
www.stockmarketphoto.com
Offers six thousand images from its extensive library on CD-ROM for $59.95. Images are low-resolution versions of photos from the agency's files. Users pay usage fees when high-resolution originals are furnished for publication.

SuperStock

7660 Centurion Pkwy.
Jacksonville, FL 32256
(800) 828-4545, (904) 565-0066, (800) 246-3378
(for catalog and CD-ROM browser)
Fax: (904) 641-4480
Offers eleven hundred low-resolution images from its library of close to four million photos on a CD-ROM browser. Browser is free of charge and accompanied with a catalog. Users pay a usage fee when high-resolution originals are furnished for publication.

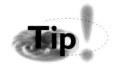

Stock Photo Agencies

Stock agencies lend photographic images to users who are charged onetime fees for publishing these images. If you're looking for a particular photographic image, call a stock agency, describe what you want, and the agency will call, fax or send you a description or preview of the images it has that meet your requirements. Some stock agencies offer Web sites that will let you search for a particular image.

Photographic images are available in prints, slides, 4″ × 5″ and larger-sized transparencies, and digital files. Fees will vary, depending on the image format, usage and agency research time involved. If you contract to use a specific image, in addition to paying the fee, you are responsible for returning the original to the agency in a timely manner.

The listings in this section carry a variety of subject matter. Many agencies offer images specific to their locales. All will respond to phone inquiries by sending free catalogs or descriptions of their photographic subject areas.

Comstock

30 Irving Pl.
New York, NY 10003
(800) 225-2727, (212) 353-8600
Fax: (212) 353-3383
www.comstock.com
Offers over five million photographs covering all types of subject matter. In addition to traditional photographic formats, it offers royalty-free photographs from its collection on CD-ROM. See listing under Royalty-Free Collections on CD-ROM.

Corbis-Bettman

902 Broadway, 5th Fl.
New York, NY 10010
(888) 771-6200, (212) 777-6200
Fax: (212) 533-4034
or
Corbis Corp.
15395 SE 30th Pl., Ste. 300
Bellevue, WA 98007
(425) 641-4505
Fax: (425) 643-9740
www.corbis.com
Stocks millions of photos and some illustrations, including what was formerly the Bettman Archive collection of vintage photos. Also sells royalty-free images on CD-ROM and offers an on-line catalog and ordering.

FPG International

32 Union Square E.
New York, NY 10003
(212) 777-4210
Fax: (212) 995-9652
www.fpg.com
Stocks approximately six million images covering all types of subject matter. Also offers CD-ROM browser.

Fundamental Photographs

210 Forsythe St.
New York, NY 10002
(212) 473-5770
Fax: (212) 228-5059
www.fphoto.com
Science stock agency specializing in chemistry and physics photos. Collection is used primarily as textbook visuals.

Grant Heilman Photography, Inc.

506 W. Lincoln Ave.
Lititz, PA 17543
(800) 622-2046, (717) 626-0296
Fax: (717) 626-0971
Offers close to 400,000 images covering all types of subject matter, including contemporary and historical. Charges no research fee.

H. Armstrong Roberts

4203 Locust St.
Philadelphia, PA 19104
(800) 786-6300, (215) 386-6300
Fax: (800) 786-1920
In business since 1926, the agency offers an extensive file of black-and-white archival images as well as over 500,000 color images.

Harold M. Lambert Studios, Inc.

2801 W. Cheltenham Ave.
Philadelphia, PA 19150
(215) 224-1400
Close to one million color and black-and-white images, many historical.

The Image Bank

2777 Stemmons Frwy, Ste. 600
Dallas, TX 75206
(214) 863-4900
Fax: (214) 863-4860
or
111 5th Ave.
New York, NY 10003
(212) 539-8300
Fax: (212) 539-8391
www.theimagebank.com
Over a million images, historical as well as contemporary, black and white or color. In addition to photography, offers illustration and film.

Index Stock

23 W. 18th St., 3rd Fl.
New York, NY 10011
(212) 929-4644
Fax: (212) 633-1914
or
6500 Wilshire Blvd., Ste. 500
Los Angeles, CA 90048
(213) 658-7707
Fax: (213) 651-4975
or
67 Broad St.
Boston, MA 02109
(617) 443-1113
Fax: (617) 443-1114
or
1822 Blake St., Ste. A
Denver, CO 80202
(800) 288-3686, (303) 293-0202
Fax: (303) 293-3140
www.indexstock.com
Offers close to a half million contemporary and vintage photographs covering a broad range of subject matter. Also offers images over the Internet.

Jay Maisel Photography

190 Bowery
New York, NY 10012
(212) 431-5013
Fax: (212) 925-6092
www.jaymaisel.com
Over one million photographs covering a broad range of subject matter. All color and contemporary imagery.

Liaison International

11 E. 26th St., 17th Fl.
New York, NY 10010
(800) 488-0484, (212) 779-6300
www.liaisonintl.com
Represents 225 photographers worldwide and offers over 250,000 mostly contemporary images.

Magnum Photos

151 W. 25th St., 5th Fl.
New York, NY 10001
(212) 929-6000
Fax: (212) 929-9325
http://magnumphotos.capgemini.co.uk
Offers millions of journalistic photos covering a broad range of subject matter from the 1930s to present. Specialty is World War II photographs.

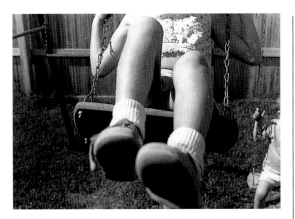

Masterfile

35 E. Wacker Dr., Ste. 2188
Chicago, IL 60601
or
175 Bloor St. E.
South Tower, 2nd Fl.
Toronto, Ontario M4W 3RI
Canada
(800) 387-9010, (416) 929-3000
Fax: (415) 929-2104
www.masterfile.com
Offers a large collection of contemporary black-and-white and color imagery. Also offers illustrations.

PhotoBank

17952 Skypark Cir., Ste. B
Irvine, CA 92714
(800) 383-4084, (714) 250-4480
Fax: (714) 752-5495
Offers about a half million images covering a broad range of subject matter, including some illustration. Offers free CD-ROM browser.

The PhotoFile

48 Century Ln.
Petaluma, CA 94952
(800) 334-5222, (415) 397-3040
Fax: (707) 766-8811
General stock agency offering about one million images, the majority in color. Also offers regional subject matter under the name San Francisco Stock.

Photo Researchers, Inc.

60 E. 56th St.
New York, NY 10022
(800) 447-0733, (212) 620-3955,
Fax: (212) 645-2137
www.photoresearchers.com
Over one million color and black-and-white images. Offers an extensive file of science, nature and medical imagery.

The Image Bank stocks over a million images covering a broad range of eras and subject matter.

31

Photri-Microstock
3701 S. George Mason Dr., Ste. C2N
Falls Church, VA 22041
(800) 544-0385, (703) 836-4438
Fax: (703) 998-8407
www.microstock.com
General stock agency offering close to one million
contemporary images.

The Picture Cube
67 Broad St.
Boston, MA 02129
(800) 335-CUBE, (617) 443-1113
Fax: (617) 443-1114
www.picturecube.com
Stocks black-and-white as well as color images. Also
has vintage photos. Extensive file of regional images.

Retna
18 E. 17th St., 3rd Fl.
New York, NY 10003
(212) 255-0622
Fax: (212) 255-1224
Specializes in celebrities, particularly pop musicians.
Library includes images dating from the 1950s to
present.

Sharpshooters, Inc.
4950 SW 72nd Ave., Ste. 114
Miami, FL 32155
(800) 666-1266, (305) 666-1266
Fax: (305) 666-5485
www.sharpshooters.com
Subject matter covers people of all ages in a variety
of settings, business situations, sports, nature and
wildlife. Does not charge research fees. Offers free
CD-ROM browser.

Stock Imagery, Inc.
711 Kalamuth St.
Denver, CO 80204
(800) 288-3686, (303) 293-0202
Fax: (303) 293-2140
www.stockimagery.com
Offers over 100,000 images covering a broad range of
contemporary subject matter. Most recent additions to
photo library include A Taste of Europe, consisting
of thousands of images of European people and sights.

The Stock Market
360 Park Ave. S., 16th Fl.
New York, NY 10010
(800) 999-0800, (212) 684-7878
Fax: (800) 283-0808
www.stockmarketphoto.com
General subject matter, some illustration, mostly color.
Over two million images covering all types of subject
matter. Offers some illustration as well as an extensive
collection of images on its Web site.

Stockworks
11936 W. Jefferson Blvd., Ste. C
Culver City, CA 90230
(310) 390-9744
Fax: (310) 390-3161
Over four hundred images, primarily contemporary.

Streano/Havens
P.O. Box 488
Anacortes, WA 98221
(360) 293-4525
Fax: (360) 293-2411
Offers over 150,000 contemporary photos, primarily
general subject matter but also many regional images
of the Pacific Northwest.

SuperStock
7660 Centurion Pkwy.
Jacksonville, FL 32256
(800) 828-4545, (904) 565-0066, (800) 246-3378 (for
catalog and CD-ROM browser)
Fax: (904) 641-4480
Offers close to four million photos spanning all types
of subject matter, including vintage clips. In addition
to photography, collection includes over fifty thouand
fine art masterpieces. Offers free CD-ROM browser.
Also stocks illustrations.

Tom Stack and Associates
3645 Jannine Dr., Ste. 212
Colorado Springs, CO 80917
(800) 648-7740, (719) 570-1000
Fax: (719) 570-7290
Agency specializes in international wildlife, nature
and space. Over a million images available.

Tony Stone Images
500 N. Michigan Ave., Ste. 1700
Chicago, IL 60611
(800) 234-7880, (312) 644-7880
Fax: (312) 351-0758
www.getty-images.com
Extensive image library includes the Hulton Getty
Photo Collection, an archive of historic photojournalis-
tic images. Based in London, agency also has offices
in New York, Toronto and Los Angeles. Charges no
research fee.

Uniphoto
19 W. 21st St., Ste. 901
New York, NY 10010
(800) 225-4060, (212) 627-4060
Fax: (212) 645-9619
or
3307 M St. NW, Ste. 300
Washington, DC 20007
(800) 345-0546
Fax: (202) 338-5578
www.uniphoto.com

Offers over three million mostly color images, dating from the late 1950s to present.

Visuals Unlimited

P.O. Box 10246
Swanzey, NH 03446
(603) 352-6436
Fax: (603) 357-7931
Offers 400,000 contemporary images, 80% color, encompassing work of over four hundred photographers. Large file of science and geographical images.

Westlight

2223 S. Carmelina Ave.
Los Angeles, CA 90064
(800) 872-7872, (310) 820-7077
Fax: (310) 820-2687
General subject matter, mostly contemporary. Millions of images available.

West Stock

101 Stewart St., Ste. 800
Seattle, WA 98101
(800) 821-9600, (206) 728-7726
Fax: (206) 728-7638
www.weststock.com
Offers millions of images ranging from historical to contemporary. In addition to functioning as a traditional stock photo agency, West Stock also sells images on-line.

Zephyr Images

339 N. Hwy. 101
Solana Beach, CA 92705
(800) 537-3794, (619) 755-1200
Fax: (619) 755-3723
Over 100,000 contemporary images of people and lifestyle subject matter.

Specialty Stock Agencies

Looking for a photo specific to a region or a particular subject? These stock agencies focus on specific subject matters or regions of the country.

Adstock Photos

2614 E. Cheryl Dr.
Phoenix, AZ 85028-4349
(800) 266-5903, (602) 277-5903
Fax: (602) 992-8322
www.adstockphotos.com
General and regional contemporary subject matter (majority of photographers are based west of the Mississippi).

Tony Stone Images offers a broad range of subject matter ranging from historical to contemporary.

Animals, Animals Enterprises

580 Broadway, Ste. 1102
New York, NY 10012
(212) 925-2110
Fax: (212) 925-2796
or
17 Railroad Ave.
Chatham, NY 12037
(518) 392-5500
Fax: (518) 392-5550
www.animalsanimals.com
Specializes in nature and wildlife photography as well as people in outdoor settings.

Archive Photos/Archive Films

530 W. 25th St., 6th Fl.
New York, NY 10001
(800) 688-5656, (212) 675-0115
Fax: (212) 675-0379
www.archivephotos.com
Offers over twenty thousand historical news photos. File also includes nineteenth-century engravings. Can supply images on CD-ROM.

Arms Communications

1517 Maurice Dr.
Woodbridge, VA 22191
(703) 690-3338
Fax: (703) 490-3298
www.armscomm.com
Specializes in military subject matter. Collection is mostly contemporary, with some images dating back to Vietnam era.

Can't find what you need from a stock agency? Need to hire a photographer to get that specific shot? Check the photography organizations in chapter eight, "Professional Information." They can help direct you to member photographers in your area.

Art On File

1837 E. Shelby
Seattle, WA 98112
(206) 322-2638, (206) 329-1928
Offers images of great art and architecture. Special rates available for educational use. Can supply digitized images on CD-ROM as well as traditional photographic formats.

Art Resource

65 Bleecker St.
New York, NY 10012
(212) 505-8700
Fax: (212) 420-9286
www.artres.com
Agency accesses archival sources, including the Smithsonian Institution, for photos of great art and architecture.

Biological Photo Service/ Terraphotographics

P.O. Box 490
Moss Beach, CA 94038
(650) 359-6219
Fax: (650) 359-6219
www.agpix.com/biologicalphoto.shtml
Offers close to 100,000 earth, environmental, geological, medical and life science images plus others of nature subjects, including flowers, skies, animals and water.

Black Star

116 E. 27th St.
New York, NY 10016
(212) 679-3288
Fax: (212) 447-9732
www.blackstar.com
Stocks close to four million photos on mostly social issues and politically-related subject matter. Includes historical as well as contemporary imagery. Will also send photographers on assignment.

CapeScapes

P.O. Box 247
Cummaquid, MA 02637
(508) 362-8222 (phone and fax)
Stock/assignment agency specializes in seascapes, backgrounds, generics, icons and details. Offers twenty thousand images covering New England, Maine, Cape and Islands, central California, Atlantic coast and New Orleans. Will send free poster and promo pack.

Refer to image on page 36.

Culver Pictures, Inc.

150 W. 22nd St., Ste. 300
New York, NY 10011
(212) 645-1672
Fax: (212) 627-9112
Offers close to ten million color and black-and-white images predating the 1950s. Collection includes millions of movie stills as well as vintage illustrations.

Custom Medical Stock Photo

3660 W. Irving Park Rd.
Chicago, IL 60618
(800) 373-2677
www.cmsp.com
Stocks millions of photos and illustrations dealing with scientific subject matter, particularly medicine, psychology and chemistry. Offers an electronic bulletin board where images can be previewed. Will also supply images on CD-ROM.

Duomo Photography, Inc.

133 W. 19th St.
New York, NY 10014
(212) 243-1150
Fax: (212) 633-1279
Specializes in sports photos dating from the 1960s to the present.

ESTO

222 Valley Pl.
Mamaroneck, NY 10543
(914) 698-4060
Fax: (914) 698-1033
www.esto.com
Specializes in photos of art and architecture. Can draw from existing supply of images or send photographers on assignment.

First Image West

104 N. Halstead, Ste. 200
Chicago, IL 60661
(312) 733-9875
Fax: (312) 733-2844
Specializes in Midwestern, Western and Southwestern photography, primarily scenic. Also offers general stock images.

Focus on Sports, Inc.

222 E. 46th St., 4th Fl.
New York, NY 10017
(212) 661-6860
Fax: (212) 983-3031
Stocks sports-related subject matter dating from the 1960s to present.

Kulik Photographic/Military Stock

7209 Deerfield Ct.
Falls Church, VA 22043
(703) 979-1427
Fax: (703) 204-0966 (Mike Kulik)
Specializes in military photos dating from World War I to present.

Long Photography

5765 Rickenbacker Rd.
Los Angeles, CA 90040
(213) 888-9944
Fax: (213) 888-9997
www.longphoto.com
Specializes in contemporary sports-related images dating back to the 1970s. Will preview images on-line and supply customers with images on CD-ROM or in traditional photographic mediums.

Mountain Stock Photography and Film, Inc.

P.O. Box 1910
Tahoe City, CA 96145
(916) 583-6646
Fax: (916) 583-5935
Specializes in adventure sports, scenic and lifestyle imagery from around the world. As its name suggests, it also has all types of spectacular mountain images.

Refer to image on page 37.

Movie Star News

134 W. 18th St.
New York, NY 10011
(212) 620-8160
www.moviestarnews.com
Offers millions of images from classic movies, from the silent era to present. Library also includes movie posters.

National Baseball Library

P.O. Box 590
Cooperstown, NY 13326
(607) 547-7200
Fax: (607) 547-4094
www.baseballhalloffame.org
As part of the Baseball Hall of Fame, this library offers over 400,000 current and historical images relating to baseball, including team photos, players and stadiums. Collection dates back to the mid-1800s and includes some etchings as well as color and black-and-white photos.

Biological Photo Service/ Terraphotographics specializes in nature and life science subject matter. Photos cover the range between microscopic images to panoramic nature and underwater shots.

Nawrocki Stock Photos

20-L W. 15th St.
Chicago, IL 60605
(800) 356-3066, (312) 427-8625
Fax: (312) 427-0178
Historical photos and etchings, movie stills and a broad range of contemporary subject matter. Known mostly for model release and travel photography. Offers several catalogs specific to subject areas.

Pacific Stock

758 Kapahulu Ave., Ste. 250
Honolulu, HI 96816
(800) 321-3239, (808) 735-5665, (808) 736-7891
Fax: (808) 735-7801
www.pacificstock.com
Offers a broad range of subjects but specializes in Hawaiian, South Pacific and Asian imagery, including scenic, nature and lifestyle photos from these regions.

Panoramic Stock Images

230 N. Michigan Ave.
Chicago, IL 60601
(800) 543-5250, (312) 236-8545
Fax: (312) 704-4077
www.panoramicimages.com
Offers panoramic landscapes from all over the world, primarily color, contemporary imagery. Specializes in large-format transparencies, 8″ × 10″ and larger.

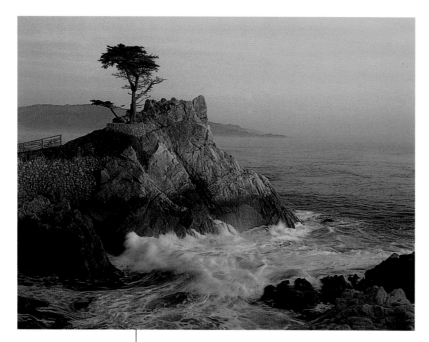

CapeScapes offers coastline images from New England, the Atlantic Coast, New Orleans and central California. Shots range from iconographic and scenic to local interest. For more information, see their listing on page 34.

Peter Arnold, Inc.

1181 Broadway
New York, NY 10001
(800) 289-7468, (212) 481-1190
Fax: (212) 481-3409
Offers close to 400,000 images, mostly color. Specializes in animals, wildlife, nature, medical and scientific subject matter. Also offers travel and traditional subject matter.

Plastock

30 N. 1st St., 4th Fl.
Minneapolis, MN 55401
(612) 339-5181
Fax: (612) 339-3283
Founded by designer Charles Spencer Anderson, Plastock specializes in photos of plastic objects. Library consists of approximately twenty-four hundred color images of mostly vintage subject matter.

Shooting Star International Photo Agency

1441 N. McCaddan Pl.
Hollywood, CA 90028
(213) 469-2020
Fax: (213) 464-0880
Specializes in photos of entertainers, politicians and other celebrities.

Stockshop/Medichrome/ Anatomy Works

232 Madison Ave.
New York, NY 10016
(212) 679-8480
Fax: (212) 532-1934
Medichrome, one of this agency's three divisions, specializes in medical subject matter, while Stockshop

offers general subjects. Also carries medical illustrations.

Time Life Syndication

1271 6th Ave., Rm. 2858
New York, NY 10020
(212) 522-4800
Fax: (212) 522-0328
www.pathfinder.com
Offers primarily fashion and human interest subject matter from the archives of *Time* and *Life*.

Visions Photo Agency, Inc.

220 W. 19th St., Ste. 500
New York, NY 10011
(212) 255-4047
Fax: (212) 691-1177
Stocks mostly travel and adventure photos. Images are all contemporary.

WeatherStock

P.O. Box 31808
Tucson, AZ 85751
(520) 751-9964, (520) 751-1185
www.stormchaser.com
Weather-related imagery. Over ten thousand images of tornadoes, rain and so on. Also has scenic shots. Over ten thousand contemporary images. Also sells royalty-free images.

Refer to image on page 38.

Budget Sources for Stock Photography

The following federal and state agencies maintain photo libraries of images that you may rent at a nominal fee, or pay handling charges to borrow. Because these agencies'research capabilities aren't on par with those of commercial agencies, it may take a while before these agencies can locate what you need. But if you've got the time, they've got visuals at prices just about anyone can afford.

Hunt Institute for Botanical Documentation

Carnegie Mellon University
5000 4th Ave., 5th Fl.
Pittsburgh, PA 15213
(412) 268-2434
Fax: (412) 268-5677
Specializes in nature scenes, botanical images. Fees start at $75 for black-and-white photos or color transparencies. Normal turnaround is twenty to thirty working days. Rush service is available for a higher fee.

NASA

400 Maryland Ave. SW, Rm. 6035
Washington, DC 20546
(202) 358-1900
Fax: (202) 358-4333

Loans shots of earth from space, space shuttle liftoffs and landings, moon landings and so on for editorial use at no charge. Some restrictions apply for promotional or advertising applications. Requests need to be made in writing on company letterhead. Images are supplied within two weeks, and users can keep visuals up to two weeks.

National Archives at College Park

8601 Adelphi Rd.
College Park, MD 20740-6001

The National Archives makes reproductions of its collection available through private vendors. Charges average around $8 for a black-and-white photograph and $10 for a color 35mm slide. Scans are also available on disk and CD-ROM as well as various types of color prints. Write to the address above for a list of vendors and their prices.

Parks & History Association

126 Raleigh St. SE
Washington, DC 20032
(202) 472-3083
www.parksandhistory.org

Web site has browser that allows access to thumbnails of library's digital images. Photos are organized by park name and subject matter. Prices vary, depending on size, but start at $31.50 for a 300-dpi, 2″ × 3″ color image. When selections are made, high-resolution images are delivered as TIFF or Photoshop files on CD-ROM, zip and jazz discs or diskette. Images can also be downloaded from Web site free of charge for non-commercial use.

Internet Sources for Stock and Royalty-Free Photography

Although many stock agencies have Web sites, only these agencies offer Web sites with search engines that will allow you to search for and select specific images within their libraries. All will furnish downloadable comp images free of charge. Payment terms vary, depending on the agency, as do delivery options. Some agencies let you download your selected images from their Web sites, while others furnish image selections on CD-ROM.

Looking for shots of mountains? Mountain Stock Photography and Film covers all aspects of mountain-related imagery ranging from scenic to lifestyle. For more information, see their listing on page 35.

Corel Galleria

(800) 772-6735, (613) 728-3733
www.corel.com

This ever-growing library includes over eighty thousand photos available in different sizes and resolutions. Low-resolution viewing images are watermarked. Once an image is selected, it can be downloaded or purchased on CD-ROM.

Digital Stock

(800) 545-4514, (619) 794-4040
www.digitalstock.com

This on-line division of Corbis-Bettman offers over sixty-six hundred royalty-free images covering a wide range of subject matter. Once selections are made, images are delivered on CD-ROM in collections of one hundred images for $249. Also sells individual images on-line.

Index Stock

www.indexstock.com

This traditional stock agency is constantly digitizing its library of 280,000 photos and adding to its on-line portfolio, which offers over 20,000 images. High-quality comp images are furnished at no charge. The Web site is divided into consumer and professional sections. Purchases from the professional section are handled by calling the agency, whereas purchases of images from the consumer section can be accomplished with a credit card.

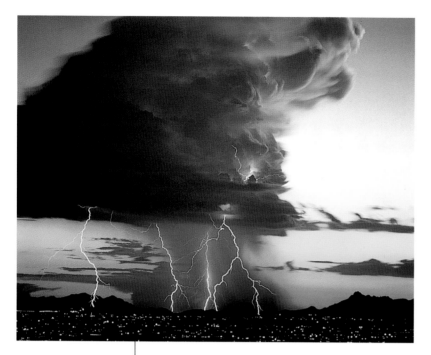

WeatherStock licenses all kinds of weather-related imagery, including tornadoes, rain and sunny-day scenery. For more information, see their listing on page 36.

John Foxx Images

(212) 644-9123

www.johnfoxx.com

Over five thousand royalty-free images are offered covering a variety of subject matter, with a large portion devoted to business concepts. Once selections are made, images are sold individually, by special order or in collections of 240 on CD-ROM for $295.

Muse

West Stock

(800) 821-9600, (206) 728-7726

www.weststock.com

Muse is the Web site for West Stock, a traditional stock agency that has made over twenty-thousand of its one-million-image collection available to users through this site. (As West Stock continues to digitize its collection, the number of images Muse offers is continually growing.) An image selection can be licensed for single use for a cost of $10 to $70, depending on size and usage. This agency allows users to download free comp images. Final images can be purchased by credit card and immediately downloaded from the Web site.

PhotoDisc

(206) 441-9355

www.photodisc.com

Offering over fifty thousand royalty-free images to choose from, PhotoDisc will sell individual images through its Web site for $50 or allow you to purchase your selections as CD-ROM collections ranging from $149 to $299, depending on the size and quantity of images purchased. CD-ROM delivery is overnight.

PhotoSphere Images, Ltd.

(800) 655-1496, (604) 876-3206

www.photosphere.com/photos

Offers an extensive library of people, places, backgrounds and more. Available as single images, which can be downloaded on-line, or in collections of one hundred images on CD-ROM for $195 to $250. A five-hundred-photo sampler is also available for $25.

PNI/Publishers Depot

(703) 312-6210

www.publishersdepot.com

The site of Picture Network International offers the Internet's largest collection of images. Over 375,000 can be licensed for single use, while at least 25,000 are available royalty-free from this ever-expanding collection. Prices range from $10 to $120 for royalty-free images, furnished on-line. Onetime usage fees from the stock collection are negotiated for images that are delivered on-line.

The Stock Market

(800) 999-0800, (212) 684-7878

www.stockmarketphoto.com

With a library of over two million images, The Stock Market is constantly digitizing and expanding its on-line offerings. Web site allows users to search categories by typing in a keyword. Low-resolution thumbnails can be downloaded free of charge for comps. When a high-resolution image is needed, onetime usage fees are negotiated by phone before images are delivered on-line or via disc. Images cover all types of subject matter.

Manufacturers of Image-Editing Programs

These programs can be used to retouch and alter photographic images and otherwise prepare them for print or multimedia use. Applications specific to multimedia or Internet use can be found in chapter ten.

Adobe Systems

411 1st Ave. S.

Seattle, WA 98104-2871

(800) 833-6687, (206) 628-3955

www.adobe.com

Manufactures:

Photoshop (Mac, PC)—World recognized as the standard for photo- and image-editing in the studio.

Corel Gallery

1600 Carling Ave.

Ottawa, Ontario K1Z 8R7

Canada

(800) 772-6735, (613) 728-3733

Fax: (613) 761-9176

www.corel.com

Manufactures:

Photopaint (PC)—Photo-retouching and painting program with image-enhancing filters for Windows users.

JASC

P.O. Box 44997
Eden Prairie, MN 55344
(800) 622-2793, (612) 930-9800
Fax: (612) 930-9172
www.jasc.com
Manufactures:

Paint Shop Pro (PC)—Budget-priced photoediting software for Windows users performs many of the tasks of the more expensive programs.

Microspot USA, Inc.

12380 Saratoga-Sunnyville Rd., Ste. 6
Saratoga, CA 95070
(800) 622-7568, (408) 253-2000
Manufactures:

PhotoFix (Mac)—Stripped-down photoediting program is budget priced.

Manufacturers of Plug-ins and Accessory Software

In addition to the plug-ins and accessories listed in this section, many of the products listed in the plug-in section at the end of chapter one, "Illustration," have the potential to work with the image-editing programs listed in this chapter. Review chapter one's plug-in section, and contact individual manufacturers for more information on program compatibility.

Alien Skin Software

1100 Wake Forest Rd., Ste. 101
Raleigh, NC 27604
(888) 921-7546, (919) 832-4124
Fax: (919) 832-4065
www.alienskin.com
Manufactures:

Black Box (Mac)—Collection of Photoshop plug-ins creates a variety of special effects without dealing with channels.

Eye Candy (Mac, PC)—Plug-in gives Photoshop user shortcuts to a wide range of special effects, including flames, water droplets and weave textures.

Altamira Group

1827 W. Berdugo Ave., 2nd Fl., Ste. C
Burbank, CA 91506
(800) 913-3391
www.altamira-group.com

Manufactures:

Genuine Fractals—Photoshop fractal compression plug-in minimizes size of large image files.

Andromeda Software, Inc.

699 Hampshire Rd., Ste. 109
Thousand Oaks, CA 91361
(800) 547-0055, (805) 379-4109
www.andromeda.com
Manufactures:

Series 1: Photography Filters (Mac, PC)—Lets Photoshop users create optical lens effects.

Series 2: 3-D Filter (Mac, PC)—Plug-in lets users add 3-D viewpoint control, image and surface manipulation and 3-D scene building to 2-D programs.

Series 3: Screens Filter (Mac, PC)—Gives users precise control over creating halftone screens and a variety of options, including mezzotint effects and looks that replicate etchings and engravings.

Series 4: Techtures Filter (Mac, PC)—Includes nine hundred hand-rendered titles that can be modified to add blending, texturing and other effects to image-editing and painting programs.

Auto F/X Corp.

P.O. Box 1415
Alton, NH 03809
(800) 839-2008, (603) 875-4400
www.autofx.com
Manufactures:

Photo/Graphic Edges (Mac, PC)—Offers three volumes, each consisting of 750 edge effects that can be added to any image.

Photo/Graphic Patterns (Mac, PC)—Lets Photoshop users add background patterns to photos and other images.

Power/Pac 1 (Mac)—Photoshop plug-in adds special effects to graphics and type.

On-line Plug-in Source for Adobe Photoshop Users

www.pluginsource.com

Many of the programs that are Photoshop plug-ins can be accessed through the Adobe Plug-in Source Web site. The site gives descriptions and visual demos of each program's capabilities and system requirements. The plug-in source will also let you order and download many programs on-line. Programs that can't be downloaded from the Web site may be ordered by calling (800) 685-3547, sending a fax to (800) 648-8512 or E-mailing plugin@imageclub.com. In addition to Photoshop plug-ins, the site also offers Adobe Acrobat, Illustrator, PageMaker, Premiere and After Effects plug-ins.

When looking for photos of regional landmarks and geography, don't overlook a city's chamber of commerce as a photo source. The chamber of commerce in a particular locale will generally loan slides and transparencies for a nominal fee or at no charge, particularly if you're involved in promoting an event that will take place in or near that city. State and local boards of tourism are also good sources for low-cost visuals, as are universities, government agencies and trade associations.

Ultimate Texture Collections (Mac, PC)—Three volumes of textural effects let Photoshop users layer paper and fabric textures, stone and metal, or art and organic textures over existing images.

Typographic Edges (Mac, PC)—Photoshop plug-in adds interesting edge effects to type and graphics.

Chroma Graphics
577 Airport Blvd., Ste. 730
Burlingame, CA 94010
(888) 824-7662, (415) 375-1100
www.chromagraphics.com
Manufactures:

MagicMask (Mac, PC)—Masking tool lets Photoshop users easily isolate complex image selections.

Cytopia Software, Inc.
812 9th Ave.
Redwood City, CA 94063
(800) 588-0274, (650) 364-4594
Fax: (650) 364-4592
www.cytopia.com
Manufactures:

CSI PhotoOptics (Mac)—Photoshop plug-in gives digital photographers familiar photographic tools for creating professional halftones.

Digital Frontiers
1019 Asbury
Evanston, IL 60202
(800) 328-7789, (847) 328-0880
www.digfrontiers.com
Manufactures:

HVS ColorGIF (Mac, PC)—Plug-in lets users of image-editing programs reduce an image's colors from 24 bit to 8 bit without loss of quality.

HVS JPEG (PC)—Image-editing plug-in lets users compress images into high-quality JPEG files.

HVS WebFocus (PC)—Lets users of image-editing programs reduce the size of images and animations for high-quality, low-memory GIF and JPEG files.

Extensis
1800 SW 1st Ave., Ste. 500
Portland, OR 97201
(800) 796-9798, (503) 274-2020
Fax: (503) 274-0530
www.extensis.com
Manufactures:

Intellihance (Mac)—Lets Photoshop users save time when processing lots of images by instantly color correcting image scans.

Mask Pro (Mac)—Photoshop plug-in lets users easily make masks with vector-based clipping paths.

PhotoFrame (Mac)—Creates image frames and border effects.

PhotoTools (Mac)—Plug-in bundles tools that make typesetting easy in Photoshop and create special effects such as glows, beveled edges and embossed looks.

Human Software
P.O. Box 2280
Saratoga, CA 95070
(408) 399-0057
www.humansoftware.com
Manufactures:

Automask (Mac)—Photoshop plug-in improves path making around details such as hair and trees.

Medley (Mac)—Plug-in for QuarkXPress, FreeHand and Illustrator offers Photoshop effects such as retouching, layers and color separations while working in these programs.

Ottopaths (Mac, PC)—Photoshop plug-in improves path making in Photoshop.

Textissimo (Mac)—Allows for custom type effects in Photoshop.

SafeProof (Mac)—Photoshop plug-in lets users see on screen what digital proofs will look like.

Intown Software
319 E. 2nd St., Ste. 203
Los Angeles, CA 90012
(213) 626-7779
www.intownsoft.com
Manufactures:

WildRiverSSK (Mac, PC)—Collection of seven Photoshop plug-ins offers users lots of special effects, including bevel edges and beam effects.

Live Picture
910 E. Hamilton, Ste. 300
Campbell, CA 95008
(800) 724-9610, (408) 438-9610
www.livepicture.com
Manufactures:

Live Picture (Mac)—Image-editing program helps users who work with huge files. Programs comes with over six hundred royalty-free images.

A Lowly Apprentice Production

5963 La Place Ct., Ste. 206
Carlsbad, CA 92008-8823
(888) 818-5790, (720) 438-5790
Fax: (720) 438-5791
www.alap.com
Manufactures:

Platemaker—Photoshop plug-in lets users convert CMYK files into spot color files.

MetaCreations Corp.

P.O. Box 724
Pleasant Grove, UT 84062-9914
(800) 846-0111, (800) 472-9025, (805) 566-6200
Fax: (888) 501-6382
www.metacreations.com
Manufactures:

Kai's Power Goo (Mac)—Gives photos a liquid feel. Users can smear, smudge and move pictures in real time.

Kai's Power Tools (Mac, PC)—Popular Photoshop plug-in filter set allows users to create a vast array of image special effects, including spheroid effects, a variety of blurs and much more.

KPT Actions (Mac, PC)—Add-on to Kai's Power Tools adds scripting capabilities to Photoshop.

Paragate Systems

Koppelweg 36
30655 Hannover
Germany
49-511-541-4224
Fax: 49-511-541-4225
www.paragate.com
Manufactures:

HoloDozo (Mac)—Photoshop plug-in allows users to map images onto 3-D shapes.

SISNIKK Pro—Lets Photoshop users create Image Sterograms, pictures with hidden 3-D information that reveals a 3-D image when viewer focuses beyond the 2-D picture.

Second Glance Software

7248 Sunset Ave.
Bremerton, WA 98311
(360) 692-3694
Fax: (360) 692-9241
www.secondglance.com

Manufactures:

Chromassage (Mac)—Lets Photoshop users manipulate program's color table and create effects ranging from simple colorization to psychedelic effects.

LaserSeps Pro (Mac)—Filter lets Photoshop users create process color separations without halftone screens.

PhotoSpot (Mac)—Photoshop plug-in lets users create continuous-tone color separations using spot color inks.

Ulead Systems, Inc.

970 W. 190th St., Ste. 520
Torrence, CA 90502
(800) 858-5323, (310) 523-9393
Fax: (310) 523-9399
www.ulead.com
Manufactures:

Ulead Photoshop Impact (PC)—Inexpensive photo-editing program lets Windows users view and organize images.

Vivid Details

8228 Sulphur Mountain Rd.
Ojai, CA 93023
(800) 948-4843, (805) 646-0217
www.vividdetails.com
Manufactures:

Test Strip (Mac)—Plug-in improves performance of Photoshop's Variations feature, allowing users to adjust image color and tonal value.

Xaos Tools, Inc.

P.O. Box 629000
Eldorado Hills, CA 95762
(800) 289-9267, (415) 487-7000
www.xaostools.com
Manufactures:

FlashBox (PC)—Special-effects plug-in lets Windows users add borders and backgrounds to images as well as other photographic special effects.

Paint Alchemy (Mac)—Plug-in filter adds artistic effects.

Terrazzo (Mac, PC)—Adds symmetrical patterns and backgrounds to images.

TypeCaster (Mac)—Photoshop plug-in lets users create realistic 3D type effects.

Paper

Sources for Decorative

and Printing Papers

Handmade and Specialty Papers

These companies offer handmade, marbled, metallic and otherwise unusual papers that are highly decorative. Most of the handmade papers in this listing aren't offset or laser compatible. Use them for fly leaves, covers, wrappers and applications where letter-press or screen printing will be applied. Check individual listings or call to check on laser and offset compatibility of papers offered.

Aiko's Art Materials Import

3347 N. Clark St.
Chicago, IL 60657
(773) 404-5600
Fax: (773) 404-5919
Offers a large supply of Japanese papers—over two hundred varieties, including tie-dyed and stencil-dyed.

Amsterdam Art

1013 University Ave.
Berkeley, CA 94710
(800) 994-2787, (510) 649-4800
Fax: (510) 883-0338

Extensive selection of handmade and specialty papers, including Japanese and European handmade papers. Offers largest collection of Asian papers in the state. Also sells handmade papers from domestic makers.

Atlantic Papers

P.O. Box 1158
Lemont, PA 16851
(800) 367-8547
Fax: (800) 367-1016
Offers handmade papers from the Czech Republic and Germany suitable for letterheads, invitations and announcements. Also carries matching envelopes. Papers are also available at art supply stores.

Dieu Donne Papermill

433 Broom St.
New York, NY 10013
(212) 226-0573
Fax: (212) 226-6088
New York City–based mill makes and sells its own papers. Specializes in archival rag and custom, handmade papers. Offers catalog.

Evanescent Press

P.O. Box 64
Leggett, CA 95585
(707) 925-6494
Fax: (707) 925-6472

Offers domestic handmade papers. Also does letterpress printing and hand-bookbinding. Distributes hemp fiber and other natural materials. Offers price list and sample swatches.

Flax Art & Design
P.O. Box 7216
San Francisco, CA 94120-7216
(415) 468-7530
Stocks hundreds of types of handmade and hand-decorated papers, both domestic and imported.

Flax Art Materials
62 E. Randolph
Chicago, IL 60601
(312) 431-9588
Fax: (312) 431-9616
Offers Japanese handmade papers and Wyndstone papers.

The Friendly Chameleon
4438 Silverwood St.
Philadelphia, PA 19127
(800) 717-8242, (215) 487-3317
Fax: (215) 508-1690
Specializes in tree-free paper products, including papers and envelopes made from hemp, flax and cotton. Also sells gifts bags and boxes made from corrugated hemp paper. Can handle small and large quantities.

Green Earth Office Supply
P.O. Box 719
Redwood Estates, CA 95044
(800) 327-8449
Fax: (408) 353-1346
www.webcom.com/geos
Stocks tree-free and other eco-friendly papers made from materials such as hemp and hemp/cotton fiber, and coffee beans. Most are laser and offset compatible. Available in reams and cases in a range of sizes. Catalog available.

Jam Paper & Envelope
111 3rd Ave.
New York, NY 10003
(800) 8010-JAM, (212) 473-6666
Fax: (212) 473-7300
www.jampaper.com
Carries papers printed with a map motif as well as a variety of translucent vellums. Offers a wide selection of envelopes. Also carries shopping bags, gift boxes, art folios and other paper and plastic products. Offers free catalog.

Refer to image on page 45.

The Japanese Paper Place
887 Queen W.
Toronto, Ontario M6J 1G5
Canada
(416) 703-0089
Fax: (416) 703-0163
Carries over two hundred handmade Japanese papers and provides a sample service. Cash and carry is preferred. Minimum ship order is $50.

Jerusalem Paperworks
1060 N. Capitol Ave., C-310
Indianapolis, IN 46204
(317) 951-0908
Fax: (317) 849-9846
Specialty handmade papers, including those made from coffee, herbs, fabric, leaves, money, tea, flowers, corn husks, junk mail and much more. Samples available.

Kate's Paperie
8 W. 13th St.
New York, NY 10011
(212) 633-0570
Fax: (212) 366-6532
New York City–based outlet carries a variety of handmade papers and offers sample service. Also sells papermaking supplies, instructional materials and kits.

KP Products
P.O. Box 20399
Albuquerque, NM 87154-0399
(505) 294-0293
Fax: (505) 294-7040
Carries offset- and laser-compatible kenaf papers in a variety of weights, sizes and finishes. Paper is sold by the ream and by the carton.

Loose Ends
P.O. Box 20310
Keizer, OR 97307
(503) 390-7457
Fax: (503) 390-4724
www.loosend.com

Jerusalem Paperworks specializes in custom handmade papers made from client-specified inclusions. Clients include the Des Moines Solid Waste Agency, which had the paper for its annual report cover made from area trash. The papermaker also carries a line of stock handmade papers made from celery, tea leaves, fabric and more.

New York Central Art Supply stocks handmade and hand-decorated papers from all over the world, including these paste paper-patterned papers made by Maziarczyk Paperworks.

Specializes in paper products with a natural kraft look and heavily textured handmade papers. Also stocks kraft bags, corrugated paper and boxes, natural gift wrap, raffia and other nature-inspired products.

Magnolia Editions
2527 Magnolia St.
Oakland, CA 94607
(510) 839-5268
Fax: (510) 893-8334
Makes and sells custom papers. Papers are suitable for letterpress or screen printing but are not offset compatible. Will sell overstock of its custom papers.

Mickey's Paper
1801 4th St.
Berkeley, CA 94710
(510) 845-9530
Fax: (510) 845-5619
Offers over two hundred varieties of Japanese papers, including stencil-dyed and tie-dyed papers. Offers free catalog.

New York Central Art Supply
62 3rd St.
New York, NY 10003
(800) 950-6111 (warehouse), (212) 473-7705 (store)
Fax: (212) 475-2542
Approximately twenty-five hundred kinds of paper in stock from all over the world. Handmade and hand-marbled papers a specialty. Catalog available.

Ohio Hempery
7002 State Rte. 329
Guysville, OH 45735
(800) BUY-HEMP, (614) 662-6446
Sells letter-sized and larger sheets of hemp paper by the ream. Offers free catalog.

If you're looking for industrial papers, such as kraft or corrugated cardboard, chipboard, packing and butcher paper, check your local paper converter or distributor. One can usually be found in your local yellow pages or business-to-business directory. Art supply stores are also a good source for small quantities of newsprint paper.

Opsec
P.O. Box 151
Riderwood, MD 21139
(410) 666-1144
Fax: (410) 472-4911
Over one hundred patterns of hologramic paper in a variety of colors. Comes in rolls or sheets.

The Paper Source
232 W. Chicago Ave.
Chicago, IL 60610
(312) 337-0798
Fax: (312) 337-0741
Oriental, handmade, commercial and speciality papers. Also offers classes on bookmaking, box making and more.

Semper Paper
25 Rte. 22 E.
Springfield, NJ 07081
(973) 383-2826
Fax: (973) 921-0104
Chicago Office: (630) 529-5090
Midwest Office: (606) 341-7100
New England Office: (401) 333-1966
Offers pearlescent, moiré patterned, foil-textured and other unusual papers, many suitable for offset printing. Also sells tissue and gift wrap papers.

Refer to image on page 45.

Twin Rocker Paper Mill
100 E. 3rd St.
P.O. Box 413
Brookston, IN 47923
(765) 563-3119
Mill makes its own papers in sizes up to 4′ × 8′. Also makes custom papers and specializes in small quantities. Takes mail orders and also sells many of its papers through art supply stores.

Van Leer Metallized Products
24 Forge Park
Franklin, MA 02038
(800) 343-6977, (508) 541-7700
Fax: (508) 541-7777
Carries holographic papers in a variety of colors and patterns. Offers sample kit of its products.

Vicki Schober Co.
2363 N. Mayfair Rd.
Milwaukee, WI 53226
(414) 476-8000
Fax: (414) 476-8041
Milwaukee-based paper supply firm. Offers over six hundred types of papers, including marbled and other decorative types, such as bark, lace and rice papers.

Victoria Paper
80-28 Springfield Blvd.
Hollis Hills, NY 11427
(800) 898-1340, (718) 740-0990
Fax: (800) 898-1346, (718) 740-0949
Offers laser-compatible and handmade papers made from bananas, straw, silk and other exotic materials. Will send sample swatches.

Wet Paint
1684 Grand Ave.
St. Paul, MN 55105
(612) 698-6431
Carries handmade and machine-made papers made from straw, hemp and other earth-friendly materials. Over-the-counter sales only.

Wyndstone
Graphic Products Corp.
1480 S. Wolf Rd.
Wheeling, IL 60090-6514
(847) 537-9300
Fax: (847) 215-0111
Manufactures specialty papers with distinctive textures and finishes. Available at most art supply stores. Wyndstone also sells a specifier with 186 sample swatches of its papers for $39.95.

Papermaking Supplies and Instructional Materials

If you want to look into making your own paper, these companies can show you how and supply you with the equipment you need.

Dieu Donne Papermill
433 Broom St.
New York, NY 10013
(212) 226-0573
Fax: (212) 226-6088

Gold's Artworks, Inc.
2100 N. Pine St.
Lumberton, NC 28358
(800) 356-2306, (919) 739-9605

Kate's Paperie
8 W. 13th St.
New York, NY 10011
(212) 633-0570
Fax: (212) 366-6532

Magnolia Editions
2527 Magnolia St.
Oakland, CA 94607
(510) 839-5268
Fax: (510) 893-8334

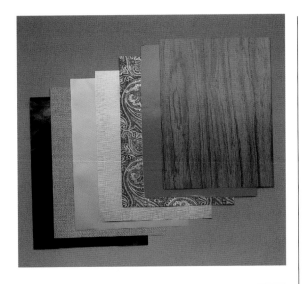

Twin Rocker Paper Mill
100 E. 3rd St.
P.O. Box 413
Brookston, IN 47923
(765) 563-3119

Laser-Compatible Papers Sold in Small Quantities

These companies offer papers that can be run through laser printers or photocopiers. In addition to simulating parchment, coated and flocked papers, and many other commercial printing papers that may not be laser compatible, most of these manufacturers sell papers that have been preprinted with background, borders and other graphics. You'll also find laser-compatible labels, Rolodex cards, certificates and other items that go beyond ordinary papers. All of the companies in this listing accept mail orders. Call them for free catalogs or sample packs.

Semper Paper manufactures a variety of specialty papers, including patterned papers, those with pearlescent and moiré finishes, metallics and much more. For more information, see their listing on page 44.

In addition to envelopes in every conceivable color and size, Jam Paper & Envelope offers transluscent envelopes, a variety of specialty papers, presentation folders and much more. For more information, see their listing on page 43.

Permalin Product's line includes bonded cloth and leather products, often used on book and brochure covers, packaging and other applications where a rich, natural texture is sought. For further information, see their listing on page 50.

Zanders USA is known for unusual papers. Lines include Elephant Hide, a stock that resembles handmade paper, Chromolux, a cast-coated line that comes in a wide range of metallics and colors, and Miri, a mirror-finished paper that comes in ten colors. For additional information, see their listing on page 51.

Four Corners Papers

15757 N. 78th St.
Scottsdale, AZ 85260
(602) 991-2320
Fax: (602) 991-2148
Collection of earth-friendly, laser-compatible papers is offered in four product lines: Earth Cast, LaserCast, ImageCast and Overcast envelopes. Each line is color coordinated to work with the other lines that comprise the Four Corners collection. The collection encompasses all kinds of papers and includes writing papers, text stock and lightweight cover stocks (suitable for business cards) as well as a 100% recycled line and coated papers in a variety of colors. Available at most art supply stores.

Idea Art

P.O. Box 291505
Nashville, TN 37229-1505
(800) 433-2278
Fax: (800) 435-2278

Offers over one thousand preprinted designs on laser-compatible paper for letterhead, newsletters, cards, invitations, trifold brochures and certificates.

LeDesktop

P.O. Box 45000
Phoenix, AZ 85064
(800) LE DESKTOP, (602) 991-2320
Fax: (800) 533-7911, (602) 991-2148
Stocks eco-friendly, laser-compatible papers made from renewable resources, such as seaweed, golf course clippings, denim and more. Will send sample swatches.

Paparazzi Papers

Letraset USA
40 Eisenhower Dr.
Paramus, NJ 07653
(800) 526-9073
Fax: (201) 909-2451
www.letraset.com
Preprinted papers and coordinated envelopes in a variety of colors, graduated color blends, simulated textures, borders and other graphic effects. Some designs include coordinated business cards. Available at most art supply stores.

Paper Access

23 W. 18th St.
New York, NY 10011
(800) PAPER-01, (212) 463-7035
Fax: (212) 463-7022
Offers over two hundred paper products, including papers preprinted with borders and textures, laser-compatible mill papers in small quantities and specialty papers such as crack-and-peel labels. New York address serves as a retail outlet.

PaperDirect

100 Plaza Dr.
Secaucus, NJ 07094-3606
(800) A-PAPERS
Fax: (201) 271-9601
Papers preprinted with patterns and borders, including coordinated packages consisting of three-panel mailers, postcards, business cards, presentation folders, envelopes and more. Also offers unprinted papers, envelopes and labels.

Queblo Images

1000 Florida Ave.
Hagerstown, MD 21741
(800) 523-9080
Fax: (800) 55-HURRY
Offers scored and perforated papers that include business-reply cards, tent cards with unusual shapes, preprinted papers and unusual papers such as woodchip and parchment. Also offers envelope labels, foil holiday cards and books.

Project

When commissioned by Crane & Company to design an invitation to a cocktail reception and discussion of business stationery, New York City–based Design: M/W was faced with the challenge of conceiving an invitation that would impress the savvy group of designers who would receive it, and at the same time showcase the design possibilities and printing capabilities of Crane's 100% cotton business papers.

The design firm's principal, Allison Muench Williams, started by researching Crane's paper products and was immediately drawn to Crane's business card-sized envelopes. "I thought it would be great to use that as part of the invitation because it's so unique to Crane," says Williams.

With the help of staff designer and illustrator Peter Phong, a design was developed that consists of an invitation-sized envelope containing a base card, engraved with a hand. The hand is die cut in a way that enables an ivory-colored business card envelope to be slotted beneath the fingers. The actual invitation to the event is within this envelope, a 3⅜″ × 8⅜″ sheet of ivory writing-weight paper, accordion-folded so it fits neatly within the tiny envelope.

Because Crane's 100% cotton papers are often selected to convey a sense of quality and prestige, the offset printing on the invitations was limited to background colors of lime green and pale blue. Type and illustrations were engraved.

Crane & Company manufactures the business card-sized envelope that is integral to the design of this unique invitation. For more information, see Crane's listing on page 48.

Williamhouse
245 5th Ave., Ste. 502
New York, NY 10016
(212) 689-8811
Fax: (212) 689-5989
Stocks presentation folders with matching envelopes, laser-compatible announcement papers with recessed panels and foil edges plus other types of papers.

Small Quantities of Envelopes

These companies sell blank envelopes ranging from invitation- to folder-sized. Many types of envelopes can also be found at the retail outlets that sell small quantities of mill papers listed elsewhere in this chapter. For manila envelopes and preprinted business envelopes, check listings for office supplies in chapter eleven. For custom envelopes, see Envelope Converters in chapter fourteen.

Jam Paper & Envelope
111 3rd Ave.
New York, NY 10003
(800) 8010-JAM, (212) 473-6666
Fax: (212) 473-7300

In addition to all types, sizes and colors of envelopes, including foil-lined, the company sells a variety of presentation folders with matching booklet envelopes. Call for free catalog.

Williamhouse
245 5th Ave., Ste. 502
New York, NY 10016
(212) 689-8811
Fax: (212) 689-5989
This envelope converter will also sell small quantities of its stock envelopes in a variety of sizes and colors.

Sources for Fine Printing Papers— Major Manufacturers

Contact the following paper manufacturers for swatch books of their printing papers. Many of these mills also offer technical guidebooks and promotional brochures that demonstrate how their papers perform under various printing and finishing techniques. Some will also make up comps, utilizing their papers, of folders, boxes, brochures and other items, custom-made to your specifications. When calling, ask for the sample department or customer service.

> *Love the look of industrial stock but need a paper that's laser compatible? French Paper carries a line of printing papers under the name Dur-o-tone that includes construction, newsprint, butcher, packing and kraft paper. All of them are offset-compatible, and the butcher paper and newsprint lines are also laser-compatible. Contact your local French Paper merchant or contact French Paper directly to locate a merchant in your area (the company's address and phone number are listed in this chapter).*

Appleton Papers, Inc.

825 E. Wisconsin Ave.
P.O. Box 359
Appleton, WI 54912
(888) 488-6742, (920) 734-9841
Fax: (920) 991-8796
Carries coated printing and specialty papers, including a metallic-finish line and a line of fluorescent-colored stock.

Beckett Paper Co.

2 Gateway Blvd.
East Granby, CT 06026
(800) 423-2259, (814) 870-9657
www.ipaper.com
Specializes in uncoated recycled text and cover stocks in a variety of colors, textural finishes and flocking options.

Champion International Corp.

1 Champion Plaza
Stamford, CT 06921
(800) 442-3463, (203) 358-7000
www.championpaper.com
With seven mills, Champion is one of the United States' largest paper manufacturers. Offers coated, cast-coated and uncoated papers in text and cover weights.

Consolidated Papers, Inc.

P.O. Box 227
Stevens Point, WI 55481
(800) 322-7377, (715) 345-8060
www.consolidatedpapers.com
Specializes in coated stock ranging from dull-coat finishes to high-gloss in all grades.

Crane & Co., Inc.

30 South St.
Dalton, MA 01226
Crane: (888) 272-6326, (413) 684-6316
Pioneer: (413) 684-6271

Well known for its archival-grade cotton papers with 100% rag content, Crane has recently expanded into producing other rag content papers, including Old Money, made from recycled currency. A new division, Pioneer Papers, produces paper for digital fine art applications.

Refer to image on page 47.

Crown Vantage

145 James Way
Southampton, PA 18966
(800) 441-9292, (215) 364-3900
www.crownvantage.com
This manufacturer produces James River's former product line under the Curtis Fine Papers name. Well-known papers include the King James cast-coated line as well as an extensive collection of uncoated text and cover stocks.

CTI Paper USA

1545 Corporate Center Dr.
Sun Prairie, WI 53590
(800) 284-7273, (608) 246-4000
www.thepapermill.com
Best known for its line of Glama Natural translucent vellums, CTI also manufactures a cast-coated line under the name of BINDAKOTE, which comes in white and nineteen colors. Both papers are noteworthy for their eco-friendly attributes. Glama Natural is 100% recycled, and both paper lines are elemental chlorine-free.

Decorated Paper Corp.

8th and Erie Sts.
Camden, NJ 08102
(609) 365-4200
Fax: (609) 365-0102
Manufactures coated text and cover weights. Primarily known for its high-gloss cover stocks in a variety of colors, including fluorescents and metallic. Also manufactures white coated display board.

Domtar

P.O. Box 7211
Montreal, Quebec H3C 3M2
Canada
(800) 267-3060, (514) 848-5400
Fax: (800) 267-8899
www.domtar.com
Specializes in earth-friendly uncoated writing-, text- and cover-weight papers that come in a variety of colors. Also manufactures a color-coordinated line of corrugated stock.

Donside North America

1600 Johnson Way
New Castle, DE 19720
(800) 220-8577, (302) 326-1262
Fax: (302) 326-1277
Formerly marketed under U.K. Paper, Donside offers specialty coated papers in a variety of finishes and colors.

Eastern Fine Paper, Inc.

P.O. Box 129
Brewer, ME 04412
(207) 989-7070
Fax: (207) 989-4663
Specializes in uncoated papers in weights ranging from writing to cover weights. Offers a variety of finishes and colors.

E.B. Eddy Forest Products, Ltd.

1600 Scott St.
Ottawa, Ontario K1Y 4N7
Canada
(800) 267-0702, (613) 782-2600
Fax: (613) 725-6759
Produces both uncoated and coated lightweight papers for dictionaries, textbooks, magazines and other publications needing lightweight papers.

FiberMark

161 Wellington Rd.
Brattleboro, VT 05302
(800) 451-4378, (802) 257-0365
www.fibermark.com
Manufactures presentation materials, art papers and book cover materials as well as coated and uncoated cover stocks. Specialty papers are especially suitable for covers and packaging; some exhibit unusual finishes that imitate other materials, such as leather and acrylics.

Finch, Pruyn & Co., Inc.

1 Glen St.
Glen Falls, NY 12801
(800) 833-9983, (518) 793-2541
Fax: (518) 743-9656
www.finchpaper.com
Mill produces an extensive line of uncoated printing papers in various shades of white. All are suitable for offset printing, and many are also laser compatible.

†*Fox River Paper Co.

200 E. Washington St.
Appleton, WI 54913
(800) 933-7300, (920) 733-7341
Fax: (920) 733-2975

Long known for its recycled line of writing papers, Fox River recently purchased Simpson Paper's line of uncoated papers, streamlining and consolidating both mills' offerings to include a selection of popular writing, text and cover papers.

Fraser Papers

70 Seaview Ave.
Stamford, CT 06902
(800) 920-9988, (203) 705-2800
Uncoated, recycled papers formerly marketed under the name of Cross Pointe are now available through Fraser. In addition to traditional uncoated papers, Fraser also manufactures a line of industrial-like corrugated stocks under the name of Outback, in colors that complement those of Fraser's text and cover papers.

†French Paper Corp.

P.O. Box 398
Niles, MI 49120
(616) 683-1100
Fax: (616) 683-3025
Well known for its most popular paper, Speckletone, French Paper has built a reputation on manufacturing 100% recycled papers for over fifty years. French continues to produce uncoated recycled papers, including brands that mimic the look of industrial-grade papers such as chipboard.

†George Whiting

P.O. Box 28
Menasha, WI 54952
(920) 722-3351
Fax: (920) 722-9553
Specializes in 100% recycled uncoated text and cover stocks. Is best known for being able to match colors and texture in production of small quantities of custom papers.

Georgia-Pacific Papers

P.O. Box 105237
Atlanta, GA 30348
(800) 635-6672, (404) 652-4000
www.gp.com
Better known for its business papers, Georgia-Pacific manufactures a line of fine printing papers under the name of Hopper. The Hopper line has recently been expanded to include Skytone, a line of muted pastels, and Hots, a line of fluorescents.

†*Gilbert Paper

Division of Mead
430 Ahnaip St.
Menasha, WI 54952
(800) 445-7329, (414) 722-7721
Fax: (800) 445-6309
Mill produces many lines of uncoated, fine printing

†These manufacturers offer custom papers matched to your color, texture and flocking specifications.

**These manufacturers will make papers with custom watermarks. For minimum quantities, call or ask your local paper merchant.*

papers ranging from writing to cover weights, in a variety of colors, textures and flocking patterns. Also manufactures GilClear, a translucent vellum that comes in different textures.

Hammermill Papers

6400 Poplar Ave.
Memphis, TN 38197
(800) 242-2148, (901) 763-7800
Fax: (901) 763-6396
Known for its line of office papers, Hammermill also produces a wide range of uncoated stocks. Paper lines include fluorescent text and cover sheets, and coordinated lines of text, writing and cover stocks.

Island Paper Mills

1010 Derwent Way
P.O. Box 2170
New Westminster, British Columbia VSL 5A5
Canada
(800) 663-6221, (604) 527-2610
Fax: (604) 526-0701
A division of E.B. Eddy Paper, Island Paper Mills specializes in coated papers. Lines include Bravo and Luna. The mill also makes Resolve Premium Opaque, a white, uncoated paper.

Lyons Falls Pulp & Paper

P.O. Box 338
Lyons Falls, NY 13368
(800) 648-4458, (315) 348-8629
Fax: (315) 348-8629
Manufactures uncoated papers used primarily in book publishing. Uses an eco-friendly chlorine-free bleaching process in the production of its papers.

Manistique Papers

453 S. Mackinac
Manistique, MI 49854
(800) 743-2389, (906) 341-2175
Mill produces 100% recycled papers. Offers a line of uncoated text papers in pastels and neutrals.

Mead Corp.

Fine Paper Division
Courthouse Plaza NE
Dayton, OH 45463
(800) 638-3313, (937) 495-6323
Fax: (937) 495-3192
www.meadpaper.com
Specializes in no. one and premium-grade coated papers. Offers dull, matte, glossy and cast-coated lines.

†Mohawk Paper Mills, Inc.

465 S. Saratoga St.
P.O. Box 497
Cohoes, NY 12047
(800) THE-MILL, (518) 233-6273
Fax: (518) 233-7102

Offers several lines of uncoated stock ranging from writing to cover weights. In addition to producing good results on offset presses, many of its lines also perform well on digital presses.

Monadnock Paper Mills, Inc.

117 Antrim Rd.
Bennington, NH 03442
(603) 588-3311
Fax: (603) 588-3158
Produces smooth, white, uncoated text and cover papers. Popular line is Astrolite, a premium brilliant white text stock that comes in cover as well as several text weights.

Neenah Paper

1400 Holcomb Bridge Rd.
Roswell, GA 30076-2199
(800) 241-3405, (770) 587-8730
Specializes in producing a variety of uncoated stocks in colors and textures that are tailored to meet the current needs and desires of graphic designers. A popular grade, Columns, has an unusual groove finish. Other lines offer other finishing textures in a wide range of colors.

Permalin Products Co.

109 W. 26th St.
New York, NY 10001
(800) 544-3454, (212) 627-7750
Fax: (212) 463-9812
Produces specialty papers consisting of bonded cloth and leather products for use on binders, boxes, packaging, book covers and slipcases.

Refer to image on page 46.

Potlatch Corp.

P.O. Box 510
Cloquet, MN 55720
(800) 447-2133, (218) 879-2300
www.potlatchcorp.com
Mill is perhaps best known for its Karma, Eloquence and Quintessence premium lines of coated papers. All are available in white and ivory as well as gloss, dull, velvet, silk and matte finishes.

S.D. Warren Co.

225 Franklin St.
Boston, MA 02110
(800) 882-4332, (617) 423-7300
Fax: (800) SDW-1770, (617) 423-5491
http://warren-idea-exchange.com
Makes uncoated papers under the name of Spectra-Tech but is best known for its various lines of coated white papers, offered in a variety of grades and finishes.

Simpson Paper Co.
1301 5th Ave.
Seattle, WA 98101
(800) 993-6300, (206) 224-5700
Fax: (206) 224-5899
The mill's uncoated stocks are now offered by Fox River. Simpson now specializes in coated papers offering a variety of grades and finishes.

†Strathmore Paper Co.
135 Center St.
Bristol, CT 06010
(800) 353-0375, (860) 844-2400
Fax: (800) 635-3199
www.ipaper.com
Makes uncoated text and cover stocks in a variety of colors and textures. Particularly noteworthy is the assortment of unusual finishing textures and surface patterns in some of the papers Strathmore manufactures.

Union Camp Fine Papers
P.O. Box 1812
Durham, NC 27702
(888) 426-5524, (757) 569-4321
www.unioncamp.com
Manufactures white, sheetfed papers designed specifically for digital color printing. Offers coated and uncoated text and cover weights.

Westvaco Corp.
Fine Papers Division
399 Park Ave.
New York, NY 10171
(800) 235-3782, (212) 688-5000
Fax: (212) 318-5075
Specializes in coated sheetfed papers in a variety of finishes, including gloss, dull, matte and satin. Westvaco is one of few paper manufacturers that will sell its paper directly to printers and designers, as opposed to selling exclusively through local merchants.

Weyerhauser Paper Co.
P.O. Box 829
Valley Forge, PA 19382
(610) 251-9220
Fax: (610) 647-2002
Specializes in coated stocks. One of its best known papers, Cougar, is a premium-grade coated paper that comes in dull, gloss and satin finishes and a variety of whites and ivory. Other grades are available in a variety of coated finishes.

Zanders USA
100 Demarest Dr.
Wayne, NJ 07470
(888) 305-9291, (973) 305-1990
Fax: (973) 305-1888

Carries a variety of unusual papers noted for their distinctive finishes, colors or textures. For instance, Chromolux, Zanders's cast-coated line of text and cover weights, comes in metallics and a wide range of colors. Elephant Hide Paper has a look of marble veining that resembles handmade papers. The company also produces other coated and uncoated lines, including a translucent vellum.

Refer to image on page 46.

Sources of Small Quantities of Mill Papers

If you'd like to purchase a ream or less of the printing papers produced by the paper manufacturers listed in this chapter, these outlets sell these papers and matching envelopes in small quantities off the shelf.

Arvey
3352 W. Addison
Chicago, IL 60618
(800) 866-6332, (773) 463-6423
Over forty locations in major U.S. cities. Call for nearest location.

If It's Paper
XPEDX
3900 Spring Garden St.
Greensboro, NC 27407
(910) 299-1211
This paper retailer has over forty-one stores in North Carolina, South Carolina, Virginia, Georgia, Tennessee and Alabama.

Kelly Paper
1441 E. 16th St.
Los Angeles, CA 90021
(800) 67-KELLY, (213) 749-1311
Twenty-two locations in California, Arizona and Nevada.

Limited Papers
80 Washington St.
New York, NY 10006
(212) 797-7022
Retail outlet also takes mail orders. Call for free catalog.

Paper Access
23 W. 18th St.
New York, NY 10011
(800) PAPER-01, (212) 463-7035
Retail outlet also handles mail orders. Call for free catalog.

If you print a job on paper with recycled content, this icon can be obtained from your printer. The American Forest and Paper Association supplies the logo to printers through their trade associations. For more information, contact the association at 1111 19th St. NW, Ste. 800, Washington, DC 20036, (202) 463-2700, Fax: (202) 463-2783.

Paper and Graphic Supply Centers

XPEDX
200 Howard St.
Detroit, MI 48216
(800) 477-0050, (313) 496-3131
Affiliated with Seaman-Patrick. Offers retail centers in eleven cities throughout Michigan and Ohio.

The Paper Shop

P.O. Box 3838
Scranton, PA 18505
(717) 457-1628
This division of Alling and Cory has close to twenty stores in the Northeast. Call for nearest location.

Parsons

2270 Beaver Rd.
Landover, MD 20785
(301) 386-4700
Retail outlet will take phone orders for its papers.

Press Stock/The Supply Room

3131 New Mark Dr.
Miamisburg, OH 45342
(800) 822-6323, (937) 495-6000
A division of Zellerbach, this retail division has over thirty-one stores in major metropolitan areas.

Type

Computer Fonts

The following companies make computer fonts. Compatibility with Macintosh, PC and other computer formats are indicated within each listing. See individual listings for special packages, prices and purchasing information.

Adobe Systems, Inc.

345 Park Ave.
San Jose, CA 95110
(800) 445-8787, (888) 502-8393, (408) 536-6000
Fax: (800) 814-7783, (408) 536-6799
www.adobe.com www.adobestudios.com
Over twenty-three hundred fonts in Mac-compatible and PC-compatible Type 1 and TrueType formats. Library includes traditional and contemporary text and display typefaces, including many in Multiple Master format (fonts that can be scaled and weighted without destroying integrity of design). Fonts are sold separately, starting at $25.99 per font and as collections. Adobe Type Basics, containing sixty-five of Adobe's most popular fonts, retails for $99. Font Folio, the entire Adobe library, plus font utilities and tools can be purchased for $7,500. Fonts are sold by mail and through retailers and distributors located via Adobe's

Web site. Fonts are available on-line as well as furnished on diskette and CD-ROM.

Agfa Division, Bayer Corp.

90 Industrial Way
Wilmington, MA 01887
(800) 424-TYPE, (508) 658-5600
Fax: (508) 657-5328
www.agfahome.com/agfatype/
Over sixty-three hundred text, display and symbol fonts ranging in price from $22 to $90. Sold individually and as collections on CD-ROM. Agfa's Creative Alliance CD combines the Agfa and Monotype libraries into the industry's largest font collection on CD-ROM. Typefaces by David Berlow, Sumner Stone and Matthew Carter are included as well as those from newcomers, such as Nick Shinn and Jeremy Tanker. In addition to fonts from Adobe, Monotype and other foundries, Agfa offers a collection of logos and symbols consisting of ten thousand company logos, icons and decorative borders. Fonts are available on diskette and CD-ROM in Mac- and PC-compatible Type 1 and TrueType formats.

Alpine Electronics

526 W. 7th St.
Powell, WY 82435
(307) 754-6050
http://wave.park.wy.us/~alpine/main.html
Offers fonts specifically for diagramming games. Included in the collection of 1,350 fonts are notation and diagram fonts for chess, dice, mah-jongg, Othello and bridge. Fonts are frequently used by game book and game magazine publishers. Mac-compatible Type 1 and PC-compatible TrueType fonts are furnished on diskette. Prices range from $29 to $79 per family.

Altemus Creative Servicecenter

225 Lafayette St., Rm. 709
New York, NY 10012
(212) 965-9840
Fax: (212) 965-9842
www.altemus.com
Offers thirty-six symbol fonts specifically for use as bullets, borders, end slugs and other graphic elements. Mac-compatible and PC-compatible Type 1 and TrueType fonts are available on diskette for $29 each. Entire collection costs $626.

Architext, Inc.

121 Interpark Blvd., Ste. 208
San Antonio, TX 78216
(210) 490-2240
Fax: (210) 490-2242
www.architext-inc.com
Specializes in bar code fonts, digitized signatures and logos. Also produces custom fonts and typeface reproductions. Current library consists of over ten thousand fonts, including bar code symbols. Type 1, Type 3 and TrueType fonts available for PC only on diskette for $175 per font.

Attention Earthling Type Foundry

1299 Palmer Ave., #210
Larchmont, NY 10538-3124
(914) 834-9429
www.attention-earthling.com
Offers over one hundred typefaces on the cutting edge of current design trends. Noteworthy Web site previews Shockwave samples of foundry's typefaces and links to other Web sites. Free catalog can also be ordered from Web site. Mac- and PC-compatible Type 1 and TrueType fonts ranging from $19 to $39 are delivered on-line as downloadable fonts.

The Beatty Collection

2312 Laurel Park Hwy.
Hendersonville, NC 28739
(704) 696-8316
Type designer Richard Beatty has been designing elegant and distinctive typefaces since 1961. Over 260 of his designs are available on diskette in Mac and PC format for $20 per font. Collection consists of display and script faces, many with an architectural look. Order fonts by obtaining free catalog and mailing in order form. Fonts are furnished on diskette.

Bersearch Information Services

26160 Edelweiss Cir.
Evergreen, CO 80439
(800) 851-0289, (303) 674-8875
Fax: (303) 674-1850
Offers Russian font that conforms to the Apple Cyrillic encoding standard. Font available as Type 1 for Mac only on diskette for $49.

Bitstream, Inc.

215 1st St.
Cambridge, MA 02142
(800) 522-3668, (617) 497-6222
Fax: (617) 868-0784
www.bitstream.com
Over thirteen hundred typefaces from sources that range from ITC to European foundries. Fonts are available as Type 1, TrueType and QuickDraw GX formats. Typefaces include designs commissioned from Herman Zapf and John Downer and traditional favorites. Web site lets users see samples of typefaces by keying in the name, browse alphabetical listings of the entire font library, or locate Bitstream resellers. Available on diskette, CD-ROM and as downloadable fonts from Bitstream's Web site in Mac- and PC-compatible formats starting at $25 per font.

Callifonts

P.O. Box 224891
Dallas, TX 75222-4891
(972) 504-8808
Offers a collection of eighty-four calligraphic typefaces with a historical connection. Styles range from Rustica faces, based on fourth-century Italian letterforms, through contemporary looks from the United States and Great Britain. Collection can only be purchased in its entirety. Mac- and PC-compatible fonts can be ordered by phone or by mail and are furnished in Type 1 and TrueType formats on diskette. Call for free poster showing typefaces.

Carter and Cone Type, Inc.

30321 Point Marina Dr.
Canyon Lake, CA 92587
(800) 952-2129, (909) 244-5965
Fax: (909) 244-0946
Offers four fonts designed by renowned type designer Matthew Carter: Big Caslon, Mantinia, Sophia and ITC Galliard. Also distributed through FontHaus, FontShop and Precision Type. Prices range from $60 to $150. Fonts are both Mac- and PC-compatible and available on diskette.

Casa de Toad

P.O. Box 609586
Cleveland, OH 44109-0586
(216) 741-4349
www.cdtoad.com/fonts.html
In addition to making records, Casa de Toad also functions as a graphic design studio and foundry. The group offers four gutsy typefaces, free for the taking, that defy traditional typographic standards. Web site affords a preview of these typefaces and access to downloadable fonts. TrueType fonts are available for PCs only.

Casady & Greene, Inc.

22734 Portola Dr.
Salinas, CA 93908-1119
(800) 359-4920, (408) 484-9218
Fax: (800) 359-4264
Library of specialty fonts includes musical symbols, plus eastern European and Cyrillic alphabets. Mac- and PC-compatible fonts are available on diskette and start at $40 per font.

Castcraft Software, Inc.

3649 W. Chase
Skokie, IL 60076
(888) 893-6687, (847) 675-6530
Fax: (847) 675-6563
www.castcraft-software.com
Offering over six thousand display and text fonts, Castcraft has a sixty-year history of type crafting that dates back to the days of hot metal. Web site lets viewers browse its extensive library and includes an on-line order form. Also sells clip art and software. Prices start at $47.50 per font. Optifont designer collections of eighty typefaces each are $89.95. Type 1 and TrueType fonts available for Mac and PC on diskette and CD-ROM.

Castle Systems

1306 Lincoln Ave.
San Rafael, CA 94901-2105
(415) 459-6495
www.castletype.com
E-mail: castlesys@earthlink.net
Library of over sixty fonts consists primarily of resurrected vintage typefaces, including those of art deco and Cyrillic vintage as well as some original designs. Type 1 and TrueType fonts available in both Mac and PC formats on diskette. Price is $39 per font. Order by phone or get downloadable fonts from Castle Systems' Web site.

The Chank Co.

P.O. Box 580736
Minneapolis, MN 55458-0736
(612) 782-2245
Fax: (612) 782-1958
www.chank.com

Chank Diesel offers a library of over fifty display fonts. Typefaces range from retro to funky. Chank's Web site lets browsers view samples of the Chank library and circle the fonts they want. Free fonts, updated weekly, can also be downloaded from the Chank Web site. Mac- and PC-compatible Type 1 and TrueType fonts are $30 each or $49 for three. Fonts can be ordered by phone or via Web site and are furnished on diskette or on-line.

Comicraft

430 Colorado Ave., #302
Santa Monica, CA 90401
(310) 458-9094
Fax: (310) 451-9761
www.comicbookfonts.com
Until recently, only professionals in the comic business were able to purchase Comicraft's line of hand-rendered looks and other comics-related typefaces. However, under the name of Active Images, Comicraft's fonts are now available to anyone wanting to replicate the look of type seen in Spider-Man, Batman and other comics titles. Mac- and PC-compatible TrueType fonts can be ordered for $29.95 each and are furnished on diskette. Comicraft also sells T-shirts bearing comic book images and other comic book-related items.

Coniglio USA

124 Woodside Green, #2B
Stamford, CT 06905
(203) 975-8111
Fax: (203) 967-3123
www.conigliotype.com
This group of designers offers an eclectic selection of typefaces inspired by the commonplace. Offerings such as Black Tape recreate the look of plastic label-gun letters, whereas typefaces such as Corona and Under-

wood resurrect old typewriter type. Library of forty-plus fonts is available on diskette in Type 1 format for Mac and TrueType for PC. Prices are $24 per font, with a discount of 10% for orders of five or more.

Cool Fonts

Long Beach, CA
www.cool-fonts.com
or available from
Softedge Inc.
(800) 363-7709, (603) 382-4389
Fax: (603) 382-9353
Offers eighteen grunge-style fonts created by video producer and print artist Todd Dever, who started this on-line business in 1994. Since then many of his offerings, such as Freak and Smash, have appeared in *MAD* magazine and *Access Hollywood*. Type 1 and TrueType fonts for Mac and PC are $29.95 each. Order fonts from Web site or contact Softedge, Cool Fonts' distributor. (For more information on Softedge products, see Softedge's listing in chapter one, "Illustration," or chapter two, "Photography.")

Deniart Systems

1074 Adelaide Station
Toronto, Ontario M5C 2K5
Canada
(800) 725-9974, (416) 941-0948
Fax: (416) 941-0948
www.deniart.com

Foundry specializes in Morse code, Braille, Sanskrit, chemical symbols, Egyptian hieroglyphics and other symbols for communication. Unusual fonts include the writing system developed by J.R.R. Tolkien in his classic *The Lord of the Rings*. Offers thirty-nine fonts on diskette and on-line ranging from $10 to $30 per font. Mac- and PC-compatible Type 1 and TrueType formats.

Dennis Ortiz-Lopez

267 W. 70th St., #2C
New York, NY 10023
(212) 501-7077
Fax: (212) 769-3783
http://soho.ios.com/~sini4me2
Known for his typeface designs for *Rolling Stone*, *Sports Illustrated* and other publications, Ortiz-Lopez offers sixty of his fonts on diskette and via his Web site. In addition to traditional display looks, his designs include "layers" fonts, an unusual collection of ornaments and alphabets with drop shadows. Prices for Mac-compatible Type 1 fonts range from $20 to $80 per font.

DesignPlus

853 Broadway
New York, NY 10003
(800) 231-3461, (212) 477-8811
Fax: (212) 477-8969
Font library includes Swiss designer Urs Köhli's collection of thirty-three typefaces. The Köhli collection includes symbol fonts; Sports Figures, a series of athletic figures in silhouette; and an Initial Caps collection made up of 1,535 characters. Prices range from $19 to $95 per font. Type 1 and TrueType fonts are available on diskette in Mac- and PC-compatible formats. Offers thirty-six fonts ranging in price from $25 to $45 per font.

The Electronic Typographer

P.O. Box 224
Audubon, IA 50025
(712) 563-3799
Fax: (712) 563-3799

Specializes in calligraphic typefaces inspired by typographic styles that range from Renaissance scripts to more contemporary looks. Fonts include decorative initials, flourishes and alternative letters to ensure a hand-lettered look. Over fifty Mac- and PC-compatible fonts are offered in Type 1 and TrueType formats and delivered on diskette. Prices range from $25 to $45 per font.

Elfring Soft Fonts, Inc.

P.O. Box 61
Wasco, IL 60183
(630) 377-3520
Fax: (630) 377-6402
www.elfring.com

Founded in 1979, company specializes in fonts and clip art for Windows and DOS platforms. Collection of eight families includes bar codes and fonts used for other character-reading and scanning equipment. Foundry also produces display typefaces. Prices range from $25 to $50 for fonts delivered on diskette, on CD-ROM or on-line.

Emboss

178 E. Main St., 1st Fl.
Gloucester, MA 01930
(978) 283-2861
Fax: (978) 283-0156
www.embossdesign.com

Newly formed foundry offers about twenty fonts with a raw, primal feeling. Emboss's trendsetting looks have been used by *SkateBoarder* and *Snowboarder* magazines, among others. Type 1 and TrueType fonts for Mac only are furnished on diskette for $29 to $49 per font.

Emigre Graphics

4475 D St.
Sacramento, CA 95819
(800) 944-9021, (916) 451-4344
Fax: (916) 451-4351
www.emigre.com

One of the first type foundries to bring original digital type designs into desktop mainstream, Emigre offers its own unique, award-winning designs as well as those from other designers known for their cutting-edge work. Because founders Rudy Vanderlans and Zuzana Licko pioneered production of computerized fonts long before the advent of font design software, some of their designs have a distinctly digital look. Emigre also publishes a quarterly magazine that focuses on contemporary design and typography issues (see page

The Electronic Typographer specializes in calligraphic typefaces. Many come with decorative initials and other embellishments.

105). Prices start at $59 per font. Fonts are also sold in volumes. Library of about seventy fonts is available on-line as well as on diskette and CD-ROM. Mac- and PC-compatible fonts are available in Type 1 and TrueType formats.

The Exploding Font Co.

P.O. Box 90100
San Diego, CA 92169
(619) 234-9429
Fax: (619) 234-9479
www.typesite.com

Offers sixty-plus fonts from designers such as Chank Diesel, Gary Hustwit and Swedish designers Peter Bruhn and Claes Källarsson. Mac- and PC-compatible fonts are available in Type 1 and TrueType formats at $29 to $59 per family.

The Font Bureau, Inc.

175 Newbury St.
Boston, MA 02116
(617) 423-8770
Fax: (617) 423-8771

Founded by type designers David Berlow and Roger Black, The Font Bureau offers a collection of over five hundred fonts. They include Rolling Stone, originally designed for the magazine whose name it bears, and other fonts designed for publications. Foundry also does custom font design. In addition to *Rolling Stone*, clients have included *Esquire* and *PC Week*. Mac- and PC-compatible fonts are available in Type 1, Type 3, TrueType, QuickDraw GX and Multiple Master formats. Fonts are delivered on-line, on diskette and on CD-ROM at $30 to $40 per font.

FontFont

FontShop International
Berlin, Germany
49-30-693-70-22 (Germany)
(415) 398-7677, (888) 333-6687 (United States)
www.fontfont.de
Representing more than thirty independent foundries, this distributor offers font designs, many of them classics, from such eminent typographers as Erik Spiekermann and Neville Brody. Company also is the exclusive dealer of Neville Brody's award-winning typographic publication, *FUSE* (for more information, see listing on page 105). Library consists of over one thousand Mac- and PC-compatible fonts at $39 each, available in Type 1 and TrueType formats on diskette and CD-ROM. Font-Fonts are also available from FontHaus, Agfa and Phil's Fonts.

FontHaus, Inc.

15 Perry Ave., A7
Norwalk, CT 06850
(800) 942-9110, (203) 367-1993
Fax: (203) 367-7112
www.fonthaus.com
Foundry has been developing, licensing and marketing digital fonts since 1990, and over the years, has built up one of the most diverse font collections in the industry. In addition to Fonthaus's own exclusive collection, this clearinghouse represents over sixty independent type designers and foundries. Library of more than one thousand type and picture fonts includes typefaces from Bitstream, Adobe, ITC, PaloAlto, Treacyfaces, [T-26], Linotype and many others. Offers custom packages of client-specified typefaces on diskette. Available in Type 1 and TrueType formats for Mac and PC on diskette and CD-ROM.

Fonthead Design

20942 Estada Ln.
Boca Raton, FL 33433-1769
Fax: (561) 482-3630
www.fonthead.com
Foundry offers about seventy original display faces composed of whimsical, hand-rendered and other popular looks. In addition to its catalog, the Web site features a type "cookbook." Mac- and PC-compatible fonts are available in Type 1 and TrueType formats and can be ordered on-line as well as by fax or mail. Fonts are furnished on-line and on diskette and sold by volumes of ten to twenty typefaces for $30 per volume.

FontWorld, Inc.

1746 Ocean Ave.
Brooklyn, NY 11230
(718) 252-1121
Fax: (718) 252-1120
www.fontworld.com

Established in 1986, foundry specializes in international language fonts, including Middle Eastern, Greek, Cyrillic, Turkish, Vietnamese and European/Baltic. Company also can meet custom typeface requirements and develop fonts for languages not part of its current library. Fonts are available in Type 1 and TrueType formats for Mac only and delivered on diskette or on-line. Prices range from $49 to $299 per family.

Foster and Horton/FoHo Fonts

211 W. Gutirez, #3
Santa Barbara, CA 93101
(805) 962-3964
Fax: (805) 962-7388
Offers thirty-six historical display typefaces scanned from letterpress originals. Prices range from $20 to $45 per font, available in Type 1 format for Mac only on diskette.

Fountain

Södra Parkgatan 29A
S-214 22 Malmö
Sweden
www.fountain.nu
This Swedish independent foundry offers over sixty fonts from young designers exploring the new wave of digital typography. Type 1 and TrueType Mac- and PC-compatible fonts are available on diskette and on-line for $29 per font.

Galápagos Design Group

256 Great Rd., Ste. 15
Littleton, MA 01460-1916
(978) 952-6200
Fax: (978) 952-6260
www.galapagosdesign.com
Foundry is made up of an enterprising group of designers who formerly worked at larger foundries, including Linotype, Agfa and Bitstream. Original designs range from cutting-edge to more traditional looks. This design group also produces Web art and illustration as well as custom font design. Over ten Mac- and PC-compatible fonts, available in Type 1 and TrueType formats, are delivered on-line or on diskette starting at $49 per font.

GarageFonts

703 Stratford Ct., #4
Del Mar, CA 92014
(760) 755-4761
Fax: (760) 755-4761
www.garagefonts.com
This southern-California foundry got its start offering fonts from *Ray Gun* magazine as well as work from other type designers who produce similar grunge looks.

Fonts are not intended for text but are especially well suited to *Ray Gun*-style typographic illustration. Offers about 150 Mac- and PC-compatible fonts on diskette. Prices range from $65 to $100 per font.

Harris Design

P.O. Box 377
Santa Rosa, CA 95402-0377
(707) 585-0265
Fax: (707) 585-0265
www.sonic.net/~hdfonts
Offers ten display faces as well as a Logos2Fonts service that converts anyone's corporate logo to a font. Browsers can view offerings through Web site. Typefaces are also available through FontHaus. Type 1 and TrueType Mac-and PC-compatible fonts are delivered on diskette.

The Hoefler Type Foundry, Inc.

612 Broadway, Ste. 815
New York, NY 10012-2608
(212) 777-6640
Fax: (212) 777-6684
www.typography.com
Established by Jonathan Hoefler in 1990, the Hoefler collection consists of over twenty typefaces, many of which are historical revivals. Hoefler, who also designs type for magazines such as *Sports Illustrated* and *Rolling Stone*, is a perfectionist in his production of fonts that are supremely kerned and proportioned. Fonts are available on diskette in Type 1 format for Mac only. Prices start at $49 per font.

House Industries

814 N. Harrison St., 36th Fl.
Wilmington, DE 19806
(800) 888-4390, (302) 888-1218
Fax: (302) 888-1650
www.houseind.com
Offers over 120 original typefaces with a contemporary look. Trendsetting designs have appeared in all types of venues, including network television, MTV and thousands of print applications. House Industries also offers hand-rendered looks, such as the Rat Fink set from Big Daddy Roth, a cult figure among car buffs. Offers Mac- and PC-compatible Type 1 and TrueType fonts on diskette and CD-ROM starting at $50 per font.

Image Club Graphics

A Division of Adobe Systems, Inc.
Calgary, Alberta
Canada
(800) 661-9410, (403) 262-8008
Fax: (800) 814-7783
www.imageclub.com
Offers a variety of display, text and picture fonts ranging from traditional and vintage looks to more contem-

GarageFonts is known for fonts that embody the grunge look popularized by Ray Gun magazine.

porary faces. About 30 percent of the collection is exclusive; the rest are fonts licensed from Adobe, Letraset, ITC and other sources. Mail catalog is full of design tips. Library of about nine hundred typefaces is available for Mac and PC in Type 1 and TrueType formats for $20 per font. Also offers a variety of discount packages. Downloadable fonts can be ordered on-line or delivered on diskette or CD-ROM.

International Typeface Corp. (ITC)

866 2nd Ave.
New York, NY 10017
(800) 634-9325, (212) 949-8072
Fax: (212) 949-8485
www.itcfonts.com
Since it was founded more than twenty-five years ago, ITC has worked closely with the world's foremost typeface designers to develop a library that now includes more than one thousand classic and contemporary names in typeface design and distribution. Long known for its classic typeface designs, ITC has aggressively expanded its library and broadened the range of typefaces offered. The addition of Fontek display typefaces and a line of illustration fonts has expanded the ITC library considerably in recent years. ITC continues to grow at the rate of sixty new fonts per year and publicizes its new additions through *U&lc*, its quarterly tabloid (see page 107). State-of-the-art Web site includes an on-line version of *U&lc* and allows viewers to set their own words with ITC type. Type 1 and TrueType fonts are Mac- and PC-compatible and are available on CD-ROM, diskette and as downloadable fonts on-line.

Jonathan Macagba

244 5th Ave., Ste. 2246
New York, NY 10001-7604
(212) 591-0208
Fax: (212) 388-1497
http://users.aol.com/jonathan45
Illustrator, designer and typographer Jonathan Macagba has been offering his original designs since 1991. His library of over thirty display faces ranges from whimsical to historical revivals. Macagba also digitizes and designs custom fonts for clients such as *TV Guide* and *American Health* magazines. Mac- and PC-compatible Type 1 and TrueType fonts are $45 and are available on diskette or CD-ROM.

Keystrokes

222 Peerless Ave.
Birmingham, AL 35209
(205) 871-8803
Fax: (205) 871-8803
http://users.quicklink.net
Foundry specializes in revival typefaces, particularly art deco fonts. Other display faces include Western looks and script styles. Library consists of 104 fonts. Mac- and PC-compatible Type 1 and TrueType fonts are available on diskette or as downloadable fonts from Web site. Fonts are sold individually and as collections. Prices start at $18 for a custom selection of nine fonts.

Kiwi Media, Inc.

2206 Kendall Ave., #D
Madison, WI 53705
(608) 231-3225
www.itis.com/kiwi
This multimedia design firm's on-the-edge display faces explore the limits of shareware font design. Collection includes over twenty Mac- and PC-compatible fonts in Type 1 and TrueType formats. Fonts are delivered on-line for $5 to $15 per font.

Lanston Type Co., Ltd.

6 Egan St.
P.O. Box 60
Mt. Stewart, Prince Edward Island C0A 1T0
Canada
(800) 478-8973, (902) 676-2835
Fax: (902) 676-2268
Offers over forty-five fonts that are faithful replicas of the foundry's century-old library of metal fonts. Collection is Mac- and PC-compatible and available on diskette starting at $75 per font. Company also does custom work, including digital logotypes.

LetterPerfect

6606 Soundview Dr.
Gig Harbor, WA 98335
(800) 929-1951, (206) 467-7275
Fax: (800) 929-1951
www.letterspace.com
Collection of over fifty display faces is based on original hand-lettered designs of former greeting card letterer. Library includes many contemporary faces plus historically inspired designs. Type 1 and TrueType Mac- and PC-compatible fonts are available on diskette for $35 to $49 per font. Fonts can be delivered on-line, on diskette or on CD-ROM.

Linguist's Software

P.O. Box 580
Edmonds, WA 98020
(425) 775-1130
Fax: (425) 771-5911
www.linguistsoftware.com
Founded by Phillip B. Payne, a former missionary who received a doctorate in New Testament Greek, this foundry offers fonts for more than three hundred languages. Many have been used in Bible reproduction. Offers about four hundred typefaces for NeXT and UNIX as well as Mac- and PC-compatible Type 1 and TrueType fonts on diskette at $24.95 to $149.95 per family.

Linotype Library

Du-Pont-Str.1
61352 Bad Homburg
Eschborn, Germany
49 (0) 180-5466 546
Fax: 49 (0) 180-5466 329
www.linotypelibrary.com
The Linotype library consists of over five thousand typefaces accumulated over more than a hundred years in the business. Collection also includes ITC's Fontek line. In addition to Type 1 and TrueType fonts that are Mac- and PC-compatible, Linotype-Hell also offers GX-compatible typefaces. Fonts are $42 each and are available on diskette, on CD-ROM and on-line. Fonts can also be purchased through Precision and Type Associates.

Lux Typographics

40120 Michael Ave.
Los Angeles, CA 90066
(310) 822-7919
Fax: (310) 821-5279
New foundry is dedicated to producing fonts that challenge traditional ideas of legibility. Offers six unusual display faces ranging from $59 to $99 per font. Mac- and PC-compatible Type 1 fonts are delivered on diskette.

Majus Corp.

P.O. Box 140584
Dallas, TX 75214
(214) 828-1907
Fax: (214) 828-1907
Offers about thirty typefaces crafted by industry veteran George Thomas. Collection of text and display faces consists of historical revivals and more contemporary looks. Mac- and PC-compatible Type 1 and TrueType fonts are delivered on diskette starting at $19.95 per font.

MindCandy

1712 E. Riverside, Ste. 88
Austin, TX 78741
(512) 263-3200
Fax: (512) 448-3760
www.mindcandy.com
Over thirty display fonts with a contemporary, whimsical look. Foundry features original designs as well as new designs from other foundries, including The Chank Company, 2Rebels and Radiateurfonts (France). Prices range from $40 to $50 per font. Mac- and PC-compatible fonts are available on diskette and on-line in Type 1 and TrueType formats.

Monotype Typography, Inc.

150 S. Wacker Dr., Ste. 2630
Chicago, IL 60606
(800) 666-6897, (847) 718-0400
Fax: (847) 718-0500
www.monotype.com
Founded in 1897, Monotype offers its own extensive library of six thousand fonts as well as those of Adobe and Agfa. Monotype's Creative Alliance CD combines the Agfa and Monotype libraries into the industry's largest font collection on CD-ROM. Typefaces by David Berlow, Sumner Stone and Matthew Carter are included plus those from newcomers, such as Nick Shinn and Jeremy Tanker. In addition to thousands of fonts, the foundry offers custom font design and foreign language fonts. Type 1, TrueType and Multiple Master Mac- and PC-compatible fonts are available on diskette and CD-ROM starting at $19.99 per font.

Nimx Foundry

3878 Oak Lawn Ave., Ste. 100B-177
Dallas, TX 75219
(214) 340-1645
Fax: (214) 340-6399
www.nimx.com
Offers a collection of thirty-eight funky display fonts, dingbats and picture fonts. Firm also makes a picture font called Faces, which allows for mixing and matching facial parts to create unusual creatures. Mac- and PC-compatible fonts come on diskette or CD-ROM in Type 1, TrueType and Multiple Master formats. Prices start at $20 per family.

International Type Founders is an organization of small type foundries that have joined forces to market their fonts on CD-ROM. Each foundry sets its own prices on a locked CD-ROM, which can be unlocked by purchasing keys from an ITF dealer or ITF's Web site: www.fontgallery.com. You can also contact ITF by calling Red Rooster Typefounders (page 63).

Olduvai Corp.

9200 S. Dadeland Blvd., Ste. 525
Miami, FL 33156
(800) 548-5151, (305) 670-1112
www.olduvai.com
Offers over forty-three fonts in packages that contain ten to twenty typefaces apiece plus picture fonts for $59 to $149 per package. All typefaces include foreign language characters. Type 1 and TrueType fonts for Mac only are delivered on diskette, on CD-ROM or on-line.

1-800-TYPE-USA, Inc.

47 W. Polk St., #100-310
Chicago, IL 60605
(800) TYPE-USA
Fax: (312) 922-8949
Distributes fonts for the following foundries: Adobe, E-Fonts, ITC, Emigre, Fontek Font Bureau and Letter-Perfect. Sells custom packages of fonts with quantity discounts. Prices start at $18 per font and range to packages of eight or more for $144. Mac- and PC-compatible Type 1 fonts are delivered on diskette and CD-ROM.

One Way Out

890 Promontory Pl. SE
Salem, OR 97302
(503) 370-9377
Fax: (503) 362-5231
New foundry is an offshoot of Church Art Works, offering twelve unconventional display faces called The Generation X Font Collection. Also sells T-shirts. Fonts are offered in packages of six for $99. Mac- and PC-compatible Type 1 and TrueType fonts are delivered on diskette.

ONGdesign

2474-A NW Marshall
Portland, OR 97210
(503) 223-2159
www.ongdesign.com
Designer, illustrator and font designer Jeff Ong offers his Web site visitors free downloadable fonts of four

Plazm Media's collection of over one hundred display faces covers a wide range of popular contemporary looks.

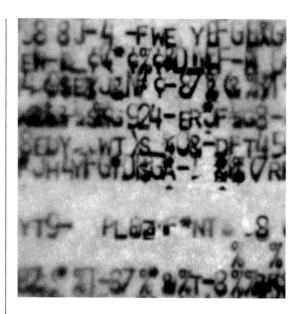

of his original type designs that have appeared in various on-line venues, including America Online. Fonts are Type 1 Mac- and PC-compatible. Ong also does custom font designs, which start at $1,000.

ParaGraph International (ParaType)

Moscow, Russia
007 (095) 332-4001
Fax: 007 (095) 129-0911
www.paratype.com
From Russia with love comes this collection of over five thousand multilingual fonts. Over eighty-three languages are represented. Offers Mac- and PC-compatible Type 1, TrueType and Type 3 fonts at prices ranging from $12 to $15. Fonts are delivered on diskette, CD-ROM or on-line. Web site also offers free fonts.

Paul Baker Typography, Inc.

205 Wacker Dr., Ste. 513
Chicago, IL 60606
(312) 357-1300
www.pbtweb.com
Offers custom font and Web design. Clients include Rand McNally and the Los Angeles County Museum of Art. Font production is limited to PC-compatibles.

Phil's Fonts, Inc.

14605 Sturtevant Rd.
Silver Spring, MD 20905
(800) 424-2977, (301) 879-0601
Fax: (301) 879-0606
www.philsfonts.com
Business evolved out of Phil's Photo, one of the best-known photolettering companies in the industry. Phil's Photo distributes fonts from over fifty-five foundries, large and small. The library includes over twenty thousand Mac- and PC-compatible Type 1 and TrueType

fonts. Also produces original fonts and commissions font designs from independent designers. Award-winning Web site includes a font search engine and on-line order form, as well as contests and a free downloadable font that changes every month.

Plazm Media

P.O. Box 2863
Portland, OR 97208-2863
(800) 524-4944, (503) 222-6389
Fax: (503) 222-6356
www.plazm.com
Founder Josh Berger and his partners in design have been producing their experimental typefaces since 1991. The foundry commissions typefaces from designers all over the world and offers an eclectic collection of over one hundred display faces that range from ultracontemporary to grunge looks. Plazm also publishes a magazine that features its typefaces within the context of cutting-edge art and editorial (see page 106). Mac- and PC-compatible Type 1 and TrueType fonts are delivered on diskette or on-line and start at $40 per font.

Precision Type

47 Mall Dr.
Commack, NY 11725-5703
(800) 248-3668, (516) 864-0167
Fax: (516) 543-5721
precisiontype.com
Looking for a single source for all of your font and font software needs? Precision Type distributes fonts for most of the major foundries and a large number of designer foundries as well. Companies represented include Adobe, Agfa, Bitstream, ITC, Emigre and many more. Precision also sells font software and offers technical assistance. Fonts are delivered on diskette, CD-ROM and on-line. The company's massive seven-hundred-page catalog lists its more than twenty thousand typefaces as well as the software it carries. This impressive volume sells for $39.95, but the access it affords to practically every font you could ever want makes the price well worth it.

PrePress Solutions

11 Mt. Pleasant Ave.
East Hanover, NJ 07936
(800) 631-8134, (716) 637-9390
Contact: Dan Gray, (800) 631-8134, ext. 5512
This catalog company offers typefaces formerly owned by Varityper. Library also includes fonts from Adobe, Bitstream and other foundries. In addition to text and display fonts, collection includes foreign language fonts. Mac- and PC-compatible fonts start at $39 and are available on diskette.

Prototype Experimental Foundry

2318 N. High St., #9
Columbus, OH 43202
(614) 447-8103
Fax: (614) 447-8014
www.prototype-typeo.com
Typehouse specializes in experimental typefaces. Offerings include typefaces inspired by handwriting found at local flea markets as well as Japanese comics. Collection consists of more than twenty-five fonts delivered on diskette and on-line for $50 to $65 per font. Available in Mac- and PC-compatible Type 1 and TrueType formats.

Psy/Ops Type Foundry

481 Mississippi St.
San Francisco, CA 94107-2927
(888) 779-3663, (415) 896-5788
Fax: (415) 896-2290
www.psyops.com
San Francisco foundry offers over ninety original text and display faces. Founder Rodrigo Cavazos's unique aesthetic vision is reflected in this cutting-edge collection of fonts that convey a range of contemporary looks. Mac- and PC-compatible Type 1 and TrueType fonts are available on diskette and on-line for $35 to $175 per font.

Refer to image on page 64.

P22 Type Foundry

P.O. Box 770
Buffalo, NY 14213
(800) 722-5080, (716) 885-4490
Fax: (716) 885-4482
www.p22.com
Foundry specializes in historic revivals as well as other innovative concepts. Library includes fonts based on the handwriting of renowned artists, such as Marcel Duchamp and Josef Albers. The P22 conglomerate includes artists, programmers and architects who are all involved in creating the foundry's collection of close to one hundred fonts. Mac- and PC-compatible Type 1 and TrueType fonts are available on diskette or on-line starting at $23.95 per family.

Refer to image on page 65.

Quadrat Communications

12 Grenville St., Ste. 1501
Toronto, Ontario M4Y 3B3
Canada
(416) 960-0606
Fax: (416) 960-6054
www.interlog.com/~quadrat
Founded by graphic designer and type designer David Vereschagin, this foundry offers over twenty-five original fonts. Vereschagin also does custom typography

and font production. Offers free Ratsample font from Web site. Mac- and PC-compatible fonts are available on diskette in Type 1 and TrueType formats for $25 per font.

Red Rooster Typefounders

1915 White Hall Rd.
Norristown, PA 19403
(800) 251-5108, (610) 584-1011
Fax: (610) 584-8859
www.fontgallery.com
Represents fifty independent foundries, together offering over ten thousand typefaces. Headed by Steve Jackaman, founder of International Type Founders (ITF), Red Rooster offers the International Type Founders collection on CD-ROM. The company is constantly adding to its library of typefaces, which includes turn-of-the-century revivals, contemporary and traditional faces. Mac- and PC-compatible Type 1 and TrueType fonts are available on diskette, CD-ROM and on-line.

San Gabriel Custom Fontologists

P.O. Box 3000-256
Georgetown, TX 78628
www.sangabriel.com
Does custom work only. Will develop a font from your own design, handwriting, logo and so on. Prices start at $35 for your signature as a font. A font based on your handwriting costs $100. Doesn't take phone orders. Mac- and PC-compatible Type 1 and TrueType fonts are delivered on diskette and on-line.

The Scriptorium

P.O. Box 140333
Austin, TX 78714
(800) 797-8973, (512) 472-6535
Fax: (512) 472-6220
www.ragnarokpress.com/scriptorium

Psy/Ops Type Foundry offers a variety of unique fonts with a distinctive contemporary look. For additional information, see their listing on page 63.

Offers over eight hundred text, display and picture fonts, many based on historical scripts and other antique typefaces. Many unique packages and other products are offered, such as a Digital Coloring Book of traditional black-and-white line art illustrations that can be colored as you wish on the computer. Type 1 and TrueType Mac- and PC-compatible fonts are available on diskette, CD-ROM and on-line.

Shift

P.O. Box 4
Burlingame, CA 94011-0004
(650) 343-3940
Fax: (650) 343-3498
www.shiftype.com
Offers a growing library of fonts with a technological theme. Collection of about twenty fonts includes picture fonts as well as display faces. Some of foundry's typefaces have appeared in *Communication Arts* magazine. Type 1 fonts for Mac only are delivered on diskette or on-line (Shift prefers on-line orders).

Stone Type Foundry, Inc.

626 Middlefield Rd.
Palo Alto, CA 94301
(800) 557-8663, (415) 324-1870
Fax: (415) 324-1783
Founded by renowned type designer and former Adobe type director Sumner Stone, this foundry offers some of the most versatile text and display typefaces to be found. Fonts include a text typeface originally designed for *PRINT* as well as other fonts suitable for magazines and other text-intensive publications. Many designs come with old-style figures and small caps. All fonts are designed with extensive kerning tables. Stone also does custom work. Fonts start at $58 each. Over one hundred typefaces are available on diskette in Type 1, Mac and PC formats.

Studio Daedalus

P.O. Box 11521
Champaign, IL 61826-1521
(217) 398-8443
Fax: (217) 398-8443
www.studiodae.com
Foundry offers WhizBang, a font that mimics the look of comic book lettering. WhizBang also includes a selection of EPS word balloons so users can create their own comic book panels. Cost is $35. Type 1 and TrueType versions of the font are available in Mac and PC formats, furnished on diskette or on-line.

StudioType

175 5th Ave., Ste. 2330
New York, NY 10010
(888) 339-8100, (212) 420-9017
Fax: (212) 505-9093
www.studioworld.com
A division of StudioWorld, which produces and sells clip art, fonts and Web graphics, StudioType offers fonts designed by veterans of the industry who once worked in some of New York City's largest foundries. Collection includes a selection of over fifteen text and display faces, some available as Multiple Master fonts. Fonts are available in TrueType and Type 1 formats. Mac- and PC-compatible versions are delivered on diskette, CD-ROM and on-line.

SynFonts

1338 N. 18th Plaza, #9
Omaha, NE 68154
(402) 491-3065
Fax: (402) 445-8301
www.synfonts.com
Collection of cutting-edge looks offered by founder Don Synstelien includes display faces as well as picture fonts. About forty Mac- and PC-compatible fonts are available in Type 1, Type 3 and TrueType formats. Prices range from $10 to $29 per font, although some are offered for free. Fonts are furnished on diskette, CD-ROM and on-line.

Refer to image on page 66.

Thirstype

117 S. Cook St., #333
Barrington, IL 60010
(847) 842-0333
Fax: (847) 842-0220
www.3st.com
Designer Rick Valicenti, founder of Chicago-based Thirst, offers his own unique fonts, as seen in his paper promotions for Gilbert and in *Harper's Bazaar*. To his own collection of well-known designs, such as Bronzo and Ooga Booga, Valicenti has added those of

other kindred design spirits, such as Smile, by Patricking, and the Love/Hate collection, by Chester. Collection of over twenty Type 1 fonts for Mac and PC is available on diskette or on-line for $35 to $150 per font.

Tiro Typeworks

P.O. Box 3346
Vancouver, British Columbia V6V 3Y3
Canada
(604) 669-4884
Fax: (604) 689-4022
www.tiro.com
Foundry offers high-quality text and headline faces for those who want perfect letterspacing and versatility in their fonts. Designs are by founders William Ross Mills and John Hudson. Foundry also offers design and manufacturing to type companies and others wanting to produce their own type designs. Over ten fonts are available in Mac- and PC-compatible Type 1 and TrueType formats. Fonts are delivered on diskette.

Treacyfaces/Headliners

P.O. Box 26036
West Haven, CT 06516-8036
(800) 800-6805, (203) 389-7037
Fax: (203) 389-7039
www.treacyfaces.com
High-quality typefaces designed by Joe Treacy are primarily new text typefaces that are updated versions of traditional looks produced for those who are discerning about their fonts. With over twenty years in the business, Treacy has earned a reputation for fonts that are well kerned and well designed. His extensive kerning pairs (1,700–5,000 per font) save time and money. Treacy also does custom work. Prices start at $15 for over four hundred Mac- and PC-compatible fonts available in Type 1 and TrueType formats on diskette, CD-ROM and on-line.

[T-26]

1110 N. Milwaukee Ave.
Chicago, IL 60622
(888) T26-FONT, (773) 862-1201
Fax: (773) 862-1214
www.T26FONT.com
Offers cutting-edge display faces designed by founders Carlos Segura and Scott Smith as well as unusual typefaces from others. When Segura founded [T-26] in 1994, he wanted to explore the realms of experimental typography by offering designers in the Chicago area an opportunity to produce and market their own

designs. In a short time, Segura's innovative promotions and marketing techniques have attracted design submissions from all over the country, including a collection of faces by well-known designer Margo Chase. The [T-26] library of around five hundred typefaces is available as Type 1 Mac- and PC-compatible fonts, furnished on diskette, CD-ROM and on-line for $29 to $39 per font.

TypeArt Foundry, Inc.

P.O. Box 48611
Bentall Center
Vancouver, British Columbia V7X 1A3
Canada
(800) 289-8973, (604) 602-0331
www.typeart.com
Collection of 136 fonts includes traditional, decorative, modern, script and grunge fonts. Founder Lloyd Springer claims all of his fonts are carefully kerned and complete, consisting of 230 characters each. The foundry's Web site offers type tips, a typographical reference library where fonts are organized by category, and a "Name That Font" game. Fonts are $29 each and available on diskette or on-line in Mac- and PC-compatible Type 1 and TrueType formats.

P22 Type Foundry offers fonts that reflect popular trends, including historic revivals and fonts based on artists' handwriting. For more information, see their listing on page 63.

Anyone interested in getting news on the latest goings-on in the realm of digital type design and typography in general should check out the Internet Type Foundry Index (www.typeindex.com). Chris MacGregor, of Union Type Supply, has put together an impressive Web site that includes lists of foundries, book reviews, a bookstore, which offers discounts, and much more.

SynFonts' library includes display and picture fonts. For more information, see their listing on page 64.

The Type Quarry

P.O. Box 442
Rockland, ME 04841
(207) 596-6768
Fax: (207) 596-7403
www.3ip.com/type.html
Founded by type aficionado Brian Wilson, this foundry offers over twenty-five typefaces based on antique text faces, authentic nineteenth-century handwriting samples, modern hand-rendered looks and a selection of novelty faces. In addition to showing viewers font samples, The Type Quarry's impressive Web site gives viewers demo versions of its fonts and also directs them to other type-related resources on the Internet. Those who complete an on-line survey receive a free font. Mac- and PC-compatible fonts are available for $10 to $27 per font in Type 1 and TrueType formats on diskette and on-line.

Union Type Supply

P.O. Box 890024
Houston, TX 77289
(281) 895-2924
http://members.aol.com/uniontype
Font activist Chris MacGregor founded this company in 1997 to market his own font designs plus those from other cutting-edge foundries, such as SynFonts and MindCandy. Foundry offers over thirty Mac- and PC-compatible Type 1 and TrueType fonts on diskette and on-line. Cost is $40 per font.

URW America, Inc.

P.O. Box 700
Barrington, NH 03825
(800) 229-8791, (603) 664-2130
www.urwpp.de
Widely regarded as a pioneer in digital type, URW brings the technology of its parent company in Germany to its type library and Ikarus font-making software. Offers over three-thousand text and display fonts from the world's leading foundries, as well as exclusive typefaces from its Hamburg, Germany–based studio. URW also offers a collection of logo fonts from major corporations, which can be located by entering a name and searching its Web site's database. Mac- and PC-compatible Type 1 and TrueType fonts cost $49 each and are available on diskette and CD-ROM.

UTF

℅ Hybrid Communications
185 South Rd.
Marlborough, CT 06447
(800) 945-3648, (860) 295-9135
http://gs1.com/UTF/UTF.html
Foundry specializes in novelty and picture fonts. Web site makes finding picture fonts easy by organizing content into four areas: retail, industry, hotel and cuisine, and art and antiques. Over thirty Mac- and PC-compatible fonts available on diskette and on-line. Prices range from $10 to $15 per font.

Y&Y, Inc.

45 Walden St., Ste. 2F
Concord, MA 01742
(800) 742-4059, (978) 371-3286
Fax: (978) 371-2004
Offers over 150 text and mathematical fonts for use in textbooks, diagrams and other technical drawings. Mac- and PC-compatible Type 1 fonts start at $45 each and are available on diskette.

Typehouses Offering Rare and Unusual Typefaces

If you can't find the typeface you need in a computer font, these typehouses can set type for you. Each company offers an extensive library of vintage and exotic typefaces as well as practically every other imaginable typeface, including standard faces. Most will accept out-of-town orders by fax or modem; however, turnaround times shown may not include overnight shipping.

Aldus Type Studio

731 S. LeBrea
Los Angeles, CA 90036
(213) 933-7371
Fax: (213) 933-8613
More than eight thousand headline fonts and two thousand text fonts. Normal turnaround time is twelve to fourteen hours.

Andresen Typographics

1500 Sansome St., Ste. 100
San Francisco, CA 94111
(415) 421-2900
Fax: (415) 421-5842
E-mail: andresen@planeteria.net
About seven thousand headline fonts and four thousand text typefaces. Overnight service, with rush service available.

Insync

100 Broadway
San Francisco, CA 94111
(415) 421-6700
Fax: (415) 421-5090
Approximately seven thousand typefaces, half of them exclusively display. Turnaround time is twenty-four hours or overnight.

Latent Symphony

54 W. 21st St.
New York, NY 10010
(212) 604-0055
Fax: (212) 645-3276
Approximately seven thousand headline fonts and twenty-five hundred text typefaces. Twelve- to fourteen-hour turnaround, with two-hour rush available.

Linographic Services

610 S. Jennings
Fort Worth, TX 76104
(817) 332-4070
Fax: (817) 429-9780
Approximately ten thousand typefaces, including some hot metal. Turnaround time depends on client's request.

M&H Type

460 Bryant St.
San Francisco, CA 94107
(415) 777-0716
Fax: (415) 777-2730
Offers hot-metal type with about five hundred faces available, many of them vintage. Also offers computerized typesetting. Digital library consists of about five hundred fonts. Turnaround time is approximately twenty-four hours.

Custom Lettering

These custom-lettering services and calligraphers take commissions for hand-lettered typography. Typical applications include logos, headlines, movie titles, brand identity and packaging applications.

The Type Quarry specializes in antique typefaces, including resurrections of old text faces and handwriting samples.

Brenda Walton

P.O. Box 161976
Sacramento, CA 95816
(916) 452-8977
Fax: (916) 452-8978
www.ns.net/users/peckham/bw/
Walton's speciality is romantic scripts with a vintage look. In addition to creating script for greeting cards and gift products, Walton has created lettering for many packaging and advertising applications and has produced lettering styles that have ultimately been digitized into fonts. Clients include Hanes, Intel Corporation, Kraft, United Airlines and Sara Lee. One of Walton's lettering styles is also available as a font through ITC.

Refer to image on page 69.

Dennis Ortiz-Lopez

267 W. 70th St., #2C
New York, NY 10023
(212) 501-7077
Fax: (212) 769-3783
http://soho.ios.com/~sini4me2

For those who are interested in achieving copyright protection for their original font designs, TypeRight is an independent organization of type designers and specialists who have formed an advocacy group determined to achieve copyright protection for font designs in the United States. The group is a virtual organization and has no address or phone number, but it can be contacted via its Web site at www.typeright.org.

Jill Bell's custom typography covers a broad range of contemporary looks.

Known for his hand-lettered headlines and other display lettering for *Rolling Stone*, *Sports Illustrated* and other publications, Ortiz-Lopez creates custom lettering to meet the most demanding client specifications.

House Industries

814 N. Harrison St., 36th Fl.
Wilmington, DE 19806
(800) 888-4390, (302) 888-1218
Fax: (302) 888-1650
www.houseind.com
House Industries is well known for creating fonts popularized on MTV and many other venues. (See listing under Computer Fonts.) The foundry also does custom lettering created by founders Rich Roat and Andy Cruz, the designers behind many of the foundry's popular fonts. House Industries has produced logotypes and lettering applications, many of them with a 1970s look, for Nickelodeon, Phish, Motel 6, A&M Records and ESPN.

Jill Bell Design and Lettering

521 Indiana St., Unit C
El Segunda, CA 90245
(310) 322-5542
Fax: (310) 640-0819
www.jillbell.com
Creates original lettering for film, advertising, television, logotypes and other applications. Clients include ABC, Disney, Jack-in-the-Box, Microsoft, Neiman Marcus, Universal Studios and Toyota. Lettering styles cover a broad range from child-look to raw hand-rendered looks as well as more formal calligraphic

scripts. Bell has also created hand-lettered alphabets that have been digitized into fonts for ITC.

John Stevens Design

560 N. Trade St.
Winston-Salem, NC 27101
(910) 922-5455
Fax: (910) 924-5146
www.calligraphycentre.com
Work includes custom calligraphy, logotypes and illustrative lettering, covering a broad range of styles. Many of Stevens's logo designs incorporate design elements and illustrations. Clients include Pepsi, Let-Life, New York Public Library, HBO and Atlantic Records.

Lilly Lee

1021 University Ave.
Berkeley, CA 94710
(510) 849-1900
Fax: (510) 849-1905
Lee's work covers a broad range of hand-lettered looks. Many of them replicate the look of different mediums, ranging from felt-tip markers to expressive, bamboo brushstrokes or fountain pens. Styles run the gamut as well, from nostalgic to contemporary, and playful to sophisticated. Lee also renders formal calligraphic styles. Clients include AT&T, Chiat Day, Chronicle Books and Warner Bros. Records.

Margo Chase Design

2255 Bancroft Ave.
Los Angeles, CA 90039
(213) 668-1055
Fax: (213) 668-2470
www.margochase.com
Margo Chase Design is well known as a trendsetting graphic design studio. The firm has also earned recognition for broadcast logo animation, original lettering for movie titles and logotypes, and logo designs for labels produced by a host of recording artists, including Madonna, Bonnie Raitt, Keith Richards and Melissa Etheridge, all bearing Chase's distinctive lettering style.

Clip Art Alphabet Sources

These sources offer typefaces as printed alphabets in books. These alphabet books can be an inexpensive alternative to commercial fonts where type applications are limited. For instance, individual letters can be scanned and placed in documents as first initial caps or brought into illustration programs to be arranged into headlines or logotypes.

Dover Publications, Inc.

31 E. 2nd St.

Mineola, NY 11501

(516) 294-7000

Dover publishes eighteen books of copyright-free typography by Dan X. Solo. Each volume is classified by style and contains one hundred complete fonts. Available styles are as follows: Art Deco, Art Nouveau, Bold Script, Brushstroke and Free-Style, Circus Alphabets, Condensed Alphabets, Decorative and Display, Gothic and Old English, Outline, Rustic and Rough-Hewn, Sans Serif, Special Effects and Topical, Stencil, 3-D and Shaded, and Victorian. Also publishes books of copyright-free borders and other graphic elements.

Clipper

Dynamic Graphics

6000 N. Forest Park Dr.

P.O. Box 1901

Peoria, IL 61656-9941

(800) 255-8800, (309) 688-8800

Fax: (309) 688-5873

Offers clip alphabets as well as digital files of alphabets.

Manufacturers of Dry Transfer Lettering

The products in this listing can be purchased off the shelf at art and graphics supply stores. Call manufacturers for a retail outlet in your area.

Chartpak

1 River Rd.

Leeds, MA 01053

(800) 628-1910, (413) 584-6781

In addition to transfer lettering, company also makes large, self-adhesive letters suitable for display purposes in a variety of colors.

Graphic Products Corp.

1480 S. Wolf Rd.

Wheeling, IL 60090-6514

(847) 537-9300

Fax: (847) 215-0111

Offers graphic symbols, rules, boxes and borders as well as a variety of headline typefaces. Also sells color, tint and texture films.

Letraset USA

40 Eisenhower Dr.

Paramus, NJ 07653

(800) 526-9073

Fax: (201) 909-2451

www.letraset.com

Offers a wide range of rubdown display typefaces, including faces licensed by ITC. Also offers rubdown borders, symbols and other graphic elements as well as tint and texture films.

Font Software

These companies manufacture software that can be used to create computer fonts, enhance the performance of existing fonts and manipulate fonts to your specifications. Compatibility with Mac and PC equipment is indicated within each software listing.

Adobe Systems, Inc.

345 Park Ave.

San Jose, CA 95110

(800) 445-8787, (408) 536-6000

Fax: (408) 536-6799

www.adobe.com

Manufactures:

TypeManager Deluxe (Mac, PC)—Provides sharp, smooth type on screen. Lets users organize typefaces to suit the ways they work. $65.

Brenda Walton's calligraphic specialty is vintage and romantic looks. See her listing on page 67.

Type on Call (Mac, PC)—Contains more than twenty-three hundred encrypted typefaces and initial caps clip art from the Adobe Type Library. Lets users access these fonts in minutes by purchasing an access key from the Web.

TypeReunion (Mac)—Alphabetizes font menu names and groups styles into submenus.

WebType (Mac, PC)—Features twelve Adobe typefaces optimized for readability on Web pages.

Bitstream, Inc.

215 1st St.
Cambridge, MA 02142
(800) 522-3668, (617) 497-6222
Fax: (617) 868-0784
www.bitstream.com
Manufactures:

Font Navigator (PC)—Manages fonts for use in Microsoft Word and Windows environments. Allows users to install, sort, group, sample view and manage Type 1 and TrueType fonts.

TrueDoc (PC)—Solves problems associated with fonts in portable documents, electronic publishing and electronic delivery. Helps transfer fonts across applications, operating systems, platforms and so forth and ensure total font rendering.

Broderbund

P.O. Box 6125
Novato, CA 94948-6125
(800) 521-6263
Fax: (415) 382-4419
Manufactures:

TypeStyler (Mac)—Allows for blending, stretching, creating drop shadows and other special effects.

DiamondSoft

351 Jean St.
Mill Valley, CA 94941
(415) 381-3303
www.fontreserve.com
Manufactures:

Font Reserve (Mac)—Font management program that makes it easy to cope with a large quantity of fonts.

Extensis

1800 SW 1st Ave., Ste. 500
Portland, OR 97201
(800) 796-9798, (503) 274-2020
Fax: (503) 274-0530
www.extensis.com
Manufactures:

QX-Effects (Mac)—Creates text effects such as perspective shadows, drop shadows, bevels and embosses within QuarkXPress.

Fifth Generation/Symantec Corp.

10201 Torre Ave.
Cupertino, CA 95014-2132
(408) 253-9600
www.symantec.com
Manufactures:

Suitcase (Mac)—Eliminates the need to place fonts in your system folder and aids in the organization and identification of fonts. $69.

Insider Software

6412 Merlin Dr.
Carlsbad, CA 92009
(800) 700-6340, (619) 622-9900
www.theinside.com
Manufactures:

Font Box Professional (Mac)—Helps users solve font-related system and printing problems. Sold in two editions: a more expensive Professionals version, and a less expensive Preferred edition.

A Lowly Apprentice Production

5963 La Place Ct., Ste. 206
Carlsbad, CA 92008-8823
(888) 818-5790, (720) 438-5790
Fax: (720) 438-5791
www.alap.com
Manufactures:

FingerType (Mac)—QuarkXTensions allows for instant type scaling and kerning by letting users drag characters on screen.

ShadowCaster (Mac)—QuarkXTensions lets users add soft drop shadows to type and picture boxes.

XPert CharacterStyles (Mac)—QuarkXTensions lets users define a type style with any combination of character attributes and apply this style by choosing its name.

XPert Tools (Mac)—QuarkXTensions bundles a variety of timesaving options: eliminates tiling, lets users scale grouped objects and more.

Pyrus NA, Ltd.

www.pyrus.com

This Web site includes a font locator, bookstore and links with font and font utility providers. Many links give access to demoware and shareware. Primarily for PC users, but Mac users can benefit from some of the products and technologies offered on this site.

Macromedia/Altsys

600 Townsend, Ste. 310W
San Francisco, CA 94103
(800) 989-3765, (800) 288-4797, (415) 252-2000
www.macromedia.com
Manufactures:

Altsys Fontographer (Mac, PC)—Specialized graphics program that creates and produces fonts.

PageTech (Page Technology Marketing, Inc.)

12730 Carmel Country Rd., #120
San Diego, CA 92130-2153
(619) 794-6884
Fax: (619) 794-0028
Manufactures:

AllType Typeface Converter (PC)—Creates variations of existing typefaces by converting bit-mapped fonts into scalable fonts.

QualiType Software

29209 Northwestern Hwy., Ste. 611
Southfield, MI 48034
(800) 950-2921, (313) 822-2921
www.qualitype.com
Manufactures:

FontHandler (PC)—Font manager that lets Windows users view, preview, print and manage fonts by installing and removing individually or in special font groups.

FontSentry (PC)—Lets Windows users install fonts on the fly as needed by programs or documents. Allows control over font lists.

Rascal Software

sold through Phil's Fonts, Inc.
14605 Sturtevant Rd.
Silver Spring, MD 20905
(800) 424-2977, (301) 879-0601
Fax: (301) 879-0606
www.philsfonts.com
www.rascalsoft.com
Manufactures:

FONDler (Mac)—Scans, analyzes and provides detailed analysis of font components. Covers ninety-six font problems and defects with 100% accuracy.

Font Gander (Mac)—Allows users to preview fonts as they actually appear on Macintosh computers or any network in PostScript or TrueType format.

FontSneak (Mac)—Font reporting and collecting.

TypeBook (Mac)—Lets users view on screen and print all font characters in six customizeable inventory and sample styles for use as reference pages.

Type Solutions

P.O. Box 1227
Plaistow, NH 03865-1227
(603) 382-6400
Manufactures:

Incubator for PC (PC)—Modifies any TrueType font by controlling weight, contrast, width and slant.

Incubator Pro (Mac)—Modifies TrueType and PostScript Type 1 fonts so they can be saved in either format.

URW America, Inc.

P.O. Box 700
Barrington, NH 03825
(800) 229-8791, (603) 664-2130
www.urwpp.de
Manufactures:

Ikarus M (Mac, UNIX, Windows)—Program for font, letterform and logotype production.

Kernus (Mac)—Letterspacing tool.

Linus (Mac, PC and UNIX)—Auto-tracing program for incredible accuracy in reproducing alphabets, logotypes and contour representation of scanned art.

Signus (PC)—Production of lettering and graphics for all kinds of sign-making applications, including self-adhesive lettering and graphics, displays and screen-printing stencils.

Xaos Tools, Inc.

300 Montgomery St., 3rd Fl.
San Francisco, CA 94104
(800) 289-9267, (415) 477-9300
Fax: (415) 477-9303
www.xaostools.com
Manufactures:

TypeCaster (Mac)—Photoshop plug-in lets users create 3-D type.

Page Layout Software

The following companies manufacture page layout software, useful for creating multi-page documents.

Adobe Systems, Inc.

345 Park Ave.
San Jose, CA 95110
(888) 502-8393, (408) 536-6000
Fax: (800) 814-7783
www.adobe.com
www.adobestudios.com
Manufactures:

PageMaker (Mac)—Premiere page layout system for Mac users.

Corel Corp.

1600 Carling Ave.
Ottawa, Ontario K1Z 8R7
Canada
(800) 772-6735, (613) 728-3733
Fax: (613) 761-9176
www.corel.com
Manufactures:
Ventura (PC)—Premiere page layout system for PC users.

Miles 33, Ltd.

3 Parklands Dr.
Darien, CT 06820
(800) 731-1666, (203) 656-1800
www.miles33.co.uk
Manufactures:
Pianzhang (PC)—Useful page layout program for extensive documents, such as textbooks and encyclopedias.

Quark

1800 Grant St.
Denver, CO 80203
(800) 788-7835, (303) 894-8888
Fax: (303) 894-3649
www.quark.com
Manufactures:
QuarkXPress (Mac, PC)—Premiere page layout system.

SoftPress Systems, Inc.

3020 Bridgeway, #310
Sausalito, CA 94965
(800) 853-6454, (415) 331-4820
www.softpress.com
Manufactures:
UniQorn (Mac)—Allows for multipage document production. Offers efficient tool set.

URW America, Inc.

P.O. Box 700
Barrington, NH 03825
(800) 229-8791, (603) 664-2130
www.urwpp.de
Manufactures:
AdMaster (PC, Mac)—Enables efficient design and production of advertisements.

Environmental Graphics

Sign-Making Supplies

When making your own signs, these resources will help you locate what you need. Sign blanks, banners and other sign-making materials can also be purchased locally; check the business-to-business directory in your area under Signs—Equipment and Supplies.

Aluma Panel, Inc.
2410 Oak St. W.
Cumming, GA 30131
(800) 258-3003, (770) 889-3996
Fax: (770) 889-8972
Aluminum, styrene and other types of sign blanks in a variety of sizes. Also offers sign stands, magnetic sheeting, corrugated plastic, blank banners and sandblast stencils.

Art Essentials of New York, Ltd.
3 Cross St.
Suffern, NY 10901
(800) 283-5323, (914) 368-1100
Fax: (914) 368-1535
Gold leaf in sheets and rolls and related supplies and tools. Also offers silver leaf.

Barclay Leaf Imports, Inc.
21 Wilson Ter.
Elizabeth, NJ 07208
(908) 353-5522
Fax: (908) 353-5525
Gold leaf and related supplies. Includes introductory packages.

Best Buy Banner Co.
6750 Central Ave.
Riverside, CA 92504
(800) 624-1691, (909) 351-0761
Fax: (909) 351-0618
Blank banners in twenty-four different colors, trimmed and hemmed to your specifications. Sold by the foot.

Dick Blick
Rte. 150 E.
P.O. Box 1267
Galesburg, IL 61402-1267
(800) 447-8192, (309) 343-6181
Fax: (800) 621-8293, (309) 343-5785
Arts and crafts supplies as well as graphics and sign-making supplies. Offers airbrushes, banners, sign blanks and sign cloth, gold leaf, and supplies for pinstriping and screen printing. Also sells books on lettering and sign-related topics. Ask for free catalog.

Gold Leaf & Metallic Powders, Inc.

74 Trinity Pl., Ste. 1200
New York, NY 10006
(800) 322-0323, (212) 267-4900
Fax: (212) 608-4245
Genuine metallic leaf, including gold, silver, palladium, copper, bronze and other composition leaf products. Also offers gilding supplies and restoration aids.

Graphikore

Baltek Corp.
10 Fairway Ct.
Northvale, NJ 07647
(201) 767-1400
Fax: (201) 387-6631
Wooden sign blanks for sandblasting and carving. Also sells through local distributors.

Hartco

1280 Glendale-Milford Rd.
Cincinnati, OH 45215
(800) 543-1340, (513) 771-4430
Fax: (513) 771-3327
Sandmask stencils for sandblasting wood, plastic or glass; etching tape; pin-feed stencil materials; and more.

Muller Studios Sign Co.

59 Ridge Rd.
Union, CT 06076
(860) 974-2161
Fax: (860) 974-1396
Wooden sign blanks in a variety of stock sizes and shapes, including oval, rectangular, old-tavern and other vintage looks. Offers custom wooden signs built to specifications.

Nudo Products, Inc.

2508 S. Grand Ave. E.
Springfield, IL 62703
(800) 826-4132, (217) 528-5636
Fax: (217) 528-8722
Wood sign panels with smooth vinyl surface for hand or screen-printed lettering or applied vinyl lettering. Also offers fiberglass surfaced sign panels.

Scott Sign Systems

P.O. Box 1047
Tallevast, FL 34270
(800) 237-9447, (941) 355-5171
Fax: (941) 351-1787
A wide range of sign-making materials, including a full line of letters and sign blanks. Also makes interior signs to client specifications.

Sepp Leaf Products, Inc.

381 Park Ave. S.
New York, NY 10016
(800) 971-7377, (212) 683-2840
Fax: (212) 725-0308
Gold leaf and related supplies. Also offers instructional video and technical assistance.

Sign-Mart

1657 N. Glassell
Orange, CA 92667
(800) 533-9099, (714) 998-9470, (714) 998-6925
Fax: (714) 998-6925
Blank vinyl banner material sold by the foot for hand- or silkscreen lettering.

Tara Materials, Inc.

P.O. Box 646
Lawrenceville, GA 30046
(800) 241-8129, (770) 963-5256
Fax: (770) 963-1044
Vinyl banner cloth in a variety of types and sizes. Also has ready-made banners.

Trademark Sign Systems

130 Cayuga St.
Graton, NY 13073
(800) 423-6895, (607) 423-6895
Fax: (607) 347-6645
Wood sign blanks for carving and sandblasting.

Yarder Manufacturing Co.

722 Phillips Ave.
Toledo, OH 43612
(419) 476-3933
Fax: (419) 478-6886
Sign blanks in steel and aluminum.

Sign Fabricators

There are many kinds of signs, and the companies that fabricate and install them sometimes deal exclusively with a particular type of sign. This listing of sign makers has been divided into six sections: Signage Systems, Banners, Electrical Signage, Electronic Message Boards, Porcelain Enamel Signs and Other. For more information about what's included, see the description under each of these category headings.

Signage Systems

Signs that guide people through an environment (industry jargon calls this "wayfinding") must comply with codes and regulations. Whether the signage system is for a building or an office park, the signs for these applications also must maintain a degree of uniformity, and because so many different signs are involved, signage systems involve a lot of management—from the manufacture of each sign to the final installation. The companies that specialize in signage systems and their components are a special breed. Some of the companies in this category specialize in an aspect of signage systems, whereas others can handle all aspects of an entire project. Check individual listings or call to see how broad a fabricator's capabilities are.

APCO

388 Grant St. SE
Atlanta, GA 30312
(404) 688-9000
Fax: (404) 577-3847
Changeable signs and letter boards for building directories.

ASI Sign Systems

3890 W. Northwest Hwy., Suite 102
Dallas, TX 75220
(800) ASI-SPEC (call for a local affiliate)
Fax: (214) 352-9741
Manufacturer of architectural interior and exterior signage systems. Also offers modular sign systems and updatable signs for directories and other applications. Thirty-eight affiliates in the United States, Canada and United Kingdom.

Charleston Industries, Inc.

105 Tonne Rd.
Elk Grove Village, IL 60007
(800) 722-0209, (847) 228-9269
Fax: (847) 956-7968
Custom and stock interchangeable signs. Also interior directional information signage.

Howard Industries

6400 Howard Dr.
Fairview, PA 16415
(800) 458-0591, (814) 833-7000
Fax: (814) 838-0011
Exterior aluminum post and panel signage systems. Includes traffic controllers.

Nordquist Sign Co., Inc.

312 W. Lake St.
Minneapolis, MN 55408
(612) 823-7291
Fax: (612) 824-6211
Interior and exterior custom signs of all types (including electrical). Also specializes in signage systems.

Sachs Lawlor

1717 S. Acoma St.
Denver, CO 80223
(800) 278-7771, (303) 777-7771
Fax: (303) 778-7175
Raised lettering and braille signage made from glass and Plexiglas.

Scott Sign Systems

P.O. Box 1047
Tallevast, FL 34270
(800) 237-9447, (941) 355-5171
Fax: (941) 351-1787
Directory signage, interior signage systems. Also offers sign-making supplies and custom signs.

Seton Identification Products

20 Thompson Rd.
P.O. Box 3B-1331
Bramford, CT 06405
(800) 243-6624, (203) 488-8059
Fax: (800) 345-7819
Indoor/outdoor signs with universal graphic symbols. Includes parking, exit and pedestrian signs in vinyl on aluminum, engraved acrylic and more. Also offers changeable letter boards, identification badges and metal nameplates.

Spandex USA

1857 Walnut St.
Allentown, PA 18105
(800) 331-1891, (610) 434-9889
Fax: (610) 434-9868
Makes modular sign systems to customer specifications.

Banners

Your local yellow pages will probably list some banner manufacturers. If your design uses standard typefaces and conventional materials those companies should be able to accommodate you. If their selection of materials or banner sizes doesn't meet your needs, the companies listed here offer a wide range of possibilities. Check individual listings for available substrate materials.

Banner Creations

1433 E. Franklin Ave.
Minneapolis, MN 55404
(800) 326-3524, (612) 871-1015
Fax: (612) 871-0058
Manufactured in vinyl and cloth from supplied art or digital files. No limit on size.

Tip!

Need camera-ready art for the standard sign symbols that were developed for the U.S. Department of Transportation? You can buy a portfolio of fifty symbols along with their guidelines. Contact ST Publications, 407 Gilbert Ave., Cincinnati, OH 45202, (800) 925-1110.

Carrot-Top Industries
328 Elizabeth Brady Rd.
P.O. Box 820
Hillsborough, NC 27278
(800) 628-3524, (919) 732-6200
Fax: (919) 732-5526
Street and event banners, flags and pennants. Also sells hardware and patriotic products, including U.S. flags, bunting and skirting.

Creative Banner
6801 Shingle Creek Pkwy.
Minneapolis, MN 55430
(800) 528-8846, (612) 556-1118
Fax: (612) 566-8031
Paints and screen prints on nylon, vinyl, paper and other materials. Works from customer-furnished artwork as well as digital files.

Fabric Artworks International
800 W. 9th St.
Little Rock, AR 72201
(800) 445-0653, (501) 375-7633
Fax: (501) 375-7638
Custom banners and flags.

Flagraphics
30 Cross St.
Sommerville, MA 02145
(800) 323-9015, (617) 776-7549
Fax: (617) 776-4848
Banners, textile signs and murals.

Tara Materials, Inc.
P.O. Box 646
Lawrenceville, GA 30046
(800) 241-8129, (404) 963-5256
Fax: (404) 963-1044
Ready-made banners as well as vinyl banner cloth in a variety of types and sizes.

Electrical Signage

You can find many local sign shops that will manufacture and maintain neon and backlit electrical signage; however, the companies listed here are nationally known. If your signage needs go beyond regional installation, some of these sign fabricators can handle installation and maintenance from coast to coast.

Artkraft Strauss
830 12th Ave.
New York, NY 10001
(212) 265-5155
Fax: (212) 265-9436
Custom neon creations.

Collins Signs
P.O. Box 1253
Dothan, AL 36302
(334) 983-8300
Fax: (334) 983-1379
Fabricator and installer of primarily freestanding exterior signage. Includes backlit electrical and neon.

Metromedia Technologies
1320 N. Wilton Pl.
Los Angeles, CA 90028
(800) 433-4668, (213) 856-6500
Fax: (213) 467-2276
Backlit signs imprinted with computer-generated imagery and graphics.

Mulholland Harper Co.
24778 Meeting House Rd.
Denton, MD 21629
(800) 882-3052, (410) 469-1300
Fax: (410) 479-0207
Exterior illuminated signage.

Plasti-Line, Inc.
13489 Slover Ave., Bldg. B
Fontana, CA 92337
(909) 823-1239
Fax: (909) 823-2013
Manufacture, installation and maintenance of outdoor illuminated signage.

Scott Sign Systems
P.O. Box 1047
Tallevast, FL 34270
(800) 237-9447, (941) 355-5171
Fax: (941) 351-1787
Custom interior neon signs. Also offers sign-making supplies and signage systems.

Universal Sign Corp.
5818 Linebaugh Ave. W.
Tampa, FL 33624
(800) 784-SIGN, (813) 962-6200
Fax: (813) 962-6292
Builder and installer of illuminated signage and displays.

Electronic Message Boards

These companies manufacture the large-scale computer-controlled message boards that are incorporated into many exterior signs. They can also handle interior applications.

MultiMedia
3300 Monier Cir., Ste. 150
Rancho Cordova, CA 95742
(800) 888-3007, (916) 852-4220
Fax: (916) 852-8325

Time-O-Matic, Inc.
1015 Maple St.
P.O. Box 850
Danville, IL 61832
(800) 637-2645, (217) 442-0611
Fax: (217) 442-1020

Unitec
34 Main St.
Whitesboro, NY 13492
(800) 383-6060, (315) 736-3967
Fax: (315) 736-4058

Porcelain Enamel Signs

Porcelain enamel on steel offers a wide range of colors and artistic detailing that can only be equaled by painted signage. However, the long-term, fade-resistent durability of porcelain enamel signs goes far beyond that of other types of signage.

Electromark Co.
W. Port Bay Rd.
P.O. Box 25
Wolcott, NY 14590
(315) 594-8085
Fax: (315) 594-9622

Fireform Porcelain Enamel
368 Yolanda Ave.
Santa Rosa, CA 95404
(800) 643-3181, (707) 523-0580
Fax: (707) 546-4022

PG Bell/Enameltec
60 Armstrong Ave.
Georgetown, Ontario L7G 4R9
Canada
(800) 663-8543 (United States), (905) 873-1677
Fax: (905) 453-1056

Other

ALD Decal Manufacturing
435 Cleveland Ave. NW
Canton, OH 44702
(330) 453-2882
Fax: (330) 453-4313
Makes pressure-sensitive decals from customer-furnished art, photos and transparencies. Decals can be used on vehicles and other 3-D applications.

A.R.K. Ramos
P.O. Box 26388
Oklahoma City, OK 73126
(800) 725-7266, (405) 235-5505
Fax: (405) 232-8516
Specializes in cast-bronze, brass and aluminum letters and plaques.

Belsinger Sign Works, Inc.
1300 Bayard St.
Baltimore, MD 21230
(800) 428-8848, (410) 837-2700
Fax: (410) 837-6550
Custom signage (primarily exterior). Illuminated, fabricated from metal and other materials.

Cornelius Architectural Products
30 Pine St.
Pittsburgh, PA 15223
(800) 553-7722, (412) 781-9003
Fax: (412) 781-7840
Custom signs from metal.

Creative Edge Corp.
601 S. 23rd St.
Fairfield, IA 51556
(800) 394-8145, (515) 472-8145
Fax: (515) 472-2848
Waterjet fabricator of signs and architectural elements. Specializes in cutting and finishing of hard-to-shape materials, such as stainless steel, stone, glass and brass.

Goldman Arts
20 Flanders Rd.
Belmont, MA 02178
(617) 484-8842
Fax: (617) 484-8856
www.goldmanarts.com
Makes large-scale inflatable sculptures manufactured from nylon for interior and exterior applications. Fabricates from customer specifications and also offers stock items, such as bows, stars and various lengths of inflatable color tubing.

Refer to image on page 78.

Nelson-Harkins
5301 N. Kedzie Ave.
Chicago, IL 60625
(800) 882-8989, (312) 478-6243
Fax: (312) 478-8227
Custom exterior signage from a wide range of materials (nonilluminated), some interior signage.

Goldman Arts specializes in inflatable sculptures. Many, such as this twenty-foot sculpture of Arthur, are on a gargantuan scale. See page 77 for more information on Goldman Arts.

Nordquist Sign Co., Inc.

312 W. Lake St.
Minneapolis, MN 55408
(612) 823-7291
Fax: (612) 824-6211
Interior and exterior custom signs of all types (including electrical). Also specializes in signage systems.

P&D Polygraphics, Inc.

823 Manatee Ave. W.
Bradenton, FL 34205
(941) 748-5510
Fax: (941) 747-8188
Simulated cast-bronze signage and plaques.

Pannier Graphics

1239 Oak Rd.
Gibsonia, PA 15044
(724) 265-4900
Fax: (724) 265-4300
Custom and stock fiberglass signs.

Scott Sign Systems

P.O. Box 1047
Tallevast, FL 34270
(800) 237-9447, (941) 355-5171
Fax: (941) 351-1787
Custom sandblasted, screen-printed, etched and cast-metal signs.

Unitex

521 Roosevelt Ave.
Central Falls, RI 02683
(401) 729-1100
Fax: (401) 729-1287
Backlit awnings for indoor and outdoor use. Available in sixteen colors. Call the following regional offices for a supplier in your area:
Unitex South, (800) 759-0890; Unitex East, (800) 556-7254; Unitex West, (800) 456-6282; Unitex Midwest, (800) 843-6236; Unitex Southwest, Arlington, Texas, (800) 433-5000.

Formed Letters and Custom Graphics

Formed letters and graphics can be used on flush-mounted signs. (Flush-mounted signs are those that require attaching letters directly on a surface—one of many ways signs can be attached to walls, doors, posts and so on) These companies specialize in letters and graphics that can be flush mounted.

AdMart International

20 Gose Pike
Danville, KY 40422
(800) 354-2101, (606) 236-7600
Fax: (606) 236-9050
Custom-crafted letterforms, logos, signage and display graphics from foamcore board, Plexiglas and other materials.

Earl Mich Co.

806 N. Peoria St.
Chicago, IL 60622
(800) 642-4872, (312) 829-1552
Fax: (312) 829-5878
Vinyl and reflective sign letters and universal symbols. Produces custom graphics and logos from digital files. Also offers alphabet sheets, static lettering, dimensional letters, magnetic sheeting and more.

Gemini, Inc.

103 Mensing Way
Cannon Falls, MN 55009
(800) 538-8377, (507) 263-3957
Fax: (507) 263-4887
Injection-molded plastic products, letters of vacuum-formed plastic. Also offers cast aluminum and bronze letters, aluminum and bronze plaques, custom metal cutouts, custom-formed plastic and edge trim gemlite letters.

ImageWest
0-14122 Ironwood Dr. NW
Grand Rapids, MI 49544
(800) 359-6419
Fax: (616) 677-2304
Takes client-supplied Macintosh files and produces lettering and graphics from foam, metal, acrylic, wood laminates, vinyls and other materials.

Space-Rite Industries
3315 W. Vernon
P.O. Box 11978
Phoenix, AZ 85061
(800) 528-8429, (602) 233-9483
Fax: (800) 329-9489
Custom letters and graphics from pressure-sensitive vinyl. Offers over eleven hundred typestyles.

Spanjer Brothers, Inc.
1160 N. Howe St.
Chicago, IL 60610
(312) 664-2900
Fax: (312) 664-7879
Letters in a wide selection of styles and sizes and a variety of colors and finishes. Formed from plastic, wood, cast aluminum and fabricated metal. Also has stock signs.

Large-Scale Imaging and Graphics

The following companies offer supersized enlargements of customer-supplied art and transparencies as well as customer-furnished computer files on disk. Large-scale imaging is used widely for billboards, vehicle graphics, display and other purposes. Prices vary according to the substrate and type of image. Check with each company to find out which process is most cost-efficient for your needs.

Ad Graphics
1711 Blount Rd., Ste. A
Pompano Beach, FL 33069
(800) 645-5740, (954) 974-9900
Fax: (954) 974-9925
Electrostatic printing on adhesive-backed vinyl. Can work from customer-furnished images, Mac- and PC-compatible files.

ALD Decal Manufacturing
435 Cleveland Ave. NW
Canton, OH 44702
(330) 453-2882
Fax: (330) 453-4313

Offers large-scale imaging on pressure-sensitive decals from translucent Scotchcal for backlit applications and Scotchlite reflective film. Works from customer-furnished art, photos and transparencies.

Belcom Corp.
3135 Madison
Bellwood, IL 60104
(708) 544-4499
Fax: (708) 544-5607
Ink-jet process that allows Belcom to print an image on virtually any substrate, including carpet.

Creative Color
235 W. 200 S.
Salt Lake City, UT 84101
(801) 355-4124
Fax: (801) 355-4152
Mural-sized prints and backlit transparencies. Also does mounting and laminating.

Digitable Dirigible
38 Vestry St.
New York, NY 10013
(212) 431-1925
Fax: (212) 431-1978
Electrostatic printing on paper. Can work with customer-furnished art as well as Mac-compatible computer files.

Gregory, Inc.
200 S. Regier St.
P.O. Box 410
Buhler, KS 67522
(800) 835-2221, (316) 543-6657
Fax: (800) 835-2221, (316) 543-2690
Scotchprint graphics from supplied artwork, Mac and PC electronic files. Can print on paper, reflective, clear and transluscent substrates.

Joseph Merrit Co.
650 Franklin Ave.
Hartford, CT 06114
(800) 344-4477, (860) 296-2500
Fax: (860) 296-0414
Scotchprint imaging from transparencies, photos or digital files on adhesive-backed vinyl.

Lowen Color Graphics
1330 E. 4th St.
P.O. Box 1528
Hutchinson, KS 67504-1528
(800) 835-2365, (316) 663-2161
Fax: (316) 663-1429
Utilizes Scotchprint technology. Available on opaque, reflective and translucent vinyl films.

Metromedia Technologies, Inc.
1320 N. Wilton Pl.
Los Angeles, CA 90028
(800) 999-4668, (800) 433-4668 (East Coast)
Manufactures Flex-Fleet graphics—a combination of acrylic paints on vinyl substrates suitable for applying imaging on trucks and other large vehicles.

Miratec Systems, Inc.
666 Transfer Rd.
St. Paul, MN 55114
(800) 336-1224, (612) 645-8440
Fax: (612) 645-8435
Scotchprint imaging from transparencies, photos or digital files.

NSP Corporate Graphics
475 N. Dean Rd.
Auburn, AL 36830
(800) 876-6002
Fax: (334) 821-6919
Large-scale imaging on a variety of substrates using the Scotchprint electrostatic system.

Onyx Graphics
6915 S. High Tech Dr.
Midvale, UT 84047
(800) 828-0723, (801) 568-9900
Fax: (801) 568-9911
Uses ink-jet process to print on high-gloss paper. Will laminate for increased durability.

Sungraf
325 W. Ansin Blvd.
Hallandale, FL 33009
(800) 327-1530, (954) 456-8500
Fax: (954) 454-2266
Digital airbrushed images in sizes up to sixteen feet high in unlimited lengths. Mac-and PC-compatible.

Vision Graphic Technologies, Inc.
3030 W. Directors Row
Salt Lake City, UT 84104
(800) 424-2483, (801) 973-8929
Fax: (801) 973-8944
Can produce all types of large-scale imaging from posters to billboards. Products include aerial banners and images up to forty feet. Also provides electrostatic imaging on a variety of substrates and can laminate prints for increased durability.

Point-of-Purchase, Display and Trade Show Booths

The following companies produce display booths. Some of these national manufacturers also make their products available through local vendors. Also check the business-to-business directory or yellow pages in your area for stock and custom-designed trade show booths and point-of-purchase displays.

Abex Display Systems
7101 Fair Ave.
North Hollywood, CA 91605
(800) 537-0231, (818) 764-5126
Fax: (818) 503-9955
Portable trade show displays. Clients include General Electric, Hertz and Exxon. Call for local distributor.

Channel-Kor Systems, Inc.
P.O. Box 2297
Bloomington, IN 47402
(800) 242-6567, (812) 336-7599
Fax: (812) 336-8047
Specializes in portable displays ranging from tabletop to trade show exhibits.

Display One Exhibit System
2129 Portage St.
Kalamazoo, MI 49001
(800) 525-6414, (800) 525-6562 (for literature)
Fax: (616) 388-2018
Manufactures portable display units, from tabletop displays to multipanel trade show booths.

Downing Displays
550 Technecenter Dr.
Milford, OH 45150-2785
(800) 883-1800
Fax: (513) 248-2605
Sells pop-up displays, folding panel systems and other types of custom exhibits.

Featherlite Exhibits
7300 32nd Ave. N
Minneapolis, MN 55427-2885
(800) 229-5533
Fax: (612) 537-7606
Manufactures tabletop and custom portable systems. Also rents and leases displays. Call for local dealer.

The Godfrey Group, Inc.

P.O. Box 90008
Raleigh, NC 27675-0008
(919) 544-6504
Fax: (919) 544-6729
www.godfrey-expo.com
Portable trade show and tabletop exhibits. Offers free sales promotion tool book and design and planning kit.

The Great Gazebo, Inc.

1512 Meadowbrook
East Lansing, MI 48823
(800) 962-2767, (517) 337-2011
Fax: (517) 332-6126
www.greatgazebo.com
Manufactures custom exhibits in a gazebo configuration as well as rectangular stands and booths. Offers free catalog and brochure.

Intex Exhibits International

3625 N. Mississippi Ave.
Portland, OR 97227
(800) 331-6633
Fax: (503) 282-5777
Sells portable modular and folding panel displays and tabletop display systems.

Maddocks & Co.

2011 Pontius Ave.
Los Angeles, CA 90025
(310) 477-4227
Fax: (310) 479-5767
Specializes in point-of-sale merchandising displays.

M.D. Enterprises Display Systems

9738 Abernathy Ave.
Dallas, TX 75220
(214) 350-5765
Fax: (214) 350-7372
Displays made of fabric panels, knockdown panels and tubular construction.

Nomadic Display

Exhibitor Service Center
7400 Fullerton Rd.
Springfield, VA 22153-2831
(800) 732-9395
Fax: (703) 866-1869
www.nomadicdisplay.com
Portable trade show exhibits. Offers lifetime warranty.

Siegel Display Products

P.O. Box 95
Minneapolis, MN 55440-0095
(800) 626-0322, (612) 340-9235
Fax: (800) 230-5598
Display products range from countertop holders, wall-mounted and freestanding literature racks to portable trade show displays.

Skyline Displays, Inc.

12345 Portland Ave.
Burnsville, MN 55337
(800) 328-2725
Fax: (612) 895-6391
www.skycorp.com
Manufactures portable trade show displays. Also rents exhibits and provides show management, installation and dismantling services. Offers free twenty-four-page catalog.

TigerMark

21 Blandin Ave.
Framingham, MA 01701-7019
(800) 338-8465
Fax: (508) 626-0680
www.tigermrk.com
Specializes in portable exhibit systems. Offers free literature.

United Group

9700 E. Frontage Rd.
South Gate, CA 90280
(562) 927-7741
Fax: (562) 928-3132
Designer and manufacturer of high-impact displays. Handles point-of-purchase and trade show displays.

Display Items and Supplies

These companies offer components that can be useful in displaying items or putting together a trade show booth.

Creative Energies, Inc.

1609 N. Magnolia Ave.
Ocala, FL 34475
(352) 351-8889
Fax: (352) 351-5847
Public hanging systems made up of stackable panels. Company also makes canopies.

Dealers Supply

P.O. Box 717
Matawan, NJ 07747
(800) 524-0576
Fax: (732) 591-8571
Display supplies, including table covers, showcases, canopies, folding tables, booth signs, lighting, security aids and more.

Panels by Paith

2728 Allensville Rd.
Roxboro, NC 27573
(800) 67-PAITH, (910) 599-3437
Fax: (910) 599-8827
Plaques in several shapes and sizes. Bases and glass domes for display of individual items.

Scott Sign Systems

P.O. Box 1047
Tallevast, FL 34270
(800) 237-9447, (941) 355-5171
Fax: (941) 351-1787
Acrylic brochure racks, lightboxes and more.

Sign-Making Software

The following companies manufacture software that aids in the production of sign making and large-scale imaging.

Amiable Technologies

2 International Plaza, Ste. 625
Philadelphia, PA 19113-1518
(800) 229-9068, (610) 521-6300
Fax: (610) 521-0111
www.amiableworld.com
Manufactures:
 Mac- and PC-compatible sign-making, screen-printing and digital imaging software that works with scanned images and images created in other programs to drive cutters and plotters and large-format ink-jet printers.

ANAgraph, Inc.

3100 Pullman St.
Costa Mesa, CA 92626
(714) 540-2400
Fax: (714) 966-2400
www.anagraph.com
Sells and services several CAD design programs and cutting plotters for sign making and screen printing. All programs operate under Microsoft Windows.

CADlink Technology Corp.

2440 Don Reid Dr., Ste. 100
Ottawa, Ontario K1H 1E1
Canada
(800) 545-9581, (613) 247-0850
www.cadlink.com
Manufactures:
 Several Windows-compatible programs that drive large-format printers, cutters and plotters. Programs support many file formats, including EPS, GIF, Acrobat PDF, TARGA, TIFF Photo CD and WMF.

Handmade Software

48860 Milmont Dr., Ste. 106
Fremont, CA 94538
(800) 252-0101, (510) 252-0101
www.handmade.com
Manufactures:
 Image Achemy (Mac, PC, UNIX)—Budget-priced large-scale imaging program works with over seventy file formats.

Logixx Automation, Inc.

14998 W. 6th Ave., Bldg. F, Ste. 800
Golden, CO 80401
(800) 523-6989, (303) 277-1134
Fax: (303) 277-1834
www.logixx.com
Manufactures:
 Sequence Programmer (PC)—Translates files from design software to drive plotters and cutters. Transfers from CorelDRAW and programs that can be interpreted by CorelDRAW.

Onyx Graphics

6915 S. High Tech Dr.
Midvale, UT 84047
(800) 828-0723, (801) 568-9900
www.onyxgfx.com
Manufactures:
 PosterShop (Mac, PC)—Large-scale imaging program can handle BMP, EPS, GIF, JPEG, Photo CD, PostScript, Scitex CT, TARGA and TIFF files.

PhotoScript Group

5031 S. Ulster St., Ste. 460
Denver, CO 80237
(303) 804-0200
Fax: (303) 804-0300
www.photoscript.com
Manufactures:
 Several PostScript-compatible imaging programs for Mac, UNIX and Windows users.

PosterWorks
1 Kendall Sq., Bldg. 600, Ste. 323
Cambridge, MA 02139
(617) 338-2222
Fax: (617) 338-2223
www.posterworks.com
Manufactures:
 PosterWorks (Mac)—Aids in the design and production of large-format jobs, such as posters, exhibits and displays up to ten thousand square feet.

Roland Digital Group America
15271 Barranca Pkwy.
Irvine, CA 92618
(800) 542-2307, (714) 727-2112
Fax: (714) 727-2112
www.rolanddga.com
Manufactures:
 A SignMate series of Mac- and Windows-compatible programs that work with Roland cutters and plotters.

ScanVec Accuprint
155 West St.
Wilmington, MA 01887
(800) 866-6227, (978) 694-9488
Fax: (978) 694-9482
www.scanvec.com
Manufactures:
 Mac- and Windows-compatible software that drives vinyl cutters and large-format printers.

Sign MAX Enterprises, Inc.
3705 Tricentenaire Blvd.
Montreal, Quebec H1B 5W3
Canada
(514) 644-3177
Fax: (514) 644-3173
www.signmax.qc.ca
Offers Windows-compatible programs that drive engravers, routers and plotters.

SofTeam
3000 Chestnut Ave., Ste. 108
Baltimore, MD 21211
(514) 644-3177
Fax: (514) 644-3173
www.softeamweb.com
Manufactures:
 Mac-compatible sign-making programs that import Mac- and Windows-created Illustrator files.

Symbol Graphics
1047 W. 6th St.
Corona, CA 91720
(909) 736-4040
Fax: (909) 737-0652
Manufactures:
 PC-compatible software for sign making. Allows for type creation, image editing and special graphic effects.

URW America, Inc.
P.O. Box 700
Barrington, NH 03825
(800) 229-8791, (603) 664-2130
Fax: (603) 664-2295
www.urwpp.de
Manufactures:
 Signus, PC-compatible software that can be used to produce lettering and graphics for all kinds of sign-making applications, including self-adhesive lettering and graphics, displays and screen-printing stencils.

Visual Edge Technology
306 Potrero Ave.
Sunnyvale, CA 94086
(800) 662-0808, (408) 245-1100
Fax: (408) 245-1107
www.visual-edge.com
Manufactures:
 Several Mac- and Windows-compatible programs that work with ink-jet printers.

Restaurant Related

CHAPTER

6

Suppliers of Restaurant-

and Hospitality-

Industry Items

Menu Laminating

For durability, these companies will laminate preprinted menus. Check individual listings for minimum quantities. If you're interested in clear, vinyl sleeves that can be reused, see listings later in this chapter under Restaurant Supplies and Furnishings.

Accuprint & Laminating of Cincinnati
329 Walnut St.
Cincinnati, OH 45202
(513) 651-1078
Fax: (513) 651-5624

Caulastics
5955 Mission St.
Daly City, CA 94014
(415) 585-9600
Fax: (415) 585-5209

Century Plus
2701 Girard NE
Albuquerque, NM 87107
(505) 888-2901
Fax: (505) 888-2902

Commercial Laminating Co.
3131 Chester Ave.
Cleveland, OH 44114
(216) 781-2434
Fax: (216) 781-9413

D&E Vinyl Corp.
13524 Vintage Pl.
Chino, CA 91710
(800) 929-2148, (909) 590-0502
Fax: (909) 591-7822

G2 Graphic Service, Inc.
5510 Cleon Ave.
North Hollywood, CA 91601
(213) 467-7828
Fax: (213) 469-0381

International Laminating
1712 Springfield St.
Dayton, OH 45403
(937) 254-8181
Fax: (937) 256-8813

Laminating Services Co.
7359 Varna Ave.
North Hollywood, CA 91605
(818) 982-9065
Fax: (818) 982-9065

Pavlik Laminating
3418 S. 48th St., #8
Phoenix, AZ 85040
(602) 968-4601
Fax: (602) 968-6422

Superior Reprographics
1925 5th Ave.
Seattle, WA 98101
(206) 443-6900
Fax: (206) 441-8390

Signage

These companies specialize in custom and stock interchangeable signage systems, suitable for over-the-counter and freestanding letter boards where menu changes and specials can be posted on a day-to-day basis. For additional signage needs, check the other listings under Sign Fabricators in chapter five.

APCO
388 Grant St. SE
Atlanta, GA 30312
(404) 688-9000
Fax: (404) 577-3847

ASI Sign Systems
3890 W. Northwest Hwy., Ste 102
Dallas, TX 75220
(214) 352-9140
Fax: (214) 352-9741

Charleston Industries, Inc.
955 Estes Ave.
Elk Grove Village, IL 60007
(800) 722-0209, (847) 228-9096
Fax: (847) 228-9269

Seton Identification Products
P.O. Box 3B-1331
New Haven, CT 06505
(800) 243-6624, (203) 488-8059
Fax: (800) 345-7819

Apparel

These companies can supply aprons, chef hats and uniforms appropriate for restaurant personnel. For custom garment printing in a more casual mode, check listings for garment printers in chapter seven. Those manufacturers can supply you with custom-imprinted T-shirts, polo shirts, aprons and other items.

Anchortex Corp.
465 Taunton Ave.
West Berlin, NJ 08091
(609) 768-5240
Fax: (609) 768-5547

Offers stock uniforms for waiters, waitresses and kitchen personnel, including chefs' coats, hats and aprons.

Atlas Uniform Co.
5943 W. Lawrence, Dept. TR
Chicago, IL 60630
(800) 635-3578, (773) 725-1220
Fax: (773) 725-6191
Offers stock and custom designs for aprons, waiters, waitresses and chefs' clothes as well as T-shirts and jackets. Also offers career apparel.

Gael Sportswear
2740 White Oak
Orono, MN 55356
(800) 347-8856, (612) 476-6169
Fax: (612) 476-6172
Offers many styles of cloth aprons for cooks, servers and others. Will screen print and embroider to customer specifications. Advertises no minimums.

Sunshine State Textile Manufacturing
8111 Garden Rd.
Riviera Beach, FL 33404
(800) 262-7247, (561) 844-6255
Fax: (561) 844-4148
Cloth bib aprons starting as low as $2.95 each. Company will screen print and embroider aprons to customer specifications.

Restaurant Supplies and Furnishings

These manufacturers offer a variety of restaurant items that can be custom fabricated to your specifications or printed with your designs.

Booths and Upholstery by Ray
2444 W. 21st St.
Chicago, IL 60608
(773) 523-3355
Fax: (773) 523-1018
Custom-designed and -upholstered booths and other restaurant furniture. Includes counters, cabinets, booths, chairs, stools and bookshelves.

Boxerbrand
423 W. Broadway
Boston, MA 02127
(800) 253-2772, (617) 269-8244
Fax: (617) 464-4401
Makes vinyl menu covers. Offers deluxe and economy styles.

Buffalo China/Oneida Food Service Division
658 Bailey Ave.
Buffalo, NY 14206
(800) 828-7033, (716) 824-2378
Fax: (716) 361-3745
Custom and stock designs in china dinnerware. Items can be printed with customer-furnished designs. Also offers in-house design service.

Carlisle Food Service Products
P.O. Box 53006
Oklahoma City, OK 73152-3006
(800) 654-8210, (405) 528-3011
Fax: (405) 528-6338
Manufactures plastic color-coordinated dinnerware, deli displays and trays custom fabricated and printed to client specifications.

Competitive Edge
3500 109th St.
Des Moines, IA 50233
(800) 458-3343, (515) 280-3343
Fax: (515) 288-3343
Offers custom-imprinted napkins, matches, stir sticks and other specialty items.

Creative Expressions
7240 Shadeland Station, Ste. 300
Indianapolis, IN 46256
(317) 841-9999
Fax: (317) 841-7099
Manufactures printed and embossed paper napkins.

Falcon Products
16040 Stephens St.
City of Industry, CA 91745
(800) 959-0136, (626) 937-3037
Fax: (626) 444-4536
Specializes in modular furniture for cafeterias, food courts and fast-food restaurants. Offers a variety of designs and finishes in counters, countertops, stools, tables, chairs and more. Offers products for indoor and outdoor use.

Guest Checks America
P.O. Box 86845
San Diego, CA 92138
(619) 223-4242
Fax: (800) 200-1772

Offers vinyl menu covers in single-, two- or three-panel configurations. Also offers custom-printed matches and guest checks.

James River Corp.
Commercial Products Division
800 Connecticut Ave.
Norwalk, CT 06856-6000
(800) 331-1758, (203) 854-2000
Manufactures blank and printed dinner, beverage and dispenser napkins. Also makes paper and plastic cups and other paper and plastic containers with lids. Call for regional distributor.

Novelty Crystal Corp.
21005 O'Brien Rd.
Groveland, FL 34736
(800) 429-9037, (352) 429-9036
Fax: (352) 429-9039
Offers blank and custom-imprinted plastic stemware, mugs and tumblers. Many styles available in a variety of colors.

Ora/Carr Textiles
311 Park Ave. SE
Atlanta, GA 30312
(800) 533-2810, (404) 522-1885
Fax: (404) 522-1887
Manufactures cloth napkins.

Oswalt Menu Co., Inc.
1474 S. State Rd. 3
Hartford City, IN 47438
(800) 822-6368, (765) 348-3120
Fax: (765) 348-3137
Makes menu covers with plastic sleeves for inserts. Offers Lexhide or custom-printed covers, spiral binding or folded covers.

Plasticrafters
331 Market St.
Warren, RI 02885
(800) 572-2194, (401) 247-0333
Fax: (401) 247-0392
Makes tabletop display stands for specials. Offers clear plastic single-, double- and tri-panel configurations in a variety of sizes and styles.

Garments *and* Uniforms

Sources for

Printed Garments,

Uniforms and Accessories

Garment Printers by Region

These garment screen printers have appeared over the last two years in *Impressions* magazine's annual top one hundred list. *Impressions* is a trade publication for garment sceen printers and qualifies its annual top one hundred on average gross sales, number of impressions and number of pieces printed.

Items offered by these companies include T-shirts and polo shirts, sweatshirts, jackets, hats, tote bags, visors and more. In addition to screen printing, imprinting options include embroidery, appliqués, flocked imprints and more. Check individual listings for other imprinting options and minimum quantities.

East

(CT, DC, DE, MA, MD, ME, NH, NJ, NY, PA, RI, VT)

Ampro Sportswear
30 Bunting Ln.
Primos, PA 19018
(800) 341-4008, (610) 623-9000
Fax: (610) 623-1300

Apsco Enterprises
50th St. and 1st Ave.
Brooklyn, NY 11232
(718) 965-9500
Fax: (718) 965-3088

Ocean Atlantic Textile Printing, Inc.
502 S. Main St.
Cape May Court House, NJ 08210
(609) 465-2100
Fax: (609) 465-3856

Ohiopyle Prints
410 Dinnerbell Rd.
Ohiopyle, PA 15470
(412) 329-4652
Fax: (412) 329-1001

R.C. Screenprinting
32 Wesley St.
South Hackensack, NJ 07606
(201) 883-1660
Fax: (201) 883-1663

South

(AL, FL, GA, KY, LA, MS, NC, SC, TN, TX, VA, WV)

Carrousel Productions, Inc.
11000 Wilcrest, Ste. 100
Houston, TX 77099
(713) 568-9300
Fax: (713) 568-9498

Champion Awards, Inc.
3649 Winplace
Memphis, TN 38118
(901) 365-4830
Fax: (901) 365-2796

IR Sportswear, Inc.
4068 Fernandina Rd.
Columbia, SC 29212
(803) 772-2752
Fax: (803) 772-6551

Lonestar Sportswear/Timothy Bull, Inc.
2816 Shamrock Ave.
Fort Worth, TX 76107
(817) 332-7771
Fax: (817) 332-9110

Louisiana Garment Silk Screeners, Inc.
1949 Lafayette St.
New Orleans, LA 70113
(504) 525-4000
Fax: (504) 522-3535

Magnum Industries, Inc.
7636 E. 46th St.
Tulsa, OK 74145
(918) 665-7636
Fax: (918) 665-7667

Mendez Sportswear
13000 NW 42nd Ave.
Miami, FL 33054
(305) 685-3490
Fax: (305) 687-1393

PM Enterprises, Inc.
300 Jacobson Dr.
Rock Branch Industrial Park
Poca, WV 25159
(304) 755-4191
Fax: (304) 755-8703

Silverwing Productions, Inc.
11210 Goodnight Ln.
Dallas, TX 75229
(972) 243-4396
Fax: (972) 243-4107

Sportswear Promotions, Inc.
98 Belinda Pkwy.
P.O. Box 1137
Mt. Juliet, TN 37122
(615) 758-3033
Fax: (615) 758-5999

Stanley Michaels, Inc.
5280 NW 165th St.
Miami, FL 33014
(305) 621-0800
Fax: (305) 620-2666

T.B. Riddles, Inc.
635 E. Durst Ave.
Greenwood, SC 29649
(803) 223-4964
Fax: (803) 229-4382

T.S. Designs, Inc.
2053 Willow Springs Ln.
Burlington, NC 27215
(910) 229-6426
Fax: (910) 226-4418

Midwest

(IA, IL, IN, MI, MN, MO, OH, WI)

Blazer Screenprint Co., Inc.
3135 W. Grand Ave.
Chicago, IL 60622
(773) 638-2020
Fax: (773) 638-6388

Creative Silkscreen & Design, Inc.
1100 Buchanan St.
Rockford, IL 61101
(815) 963-7733
Fax: (815) 963-7722

Holoubek, Inc.
W. 238 Rockwood Dr.
Waukesha, WI 53188
(414) 547-0500
Fax: (414) 547-5847

LSJ Sportswear, Inc.
54 Golf Car Rd.
Deerfield, WI 53711
(608) 764-5425
Fax: (608) 764-5159

Palsz Apparel, Inc.
1500 Jackson St. NE
Minneapolis, MN 55413
(612) 788-9177
Fax: (612) 788-9178

Printworks, Inc.
5695 W. Franklin Dr.
Franklin, WI 53132-8606
(414) 421-5400
Fax: (414) 421-3970

Signal Artwear, Inc.
570 S. Miami St.
Wabash, IN 46992
(219) 563-8302
Fax: (219) 563-1811

Sugar Creek Designs, Inc.
202 Joplin St.
Joplin, MO 64801
(417) 781-9696
Fax: (417) 781-6409

Sunburst Sportswear
931 N. DuPage Ave.
Lombard, IL 60148
(630) 629-2700
Fax: (630) 629-8586

T-Shirts Direct
770 N. LaSalle St., Ste. 600
Chicago, IL 60610
(800) 215-8232, (312) 587-0123
Fax: (312) 587-0494

West

(CA, CO, KS, ND, NE, NV, SD, UT, WA, WY)

Action Shirts
15606 Producer Ln.
Huntington Beach, CA 92649
(714) 891-1263
Fax: (714) 891-8592

Brazos Sportswear
6520 S. 190th St.
Kent, WA 98032
(425) 251-3565
Fax: (425) 251-0527

Collegiate Graphics
2901 S. Highland, 12B
Las Vegas, NV 89101
(702) 737-0771
Fax: (702) 737-8415

Golden Squeegee
900 Santa Fe Dr.
Denver, CO 80204
(303) 572-1164
Fax: (303) 572-1190

Habitat
924 Spring Creek Rd.
Montrose, CO 81401
(970) 249-3333
Fax: (970) 249-0328

Insta Graphics Systems
13925 E. 166th St.
Cerritos, CA 90702
(562) 404-3000
Fax: (562) 404-3010

Koala Arts, Inc.
3425 Hancock St.
San Diego, CA 92110
(619) 692-9400
Fax: (619) 692-9996

McKibben Screen Printing & Dist., Inc.
2350 Pullman St.
Santa Ana, CA 92705
(949) 852-1975
Fax: (949) 852-1404

Morning Sun
3500-C 20th St. E.
Tacoma, WA 98424
(253) 922-6589
Fax: (253) 922-9440

National Garment Co.
3928 Ross Ln.
Chanute, KS 66720
(316) 431-6411
Fax: (316) 431-3904

If you're interested in finding out more about garment printing, there is a trade magazine that can provide further insights into the garment printing industry. Impressions *is published monthly and covers textile screen printing and garment printing.* Contact Impressions *at 13760 Noel Rd., Ste. 500, Dallas, TX 75240, (800) 527-0207, (972) 239-3060.*

Pacific Impressions
3535 De La Cruz Blvd.
Santa Clara, CA 95054
(408) 727-4200
Fax: (408) 988-2493

Swingster
8257 Hedge Ln. Ter.
Shawnee, KS 66227
(913) 441-2703
Fax: (913) 441-3541

Uniform and Accessories Suppliers

These manufacturers offer a variety of uniform types and imprint possibilities as well as other accessories. Check each listing for minimum orders and availability of silkscreen printing, embroidery and emblem application.

Acme Laundry Products
Division of Peerless Uniform Manufacturing Co.
21600 Lassen St.
Chatsworth, CA 91311
(800) 842-4592, (818) 341-0700
Fax: (818) 341-1546
Custom and stock designs for industry, health care, food and other service industries.

Anchortex Corp.
465 Taunton Ave.
West Berlin, NJ 08091
(609) 768-5240
Fax: (609) 768-5547
Offers stock uniforms for kitchen, security, housekeeping and medical personnel and more, plus career-look blazers and pants. Also stocks T-shirts and caps.

Antler Uniforms
34-01 38th Ave.
Long Island City, NY 11101
(800) 893-4027, (718) 361-2800
Fax: (718) 361-2680
Specializes in outerwear for security personnel, ground crews, delivery services and others.

Aramark Uniform Services
115 N. 1st St.
Burbank, CA 91502
(800) 327-2839, (818) 973-3700
Fax: (800) 436-3132
Uniform designs for all kinds of personnel, including coveralls, aprons and smocks.

ATD-American Co.
135 Greenwood Ave.
Wyncote, PA 19095-1396
(800) 523-2300, (215) 576-1000
Fax: (215) 576-1827
Specializes in a complete line of men's and women's underwear for government, institutions and retail.

Atlas Uniform Co.
5943 W. Lawrence, Dept. TR
Chicago, IL 60630
(800) 635-3578, (773) 725-1220
Fax: (773) 725-6191
Offers stock and custom designs for industrial, security, institutional and promotional purposes. Includes aprons, career looks, medical garments, outerwear and sports gear.

Cintas
6800 Cintas Blvd.
Mason, OH 45218
(513) 459-1200
Fax: (800) 800-3275 (for catalog)
Stock and custom designs for all types of uniforms, including those for industrial, security, kitchen, housekeeping and career-look personnel.

Desantis Holster & Leather Goods
149 Denton Ave.
New Hyde Park, NY 11040
(516) 354-8000
Fax: (516) 354-7501
www.desantis.com
Specializes in uniform belts, holsters and batons.

Fawn Industries, Inc. (East Coast)
Hwy. 851
P.O. Box 230
New Park, PA 17352
(800) 388-3296, (717) 382-4855
Fax: (717) 382-4711
Specializes in embroidered uniforms. Offers custom design service.

Fawn Industries, Inc. (West Coast)
1551 Stimson Rd.
P.O. Box 30727
Stockton, CA 95213
(800) 388-3296, (209) 234-0240
Fax: (209) 234-1944
Specializes in embroidered uniforms. Offers custom design service.

Garment Corp. of America
801 W. 41st St.
Miami Beach, FL 33140
(800) 944-4300, (305) 531-4040
Fax: (800) 777-1015
Offers stock designs for industrial work clothes.

George Glove Co.
266 S. Dean St.
P.O. Box 5209
Englewood, NJ 07631-5209
(800) 631-4292, (201) 567-7500
Fax: (201) 567-0567
Offers all kinds of gloves in all sizes, colors and materials, including parade gloves, waiters' gloves and work gloves.

Jeda Trading Corp.
21-05 51st Ave.
Long Island City, NY 11101
(800) 229-8919, (718) 784-1166
Fax: (718) 784-7019
Offers stock uniforms for service and security personnel, including outerwear and coordinated blazers, slacks, dress shirts and such.

Leventhal Bros. & Co., Inc.
36 Maple Pl.
Manhasset, NY 11030
(516) 365-9540
Fax: (516) 365-9547
Speciality is uniforms for security, law enforcement and industrial personnel.

Michael's Uniform Co., Inc.
7180 W. Grand Ave.
Chicago, IL 60635
(800) 828-0601, (312) 287-8700
Fax: (312) 287-3292
Industrial and career apparel. Includes smocks, coveralls, lab coats, jackets windbreakers and more.

Shirtz Unlimited
733 N. Snelling
St. Paul, MN 55104
(800) 728-4291, (612) 699-3847
Fax: (612) 645-2221
Offers sports team apparel, T-shirts, caps, polo shirts, sweatshirts and jackets.

Some's Uniforms, Inc.
65 Rte. 17 S.
Paramus, NJ 07652
(800) 631-7077, (201) 843-1199
Fax: (201) 843-3014
Specializes in career and professional uniforms for federal, state, county, security and industrial agencies and private industry in foreign countries.

Spedmill, Inc.
1132 N. Carrolton Ave.
Baton Rouge, LA 70896
(800) 922-1463, (504) 924-1463
Fax: (504) 923-3225
Specializes in industrial uniforms.

Todd Uniforms for Business
3668 S. Geyer Rd.
St. Louis, MO 63127
(800) 325-9516, (314) 984-0365
Fax: (800) 231-8633
Offers stock and custom designs for all types of personnel. Emphasizes image building.

UniFirst
3047 E. Commerce
San Antonio, TX 78220
(210) 222-8695
Fax: (210) 227-7959
Stock and custom designs for industrial and medical personnel. Also career-look blazers and slacks. Emphasizes image building.

Unitog

101 W. 11th
Kansas City, MO 64105
(816) 474-7000
Fax: (816) 842-1336
Manufactures all kinds of uniforms.

Weintraub Brothers Co., Inc.

2695 Philmont Ave.
Huntingdon Valley, PA 19006
(215) 938-7540
Fax: (215) 938-7630
Emphasizes image building. Offers custom design service. Also offers military uniforms.

Patches and Emblems

These companies specialize in custom-embroidered uniform patches. Call for minimum quantities and prices.

Fawn Industries, Inc. (East Coast)

Hwy. 851
P.O. Box 230
New Park, PA 17352
(800) 388-3296, (717) 382-4855
Fax: (717) 382-4711

Fawn Industries, Inc. (West Coast)

1551 Stimson Rd.
P.O. Box 30727
Stockton, CA 95213
(800) 388-3296, (209) 234-0240
Fax: (209) 234-1944

Recco Maid Embroidery Co.

4624 W. Cornelia Ave.
Chicago, IL 60641-3792
(773) 286-6333
Fax: (773) 286-0220

Swiss Craft Embroidery Co., Inc.

1601 N. Natchez Ave., Dept. 95
Chicago, IL 60635
(800) 835-4666, (773) 622-4646
Fax: (773) 622-5308

Professional Information

Graphic Arts Organizations

Advertising Photographers of New York (APNY)

27 W. 20th St., #601
New York, NY 10011
(212) 807-0399
Works to increase visibility of professional photographers. Offers networking events, educational seminars and a monthly newsletter. Members receive discounts on ads in creative directories and photography supplies.

American Advertising Federation

1101 Vermont Ave. NW, Ste. 500
Washington, DC 20005-06306
(800) 999-2231, (202) 898-0089
Fax: (202) 898-0159
www.aaf.org
With over fifty thousand members, the AAF represents advertising professionals in corporations, agencies, media companies, suppliers and academia. Sponsors the ADDYs, an annual competition that recognizes excellence in advertising.

American Association of Advertising Agencies

666 3rd Ave., 13th Fl.
New York, NY 10017
(212) 682-2500
Fax: (212) 682-8391
www.commercepark.com/AAAA
National association serves as a networking vehicle for the advertising industry and educates business on the value of professional advertising.

American Center for Design

325 W. Huron St., Ste. 711
Chicago, IL 60610
(312) 787-2018
Fax: (312) 649-9518
www.ac4d.org
A national association for design professionals, educators and students, the American Center for Design supports design education and educates the business community on the value of design. Sponsors annual competition and biennial design conference.

American Film Institute

2021 N. Western Ave.
Los Angeles, CA 90027
(323) 856-7600
Fax: (323) 467-4578
www.afionline.org/home.html

Dedicated to the development and appreciation of motion pictures. National members receive quarterly newsletter, access to AFI library and discounts on AFI-sponsored seminars and special events.

The American Institute of Graphic Arts (AIGA)

1059 3rd Ave.
New York, NY 10021
(212) 807-1990
Fax: (212) 807-1799
www.aiga.org
Founded in 1914, the AIGA is a nonprofit organization that promotes excellence in graphic design. The AIGA represents graphic designers on the local level with over thirty chapters in the United States. Sponsors annual competition. Holds a national design conference every other year on odd years, a biennial business conference during even years.

Art Directors and Artists Club

2791 24th St.
Sacramento, CA 95818
(916) 731-8802
Fax: (916) 731-4386
www.adac.org
Sponsors Art Directors and Artists Club Envision 23, a design conference held to motivate design students and inspire design professionals.

Association of Graphic Communications

330 7th Ave.
New York, NY 10001
(212) 279-2116
www.agcomm.org
Devoted to professional development and networking among those involved in the graphic arts, including designers, educators and students as well as production, printing and prepress professionals. Holds an annual competition and exhibition of winners of its Graphic Arts Awards Competition.

Association of Medical Illustrators

1819 Peachtree St. NE, #560
Atlanta, GA 30309
(404) 350-7900
Fax: (404) 351-3348
www.medical/illustrators.org
Organization provides networking and training opportunities for medical illustrators. Sponsors full- and half-day workshops, a job hotline and internship programs.

Broadcast Designers' Association

145 W. 45th St., Ste. 1100
New York, NY 10036
(212) 376-6222
Fax: (212) 376-6202
www.bdaweb.com
Dedicated to recognizing excellence and promoting professional development in broadcast media. Sponsors annual BDA/Promax International conference and competition.

The Color Association of the United States (CAUS)

409 W. 44th St.
New York, NY 10036
(212) 582-6884
Fax: (212) 757-4557
www.colorassociation.com
Primarily concerned with color for fashion, interior and environmental design.

Color Marketing Group

5904 Richmond Hwy., Ste. 408
Alexandria, VA 22303
(703) 329-8500
Fax: (703) 329-0155
www.colormarketing.org
A nonprofit association made up of designers, marketing experts, product developers and others whose business depends on keeping up with color trends.

Corporate Design Foundation

20 Park Plaza, Ste. 321
Boston, MA 02116
(617) 350-7097
Fax: (617) 451-6355
www.cdf.org
Dedicated to furthering the success of organizations through strategic design. Sponsors annual conferences held in San Francisco and Boston for industry professionals and educators involved in business and design.

Graphic Artists Guild

90 John St., Ste. 403
New York, NY 10038
(212) 791-3400
Fax: (212) 791-0333
www.gag.org
National advocacy organization represents graphic designers, art directors, illustrators and others in the graphic design industry. Sponsors educational seminars offering advice on business aspects of the trade, such as self-promotion, pricing strategies and tax issues. Promotes and maintains high professional standards of ethics and practice. Also produces the *Graphic Artists Guild Handbook: Pricing and Ethical Guidelines.*

Greeting Card Association
1350 New York Ave. NW, Ste. 615
Washington, DC 20005
(202) 393-1778
Fax: (202) 393-0336
www.greetingcard.org
For photographers, artists and writers in the greeting card industry. Membership benefits include a monthly newsletter on industry trends and ideas.

Picture Agency Council of America (PACA)
P.O. Box 308
Northfield, MN 55057-0308
(800) 457-PACA
Fax: (507) 645-7066
www.pacaoffice.org
Organization consists primarily of photo stock agencies. Publishes a directory of its members, available for $15 to photographers, free of charge to image users if request is mailed or faxed on company letterhead.

Society for Environmental Graphic Design (SEGD)
401 F St. NW, Ste. 333
Washington, DC 20001
(202) 638-5555
Fax: (202) 638-0891
Promotes excellence, public awareness and professional development of environmental graphic design. Benefits include a job bank, fabricator/designer referral service and national conference.

The Society for Imaging Science and Technology
7003 Kilworth Ln.
Springfield, VA 22151
(703) 642-9090
www.imaging.org
Organization is dedicated to advancing image science and technology. Offers courses and books and sponsors an exhibition and conference featuring the latest developments in digital imaging and multimedia.

Society of Illustrators
Museum of American Illustration
128 E. 63rd St.
New York, NY 10021
(800) 746-8738, (212) 838-2560
Fax: (212) 838-2561
www.society@societyillustrators.org
Headquarters includes gallery that offers monthly shows of contemporary illustration. Benefits include lectures and drawing classes. Sponsors student show and annual competition.

Society of Photographer and Artist Reps (SPAR)
60 E. 42nd St., Ste. 1166
New York, NY 10165
(212) 779-7464
Fax: (203) 866-3321
Publishes members directory and talent they represent plus quarterly newsletter. Also offers portfolio reviews and business forms.

Society of Publication Designers
60 E. 42nd St., Ste. 721
New York, NY 10165-0721
(212) 983-8585
Fax: (212) 983-6043
www.spd.org
Offers monthly luncheons, speakers' evenings and a monthly newsletter. Sponsors annual design competition and competition for best spot illustration and publishes an annual of award-winning work from its design competition. Holds a biennial conference, Zine2000, Design for New Media, during odd years. Alternates with Mag2000, which runs on even years.

Type Directors Club
60 E. 42nd St., Ste. 721
New York, NY 10165
(212) 983-6042
Fax: (212) 983-6043
www.tdc.org
Dedicated to keeping members abreast of newest trends in typography, the club publishes quarterly newsletter, *Letterspace*. Group also sponsors a yearly competition and publishes an annual book of its award winners. Sponsors six traveling exhibitions of its competition award winners. Also holds luncheon meetings with guest speakers. Sponsors annual conference, Multimedia in Realtime, that focuses on the role of graphic design and typography in digital media.

The University and College Designers Association
122 S. Michigan Ave., Ste. 1100
Chicago, IL 60603
(312) 431-0013
Fax: (312) 431-8697
Sponsors annual design competition and annual conference.

The Graphic Artists Guild Handbook: Pricing and Ethical Guidelines *is widely regarded as the definitive source for contract terms, market fees, copyright information and other common trade practices for illustrators, graphic designers and those who work with graphic arts professionals. The book includes reports on recent legislation, such as the Copyright Reform Act, and offers guidelines for fee negotiation, cancellation and rejection fees, frequency rights and other ethical issues. Sample contracts and other business forms are included. You can purchase the handbook at local bookstores or order it directly from the Graphic Artists Guild.*

National Directories of Creative Talent

These are some of the largest and best-known resource books for illustrators, photographers, designers, typographers and multimedia artists. All of them include alphabetical and regional listings as well as full-color ads that make it easy to browse for an appropriate illustration or photographic style. (See also the Creative Directories sections in chapter one, "Illustration," and chapter two, "Photography.")

These directories are usually available free of charge to agencies, design studios, publishers and others who are in a position to hire freelance talent. The directories can also be purchased by contacting the publishers directly.

The Alternative Pick/Storm Entertainment
1133 Broadway, Ste. 1408
New York, NY 10010
(212) 675-4176
Fax: (212) 675-4936
Features illustrators, designers, photographers and multimedia artists. Audience is primarily music and entertainment industry professionals.

American Showcase Illustration
915 Broadway, 14th Fl.
New York, NY 10010
(800) 894-7469, (212) 673-6600
Fax: (212) 673-9795, (212) 358-9491
Publishes two illustration volumes: One features illustrators' reps; the other features independent freelancers. Includes more than 4,500 images. Also publishes *Creative Options for Business and Annual Reports*, a directory that contains more than 150 images representing illustrators who do business-oriented work, and Virtual Portfolio, a directory of illustrators on CD-ROM as well as a national directory of photographers and photography-related services.

The Creative Black Book
The Creative Illustration Book
10 Astor Pl., 6th Fl.
New York, NY 10003
(212) 539-9800
Fax: (212) 539-9801
www.blackbook.com
Directory includes two volumes: One is devoted to examples and listings of photographers, stock photography agencies, photo labs and retouchers; the other features listings and examples from illustrators and illustrators' reps. Also sponsors roundtable discussions, locally and in other cities, that bring art directors and freelancers together to discuss pertinent issues.

RSVP
P.O. Box 050314
Brooklyn, NY 11205
(718) 857-9267
Fax: (718) 783-2376
www.rsvpdirectory.com
Directory consists of one book divided into two sections: one each for illustration and design. Printed annually. Web site features on-line gallery.

The Workbook
940 N. Highland Ave.
Los Angeles, CA 90038
(800) 547-2688, (213) 856-0008
Fax: (213) 856-4368
New York Sales Office: (212) 674-1919
Chicago Sales Office: (312) 944-7925
www.workbook.com
Photography volume offers four-color representation of thousands of photographers organized alphabetically by region. Directory volume also lists retouchers, stylists, makeup artists and model agencies. *The Workbook*'s Web site also includes the on-line portfolios of many photographers and stock agencies.

Placement Agencies for Graphic Arts Professionals

These agencies are in the business of match-making between creative professionals. Although some general employment agencies will work with graphic designers, the agencies listed here deal exclusively with graphic designers, art directors, illustrators, production managers and professionals in related areas of design.

Cheryl Roshak & Associates

Cheryl Roshak Temps
141 5th Ave., 4th Fl.
New York, NY 10010
(212) 228-5050
Fax: (212) 228-5367
Bulk of placements are in New York City area (about 75 percent). Remainder are in other major U.S. cities and Japan. Firm handles a large number of computer-related positions.

Chris Edwards Agency, Inc.

1170 Broadway
New York, NY 10001-7505
(212) 986-9400
Fax: (212) 986-6868
Handles positions in signage and exhibition, architecture and interior design as well as graphic design. Doesn't get involved in media-related positions. Bulk of placements are in New York City area but also fills positions in other U.S. cities.

The Creative Resource

127 W. 24th St., 4th Fl.
New York, NY 10011
(212) 462-4221
Fax: (212) 462-4109
Executive search firm makes placements worldwide in positions for creative professionals in all facets of design.

Janou Pakter, Inc.

5 W. 19th St., 6th Fl.
New York, NY 10003
(212) 989-1288
Fax: (212) 989-9079
Specializes in 2-D and 3-D design, new media, production services, advertising and marketing. Placements range from junior through partner level in design firms, advertising agencies, fashion and cosmetics firms, publishing and multinational corporations. Makes placements for contingency and retainer work for full-time and freelance. Also recruits talent for stock photography and illustration.

Portfolio

Atlanta: (404) 817-7000
Boston: (617) 876-3400
Chicago: (312) 739-9102
Detroit: (810) 352-5552
Houston: (713) 871-1974
Los Angeles: (310) 581-1600
New York: (212) 358-1200
Philadelphia: (610) 617-0900
San Diego: (619) 452-5500
San Francisco: (415) 391-8100
Santa Clara: (408) 492-1288
Seattle: (206) 623-3800
Washington, DC: (202) 293-5700
www.portfolio.skill.com
With offices in thirteen U.S. cities, Portfolio handles temporary, freelance and permanent positions in copy writing, illustration, graphic design, prepress, multimedia and more. Web site gives overview of job opportunities. Divisions include Mac Temps and Web-Staff.

RitaSue Siegel Resources

18 E. 48th St.
New York, NY 10017-1914
(212) 682-2100
Fax: (212) 682-2946
Handles all levels of positions in graphic, architectural, industrial, exhibit and interior design. Twenty-five percent of the agency's placements are in the New York City area. Remainder are in other U.S. cities, Europe and the Far East.

Roz Goldfarb Associates

10 E. 22nd St., 4th Fl.
New York, NY 10010
(212) 475-0099
Fax: (212) 473-8096
Agency makes placements in architecture, interior design, industrial design and graphic design. Bulk of business is in New York City.

Stone & Co.

Forbes Business Center
222 Forbes Rd., Ste. 406
Braintree, MA 02184
(781) 356-7001
Fax: (781) 356-7007
Founded in 1959, this agency is the oldest placement agency in the country specializing exclusively in design. Handles placements in major U.S. cities as well as some overseas businesses.

Update Graphics

1140 6th Ave., 6th Fl.
New York, NY 10036
(212) 921-2200
Fax: (212) 354-9530
www.updategraphics.com
Specizlies in freelance and permanent placement of computer-based artists in print and new media.

Competitions

Deadline dates listed are current at the time of publication. However, deadline dates can vary from one year to the next. Call sponsoring organizations for up-to-date deadlines, information and entry forms.

ADDYs

American Advertising Federation
1101 Vermont Ave. NW, Ste. 500
Washington, DC 20005-06306
(800) 999-2231, (202) 898-0089
Fax: (202) 898-0159
www.aaf.org
Recognizes excellence in advertising. Deadline: April. Entry fees: $95 single, $100 campaign.

AGC Annual Graphic Arts Awards Exhibit

Association of Graphic Communications
330 7th Ave.
New York, NY 10001
(212) 279-2116
www.agcomm.org
Seeks outstanding examples of print design. Awards are given in twenty-six categories to entries that exemplify the best in design and production. Winners are displayed in annual exhibition. Deadline: January. Entry fees: vary.

AIGA Communication Graphics

American Institute of Graphic Arts
164 5th Ave.
New York, NY 10010
(212) 807-1990, ext. 231
Fax: (212) 807-1799
www.aiga.org
Awards are given to every facet of communication design, including all aspects of print, except for books and book covers, plus packaging and interactive multimedia. Winners are featured in annual. Deadline: May. Entry fees: $35 AIGA members, $45 nonmembers.

AIGA 50 Books/50 Covers

(see contact information above)
Recognizes excellence in books, book covers and book jackets. Deadline: March. Entry fees: $35 AIGA members, $45 nonmembers.

American Center for Design 100 Show

American Center for Design
325 W. Huron St., Ste. 711
Chicago, IL 60610
(312) 787-2018
Fax: (312) 649-9518
www.ac4d.org
Competition selects one hundred pieces that exemplify excellence in significant trends in communication design, including all facets of print, broadcast, interactive multimedia and product design. Deadline: April. Call for entry fees.

American Corporate Identity

4100 Executive Park Dr., #16
Cincinnati, OH 45241
(513) 421-1938
Fax: (606) 324-6038
Annual competition devoted specifically to U.S. corporate identity. Publishes annual of award winners. Deadline: December. Entry fee: $20.

American Graphic Design Awards

Graphic Design: USA
111 Great Neck Rd., Ste. 202
Great Neck, NY 10031
(516) 829-1414
Fax: (516) 829-6363
Annual competition honors the best of U.S. designers in all facets of print, broadcast and interactive multimedia. Deadline: March. Call for entry fees.

American Illustration Competition

American Illustration
28 W. 25th St., 11th Fl.
New York, NY 10010
(212) 243-5262
Fax: (212) 243-5201
Annual competition seeks to honor the best in illustration. Offers awards in nine categories. Deadline: February. Entry fees: $25 single, $75 sequence, $60 for ten student submissions.

American Photography Competition

American Photography
(see contact information above)
Honors excellence in photography. Deadline: January. Entry fees: $30 single, $90 sequence.

Art Directors Club Annual Awards

Art Directors Club
250 Park Ave. St.
New York, NY 10003-1402
(212) 674-0500
Fax: (212) 228-0649
www.adcny.org
Annual competition awards gold and silver medals in print and broadcast advertising, graphic design, publication design, film and video, promotion and packaging, new media and illustration. Winners are displayed in gallery exhibition. Call for deadline and entry fee.

BDA International Design Awards Competition

Broadcast Designers' Association
145 W. 45th St., Ste. 1100
New York, NY 10036
(212) 376-6222
Fax: (212) 376-6202
www.bdaweb.com
Annual competition recognizes design excellence with gold, silver and bronze awards in one hundred categories. Winners are showcased in design annual and exhibited at BDA/Promax International annual conference. Deadline: January. Entry fees: vary

Beacon Awards

American Center for Design
325 W. Huron St., Ste 711
Chicago, IL 60610
(800) 257-8657, (312) 787-2018
Fax: (312) 649-9518
www.ac4d.org
Cosponsored by the American Center for Design and Mercer Management Consulting, this international competition recognizes innovative corporate design programs that integrate design, management and marketing. Deadline: November. Entry fees: vary.

Beckett Honors

Beckett Paper Co.
2 Gateway Blvd.
East Granby, CT 06026
(800) 423-2259, (814) 870-9657
This biennial competition recognizes outstanding design and printing on Beckett papers. Winners are awarded in two categories: business communications and general. Deadlines: June, December. Entry fee: none.

Black Book AR100

Black Book, AR 100 Dept.
10 Astor Pl., 6th Fl.
New York, NY 10003
(212) 702-9800
Fax: (212) 539-9801
www.blackbook.com
Annual design competition recognizes excellence in annual report design and production. Deadline: April. Entry fees: $75 first entry, $60 each additional entry.

CA Advertising Annual

Communication Arts
P.O. Box 10300
Palo Alto, CA 94303
(415) 326-6040
Fax: (415) 326-1648
www.commarts.com
Recognizes outstanding examples of design in print ads, posters, television and radio broadcasting and self-promotion. Winners are published in *CA* annual. Deadline: June. Entry fees: $25 single entry, $40 series, $75 single television or radio commercial, $120 series television or radio commercials.

CA Graphic Design Annual

(see contact information above)
This international competition honors the best work produced in design print. Categories include posters, brochures, packaging, corporate identity, annual reports, catalogs, letterheads and environmental graphics. Deadline: June. Entry fees: $25 single entry, $40 series.

CA Interactive Design Annual

(see contact information above)
Seeks the best in interactive media. Winners are published on diskette, CD-ROM, on-line and on an interactive kiosk. Deadline: January. Entry fees: $100 single Web site entry, $125 single disk-based entry.

Clio Awards

276 5th Ave., Ste. 401
New York, NY 10001
(800) 946-2546, (212) 683-4300
Fax: (212) 683-4796
www.clioawards.com
Recognizes excellence in all areas of advertising, direct marketing, package design and promotional merchandise. Deadline: January. Entry fees: vary.

Crown Vantage Award of Excellence

Crown Vantage
145 James Way
Southampton, PA 18966
(800) 441-9292, ext. 384; (215) 364-3900

Honors excellence in design and printing on Crown Vantage papers. Awards are given in the following categories: general collateral, collateral produced on a limited budget, and letterhead.
Deadline: ongoing. Entry fee: none.

The Donside Graphic Design and Print Awards

Donside North America
Sue Middleton
1600 Johnson Way
New Castle, DE 19720
(800) 220-8577, ext. 311; (302) 326-1262
Fax: (302) 326-1277
Recognizes excellence in design and printing on Consort Royal and Gleneagle papers. Separate awards are given in design and print categories as well as an award for corporate communications. Winners are displayed in a touring exhibition. Top winners are guests at an awards dinner in London. Deadline: September. Entry fee: none.

French Paper Excellence Award

French Paper Co.
100 French St.
Niles, MI 49120
(616) 683-1100
Ongoing competition honors excellence in design and printing on French papers. Each piece submitted is judged on its own merit. Six copies of each piece are needed to distribute to six designers who judge the competition. Deadline: ongoing. Entry fee: none.

Gilbert Graphic Greatness Awards (G3)

Gilbert Paper Co.
430 Ahnaip St.
Menasha, WI 54952
(800) 445-7329, (920) 729-7630
Recognizes outstanding design and printing on Gilbert papers in the following categories: letterhead, annual reports, brochures/catalogs, folder/cover-only application and miscellaneous. Combinations of Gilbert papers and coated stocks qualify. Award winners receive plaques. Deadline: December 31. Entry fee: none.

The Global Awards for Healthcare Communications

(see listing for The New York Festivals)

Gold Awards Competition

American Institute of Graphic Artists/Package Design Council
164 5th Ave.
New York, NY 10010
(212) 807-1990, ext. 231
Fax: (212) 807-1799
www.aiga.org
Deadline: March. Entry fees: vary.

Graphis Advertising

Graphis
141 Lexington Ave.
New York, NY 10016
(212) 532-9387
Fax: (212) 213-3229
www.graphis.com
Showcases outstanding work in print advertising. Winners are featured in annual. Deadline: October. Entry fees: $25 single entry, $65 series.

Graphis Annual Reports

(see contact information above)
Features the best in annual report design. Winners are featured in biennial publication. Deadline: November. Entry fees: $25 single entry, $65 series.

Graphis Book Design

(see contact information above)
Competition recognizes over two hundred examples of excellence in book design, including covers and interior spreads. Winners are published every three years. Deadline: August. Entry fees: $25 single entry, $65 series.

Graphis Brochures

(see contact information above)
Recognizes excellence in brochure design. Sixteen categories of covers and interior spreads are reproduced in biennial publication. Deadline: October. Entry fees: $25 single entry, $65 series.

Graphis Design

(see contact information above)
Features over seven hundred examples of the best in visual communication. Work is judged in twenty-four categories, including advertising, brochures, corporate identity, annual reports and packaging. Winners are featured in annual. Deadline: November. Entry fees: $25 single entry, $65 series.

Graphis Letterhead

(see contact information above)
Over two hundred of the industry's best stationery systems are published every three years. Deadline: November. Entry fees: $25 single entry, $65 series.

Graphis Logo

(see contact information above)
The best corporate symbols, logos and trademarks are published every three years. Deadline: November. Entry fees: $25 single entry, $65 series.

Graphis New Media

(see contact information above)
Biennial competition honors and publishes the best in interactive multimedia. Deadline: July. Entry fees: $25 single entry, $65 series.

Graphis Paper Promotions

(see contact information above)

Because paper promotions have come to showcase the best in graphic design, this competiton seeks entries from designers who have done promotions for paper companies. Winners are published every three years. Deadline: November. Entry fees: $25 single entry, $65 series.

Graphis Poster

(see contact information above)

Honors innovative poster design from an international arena. Winners appear in annual. Deadline: July. Entry fees: $25 single entry, $65 series.

Graphis Student Design

(see contact information above)

Honors student work in all areas of communication design. Deadline: June. Entry fees: $25 single entry, $65 series.

Graphis Typography

(see contact information above)

Award-winning type design from classic to modern is featured in this publication produced every three years. Deadline: November. Entry fees: $25 single entry, $65 series.

Hammermill Creative Inking

Hammermill Paper
2064 W. 16th St.
Erie, PA 16505
(901) 763-7831

This semiannual competition recognizes quality design and printing on Hammermill papers. Awards are given in print excellence and design excellence. Entries must be printed in whole or in part on Hammermill papers. Deadlines: June, December. Entry fee: none.

HOW Annual International Design Competition

HOW Magazine
1507 Dana Ave.
Cincinnati, OH 45207
(513) 531-2222
Fax: (513) 531-1843
www.howdesign.com

Recognizes outstanding design in all areas of print and multimedia, including a student category. Winners are printed in annual. Deadline: September. Entry fees: $25 single entry, $45 interactive, $50 campaign. Student entries: $15 single, $25 campaign.

HOW Annual Self-Promotion Competition

HOW Magazine
(see contact information above)

Recognizes excellence in all facets of self-promotion, including identity concepts, seasonal promotions and interactive multimedia. Also includes a student category. Deadline: March. Entry fees: $25 single entry, $45 interactive, $50 campaign. Student entries: $15 single, $25 campaign.

I.D. Annual Design Review

I.D. Magazine
440 Park Ave. S.
New York, NY 10016
(212) 447-1400
Fax: (212) 447-5221
www.idonline.com

Honors excellence in graphic design, packaging design and interactive media. Winners are published in annual. Deadlines: January, interactive media; February, graphics, packaging and other print-related design. Entry fee: $75.

International Interactive Multimedia Awards

(see listing for The New York Festivals)

International TV and Cinema Advertising Awards

(see listing for The New York Festivals)

Literary Marketplace Awards

Reed Reference Publishing
(800) 5-BOWKER
Deadline: mid-November.

London International Advertising Awards

Barbara Levy
141 E. 44th St., Ste. 610
New York, NY 10017
(212) 681-8844
Fax: (212) 681-8309

Honors excellence in print advertising, package design, television and radio advertising. Gives awards in almost fifty print categories. Winners are published in awards annual. Deadline: June. Entry fee: $150.

Mead Annual Report Show

Mead World Headquarters
Courthouse Plaza NW
Dayton, OH 45463
(800) 345-6323, ext. 53586; (937) 495-4185
Fax: (937) 495-4185
www.meadpaper.com

Recognizes and showcases the best in American annual report design. Strict eligibility rules apply for submitting an entry to this prestigious competition. Deadline: May. Entry fee: $50.

Mead Annual Report Student Competition
(see contact information above)
Judged on the same criteria and by the same judges as the Mead Annual Report Show, this competition solicits entries from students only. Deadline: May. Entry fee: none.

Mead 60
(see contact information above)
Awards sixty certificates of honor to sixty winners annually in all categories of print design. One of the sixty winners receives the Mead 60 medal of excellence. Deadline: December. Fee: none.

Mohawk Award of Excellence
Mohawk Paper Mills, Inc.
465 Saratoga St.
P.O. Box 497
Cohoes, NY 12047
(800) THE-MILL, (518) 237-1740
Recognizes outstanding design and printing on Mohawk papers. Deadline: ongoing. Entry fee: none.

Monadnock Paper Mills' Graphic Arts Awards Program
Monadnock Paper Mills
117 Antrim Rd.
Bennington, NH 03442
(603) 588-3311
Honors superior creativity and craftsmanship for work printed on Monadnock papers. Awards are given on a quarterly basis in each of four categories: annual reports, booklets and catalogs; books; prints and posters; stationery, announcements and brochures. Quarterly winners are entered in a year-end competition. Deadline: ongoing. Entry fee: none.

Neenah Paperworks Contest
Neenah Paper
1400 Holcomb Bridge Rd.
Roswell, GA 30076-2199
(800) 241-3405, (770) 587-8730
Holds two competitions honoring design excellence: a monthly letterhead competition and a quarterly competition devoted to pieces printed on text and cover stock. Also holds a year-end competition. Deadline: ongoing. Entry fee: none.

The New York Festivals
780 King St.
Chappaqua, NY 10514
(914) 238-4481
Fax: (914) 238-5040
www.nyfests.com
For over forty years, The New York Festivals has honored excellence in all types of communications media. Its family of annual international competitions includes Print and Radio Advertising, TV and Cinema Advertising, TV Programming and Promotion, Radio Programming and Promotion, Film and Video (Non-Broadcast), Interactive Multimedia, The Globals Healthcare Communications and the AME International Awards for Advertising Marketing Effectiveness. Deadline: June. Entry fees: vary.

The 100 Show
American Center for Design
325 W. Huron St., Ste 711
Chicago, IL 60610
(800) 257-8657, (312) 787-2018
Fax: (312) 649-9518
www.ac4d.org
Recognizes one hundred projects that exemplify emerging trends in design. Winners are displayed in a traveling exhibition and documented in an annual. Deadline: August. Entry fees: vary.

Premiere Print Awards (The Bennys)
Printing Industries of America
100 Daingerfield Rd.
Alexandria, VA 22314-2888
(888) 272-3329, (703) 519-8100
Fax: (703) 548-3227
Annual competition awards are given in twenty-five categories for excellence in printing and design. Deadline: May. Entry fees: $75 members, $110 nonmember printer, $95 other nonmembers, $20 students.

Presidential Design Award
Tom Grooms
General Services Administration
1800 F St. NW
Washington, DC 20405
(202) 501-4941
Fax: (202) 501-3393
Honors excellence in graphic design. Open to all types of projects, but work must be funded, sponsored or commissioned by the federal government. Deadline: April. Entry fee: none.

PRINT's Digital Design & Illustration Annual
PRINT Magazine
3200 Tower Oaks Blvd.
Rockville, MD 20852
(212) 463-0600
Fax: (212) 989-9891
www.printmag.com
Recognizes outstanding illustration in all print applications as well as illustration and design in interactive multimedia applications. Winners are featured in annual. Deadline: August. Entry fee: $25.

PRINT's Regional Design Annual
(see contact information above)
Selects outstanding examples of design from all facets of the industry. Winners are published in annual. Deadline: March. Entry fees: $25 single entry, $65 campaign or series.

RSVP "Self-Portrait" Competition
RSVP
P.O. Box 050314
Brooklyn, NY 11205
(718) 857-9267
Fax: (718) 783-2376
www.rsvpdirectory.com
Deadline: June. Entry fees: $15 first entry, $5 each additional entry.

SEGD Annual Competition
Society for Environmental Graphic Design (SEGD)
401 F St. NW, Ste. 333
Washington, DC 20001
(202) 638-5555
Fax: (202) 683-0891
Recognizes excellence in environmental graphics in twenty-five different categories. Deadline: January. Entry fees: $65 members, $85 nonmembers.

Society of Illustrators Annual Competition
Society of Illustrators
Museum of American Illustration
128 E. 63rd St.
New York, NY 10021
(800) 746-8738, (212) 838-2560
Fax: (212) 838-2561
www.society@societyillustrators.org
Competition recognizes excellence in illustration. Winners are displayed in an annual exhibition. Deadline: October. Entry fees: vary.

Society of Publication Designers Annual Competition
Society of Publication Designers
60 E. 42nd St., Ste. 721
New York, NY 10165
(212) 983-8585
Fax: (212) 983-6043
www.spd.org
Recognizes the best in magazines, books, brochures, catalogs, annual reports and interactive publications. Deadline: January. Entry fees: $25 members, $35 nonmembers.

Step-By-Step Graphics
6000 N. Forest Park Dr.
Peoria, IL 61614-3592
(309) 688-2300
Fax: (309) 688-8515
www.dgusa.com

Sponsored by *Step-By-Step Graphics* magazine, this annual competition honors excellence in thirty-seven categories of graphic design, illustration, photography, multimedia and video design. Winners are published in magazine's Design Process Annual. Deadline: October. Entry fees: vary.

Strathmore Graphics Gallery
Strathmore Paper Co.
P.O. Box 1430
Avon, CT 06001
(800) 628-8816, (860) 844-2400
Quarterly competition recognizes excellence in printing and design on Strathmore papers. Entries need to be produced in whole or in part on any Strathmore paper. Open to all areas of graphic design. Deadlines: March, June, September, December. Entry fee: none.

TDC Annual Awards
Type Directors Club
60 E. 42nd St., Ste. 721
New York, NY 10065
(212) 983-6042
Fax: (212) 983-6043
www.typedirectors.com
Sponsors a yearly competition honoring typographic excellence and publishes an annual book that features its award winners. Deadline: January. Entry fees: $20 single entry, $30 multiple entries, $40 series.

Type Directors Club Exhibition
(see contact information above)
International competition recognizes excellence in type design, typography, calligraphy and other letterform applications. Call for deadline and entry fee.

U&lc Type Competition
228 E. 45th St., 12th Fl.
New York, NY 10017
(212) 949-8072
Fax: (212) 949-8485
Honors outstanding typeface design in the following categories: text, display, design/picture fonts. Winners are published in *U&lc* and could be selected to be developed as an ITC typeface. Deadline: February. Entry fees: $25 single entry, $40 multiple-weight families, $20 multiple single-weight entries, $15 students.

UCDA Annual Design Competition
The University and College Designers Association
515 King St., Ste. 410
Alexandria, VA 22314
(703) 548-1770
Fax: (703) 836-7256
Sponsors annual design competition recognizing design excellence in publications designed by or for educational institutions. Deadline: May. Entry fees:

$20 members/$40 nonmembers single entry, $30 members/$60 nonmembers series, $25 members/$30 nonmembers Web page or site.

World and National Calendar Awards

Calendar Marketing Association
Dick Mikes
710 E. Ogden Ave., Ste. 600
Naperville, IL 60563-8603
(630) 369-2406
Recognizes quality design and printing specific to calendars. World and national awards are given in the following categories: desk calendars, planner/pocket calendars, poster calendars, wall calendars, miscellaneous and best of show. Deadline: December. Entry fees: $75 single entry for world and national categories, $45 single entry for national only.

Magazines/ Newsletters

Publications listed below are all available on a subscription basis; some can be purchased at newsstands or art supply stores. Subscription prices listed below do not reflect promotional specials that are often found within a given magazine.

Advertising Age

220 E. 42nd St.
New York, NY 10017
(212) 210-0741
Fax: (212) 210-0111
http://adage.com
National weekly advertising and marketing news publication. Yearly subscription: $109.

Applied Arts Magazine

885 Don Mills Rd., #324
Toronto, Ontario M3C 1V9
Canada
(416) 510-0909
www.interlog.com/~app-arts
Published seven times a year, magazine features freelance talent in illustration, photography, lettering, type design and art direction. Also includes reps and retouching. Yearly subscription: $49.95.

Archive Magazine (Lurzer's International)

915 Broadway, 14th Fl.
New York, NY 10010
(800) 894-7469, (212) 673-6600
Fax: (212) 673-9795
Features best advertising from around the world. Published bimonthly. Yearly subscription: $48.

The Art of Self Promotion

P.O. Box 23
Hoboken, NJ 07030-0023
(800) 737-0783, (201) 653-0783
Fax: (201) 222-2494
Quarterly newsletter published by self-promotion specialist Ilise Benun. Includes tips on topics such as writing press releases, creating a mailing list and cold calling. Yearly subscription: $30 for four issues. Benun also sells handbooks on self-promotion.

AV Video

701 Westchester Ave.
White Plains, NY 10604
(914) 328-9157
Fax: (914) 328-9093
www.kipinet.com
Features multimedia, video, audio and computer graphics information. Published monthly, the magazine has a controlled circulation and is only available to qualified video, multimedia, film and television professionals in the United States and Canada. Web site has on-line subscription application.

Board Report

P.O. Box 300789
Denver, CO 80203
(303) 839-9058
Fax: (303) 839-1272
Monthly newsletter features techniques and practical advice on producing better and more cost-effective graphic design projects. Subscription includes *Graphic Artists Newsletter*, *Designer's Compendium* and *Trademark Trends*, a monthly review of exciting new logo designs. Yearly subscription: $107, with six-month guarantee.

Communication Arts

410 Sherman Ave.
P.O. Box 10300
Palo Alto, CA 94306-1826
(650) 326-6040
Fax: (650) 326-1648
www.commarts.com
One of the design industry's most venerable journals, it showcases top U.S. design and illustration talent. Publishes four annuals per year plus an interactive annual on CD-ROM. Published eight times a year. Yearly subscription: $53.

Creative Business

233 W. Canton St.
Boston, MA 02116
(617) 424-1368
Fax: (617) 353-1391
Published by freelance expert Cameron Foote, this newsletter is about the business side of freelancing. Published ten times a year, it offers tips on making a small creative business successful. Yearly subscription: $89.

Creativity

220 E. 42nd St.
New York, NY 10017
(888) 288-5900, (212) 210-0741
Fax: (212) 210-0111
Published ten times a year, *Creativity* focuses on the creative process of advertising. Issues profile top creative people, examine trends, explore technology applications and cover the latest campaigns. Yearly subscription: $49.

Critique

120 Hawthorne Ave., Ste. 102
Palo Alto, CA 94301
(888) 274-2748, (650) 323-7225
Fax: (650) 323-3298
www.critiquemag.com
Quarterly magazine concentrates on analyzing the strategy behind a design and why it is or isn't effective. Features include a Best/Worst column where veteran designers talk about their best and worst projects. Yearly subscription: $60.

Emigre

4475 D St.
Sacramento, CA 95819
(800) 944-9021, (916) 451-4344
Fax: (916) 451-4351
www.emigre.com
Magazine showcases work of type designers, illustrators and others whose work is on the cutting edge of the creative community. Quarterly's unique design and typographic approaches are noteworthy. Emigre also sells its typefaces and picture fonts from its magazine. (See listings in chapters one and four.) Yearly subscription: $28.

Folio

Cowles Business Media
470 Park Ave. S., 7th Fl., North Tower
New York, NY 10016
(212) 683-3540
Fax: (212) 683-4572
www.mediacentral.com\folio
Magazine covers aspects of communication design and production specific to magazines and other periodicals. Yearly subscription: $96 for 19 issues.

FUSE

FontShop San Francisco
350 Pacific Ave.
San Francisco, CA 94111
(888) FF-FONTS, (415) 398-7677
Fax: (415) 398-7678
Published quarterly, FUSE is Neville Brody's award-winning publication of experimental digital typography. Each issue includes four Mac- and PC-compatible typefaces by cutting-edge designers and posters by these designers showing creative applications of their fonts. Yearly subscription: $59.

Graphic Design: USA

1556 3rd Ave.
New York, NY 10022
(212) 534-5500
Fax: (212) 534-4415
Monthly magazine features news and ideas for graphic designers and art directors. Subscription includes Digital Design & Production, a bimonthly supplement. Yearly subscription: $60, $3 per issue.

Graphis

141 Lexington Ave.
New York, NY 10016
(212) 532-9387
Fax: (212) 213-3229
www.graphis.com
Bimonthly design magazine acclaimed for its artistic presentation of showcased work. Includes news, profiles, commentary and features. Yearly subscription: $89, $18.75 per issue.

HOW

1507 Dana Ave.
Cincinnati, OH 45207
(800) 333-1115, (513) 531-2222
Fax: (513) 531-4744
www.howdesign.com
Bimonthly graphic design magazine covering ideas, techniques and other aspects of the trade. Well known for its popular business annual focusing on successful design studios and freelancers across the United States. Sponsors competitions and annual conference. Yearly subscription: $49, $7 per issue; $12 for business annual.

I.D. Magazine

440 Park Ave. S., 14th Fl.
New York, NY 10016
(212) 447-1400
Fax: (212) 447-5231
www.idmagazine.com
Explores current issues and trends in graphic, product and environmental design. Sponsors annual competition for design excellence. Published seven times a year. Yearly subscription: $60, $5.95 per issue.

The Internet Connection

Bernan Press
1130 Connecticut Ave. NW, Ste. 675
Washington, DC 20036-3901
(800) 274-4447
Fax: (800) 865-3450
www.bernan.com
Newsletter serves as a guide to free government resources available on the Internet. Yearly subscription: $89 for ten issues.

Internet Magazine

Priory Ct.
30-32 Farringdon Ln.
London EC1R 3AU
(0171) 309-2700
Fax: (0171) 309-2749
www.internet-magazine.com
Focuses on current issues and trends of importance to those involved in Web design and Global Internet marketing. Available at U.S. newsstands for $7.95 per issue.

Macworld

Editorial:
501 2nd St.
San Francisco, CA 94107
(800) 217-7874, (415) 243-0505
Fax: (415) 442-0766
Subscriptions:
P.O. Box 54529
Boulder, CO 80322-4529
(303) 665-8930
Fax: (303) 604-7455
www.macworld.com
Reports on trends and new technology and offers tips that improve Macintosh computing. Features focus on best upgrade alternatives, latest software and other newsworthy items. Published monthly. Yearly subscription: $24.97.

PC Magazine

1 Park Ave., 4th Fl.
New York, NY 10016-5802
(212) 503-5255
Fax: (212) 503-5799
www.pcmag.com
Covers new technology and trends relative to PC computing, as well as other newsworthy items. Published twenty-two times a year. Yearly subscription: $49.97.

PC World

Editorial:
501 2nd St., #600
San Francisco, CA 94107
(800) 234-3498, (415) 243-0500
Fax: (415) 442-1891
Subscriptions:
P.O. Box 55029
Boulder, CO 80322-5029
(800) 234-3498, (303) 604-1465
www.pcworld.com
Relates the newest developments in PC computing. Yearly subscription: $24.95 for twelve issues.

Plazm

P.O. Box 2863
Portland, OR 97208-2863
(800) 524-4944, (503) 222-6389
Fax: (503) 222-6356
Quarterly magazine is published by Plazm Media Co-operative, a group of kindred spirits involved in producing innovative fonts and design. *Plazm* serves as a creative outlet and forum for artists, writers, photographers and designers to present cutting-edge work. Publication also features Plazm fonts (see listing in chapter four). Yearly subscription: $16.

PRINT

RC Publications
3200 Tower Oaks Blvd.
Rockville, MD 20852-9789
(800) 222-2654, (212) 463-0600
Fax: (301) 984-3203
www.printmag.com
Covering the graphic design industry for over fifty years, *PRINT* covers all aspects of the business and publishes a yearly annual of top design work. Sponsors annual competitions and national seminars. Published bimonthly, six issues per year include three regular issues and three annuals. Yearly subscription: $57.

Publish

501 2nd St.
San Francisco, CA 94107
(800) 656-7495, (415) 243-0600
Fax: (415) 442-1891
Monthly dedicated to graphic design in electronic communication. Includes technological updates and production tips for computer publishing, interactives and other aspects of digital design. Yearly subscription: $39.90; single issue: $4.95.

Step-By-Step Electronic Design

6000 N. Forest Park Dr.
Peoria, IL 61614-3592
(309) 688-2300
Fax: (309) 688-8515
www.dgusa.com
Monthly periodical takes reader through step-by-step digital production of design projects. Yearly subscription: $48.

Step-By-Step Graphics

(see contact information above)
Bimonthly magazine focuses on how well-known designers, photographers, illustrators and other graphic arts professionals create projects, from beginning to end. Yearly subscription: $42; single issue: $7.50.

U&lc

228 E. 45th St., 12th Fl.
New York, NY 10017
www.itcfonts.com
Published quarterly by International Typeface Corporation, this tabloid includes news, features and profiles. Focus is on trends in typographic design and production. Yearly subscripton: $14.

Windows Magazine

1 Jericho Plaza, Wing A
Jericho, NY 11753
(800) 829-9150, (516) 733-6700
Fax: (904) 733-8390
www.winmag.com
Dedicated to reporting on trends and tips that help professionals working with Windows computing. Includes information on latest software and hardware developments. Published monthly. Yearly subscription: $24.94; single issue: $2.95.

Wired

520 3rd St., 4th Fl.
San Francisco, CA 94107-1815
(800) SOWIRED, (415) 276-5000
Fax: (415) 276-5150
Monthly magazine promotes and reports on technological innovations in digital communication. Features focus on newsworthy topics that affect computer publishing, multimedia and communicating on the Internet. Social commentary and trendy graphics reflect current pop culture. Yearly subscription: $39.95 for twelve issues.

Publishers of Design Books

If you need some resources for expertise, inspiration or other help in your work, call these publishers. All of them specialize in books for graphic artists and will send a free catalog.

Adobe Press

(see Macmillan Publishing Group)

Allworth Press

New York, NY
(212) 777-8395
www.allworth.com
Publishes books on design theory and marketing.

Art Direction Book Co.

456 Glenbrook Rd.
Glenbrook, CT 06906
(203) 353-1441
Specializes in general-interest books for graphic designers, illustrators and art directors that are specific to production. Offerings include *Graphics Master*, books of symbols and how-to books.

Books Nippan

1123 Dominguez St., Unit K
Carson, CA 90746
(800) 562-1410, (310) 604-9701
Fax: (310) 604-1134
Specializes in high-quality graphic design books imported from Japan and other countries. Topics include T-shirts, corporate identity, logos, brochures and catalogs. Will furnish catalog on request.

Chromatics Press/Specialty Marketing Group, Inc.

41 Monroe Turnpike
Trumbull, CT 06611
(310) 391-2039
Fax: (800) 557-5601
Publishes *Color Bytes*, a book about a new system for using color.

Chronicle Books

85 2nd St., 6th Fl.
San Francisco, CA 94105
(800) 722-6657, (415) 537-3730
Fax: (800) 858-7787
www.chronbooks.com
Offers books on design, including many nostalgic subjects, such as vintage trademarks, signs and letterheads, and titles with a unique sense of funk. Also publishes books that showcase offbeat subject matter, such as tobacco accoutrements and board games of the 1950s.

Design Press
10 E. 21st St.
New York, NY 10010
(800) 722-4726, (800) 338-3987, (212) 512-2000
A subsidiary of McGraw-Hill, this division offers titles that cover academic and historical perspectives of design.

Dover Publications, Inc.
31 E. 2nd St.
Mineola, NY 11501-3582
(516) 294-7000
In addition to clip art books (see listing in chapter one, "Illustration"), Dover's Pictorial Archive catalog offers over six hundred books that feature vintage graphics, illustration and photography, organized by category. Offerings include items such as period patterns and borders. Company also offers note cards, gift wrap and other items with a vintage theme. Only accepts mail orders.

Graphis Books
Graphis
141 Lexington Ave.
New York, NY 10016
(212) 532-9387
Fax: (212) 213-3229
www.graphis.com
Sells books on advertising, corporate identity, design, illustration, new media, photography and typography. Many books are annuals featuring winners from Graphis's competitions.

Hayden Books
(see Macmillan Publishing Group)

Macmillan Publishing Group
201 W. 103rd St.
Indianapolis, IN 46290
(800) 428-5331
Publishes the following imprints:

Adobe Press—Books specific to Adobe products, many of them coauthored by the creators of its software. Offerings include books on imaging techniques that give step-by-step instructions on how to use Adobe software in their production.

Hayden Books (www.hayden.com)—Books specific to design and print production on the computer.

New Riders—Books on digital media, including software guidebooks and books specific to designing for the Web.

Madison Square Press
10 E. 23rd St.
New York, NY 10010
(212) 505-0950
Fax: (212) 979-2207
Specializes in showcasing outstanding work in different areas of design. Offers hardbound, four-color books on typography, environmental graphics and more.

New Riders
(see Macmillian Publishing Group)

North Light Books
1507 Dana Ave.
Cincinnati, OH 45207
(800) 289-0963, (513) 531-2222
Fax: (513) 531-4744
Specializes in books for graphic designers that are both instructional and inspiring. Offers step-by-step techniques, idea and creativity books, reference books, business books and more. Also distributes other imprints (including computer instruction and reference, showcases of great design work and specialty topics) through the Graphic Design Book Club.

Peachpit Press
2414 6th St.
Berkeley, CA 94710
(800) 283-9444, (510) 548-4393
Fax: (510) 548-5991
www.peachpit.com
Publishes books on computer graphics, the Internet, virtual reality and practical issues for computer designers. Offers some excellent guides to graphics software that go beyond the information found in conventional user's manuals.

PRINT Books
RC Publications, Inc.
3200 Tower Oaks Blvd.
Rockville, MD 20852
Offers many types of books for graphic designers and illustrators. Specializes in "PRINT's Best" and case story books that feature winners from PRINT magazine's annual regional competition.

Rizzoli International
300 Park Ave. S., 5th Fl.
New York, NY 10010
(212) 387-3400
Specializes in showcase books that feature outstanding design from Europe, Great Britain and other overseas markets. Has two retail locations in New York City.

Rockport Publishers, Inc.

33 Commercial St.
Glouchester, MA 01930
(978) 282-9590
Publishes many types of design books but specializes
in showcase books that feature outstanding work in a
particular area of graphic design, such as business
cards, shopping bags or direct-mail design.

ST Publications

407 Gilbert Ave.
Cincinnati, OH 45202
(800) 925-1110, (513) 421-2050
Fax: (513) 421-5144

Specializes in books on environmental graphics, sign-
age, display and screen printing. Offerings include
the AIGA's book on symbol signs for the Department
of Transportation and a camera-ready portfolio of DOT
symbols.

Watson-Guptill

13154 Broadway
New York, NY 10036
(212) 764-7300
(800) 278-8477 (for catalog and orders)
Offers a wide variety of instructional books for graphic
designers.

Freebies

Sources for

Free Products,

Services and Information

Computer Fonts

Many foundries are marketing their own typeface designs over the Web and are luring designers to their Web sites by offering free fonts. The foundries listed below offer free, downloadable fonts. You can get more information on each of these companies by checking their listings in chapter four.

Casa de Toad Fonts

www.cdtoad.com/fonts.html
Offers four gutsy display typefaces, free for the taking. TrueType fonts are available for PCs only.

The Chank Co.

www.chank.com
The Chank Company offers fonts designed by Chank Diesel, the alter ego of Minneapolis designer Charles Spencer Anderson. Chank offers a free font every week from his collection of over fifty display fonts.

Fontek/Esselte

www.letraset.com
A division of ITC, Fontek offers free fonts that can be downloaded from the Esselte Web site. A different font is offered every month.

ONGdesign

www.ongdesign.com
Designer, illustrator and font designer Jeff Ong offers his Web site visitors free downloadable fonts of four of his original type designs that have appeared in various on-line venues, including America Online. Fonts are Type 1 Mac- and PC-compatible.

Phil's Fonts, Inc.

www.philsfonts.com
This foundry evolved out of one of the best-known photo-lettering companies in the industry and offers over twenty thousand typefaces. From its Web site, Phil's offers a free downloadable font that changes every month. Mac- and PC-compatible fonts are available in Type 1 and TrueType formats.

Quadrat Communications

www.interlog.com/~quadrat
Offers free Ratsample font from Web site. Font is Mac and PC compatible.

QualiType Software

www.qualitype.com
Offers a free PC-compatible font of the month from its Web site.

The Scriptorium
www.ragnarokpress.com/scriptorium
Offers three text faces and several display faces specifically for use in Web site design. Fonts are available in Mac and PC versions.

Surface Type
www.surface-type.com
Foundry offers thirteen fonts. Half are sold through Attention Earthling Type (see page 54); the other half are available as shareware. Fonts are both Mac- and PC-compatible.

The Type Quarry
www.3ip.com/type.html
Foundry offers twenty-five typefaces based on antique text and handwriting samples as well as contemporary and novelty looks. Those who complete an on-line survey receive a free font. Mac- and PC-compatible fonts are available in Type 1 and TrueType formats.

Free Imagery

These Web sites offer professional-quality images suitable for on-screen use in Web sites, animations and other multimedia applications.

Digital Stock Corp.
www.digitalstock.com
Offers five images from its extensive stock collection. Images change every month.

PhotoSpin
www.photospin.com
Offers five images from its Web site. Images change every month.

Seattle Support Group
www.ssgrp.com
Visitors to the site who complete a questionnaire can download two free images from this agency's royalty-free collection.

Imaging Software and Plug-ins

These Web sites offer free software and accessories that help users enhance, edit and manage image files.

Abex Services, Ltd.
http://members.aol.com/abex01
Offers Windows plug-ins for MetaCreations software, including free Nozzles, Brushes and so on for Painter, and Filter Factory plug-ins for Photoshop and Painter.

A Guide to Terms and Conditions for Downloadable Software
You'll find many Web sites offering "free" goods. But are they really free? Here's how to sort out limited usage situations from bona fide free stuff.

If the product offered is called demoware, *its usefulness is dated. Supposedly free programs called demoware will usually allow the users to operate the programs but prevent finalizing anything by inhibiting the abiliity to print or save.*

If the product is labeled shareware, *it can be used for a trial period, usually thirty days. After the trial period, users must register the product or remove it from their computers.*

If it's called freeware, *the product may truly be used free of charge.*

After downloading a program, check out the Read Me document that's often included. This will specify the terms of usage and payment information, if any compensation is involved.

Apple ColorSync
www.colorsync.apple.com
Site offers a Photoshop plug-in that lets users import and export ColorSync calibrated TIFF files from within Photoshop.

Extensis
www.extensis.com
Offers the following freeware from its Web site:
PhotoBevel (Mac, PC)—Photoshop plug-in lets users create inner and outer bevels on images or text.
Photo Navigator (Mac)—Plug-in creates a small floating palette within Photoshop that contains a thumbnail for the on-screen image.

PhotoGIF
www.boxtopsoft.com/PhotoGIF/
Browsers can download free Photoshop plug-ins by filling out an on-line questionnaire.

Pixar
www.pixar.com
Offers the following shareware from its Web site:
AC3D (UNIX)—Three-dimensional modeling package can be used with RenderMan and other animation packages to create instances of, rather than copies of, objects.
BMRT (UNIX) (Blue Moon Rendering Tools)—Package contains tools to help users create .rib files for RenderMan.
Leo 3D—Modeling system lets users render scenes with RenderMan and BMRT.

Font and Page Layout Utilities

These sites offer programs, plug-ins or links with other sites providing shareware and freeware.

Extensis

www.extensis.com
Extensis QX-Drag & Drop (Mac)—Creates an automatic picture box in QuarkXPress by letting users drag pictures into Quark documents from the Macintosh Finder.

Pyrus NA, Ltd.

www.pyrus.com
Web site includes a font locator, bookstore and links with font and font utility companies. Many of these links are to providers of PC-compatible shareware.

QualiType Software

www.qualitype.com
Web site offers free demos of the company's Windows-compatible font utility programs.

On-Line Utilities

BBedit Lite (Mac)

ftp: Sumex-Aim.Stanford.EDU
PopularWeb editor is a lightweight version of BBedit Pro.

Dartmouth College Fetch (Mac)

ftp: Sumex-Aim.Stanford.EDU
or
ftp://ftp.dartmouth.edu/pub/software/mac/
Fetch_3.0.3.hqx
A light version of this FTP client can be downloaded from this site.

Globalscape CuteFTP (PC)

www.globalscape.net/Cuteftp
A shareware version of this FTP client can be downloaded from this site.

Ipswitch WS_FTP Pro (PC)

www.ipswitch.com
This Internet file mover can be downloaded for free if it's limited to private use.

Scanning Calculator (Mac, PC)

www.hsdesign.com
On-line guru Michael Sullivan posts a special calculator on this site that helps users choose the optimal setting for their scanners.

This StuffIt Expander (Mac, PC)

www.aladdinsys.com/consumer/expander2.html
Decompression utility makes large files smaller.

ViruSafe Web (Mac, PC)

www.eliashim.com
Scans files for viruses during downloading.

Browsing Software

These programs will allow you to view images and animated sequences as well as hear audio with no problems. Access these sites for the latest versions of essential browsing software for Macs and PCs.

Adobe Acrobat Reader

www.adobe.com/prodindex/acrobat/readstep.html
Program helps convert printed materials posted on the Web to readable on-line text.

Alexa

www.alexa.com
An intuitive way to browse the Web. Program tells you about where you are and suggests where to go next.

Beatnik

www.headspace.com
Interactive music player lets Netscape Navigator users listen to music on the Web.

Cosmo Virtual Reality

http://cosmosoftware.com
Universal player for VRML content.

Macromedia Shockwave

www.macromedia.com/shockwave
Allows users to see animated special effects.

Plugsy

www.digigami.com/plugsy
Sorts out plug-in conflicts under Netscape Navigator.

QuickTime

quicktime.apple.com
Allows users to view QuickTime movies and panable 360° images unique to the program.

RealPlayer

www.real.com/products/player
Play back live audio and video over the Web with this program.

Magazine Web Sites Offering Shareware and Demoware

Advertisers have found that offering demos of their products has been an effective way of obtaining prospective customers. That's why these magazine Web sites offer a wealth of opportunity to Web browsing designers.

Publish

www.publish.com
Publish magazine's Web site offers plenty of information and directories. Site also includes a Software Closet that lets both Mac and PC users download lots of shareware and demoware after they've registered.

Macdownload.com

www5.zdnet.com/mac/download.html
www.macdownload.com
This joint site, sponsored by *Macworld* and *Mac-WEEK*, offers a variety of Mac-oriented downloads, including Internet utilities, games and screen savers.

Organizations Offering Access to Freeware and Demoware

Berkeley Mac Users Group (BMUG)

www.bmug.org
One of the largest consumer advocacy Mac user groups in the world, BMUG offers information and advice to users and developers who work on Macs. Membership benefits include newsletters with CD-ROMs full of demoware, shareware and freeware as well as Mac system updates.

Design Tools Monthly

(303) 543-8400
Fax: (303) 543-8300
E-mail: DTMonthly@aol.com
Subscriber service offers users a monthly updater disk that contains free updates and bug fixers for programs many designers use. Subscription price is $99 for one year.

Competitions

These design competitions don't require an entry fee.

Beckett Honors

Beckett Paper Co.
2 Gateway Blvd.
East Granby, CT 06026
(800) 423-2259, (814) 870-9657
This biennial competition recognizes outstanding design and printing on Beckett papers. Winners are awarded in two categories: business communications and general. Deadlines: June, December.

Crown Vantage Award of Excellence

Crown Vantage
145 James Way
Southampton, PA 18966
(800) 441-9292, ext. 384; (215) 364-3900
Honors excellence in design and printing on Crown Vantage papers. Awards are given in the following categories: general collateral, collateral produced on a limited budget, and letterhead. Deadline: ongoing.

The Donside Graphic Design and Print Awards

Donside North America
Sue Middleton
1600 Johnson Way
New Castle, DE 19720
(800) 220-8577, ext. 311; (302) 326-1262
Fax: (302) 326-1277
Recognizes excellence in design and printing on Consort Royal and Gleneagle papers. Separate awards are given in design and print categories as well as an award for corporate communications. Winners are displayed in a touring exhibition. Top winners are guests at an awards dinner in London. Deadline: September.

French Paper Excellence Award

French Paper Co.
100 French St.
Niles, MI 49120
(616) 683-1100

Ongoing competition honors excellence in design and printing on French papers. Each piece submitted is judged on its own merit. Six copies of each piece are needed to distribute to six designers who judge the competition. Deadline: ongoing.

Gilbert Graphic Greatness Awards (G3)

Gilbert Paper Co.
430 Ahnaip St.
Menasha, WI 54952
(800) 445-7329, (920) 729-7630
Recognizes outstanding design and printing on Gilbert papers in the following categories: letterhead, annual reports, brochures/catalogs, folder/cover-only application and miscellaneous. Combinations of Gilbert papers and coated stocks qualify. Award winners receive plaques. Deadline: December 31.

Hammermill Creative Inking

Hammermill Paper
2064 W. 16th St.
Erie, PA 16505
(901) 763-7831
This semiannual competition recognizes quality design and printing on Hammermill papers. Awards are given in print excellence and design excellence. Entries must be printed in whole or in part on Hammermill papers. Deadlines: June, December.

Mead Annual Report Student Competition

Mead World Headquarters
Courthouse Plaza NW
Dayton, OH 45463
(800) 345-6323, ext. 53586; (937) 495-4185
Fax: (937) 495-4185
www.meadpaper.com
Judged on the same criteria and by the same judges as the Mead Annual Report Show, this competition solicits entries from students only. Deadline: May.

Mead 60

(see contact information above)
Awards sixty certificates of honor to sixty winners annually in all categories of print design. One of the sixty winners receives the Mead 60 medal of excellence. Deadline: December.

Mohawk Award of Excellence

Mohawk Paper Mills, Inc.
465 Saratoga St.
P.O. Box 497
Cohoes, NY 12047
(800) THE-MILL, (518) 237-1740
Recognizes outstanding design and printing on Mohawk papers. Deadline: ongoing.

Monadnock Paper Mills' Graphic Arts Awards Program

Monadnock Paper Mills
117 Antrim Rd.
Bennington, NH 03442
(603) 588-3311
Honors superior creativity and craftsmanship for work printed on Monadnock papers. Awards are given on a quarterly basis in each of four categories: annual reports, booklets and catalogs; books; prints and posters; stationery, announcements and brochures. Quarterly winners are entered in a year-end competition. Deadline: ongoing.

Neenah Paperworks Contest

Neenah Paper
1400 Holcomb Bridge Rd.
Roswell, GA 30076-2199
(800) 241-3405, (770) 587-8730
Holds two competitions honoring design excellence: a monthly letterhead competition and a quarterly competition devoted to pieces printed on text and cover stock. Also holds a year-end competition. Deadline: ongoing.

Presidential Design Award

Tom Grooms
General Services Administration
1800 F St. NW
Washington, DC 20405
(202) 501-4941
Fax: (202) 501-3393
Honors excellence in graphic design. Open to all types of projects, but work must be funded, sponsored or commissioned by the federal government. Deadline: April.

Strathmore Graphics Gallery

Strathmore Paper Co.
P.O. Box 1430
Avon, CT 06001
(800) 628-8816, (860) 844-2400
Quarterly competition recognizes excellence in printing and design on Strathmore papers. Entries need to be produced in whole or in part on any Strathmore paper. Open to all areas of graphic design. Deadlines: March, June, September, December.

Free Publications

These magazines, newsletters and other resources are available at no charge, although limitations may apply in some cases.

Andover Printing

837 Industry Dr., #21
Seattle, WA 98188
(206) 575-4727
Fax: (206) 575-4502

Offers *Harvey's Cat*, a brochure that explains folds and binding techniques and what designers should know about printing pieces with multiple folds. Contact Andover Press, (206) 575-4727.

AV Video/Multimedia Producer

701 Westchester Ave.
White Plains, NY 10604
(914) 328-9157
Fax: (914) 328-9093
www.kipinet.com
This monthly features multimedia, video, audio and computer graphics information. The magazine has a controlled circulation and is only available to qualified video, multimedia, film and television professionals in the United States and Canada. Web site has on-line subscription application.

The Godfrey Group, Inc.

201 Kitty Hawk Dr., Ste. 100
Morrisville, NC 27560
(919) 544-6504
Fax: (919) 544-6729
Offers *Sales Promotion Tool Book*, a brochure that gives advice on how to market effectively with tabletop and trade show exhibits.

Monadnock Paper Mills, Inc.

117 Antrim Rd.
Bennington, NH 03442
(603) 588-3311

Offers *Offset Lithography: Issues for Printing on Uncoated Papers*. Publication informs designers of production techniques and design considerations that will help make the most out of using uncoated stocks.

Picture Agency Council of America (PACA)

P.O. Box 308
Northfield, MN 55057-0308
(800) 457-PACA
Fax: (507) 645-7066
www.pacaoffice.org
Organization publishes a directory of its members, about eighty photo stock agencies. Available free of charge to image users if request is mailed or faxed on company letterhead.

S.D. Warren Co.

225 Franklin St.
Boston, MA 02110
(800) 882-4332, (617) 423-7300
Fax: (800) SDW-1770, (617) 423-5491
http://warren-idea-exchange.com
Offers the *Warren Standard*, a monthly publication offering production, communication and design tips.

New Media

Services, Equipment and Educational

Resources for Designers of

Interactive Kiosks, CD-ROMs and

Multimedia Presentations

Stock Clips

These companies offer copyright-free video and still images and audio for multimedia productions.

Film and Video Footage

Action Sports Adventure

1926 Broadway, 5th Fl.
New York, NY 10023
(212) 721-2800
Fax: (212) 721-0191
Collection includes more than twelve thousand hours of 16mm and 35mm material, including Olympic and historic sports footage from the 1950s to present. Available on film and video.

Aerial Focus

8 Camino Verde
Santa Barbara, CA 93103
(805) 962-9911
Fax: (805) 962-9536
www.aerialfocus.com
Subject matter focuses on adventure sports, such as skydiving and hang gliding. Also offers aerial footage of Earth. Available on film and video.

BeachWare

9419 Mt. Israel Rd.
Escondido, CA 92029
(760) 735-8945
www.beachware.com
Offers Web Ware, a collection of Shockwave movies, animated GIFs, buttons, other graphic elements and sample HTML pages.

Digital Brewery

715 W. Elsworth, Ste. D
Ann Arbor, MI 48108
(800) 572-0098, (734) 327-9929
Fax: (734) 327-0425
Offers 3-D animation packages designed for video broadcast producers. Also offers copyright-free still images. Available on video and QuickTime.

Fabulous Footage

Locations in Boston, Los Angeles, Toronto and Vancouver.
East Coast: (800) 361-3456, Fax: (416) 591-1666
West Coast: (800) 665-5368, Fax: (818) 508-1293
www.digital-energy.com
Subjects include international, business, sports, wildlife and archival clips. Also carries slapstick comedy and sports bloopers. Available on film, video and CD-ROM.

Hardy Jones Productions

1252 B St.
Petaluma, CA 94952
(707) 769-0708
Fax: (707) 769-0708
Specializes in ocean-related footage, such as fish, sea-birds and marine mammals. Available on film, video and QuickTime.

Historic Films

3 Goodfriend Dr.
East Hampton, NY 11937
(800) 249-1940, (516) 329-9200
Fax: (516) 329-9260
www.historicfilms.com
Historical and musical-performance library consists of fifteen thousand hours of footage from 1896 to 1980. Available on film.

International Historic Films

3533 S. Archer Ave.
Chicago, IL 60609
(773) 927-2900
Fax: (773) 927-9211
www.IHFfilm.com
Offers military and political subject matter dating back to the turn of the century. Collection includes rare newsreels and propaganda films from Germany and the Soviet Union. Available on video. Also offers photographic stills and audio clips of historic speeches and military music.

Miramar Productions

200 2nd Ave. W.
Seattle, WA 98119
(800) 245-6472, (206) 284-4700
Fax: (206) 286-8043
www.miramarupx.com
Specializes in nature imagery and sound effects. Collection includes time-lapse and aerial-view clips. Available on film laser disc and video.

National Geographic Film Library

Washington, DC: (202) 857-7659,
Fax: (202) 429-5755
Los Angeles: (818) 506-8300, Fax: (818) 506-8200
Extensive library contains close to ten million feet of film on nature, adventure and wildlife. Available in many kinds of video formats.

Multimedia Clip Art

Multimedia images do not require the high resolution (300 dpi or more) necessary for print applications. Because standard screen resolution of 72 dpi is all that's necessary, many of the low-resolution images offered in the clip files listed in the illustration and photography chapters of this book can be used in multimedia applications as still images.

The clip libraries listed here were developed with the special needs of multimedia in mind. Some collections can be animated or incorporated into user interface designs.

Artbeats Software, Inc.

P.O. Box 709
Myrtle Creek, OR 97497
(800) 444-9392, (541) 863-4429
www.artbeatswebtools.com
Specializes in textures and backgrounds. Offers two volumes of Marble and Granite, and one each of Wood and Paper, Leather and Fabric, and Marbled Paper Textures. Offers high, medium and low resolutions for use in 3-D rendering, multimedia and print. Formats offered include BMP, PICT and TIFF. Also offers a $99.95 sampler disc.

BeachWare

9419 Mt. Israel Rd.
Escondido, CA 92029
(760) 735-8945
www.beachware.com
Offers two collections of background textures plus a Digital Swimsuit Portfolio, over one hundred photos of models in swimwear shot in tropical settings.

Digital Brewery

715 W. Elsworth, Ste. D
Ann Arbor, MI 48108
(800) 572-0098, (734) 327-9929
Fax: (734) 327-0425
Offers collections of backgrounds; globes, maps and flags; holidays; advertising; broadcast and corporate-related images. Also offers 3-D animation packages designed for video broadcast producers.

Imagetects

7200 Bollinger Rd., Ste. 2
San Jose, CA 95129
(408) 252-5487
Fax: (408) 252-7409
www.imagecels.com

A good place to locate multimedia talent is New Media Showcase. This directory is devoted exclusively to multimedia and animation freelancers and contains over three hundred images representing these artists. Contact New Media at 915 Broadway, 14th Fl., New York, NY 10010, (800) 894-7469, (212) 673-6600, Fax: (212) 673-9795, www.showcase.com

Collection includes 1,150 photo-realist textures, backgrounds and objects. Mac-, PC-, Amiga- and UNIX-compatible images available on CD-ROM.

IMSI
1895 Francisco Blvd. E.
San Rafael, CA 94901-5506
(800) 833-4674, (415) 257-3000
Fax: (415) 257-3565
www.imsisoft.com
Offers more than fifty thousand JPEG images for Mac and PC. Sold as two collections for $50 or $70.

Pixar Animation Studio
1001 W. Cutting Blvd.
Point Richmond, CA 94804
(800) 888-9856, (510) 236-4000
www.pixar.com
Offers a library of photographic textures such as fur, water and marble on CD-ROM. Can be used with any application that reads PICT or TIFF files on Mac, PC and UNIX computers. Collections start at $99 per disc.

Studio Productions
18000 E. 400 S.
Elizabethtown, IN 47232
(800) 359-2964, (513) 251-7014
Fax: (513) 861-2932
Collection on CD-ROM consists of templates for multimedia interface design. Includes floating panels, 3-D buttons, title pages and background effects.

Clip Audio

These companies offer royalty-free music and sound effects that can be used in multimedia presentations.

BeachWare
9419 Mt. Israel Rd.
Escondido, CA 92029
(760) 735-8945
www.beachware.com
Audio library includes a collection of one hundred contemporary keyboard songs as well as a collection of five thousand sound effects plus music. Also offers still images and video clips.

Creative Support Services
1948 Riverside Dr.
Los Angeles, CA 90039
(800) HOT-MUSIC, (213) 666-7968
www.cssmusic.com
Currently offers seventeen music and sound effects libraries. Web site offers sound samplings via RealAudio and Shockwave.

Historic Films
3 Goodfriend Dr.
East Hampton, NY 11937
(800) 249-1940, (516) 329-9200
Fax: (516) 329-9260
www.historicfilms.com
Offers a collection of military music and audio clips of historic speeches. Also offers video clips from vintage newsreels and propaganda films.

Miramar Productions
200 2nd Ave. W.
Seattle, WA 98119
(800) 245-6472, (206) 284-4700
Fax: (206) 286-8043
www.miramarupx.com
Specializes in nature soundtracks, including waves, calls of whales and other sounds found in natural settings. Also offers pop, rock and jazz instrumentals, many available in DVD format. Soundtracks are available on CD and cassette.

The Music Bakery
7522 Campbell Rd.
Dallas, TX 75248
(800) 229-0313, (615) 790-9897
www.musicbakery.com
Offers a broad range of royalty-free music performed by professional musicians. Available on CD-ROM.

Services and Equipment

Catalogic
935 Sienna Vista Ave.
Mountain View, CA 94043
(650) 961-4649
Fax: (650) 964-2027
www.catalogic.com
Manufacturer of CD-ROM discs. Can create masters and duplications. Also handles insert printing and packaging.

Map Quest Publishing Group
1730 Blake St., Ste. 310
Denver, CO 80202
(303) 312-0200
Fax: (303) 312-0201
www.mapquest.com
Manufactures interactive maps that lets users find their way to specific locations.

Pixel Touch

1957 Cedar St.
Ontario, CA 91761
(909) 923-6124
Fax: (909) 923-6126
www.pixeltouch.com
Manufactures touch-screen monitors for Macs and PCs, televisions and touch pads.

Reflex International

6624 Jimmy Carter Blvd.
Norcross, GA 30071
(770) 729-8909
Fax: (770) 729-8805
www.reflexintl.com
Manufactures touch-screen monitors for interactive kiosks used for point of purchase, public information systems and interactive training.

Industry Organizations and Trade Shows

ACM/SIGGRAPH

401 N. Michigan Ave.
Chicago, IL 60616
(312) 644-6610
www.siggraph.org
First formed in 1973 as the Association for Computing Machinery, this international organization now boasts close to 100,000 members. The group offers a variety of publications, local chapter workshops and an annual conference and exhibition, SIGGRAPH. SIGGRAPH is one of the United State's largest computer-oriented trade shows, offering the latest in computer graphics and interactive techniques as well as newest developments in cyberspace, entertainment media, interactive digital techniques and more. Usually held in later summer, location changes every year.

E3: Electronic Entertainment Expo

1400 Providence Hwy.
Norwood, MA 02062
(800) 315-1133
Fax: (781) 440-0357
www.e3expo.com
Annual conference holds sessions and workshops that focus on entertainment and on-line game development plus trends and business issues of interest to new media developers.

ICIA (International Communications Industries Association)

3150 Spring St.
Fairfax, VA 22031
(703) 273-7200
Fax: (703) 278-8082
www.icia.org
The International Communications Industries Association caters to the audiovisual and presentation industries. In addition to offering educational programs, the organization sponsors INFOCOMM, an annual conference and trade show that focuses on the latest developments in video and multimedia technology. The ICIA also publishes a monthly tabloid and membership directory.

Macworld

1440 Providence Hwy.
P.O. Box 9127
Norwood, MA 02062-9127
(800) 645-EXPO
Fax: (617) 440-0357
www.mha.com/macworldexpo
Sponsors Macworld Expo, an exhibition that features the wares from major Macintosh software and hardware manufacturers. Includes print as well as multimedia technology. Two shows held annually: one in New York and one in San Francisco.

Multimedia Exposition and Forum

7-70 Villarboit Crescent
Concord, Ontario L4K 4C7
Canada
(905) 660-2491
Fax: (905) 660-2492
www.newmedia.ca
Canadian conference and trade show focuses on digital imagery, virtual reality, presentation technology, multimedia and Internet communications. Features over sixty-five seminars and workshops by industry experts.

Seybold/ZD Comdex & Forums

303 Vintage Park Dr.
Foster City, CA 94404
(800) 433-5200, (650) 578-6900
Fax: (650) 525-0194
www.zdcf.com
Seybold, held twice a year in Boston and San Francisco, is one of several conferences sponsored by ZD Comdex & Forums. Seybold features computer graphics and the latest developments in interactive multimedia. Other conferences ZD Comdex & Forums sponsors include Comdex, a conference on Internet marketing and networking solutions.

Video Expo
℅ Knowledge Industry Publications
701 Westchester Ave.
White Plains, NY 10604
(800) 800-5474, (914) 328-9156
www.kipinet.com
Annual trade show and exhibition at the Jacob K. Javits Convention Center in New York City features seminars, workshops and over two hundred exhibits of video, multimedia, graphics and animation hardware and software.

Web Sites That Help Web Site Builders

The Compendium of HTML Elements
www.htmlcompendium.org
A reference source for all HTML tags in use.

Dev.X: The Development Exchange
www.java-zone.com
Web site offers books and technical articles from industry magazines, demoware, product reviews and conference listings.

Dynamic HTML Zone
www.dhtmlzone.com
Offers articles, tutorials, on-line discussion groups and other resources.

High Five
www.highfive.com
Founded by David Siegel, author of *Creating Killer Web Sites: The Art of Third-Generation Site Design*, this on-line magazine is devoted to fine design on the Web. Site includes interviews, articles and reviews of the best sites on the Web.

Inquiry.com
www.inquiry.com
In addition to publications, listings of products and services and a calendar of training events, this site offers an Ask the Pro section that helps on-line developers solve problems.

Network Solutions, Inc.
InterNIC Registration Services
www.internic.net
Registers domain names and maintains a database of existing names.

Software

These are some of the best-known programs and utilities available for interactive multimedia and Web site design and maintenance.

Adobe Systems, Inc.
345 Park Ave.
San Jose, CA 95110
(800) 445-8787, (888) 502-8393, (408) 536-6000
Fax: (800) 814-7783, (408) 536-6799
www.adobe.com
Manufactures:
 Acrobat (Mac, PC)—Provides on-line access to paper-based information.
 After Effects (Mac, PC)—Lets users create 2-D animation and special effects for film, video, multimedia applications and the Web.
 PageMill (Mac, PC)—Lets users create and manage Web sites.
 Premiere (Mac, PC)—Video-editing software combines video, animation, still images and graphics for Web sites or video production.

Advanced Media
695 Town Center Dr., Ste. 250
Costa Mesa, CA 92626
(800) 292-4264, (714) 965-7122
www.advancedmedia.com
Media Master (PC)—Edits and creates audio, images and video. Creates transitions but not pulldown menus. Programming language interfaces to others. Imports AVI and MPEG videos.

AI Internet Solutions
P.O. Box 1094
Hurst, TX 76053
(800) 242-4775
Fax: (817) 314-3014
Manufactures:
 HTML Validator (PC)—Syntax checker for Web site management.

Allaire Corp.
1 Alewife Center
Cambridge, MA 02140
(888) 939-2545, (617) 761-2100
www.allaire.com
Manufactures:
 Cold Fusion (PC)—Web development system includes a Web application server as well as visual tools.
 HomeSite (PC)—HTML editor lets users create Web pages.

Apple Computer
1 Infinity Loop
Cupertino, CA 95014
(800) 776-2333, (408) 996-1010
Fax: (408) 996-0275
www.apple.com
Manufactures:
 HyperCard (Mac, PC)—Organizes information into interactive stacks.

Quick Draw (Mac, PC)—Cross-platform application interface lets users model 3-D objects for animations.

QuickTime (Mac, PC)—Program lets users integrate video, sound and 3-D objects into multimedia presentations.

QuickTime VR (Mac, PC)—Lets users animate objects in virtual space.

Web Objects (Mac, PC)—Web developer tool lets users create Web applications.

ATI
12638 Beatrice St.
Los Angeles, CA 90066
(800) 955-5284, (310) 823-1129
www.atitraining.com
TourGuide (Windows)—Edits and creates audio, animation, images text and video. Makes pulldown menus and transitions. Offers proprietary programming language. Can import AVI and DVI videos.

Big Picture Multimedia Corp.
610 8th Ave. SW, Ste. 601
Alberta Calgary T2P 1G5
Canada
(888) 424-4742, (403) 265-8018
www.bigpic.com
Manufactures:
Mortar (PC)—Web design program lets user build, manage and maintain Web sites with HTML, CSS, JavaScript and other Web-coding specifications.

Boutell.Com, Inc.
P.O. Box 20837
Seattle, WA 98102
(206) 325-3009
Fax: (206) 324-3009
Manufactures:
Mapedit (Mac, PC)—Graphical editor for World Wide Web images (clickable imagemaps).

BoxTop Software
101 N. Lesayette
Strarkville, MS 39759
(800) 257-6954, (601) 324-1800
www.boxtopsoft.com
Manufactures:
GIFmation (Mac, PC)—Lets users animate GIF images for Web design.

Design Intelligence
1111 3rd Ave., Ste. 1500
Seattle, WA 98101
(888) 278-2547
Fax: (408) 926-9172
www.designintelligence.com

Manufactures:
Instant Coffee (PC)—Program is a WYSIWYG Java applet creator that lets users create animation, sound and interactivity without HTML coding.

Emblaze/GeoPublishing
2110 Oxnard St.
Woodland Hills, CA 91367
(800) 576-7751
Fax: (818) 703-8654
www.emblaze.com
Manufactures:
WebCharger—Designed specifically for compressing images for Web applications.

Equilibrium
3 Harbor Dr., Ste. 111
Sausalito, CA 94965
(800) 524-8651, (415) 332-4343
Fax: (415) 332-4433
www.equilibrium.com
Manufactures:
DeBabelizer (Mac, PC)—Graphics processor for Web, multimedia, digital video and print production.

Extensis
1800 SW 1st Ave., Ste. 500
Portland, OR 97201
(800) 796-9798, (503) 274-2020
Fax: (503) 274-0530
www.extensis.com
Manufactures:
BeyondPress (Mac)—QuarkXTensions helps convert QuarkXPress files to HTML.
PhotoAnimator (Mac, PC)—Program creates frames from an existing frame and animates them.

File Maker
5201 Patrick Henry Dr.
Santa Clara, CA 95054
(408) 987-7000
Fax: (408) 987-7447
www.claris.com
Manufactures:
Home Page (Mac, PC)—Budget-priced program lets users create Web pages quickly.

GoLive Systems
525 Middlefield Rd., Ste. 200
Menlo Park, CA 94025
(800) 554-6638, (415) 463-1580
www.golive.com
Manufactures:
GoLive CyberStudio (Mac)—Provides WYSIWYG way to create Web sites that require HTML coding.

Hutchinson Avenue Software

1435 Bleary, Ste. 700
Montreal, Quebec H3A 2H7
Canada
(514) 499-2067
Fax: (514) 499-3666
http://bgr.hasc.com
Manufactures:

Tree Druid (PC)—Ray Dream Designer and Light-Wave 3D plug-in lets users easily animate trees.

Thor (PC)—Plug-in for Ray Dream Designer and LightWave 3D lets users create drag and drop lightning bolt throwing.

Ipswitch, Inc.

81 Hartwell Ave.
Lexington, MA 02173
(781) 676-5700
Fax: (781) 676-5710
www.ipswitch.com
Manufactures:

WS_FTP Pro (PC)—FTP client lets users move a file from one Net location to another.

Macromedia

600 Townsend, Ste. 310W
San Francisco, CA 94103
(800) 457-1774, (415) 252-2000
www.macromedia.com
Manufactures:

Authorware Professional (Mac, PC)—Similar features to Director but more sophisticated. Offers built-in training and testing features.

Director (Mac, PC)—Enables editing and creation of animation, images and text, pulldown menus and transitions. Can import AVI and QuickTime videos.

Dreamweaver (Mac, PC)—Web-design tool blends text editor with image features. Freeware can be downloaded from Web site.

Fireworks (Mac, PC)—Web design program includes a suite of text, design, illustration, image-editing, URL, JavaScript and animation tools.

Flash (Mac, PC)—Lets Web site designers animate vector drawings created in Illustrator, CorelDRAW, Deneba Canvas or FreeHand.

Flash Generator (Mac, PC)—For automated, server-based creation of Flash and GIF Web graphics. Freeware can be downloaded from Web site.

Smart Shockwave (Mac, PC)—Automates the selection, download and installation of Shockwave players.

MBed Software

185 Berry St., #3887
San Francisco, CA 04107
(888) 778-6233, (415) 778-0930
Fax: (415) 778-0933
www.mbed.com

Manufactures:

Interactor (Mac, PC)—Web design program makes process easy by including a tutorial even beginners can follow. Comes in Lite, Standard and Professional editions.

MetaCreations Corp.

P.O. Box 724
Pleasant Grove, UT 84062-9914
(800) 846-0111, (800) 472-9025, (805) 566-6200
Fax: (888) 501-6382
www.metacreations.com
Manufactures:

Final Effects AP (Mac, PC)—Creates special visual effects, such as those seen on MTV.

Final Effects Complete (Mac, PC)—Set of sixty motion graphics effects plug-ins for After Effects.

Micrografx

13003 E. Arapaho Rd.
Richardson, TX 75081
(800) 671-0144, (972) 234-1769
www.micrografx.com
Manufactures:

Webtricity (PC)—Vector-based drawing program and image editor comes with on-line utilities and Web-oriented clip art, including animated GIF files and 3-D VRML objects.

Microsoft Corp.

1 Microsoft Way
Redmond, WA 98052
(800) 426-9400, (206) 882-8080
www.microsoft.com
Manufactures:

FrontPage (PC)—Affordable Web design program includes Web graphics, prepared scripts and other features that make Web design easy for Windows users.

PaceWorks

1261 E. Hillsdale Blvd., Ste. 6
Foster City, CA 94474
(650) 578-6765
www.paceworks.com
Manufactures:

Dance Packs (Mac)—Set of royalty-free library elements, such as animation paths, graphics and sounds, that can be used with ObjectDancer.

ObjectDancer (Mac)—Web program lets Web page designers animate text and vector drawings.

Pixar Animation Studio

1001 W. Cutting Blvd.
Point Richmond, CA 94804
(800) 888-9856, (510) 236-4000
www.pixar.com

Manufactures:

Alfred (UNIX)—Task-processing system that manages network-distributed rendering. Helps to manage a long or complex sequence of dependent events.

ATOR (UNIX)—Moves Alias model and scene data into the RenderMan environment. Users can apply RenderMan appearances and lights.

Combiner (UNIX)—Script-based compositing application that allows users to specify any number of Still Frame, Image Sequence, Display Serve and Alias Wirefile input elements.

RenderMan (UNIX)—Rendering software that enables realistic visual effects. Tool of choice for Hollywood studios in their creation of the special effects seen in movies such as *Men in Black*.

PowerProduction Software

432 Los Gatos Blvd.
Los Gatos, CA 95032
(800) 457-0383, (408) 358-2358
www.powerproduction.com
Manufactures:

StoryBoard Artist (Mac, PC)—Lets users create storyboards for scene-by-scene previsualization of animated and video sequences.

WebBurst (Mac, PC)—Program is a WYSIWYG Java applet creator that lets users create animation, sound and interactivity without HTML coding.

Rhino Software, Inc.

P.O. Box 53
Helenville, WI 53137
(414) 593-2751
Fax: (414) 593-2753
Manufactures:

FTP Voyager (PC)—Utility lets users move files from one place to another on the Internet.

NetProbe (PC)—Site maintenance utility checks FTP and Web sites to see if they are alive or have been changed.

Rogue Wave Software

5500 Flatiron Pkwy.
Boulder, CO 80301
(800) 487-3217, (303) 473-9118
Fax: (303) 447-2568
www.roguewave.com
Manufactures:

Studio J—Suite of Java tools lets users create interactive charts and spreadsheet layouts for Web sites.

SoftPress

3020 Bridgeway, #310
Sausalito, CA 94965
(800) 853-6454, (415) 331-4820
Fax: (415) 331-4824
www.softpress.com

Manufactures:

SoftPress Freeway (Mac)—This HTML editor is user-friendly for those accustomed to page layout programs.

SoftQuad

20 Eglington Ave. W., 13th Fl.
Toronto, Ontario M4R 1K8
Canada
(800) 387-2777, (415) 544-9000
www.softquad.com
Manufactures:

Author/Editor (PC)—SGML authoring tool with WYSIWYG display.

HotMetal Pro (PC)—Web authoring program lets users create Web pages.

Panorama CD Web Publisher (PC, UNIX)—Web/CD publishing tool supports audio, graphics, animation and multimedia files.

Panorama Publisher (PC)—Prepares and publishes SGML content for the Web.

Strata

2 W. St. George Blvd., Ste. 2100
St. George, UT 84770
(800) 388-8086, (801) 628-5218
Fax: (801) 628-9756
www.strata3d.com
Manufactures:

Media Paint (Mac, PC)—Special effects and painting program creates lightning, fires and other special effects for video, animation and multimedia.

Video Shop (Mac, PC)—Digital video editor.

Symantec Corp.

10201 Torre Ave.
Cupertino, CA 95014
(800) 441-7234, (888) 438-1797, (541) 334-6054
www.symantec.com
Manufactures:

Visual Café (Mac, PC)—Aids in Java database development.

Visual Page (Mac, PC)—Web design software.

Ulead Systems

970 W. 190th St., Ste. 520
Torrence, CA 90502
(800) 858-5323, (310) 523-9393
www.ulead.com
Manufactures:

GIF Animator (PC)—Lets Windows users animate GIF images for Web site design.

SmartSaver (PC)—Image-optimizing tool lets users reduce the size of graphics files.

Equipment and Supplies

CHAPTER 11

Where to Purchase General

Office, Art and Drafting

and Computer-Related

Supplies and Equipment.

Art and Graphic Arts Supplies and Equipment

Artograph, Inc.
2838 Vicksburg St.
Plymouth, MN 55447
(612) 553-1112
Fax: (612) 553-1262
Manufactures spray booths and opaque projectors.

Badger Air-Brush Co.
9128 W. Belmont Ave.
Franklin Park, IL 60131
(847) 678-3104
Fax: (847) 671-4352
Manufactures airbrushes and related equipment and supplies. Offers free catalog.

Chartpak
1 River Rd.
Leeds, MA 01053
(800) 628-1910, (413) 584-6781
In addition to transfer lettering, company also makes large, self-adhesive letters suitable for display purposes in a variety of colors as well as transfer borders and graphics. Products can be purchased from art supply stores.

Daige
1 Albertson Ave.
Albertson, NY 11507
(800) 645-3323, (516) 621-2100
Fax: (516) 621-1916
Offers tabletop waxers and wax-free adhesive system.

Dick Blick
Rte. 150 E.
P.O. Box 1267
Galesburg, IL 61402-1267
(800) 447-8192, (309) 343-6181
Fax: (800) 621-8293, (309) 343-5785
Offers an extensive line of art and drafting supplies, furniture and books. Also offers screen-printing and sign-making supplies. Ask for free catalog.

Fidelity Graphic Products
5601 International Pkwy.
P.O. Box 155
Minneapolis, MN 55440
(800) 326-7555, (612) 536-6500
Fax: (800) 842-2725
Technical pens, Pantone specifiers, flat files, drawing

tables, punch and bind machines and more. Offers many products below list price. Ask for free catalog.

Graphic Products Corp.

1480 S. Wolf Rd.
Wheeling, IL 60090-6514
(847) 537-9300
Fax: (847) 215-0111
Sells dry transfer lettering, borders and other graphic elements. Also offers line of clip art books. Products are available through art and graphics supply stores.

GTR Industries, Inc.

7905 Silverton Ave., #113
San Diego, CA 92126
(619) 238-0306
Manufactures spray booths and related equipment.

Joe Kubert Art & Graphic Supply

37A Myrtle Ave.
Dover, NJ 07801
(973) 328-3266
Fax: (973) 328-7283
Stocks a variety of papers, boards, markers, adhesives and more. Also carries silkscreen supplies, airbrushing equipment, lamps, vinyl letters and craft supplies such as clay and casting plaster.

Letraset USA

40 Eisenhower Dr.
Paramus, NJ 07653
(800) 526-9073
Fax: (201) 909-2451
www.letraset.com
Manufactures markers, pens and studio organizers; comping and imaging systems; Pantone color papers and films. Also offers software, type, paper, photographic and illustration-specific products, which are described elsewhere in this book. Products are available through art supply stores.

Morse Graphic Arts

1938 Euclid Ave.
Cleveland, OH 44115
(216) 621-4175
Fax: (216) 621-0655
Offers tabletop waxers and related supplies.

Paasche Airbrush Co.

7440 W. Lawrence Ave.
Harwood Heights, IL 60656
(708) 867-9191
Fax: (708) 867-9198
Airbrushes and related supplies and equipment. Offers free catalog.

Dick Blick offers a variety of supplies and equipment for graphic artists. The company also sells screen-printing and sign-making supplies.

Portage Artwaxers

P.O. Box 5500
Akron, OH 44334-0500
(800) 321-2183, (216) 929-4454
Fax: (216) 922-0506
Makes tabletop waxers.

Sax Arts & Crafts

P.O. Box 51710
New Berlin, WI 53151
(800) 323-0388, (414) 784-6880
Fax: (800) 328-4729
Offers paints, brushes, Prismacolor pencils, art papers, canvas and more.

Utrecht Manufacturing Corp.

33 35th St.
Brooklyn, NY 11232
Main Office and Warehouse (800) 223-9132
Berkeley, CA (800) 538-7111
Boston (800) 257-1108
Chicago (800) 352-4638
Detroit (800) 352-6883
New York City (800) 352-9016
Philadelphia (800) 257-1104
San Francisco (800) 961-9612
Washington, DC (800) 257-1102
Stocks artist's supplies such as paints, brushes and canvas. Also offers drawing and drafting tools, knives and airbrush equipment. Supplies can be ordered from warehouse as well as store locations in the cities listed above.

Craft Supplies and Equipment

American Art Clay Co.
4717 W. 16th St.
Indianapolis, IN 46222
(317) 244-6871
Fax: (317) 248-9300
Craft supplies include modeling materials, glitter, fabric dyes and a variety of paints and finishes.

Anything in Stained Glass
1060 Rte. 47 S.
P.O. Box 444
Rio Grande, NJ 08242
(609) 886-0416
Fax: (609) 886-4947
Carries over fourteen types of stained glass and stained glass supplies, including lamp forms and parts, stencils and pattern books.

Berman Leathercraft
25 Melcher St.
Boston, MA 02210
(617) 426-0870
Fax: (617) 357-8564
Offers all kinds of hides, including deerskin, bat leather and elk butt. Also carries leather-carving tools.

Brian's Crafts Unlimited
1421 S. Dixie Frwy.
New Smyrna Beach, FL 32168
(904) 672-2726
Fax: (904) 760-9246
Stocks T-shirts, visors and other garments. Also rhinestones, beads, jewelry findings, dried flowers, wreaths, macramé supplies, feathers and more.

National Artcraft Co.
23456 Mercantile Rd.
Beachwood, OH 44122
(800) 793-0152, (216) 292-4944
Fax: (800) 292-4916
Extensive collection of electrical items, such as lamp parts, kits, chains and prisms. Also stocks clock parts, water globes, kaleidoscope kits, mirrors and jewelry findings.

Office Supplies and Equipment

Bardes Products, Inc.
5245 W. Clinton Ave.
Milwaukee, WI 53223
(800) 959-0402, (414) 354-9000
Fax: (414) 354-1921
Stock and custom vinyl products for protecting and display. Includes slide and transparency holders, job envelopes and more.

Beltsville Plastic Products, Inc.
P.O. Box 98
Laurel, MD 20725
(800) 882-1022, (301) 953-2222
Fax: (301) 953-9462
Clear vinyl envelopes and sleeves for documents, photos and badges. Also makes zippered portfolios. Offers stock and custom designs hot stamped and silkscreened to your specifications.

Blanks/USA
8625 Xylon Ct.
Minneapolis, MN 55445
(612) 391-8001
Fax: (612) 391-8007
Manufactures pre-die-cut, perforated and scored paper products designed specifically for laser printers, ink-jet printers and photocopiers. Paper line includes raffle tickets, business cards, name tags and more.

Bridge Information Systems, Inc.
121 S. Wilke Rd., Ste. 103
Arlington Heights, IL 60005
(800) 323-0497, (708) 394-3450
Fax: (708) 394-3455
Stocks jumbo-sized envelopes, up to 24″×36″.

BrownCor International
770 S. 70th St.
P.O. Box 14770
Milwaukee, WI 53214-0770
(800) 327-2278, (414) 443-9700
Fax: (800) 343-9228
Sells packaging, shipping and warehouse products, such as packing tape, corrugated boxes, mailing envelopes, tubes and bags, cushioning and related supplies.

DFS Business Forms
12 South St.
Townsend, MA 01469
(800) 225-9528
Fax: (800) 876-6337
Business forms—invoices and purchase orders, for example—printable from PC-compatible computers. Forms include carbon and carbonless duplicate copies. Also makes pricing labels, certificates, envelopes, tags, presentation folders and more.

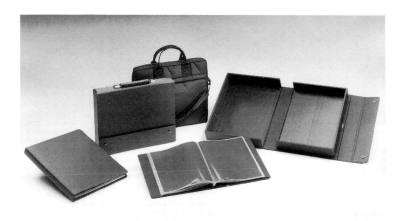

Fidelity Direct
5601 International Pkwy.
P.O. Box 155
Minneapolis, MN 55440-0155
(800) 328-3034
Fax: (800) 842-2725
Shipping boxes, mailing tubes and other mailing supplies, including postal scales.

Packaging Un-Limited, Inc.
1121 W. Kentucky St.
Louisville, KY 40210
(502) 584-4331
Fax: (502) 585-4955
Mailing tubes and mailing supplies, including bubble wrap, foam peanuts and others.

Plastic Manufacturers, Inc.
3510-30 Scotts Ln., Bldg. 31
Philadelphia, PA 19129
(215) 438-1082
Fax: (215) 438-5560
Clear and colored vinyl envelopes, sleeves and more for transparencies, documents, job holders and such. Will customize with printing and embossing, grommets, hangholes, pressure-sensitive backings and so on.

The Tracies Co., Inc.
100 Cabot St.
Holyoke, MA 01240
(800) 441-7141, (413) 533-7141
Fax: (413) 536-0223
Clear vinyl envelopes for a variety of needs, including bank passbooks, shop envelopes and more. Can customize with hot stamping and screen printing.

Visual Horizons
180 Metro Park
Rochester, NY 14623
(800) 424-1011
Fax: (800) 424-5411
www.storesmart.com
Specializes in clear vinyl, adhesive-backed pockets in a variety of sizes. Smaller pockets accommodate business cards and slides. Other sizes available are suited for CD-ROMs, diskettes and more. Also carries binder inserts for holding slides, diskettes and such.

Yazoo Mills, Inc.
305 Commerce St.
New Oxford, PA 17350
(717) 624-8993
Fax: (717) 624-4420
Mailing tubes in a variety of lengths and widths. Sold by the carton.

Portfolios

Most art and photography stores stock the portfolio standard: the black leather (or facsimile of) number, with sleeves or without, bound into a zippered, handled carrier or a clamshell box for matted prints and transparencies. These companies offer this standard, with more variations, as well as portfolios manufactured to your specifications.

Brewer Cantelmo
350 7th Ave.
New York, NY 10001
(212) 244-4600
Fax: (212) 244-1640
Offers presentation boxes with matching portfolio book, clamshell boxes in cloth and leather, presentation mailers and more. Available in a variety of colors, finishes and lining papers. Can create custom designs or customize existing products. Will blind emboss your name on its products.

Executive Express
4431 William Penn Hwy.
Murrysville, PA 15668
(724) 733-8695
Fax: (724) 327-6222
Offers zippered portfolios in a wide range of styles and sizes.

Sam Flax
12 W. 20th St.
New York, NY 10011
(212) 620-3010
Fax: (212) 633-1082
Presentation boxes, including clamshell archival boxes with single and dual compartments. Also a wide range of presentation binders and portfolio cases in a variety of materials.

Brewer Cantelmo offers stock presentation boxes with matching portfolio books, clamshell boxes in cloth and leather, presentation mailers and more. The company can create custom designs or customize existing products.

Texas Art
2001 Montrose Blvd.
Houston, TX 77006
(713) 526-5221
Fax: (713) 526-4072
Stock portfolios include zippered portfolios, showcase albums and combination presentation cases in a variety of sizes and colors. Several retail outlets in Houston area. Also takes mail orders.

Studio Furnishings

Agio Designs
322 NW 5th Ave., Ste. 234
Portland, OR 97209
(503) 242-1342
Fax: (503) 690-1423
Manufactures furniture for desktop systems.

Anthro
10450 SW Manhasset Dr.
Tualatin, OR 97062
(800) 325-3841, (800) 325-0045, (503) 691-2556
Fax: (800) 325-0045
Manufactures furniture for desktop systems.

Biomorph
129 W. 22nd St.
New York, NY 10011
(212) 647-9595
Fax: (212) 647-9596
www.biomorph-desk.com
Manufactures ergonomically designed computer furniture for home and office.

Fidelity Direct
5601 International Pkwy.
P.O. Box 155
Minneapolis, MN 55440-0155
(800) 328-3034, (612) 536-6500
Fax: (800) 842-2725
Mail-order house offering flat files, drafting tables, punch-and-bind machines and more. Offers many products below list price. Ask for free catalog.

Magna Visual, Inc.
9400 Watson Rd.
St. Louis, MO 63126-1596
(800) 843-3399, (314) 843-9000
Fax: (314) 843-0000
Makes magnetic white boards with calendars and scheduling charts, maps and message centers. Also makes in/out and magnetic work plan kits that include magnetic letters and indicators.

NuArc Company, Inc.
6200 W. Howard St.
Niles, IL 60648-3404
(847) 967-4400
Fax: (847) 967-9664
Makes precision-squared tables with built-in lightboxes.

Roconex
20 Mary Bill Dr.
Troy, OH 45373
(800) 426-6453, (937) 339-2616
Fax: (937) 339-1470
Manufactures vertical filing systems.

Winsted Corp.
10901 Hampshire Ave. S.
Bloomington, MN 55438-2385
(800) 447-2257, (612) 944-8556
Fax: (800) 421-3839, (612) 944-1546
Makes furniture for desktop systems.

Computers and Computer Equipment

Contact these computer hardware manufacturers for product information or a local representative in your area. (Note: Fax numbers vary for many of these manufacturers, depending on the fax destination. If you wish to send a fax to a company that does not have a listed fax number, ask the operator for the number for the division or department you will be faxing to.)

Computer and Hard-Drive Manufacturers

ALR
9401 Jeronimo
Irvine, CA 92718
(800) 444-4ALR, (714) 581-6770
Fax: (714) 581-9240
www.alr.com

Apple Computer
1 Infinity Loop
Cupertino, CA 95014
(800) 776-2333, (408) 996-1010
Fax: (408) 996-0275
www.apple.com

AST Research
16215 Alton Pkwy.
Irvine, CA 92718-3616
(714) 727-4141
Fax: (714) 727-9355
www.ast.com

Compaq Computer Corp.
20555 State Hwy. 249
Houston, TX 77070
(800) 345-1518, (281) 370-0670
www.compaq.com

Dell Computer
1909 W. Breaker Ln.
Austin, TX 78758
(512) 338-4400
Fax: (512) 728-3653
www.dell.com

Digital Equipment
111 Powdermill Rd.
Maynard, MA 01754
(800) 344-4825
Fax: (800) 234-2298
www.digital.com

Epson America
20770 Madrona Ave.
P.O. Box 2903
Torrance, CA 90509
(800) 463-7766, (310) 782-0770
Fax: (310) 782-5220
www.epson.com

Fujitsu Computer Products of America, Inc.
2904 Orchard Pkwy.
San Jose, CA 95134
(800) 591-5924, (408) 432-6333
www.fcpa.com

Gateway 2000
610 Gateway Dr.
North Sioux City, SD 57049
(800) 846-4208
www.gw2k.com

IBM Personal Computer Co.
3039 Cornwallis Rd.
Research Triangle Park, NC 27709
(800) 426-7355
www.pc.ibm.com

Intergraph Computer Systems
1 Madison Industrial Park
Huntsville, AL 35894
(800) 763-0242
www.intergraph.com

NEC Technologies
1255 Michael Dr.
Woodale, IL 60191
(630) 775-7900
www.nec.com

Relisys
919 Hanson Ct.
Milpitas, CA 95035
(408) 945-3100, (408) 945-6546
Fax: (408) 942-1086
www.relisys.com

Seiko Instruments
1130 Ringwood Ct.
San Jose, CA 95131
(800) 888-0817, (408) 922-5800
www.seiko-instruments-usa.com

Sharp Electronics Corp.
Sharp Plaza
Mahwah, NJ 07430
(800) 237-4277
www.sharp-usa.com

Sony Corp.
1 Sony Dr.
Park Ridge, NJ 07656
(800) 472-7669, (201) 930-1000
www.sony.com

Sun Microsystems
2550 Garcia Ave.
Mountainview, CA 94043
(800) 821-4643, (415) 960-1300
www.sun.com

Texas Instruments
5701 Airport Rd.
Temple, TX 76502
(254) 778-7766

Toshiba America Information Systems, Inc.
9740 Irvine Blvd.
Irvine, CA 92718
(800) 457-7777
www.toshiba.com

Umax Technologies, Inc.
3561 Gateway Blvd.
Fremont, CA 94538
(510) 651-4000
Fax: (510) 651-8834
www.umax.com

Xanté Corp.
2559 Emogene St.
Mobile, AL 36606
(800) 926-8839, (334) 476-8189
www.xante.com

Zenith Network Systems
1000 Milwaukee Ave.
Glenview, IL 60025
(800) 239-0900
www.zenith.com

Printer Manufacturers

Apple Computer
1 Infinity Loop
Cupertino, CA 95014
(800) 776-2333, (408) 996-1010
Fax: (408) 996-0275
www.apple.com

CalComp
2411 W. La Palma Dr.
Anaheim, CA 92803
(800) 225-2667, (714) 821-2000
www.calcomp.com

Canon U.S.A., Inc.
1 Canon Plaza
Lake Success, NY 11042
(516) 488-6700
www.usa.canon.com

Digital Equipment Corp.
% Genecom
1 Solutions Way
Waynesboro, VA 22980
(800) 365-0696
www.printers.digital.com

ENCAD, Inc.
6059 Cornerstone Ct. W.
San Diego, CA 92121-3734
(619) 452-0882
Fax: (619) 452-0891
www.encad.com

Epson America
20770 Madrona Ave.
P.O. Box 2903
Torrance, CA 90509-2842
(800) 463-7766, (310) 782-0770
Fax: (310) 782-5220
www.epson.com

Fujitsu Computer Products of America, Inc.
2904 Orchard Pkwy.
San Jose, CA 95134
(800) 591-5924, (408) 432-6333
www.fcpa.com

Hewlett-Packard
16399 W. Bernardo Dr.
San Diego, CA 92127
(800) 851-1170
Fax: (619) 487-1236
www.hp.com

IBM Printing Systems
Old Orchard Rd.
Armonk, NY 10504
(800) 358-6661
www.printers.ibm.com

Kyocera Electronics
100 Randolph Rd.
Somerset, NJ 08875
(732) 560-3400
Fax: (732) 560-8380
www.kyocera.com

LaserMaster
7156 Shady Oak Rd.
Eden Prairie, MN 55344
(800) 950-6868, (612) 944-9330
www.laserspan.com

Lexmark International
740 New Circle Rd. NW
Lexington, KY 40550
(800) 358-5835, (606) 232-2000
www.lexmark.com

Minolta Corp.
101 Williams Dr.
Ramsey, NJ 07446
(201) 825-4000
Fax: (201) 818-3290
www.minoltausa.com

Mita
225 Sand Rd.
Fairfield, NJ 07004-0008
(800) 222-6482
Fax: (973) 882-4421
www.mita.com

NEC Technologies
1255 Michael Dr.
Woodale, IL 60191
(630) 775-7900
www.nec.com

NewGen Systems
17550 New Hope St.
Fountain Valley, CA 92708
(714) 641-8600
Fax: (714) 436-5189
www.newgen.com

QMS
P.O. Box 81250
Mobile, AL 36689
(334) 633-4300
www.qms.com

Ricoh Imaging Peripheral Products
3001 Orchard Pkwy.
San Jose, CA 95134
(800) 955-3453, (408) 432-8800
www.ricoh-usa.com

Roland DGA Corp.
15271 Barranca Pkwy.
Irvine, CA 92618
(800) 542-2307
Fax: (714) 727-2112
www.rolanddga.com

Seiko Instruments
1130 Ringwood Ct.
San Jose, CA 95131
(800) 888-0817, (408) 922-5800
www.seiko-instruments-usa.com

Sharp Electronics Corp.
Sharp Plaza
Mahwah, NJ 07430
(800) 237-4277
www.sharp-usa.com

Tektronix, Inc.
26600 SW Parkway Ave.
Wilsonville, OR 97070
(800) 835-6100, (503) 682-7377
www.tek.com

Torque Systems, Inc.
625 2nd St., Ste. 211
San Francisco, CA 94107
(800) 846-3789, (415) 543-6555
Fax: (415) 543-7434
www.torque.com

Xanté Corp.
2559 Emogene St.
Mobile, AL 36606
(800) 926-8839, (334) 476-8189
www.xante.com

Xerox Corp.
100 S. Clinton Ave.
Rochester, NY 14644
(800) ASK-XEROX
www.xerox.com

Monitor Manufacturers

Apple Computer
1 Infinity Loop
Cupertino, CA 95014
(800) 776-2333, (408) 996-1010
Fax: (408) 996-0275
www.apple.com

AST Research
16215 Alton Pkwy.
Irvine, CA 92718-3616
(714) 727-4141
Fax: (714) 727-9355
www.ast.com

Barco, Inc.
1000 Cobb Pl. Blvd.
Kennesaw, GA 30144
(770) 218-3200
www.barco-usa.com

EIZO Nanao
23535 Kellog Ave.
Torrance, CA 90505
(800) 800-5202, (310) 325-5202
www.eizo.com

KDS USA
12300 Edison Way
Garden Grove, CA 92841
(800) 237-9988, (714) 379-5599
www.kdsusa.com

Mag Innovision
20 Goodyear
Irvine, CA 92618-1813
(800) 827-3998, (949) 855-4930
Fax: (949) 855-4535
www.maginnovision.com

Mitsubishi Electronics America, Inc.
5665 Plaza Dr.
P.O. Box 6007
Cypress, CA 90630-0007
(800) 843-2515, (800) 344-6352, (714) 220-2500
www.mitsubishi-display.com

NEC Technologies
1255 Michael Dr.
Woodale, IL 60191
(630) 775-7900
www.nec.com

Optiquest Corp.
438 Cheryl Ln.
Walnut, CA 91789
(800) 843-6784, (909) 869-7976
Fax: (909) 468-1202
www.optiquest.com

Philips Consumer Electronics Co.
64 Perimeter Center E.
Atlanta, GA 30346
(800) 835-3506
Fax: (423) 475-0387
www.philipsmonitors.com

Portrait Displays
5117 Johnson Dr.
Pleasanton, CA 94588
(800) 858-7744, (254) 754-1011
www.portrait.com

Princeton Graphics Systems
2801 S. Yale St.
Santa Ana, CA 92704
(800) 747-6249, (714) 751-8405
Fax: (714) 751-5736
www.prgr.com

Radius
215 Moffett Park Dr.
Sunnyvale, CA 94089
(800) 227-2795, (408) 541-6100
Fax: (408) 541-6150
www.radius.com

Relisys
919 Hanson Ct.
Milpitas, CA 95035
(408) 945-3100, (408) 945-6546
Fax: (408) 942-1086
www.relisys.com

Seiko Instruments
1130 Ringwood Ct.
San Jose, CA 95131
(800) 888-0817, (408) 922-5800
www.seiko-instruments-usa.com

Sony Corp.
1 Sony Dr.
Park Ridge, NJ 07656
(800) 472-7669, (201) 930-1000
www.sony.com

Toshiba America Information Systems, Inc.
9740 Irvine Blvd.
Irvine, CA 92718
(800) 457-7777
www.toshiba.com

ViewSonic
12130 Mora Dr.
Santa Fe Spring, CA 90670
(800) 888-8583, (909) 869-7976
Fax: (909) 869-7958
www.viewsonic.com

VisionMaster
575 Anton Blvd., Ste. 590
Costa Mesa, CA 92626
(800) 303-IDEK
www.iiyama.com

Scanner Manufacturers

A4Tech
717 Brea Canyon, Ste. 12
Walnut, CA 91789
(800) 760-9888, (909) 468-0071
www.a4tech.com

Agfa Division, Bayer Corp.
90 Industrial Way
Wilmington, MA 01887
(800) 227-2780, (508) 658-5600
Fax: (508) 657-5328
www.agfahome.com

Apple Computer
1 Infinity Loop
Cupertino, CA 95014
(800) 776-2333, (408) 996-1010
Fax: (408) 996-0275
www.apple.com

Caere Corp.
100 Cooper Ct.
Los Gatos, CA 95030
(800) 535-7226, (408) 395-7000
Fax: (408) 354-2743
www.caere.com

CalComp
2411 W. La Palma Dr.
Anaheim, CA 92803
(800) 225-2667, (714) 821-2000
www.calcomp.com

Canon Computer Systems, Inc.
2995 Redhill Ave.
Costa Mesa, CA 92626
(800) 848-4123, (714) 438-3000
www.ccsi.canon.com

DPI Electronic Imaging
629 Old State Rte. 74, Ste. 1
Cincinnati, OH 45244
(800) 597-3837, (513) 528-8668
www.jetsoftdev.com

Eastman Kodak Co.
343 State St.
Rochester, NY 14650
(800) 242-2424, (716) 724-4000
www.kodak.com

Epson America
20770 Madrona Ave.
P.O. Box 2903
Torrance, CA 90509-2842
(800) 463-7766, (310) 782-0770
Fax: (310) 782-5220
www.epson.com

Fujitsu Computer Products of America, Inc.
2904 Orchard Pkwy.
San Jose, CA 95134
(800) 591-5924, (408) 432-6333
www.fcpa.com

Hewlett-Packard
16399 W. Bernardo Dr.
San Diego, CA 92127
(800) 851-1170
Fax: (619) 487-1236
www.hp.com

Howtek, Inc.
21 Park Ave.
Hudson, NH 03051
(800) 444-6983, (603) 882-5200
Fax: (603) 880-3843
www.howtek.com

ICG Imaging
113 Main St.
Hackenstown, NJ 07840
(908) 813-3101

LaCie
8700 SW Creekside Pl.
Beaverton, OR 97008
(800) 999-0143, (503) 844-4500
www.lacie.com

Lasergraphics, Inc.
20 Ada
Irvine, CA 92718
(800) 727-2655, (714) 753-8282
www.lasergraphics.com

LinoColor
Linotype-Hell Co.
425 Oser Ave.
Hauppage, NY 11788
(888) LINOCOLOR, (516) 233-2166
Fax: (516) 233-2166
www.linocolor.com

Logitech
6505 Kaiser Dr.
Fremont, CA 94555
(800) 231-7717, (510) 795-8500
www.logitech.com

Microtek Lab, Inc.
3715 Doolittle Dr.
Redondo Beach, CA 90278
(800) 654-4160, (310) 297-5000
www.microtekusa.com

Mustek
121 Waterworks Way, #100
Irvine, CA 92618
(800) 468-7835, (714) 790-3800
www.mustek.com

Nikon Electronic Imaging
1300 Walt Whitman Rd.
Melville, NY 11747
(800) 526-4566, (516) 547-4200
www.nikon.com

Optronics
21 Alpha Rd.
Chelmsford, MA 01824
(978) 256-4511
Fax: (978) 256-1872
www.optronics-intel.com

Pacific Image Electronics
1830 W. 108th St.
Torrance, CA 90501
(310) 618-8100
Fax: (310) 618-8200
www.scanace.com

Panasonic
1 Panasonic Way
Secaucus, NJ 07094
(800) 742-8086, (708) 468-4308
www.panasonic.com

Plustek USA, Inc.
1362 Bordeaux Dr.
Sunnyvale, CA 94089
(800) 685-8088, (408) 453-5600
Fax: (408) 745-7562
www.plustekusa.com

Polaroid
784 Memorial Dr.
Cambridge, MA 02139
(800) 343-5000, (800) 765-2764
Fax: (617) 386-2000
www.polaroid.com

Relisys
919 Hanson Ct.
Milpitas, CA 95035
(408) 945-3100, (408) 945-6546
Fax: (408) 942-1086
www.relisys.com

Ricoh Imaging Peripheral Products
3001 Orchard Pkwy.
San Jose, CA 95134
(800) 955-3453, (408) 432-8800
www.ricoh-usa.com

Scitex Corp.
8 Oak Park Dr.
Bedford, MA 01730
(800) 456-0203, (781) 275-5150
www.scitex.com

Screen USA
5110 Tollview Dr.
Rolling Meadows, IL 60008
(800) 372-7737, (847) 870-1960
www.screenusa.com

Seiko Instruments
1130 Ringwood Ct.
San Jose, CA 95131
(800) 888-0817, (408) 922-5800
www.seiko-instruments-usa.com

Sharp Electronics Corp.
Sharp Plaza
Mahwah, NJ 07430
(800) 237-4277
www.sharp-usa.com

Umax Technologies, Inc.
3561 Gateway Blvd.
Fremont, CA 94538
(510) 651-4000
Fax: (510) 651-8834
www.umax.com

VisionShape
1434 W. Taft
Orange, CA 92665
(714) 282-2668
Fax: (714) 282-2673
www.visionshape.com

Wacom Technology Corp.
1311 SE Cardinal Ct.
Vancouver, WA 98683
(800) 922-6613, (360) 896-9833
Fax: (360) 896-9724
www.wacom.com

Manufacturers of Digital Cameras

Agfa Division, Bayer Corp.
90 Industrial Way
Wilmington, MA 01887
(800) 227-2780, (201) 440-2500
Fax: (508) 657-5328
www.agfa.com

Arca-Swiss, Inc.
Dicomet, Inc.
12270 Nicollet Ave.
Burnsville, MN 55337
(800) 888-7979, (612) 895-3000
Fax: (612) 895-3258
www.dicomed.com

Connectix
2655 Campus Dr., Ste. 100
San Mateo, CA 94403
(800) 950-5880, (415) 513-6510
Fax: (650) 571-5195
www.connectix.com

Eastman Kodak Co.
343 State St.
Rochester, NY 14650
(800) 235-6325, (716) 724-4000
www.kodak.com

Epson America
20770 Madrona Ave.
P.O. Box 2903
Torrance, CA 90509-2842
(800) 463-7766, (310) 782-0770
Fax: (310) 782-5220
www.epson.com

Fujifilm
1 Bert Dr.
West Bridgewater, MA 02333
(800) 378-3854, (914) 789-8100

Kaiser Division, HP Marketing Corp.
16 Chapin Rd.
Pine Brook, NJ 07058
(973) 808-9010

MegaVision, Inc.
5765 Thornwood Dr.
Golita, CA 93117
(805) 964-1400
www.mega-vision.com

Nikon Electronic Imaging
1300 Walt Whitman Rd.
Melville, NY 11747-3064
(800) 526-4566, (516) 547-4200
Fax: (516) 547-0299
www.nikonusa.com

Phase One U.S., Inc.
24 Woodbine Ave., Ste. 15
Northport, NY 11768
(888) 742-7366, (516) 757-0400
Fax: (516) 757-2217
www.phaseone.com

Polaroid Corp.
103 4th Ave., 1st Fl.
Waltham, MA 02154
(800) 816-2611, (617) 386-2000
www.polaroid.com

Rollei Photo Technique Division, HP Marketing Corp.
16 Chapin Rd.
Pine Brook, NJ 07058
(973) 808-9010

ScanView, Inc.
8275 S. Grant St., Ste. 750
San Mateo, CA 94402
(650) 378-6360
www.scanview-inc.com

Scitex Corp.
8 Oak Park Dr.
Bedford, MA 01730
(800) 456-0203, (781) 275-5150
www.scitex.com

Sony Corp.
1 Sony Dr.
Park Ridge, NJ 07656
(800) 472-7669, (201) 930-1000
www.sony.com

Umax Technologies, Inc.
3561 Gateway Blvd.
Fremont, CA 94538
(510) 651-4000
Fax: (510) 651-8834
www.umax.com

Other

CalComp
2411 W. La Palma Dr.
Anaheim, CA 92803
(800) 225-2667, (714) 821-2000
www.calcomp.com
Digitizing tablets.

Connectix
2655 Campus Dr., Ste. 100
San Mateo, CA 94403
(800) 950-5880, (415) 513-6510
Fax: (650) 571-5195
www.connectix.com
Makes digital video camera for the Mac.

Logitech
6505 Kaiser Dr.
Fremont, CA 94555
(800) 231-7717, (510) 795-8500
www.logitech.com
Track balls, mice.

Seiko Instruments

1130 Ringwood Ct.
San Jose, CA 95131
(800) 888-0817, (408) 922-5800
www.seiko-instruments-usa.com
Makes digitizing tablets.

Techworks

4030 W. Braker Ln.
Austin, TX 78759-5319
(800) 631-3918, (512) 794-8533
Fax: (512) 794-8520
www.techworks.com
Manufactures memory upgrade kits and video accelerators for PCs and laptop computers.

Wacom

501 SE Columbia Shores Blvd., Ste. 300
Vancouver, WA 98661
(800) 922-6613, (206) 750-8882
www.wacom.com
Digitizing tablets.

Software and Computer Equipment Mail-Order Houses

Many of the computers, computer-related products and software listed elsewhere in this book can be ordered from these distributors. Call these companies for copies of their catalogs.

APS Technologies

6131 Deramus
P.O. Box 4987
Kansas City, MO 64120-0087
(800) 354-1213, (816) 483-1600
Fax: (816) 483-3077
www.apstech.com
Specializes in external drives and other data storage equipment. Also sells modems, cables and other peripheral equipment as well as software. For Mac and PC.

Computer Discount Warehouse

200 N. Milwaukee Ave.
Vernon Hills, IL 60061
(800) 716-4239
www.cdw.com
PCs and peripheral products at discount prices. Also stocks software.

Dartek

949 Larch Ave., Dept. 976
Elmhurst, IL 60126
(800) 832-7835, (708) 832-2100
Fax: (708) 941-1106
www.dartek.com
Software and accessories for Macintosh and PCs. Also offers discs, printers, technician's tools, storage and furniture.

DTP Direct

5198 W. 76th St.
Edina, MN 55439
(800) 643-0629
Fax: (612) 832-0052
www.dtpdirect.com
Catalog offers desktop publishing software for Mac and PC platforms. Includes a wide range of software and hardware, including printers and scanners. Can order software off Web site.

Image Club Graphics

A Division of Adobe Systems, Inc.
1525 Greenview Dr.
Grand Prairie, TX 75050
(800) 387-9193
Fax: (800) 814-7783
www.imageclub.com
As you might expect, this mail-order company offers Adobe software and fonts, but it also carries a wide range of fonts from other foundries, including ITC, and clip art and royalty-free photography from a variety of sources.

MacWarehouse

1720 Oak St.
P.O. Box 3013
Lakewood, NJ 08701-5926
(800) 255-6227
www.warehouse.com
Mail-order house for Macintosh computers, Apple equipment and Mac-compatible peripherals and software.

The Mac Zone

15815 SE 37th St.
Bellevue, WA 98006-1800
(800) 248-0800
Fax: (425) 430-3500
www.maczone.com
Catalog of over one hundred pages and Web site offers everything Macintosh related, from computers to cables and scanners. Offers major graphics and illustration programs, fonts and clip art as well as business and game software.

Project

Sometimes a poster mailing tube can go beyond its traditional shipping duties to serve as a colorful container. The designers at Albuquerque-based Vaughn Wedeen Creative discovered this when faced with the challenge of creating a promotional concept that required the production of eight incentive packages in quantities of about seventy-five each for employees of US West Communications. The designers' easy and inexpensive solution was to bring their container production in-house by customizing mailing tubes with their own ink-jet-printed labels.

Vaughn Wedeen Design fashioned these containers by affixing studio-printed labels to mailing tubes.

The mailing tube containers were conceived as part of a year-long "Heat It Up" campaign designed to encourage employees to promote and sell various telephone products and services. For top sellers, US West offered incentives and rewards, including a Corvette for the employee who sold the most new product lines. As the design firm for the campaign, Vaughn Wedeen developed a series of eight promotional pieces tied in with the "Heat It Up" theme.

The "Strike-a-Match" campaign was conceived to excite employees about a matchup of two popular telephone product lines: call waiting and caller ID. The components of the campaign included a poster, T-shirt, boxed matches, portable radio, stationery, a congratulations card and other miscellaneous trinkets that played off the "Strike-a-Match"theme.

To package it all, Vaughn Wedeen ordered five hundred 10″×14″ mailing tubes from Yazoo Mills. The mailing tubes were used over the year as containers for about seventy-five promotional packages that were created for each of the eight promotions that comprised the entire "Heat It Up" campaign. Vaughn Wedeen printed the wraparound and lid labels for the tubes on a studio color printer and applied them by hand to the mailing tubes.

For information on how to contact Yazoo Mills, see listing on page 127.

Precision Type Reference Guide
47 Mall Dr.
Commack, NY 11725-5703
(800) 248-3668, (516) 864-0167
Fax: (516) 543-5721
Offers digital fonts from major font manufacturers (indexed by font family) and a wide range of picture fonts. Also carries font-related software and books on typographic design and production. Seven-hundred-page catalog lists more than twenty thousand typefaces as well as other type-related products.

Shreve Systems
1200 Marshall St.
Shreveport, LA 71101
(800) 227-3971, (318) 424-9791
Fax: (318) 424-9771
www.shrevesystems.com

Mail-order source for Macintosh computers, Mac parts and Mac-compatible peripherals. Also sells printers, monitors and external drives.

Software Spectrum
22721 E. Mission St.
Liberty Lake, WA 99019
(800) 669-9997
Fax: (800) 697-3447
www.swspectrum.com
Business and graphics applications for Mac and PCs.

Tiger Software
P.O. Box 569005
Miami, FL 33256-9005
(800) 335-4054
Fax: (305) 443-8212

Specializes in image-related products, such as royalty-free photography and clip art as well as scanners, tablets and image-related software. Also offers printers and printer supplies and some font collections.

Business Software

For managing the day-in and day-out operations of your business, these programs have been developed specifically to help graphic arts professionals track and bill their projects and produce marketing and business plans.

Cortex Software

Opera Plaza 601
Van Ness, #E3822
San Francisco, CA 94012
(800) 543-7788, (714) 720-8462, (714) 248-9686
Manufactures:

Sales & Marketing Success (PC)—Software that aids in producing a marketing plan.

Success (PC)—Software that helps with producing a business plan.

The DesignSoft Co.

610 Rushdale Cir.
Lombard, IL 60148
(630) 620-4618
Fax: (630) 629-0555
Manufactures:

DesignSoft (Mac, PC)—Designer's job billing software.

QuickBooks

Intuit
2650 E. Elvira St., Ste. 100
Tucson, AZ 85706
(520) 295-3000
Fax: (520) 295-3200
www.intuit.com
Manufactures:

QuickBooks (Mac)—Bookkeeping software from the makers of Quicken that includes payroll, invoicing, accounts receivable and check writing.

SilentPartner

℅ Medi Group
180 Black Rock Rd.
Oaks, PA 19456
(610) 666-1955
Fax: (610) 666-5911
Job tracking, scheduling and accounting software for creative professionals. Mac and PC compatible.

Working Computer

4755 Oceanside Blvd., Ste. 200
Oceanside, CA 92056
(760) 945-4334
Fax: (760) 945-2365
Manufactures:

Clients & Profits (Mac)—Job tracking, costing, billing and accounting software.

Custom imprinted Products

CHAPTER 12

Suppliers of Items

That Can Be Printed

With Your Designs

Binders and Folders

These folders and binders can be ordered preprinted with your graphics. For smaller orders or to order blank folders that can be customized with preprinted pressure-sensitive labels, see listings in chapter three, "Paper."

Admore
24707 Wood Ct.
Mt. Clemens, MI 48045
(800) 523-6673, (810) 949-8200
Fax: (810) 949-8968
Custom presentation folders employing a number of processes: four color, foil-stamping, embossing and lamination.

American Thermoplastic Co.
106 Gama Dr.
Pittsburgh, PA 15238-9857
(800) 245-6600, (412) 967-0900
Fax: (412) 967-9990
Custom-imprinted binders and index sets. Offers free catalog.

Crestline Co., Inc.
Mt. Hope Ave.
P.O. Box 2027
Lewiston, ME 04241
(800) 221-7797, (207) 777-7075
Fax: (800) 242-8290
Custom-imprinted pocket folders and binders. Offers free samples and catalog.

Folder Factory
P.O. Box 429
Edinburg, VA 22824-0429
(800) 296-4321, (540) 984-8852
Fax: (540) 984-9699
Manufactures custom-imprinted pocket folders. Offers free catalog.

Vinyl Industrial Products
1700 Dobbs Rd.
St. Augustine, FL 32086-5334
(800) 874-0855, (904) 824-0824
Fax: (904) 829-6903
In addition to pocket folders, pad holders and binders, also prints index tabs and cassette albums. Offers free catalog.

Labels and Stickers

These companies will manufacture labels and stickers to customer specifications. For smaller quantities of pressure-sensitive labels, check your local business-to-business directory.

For holographic labels and stickers, see the listings under Suppliers of Holography in chapter fourteen.

Dana Labels, Inc.

7778 SW Nimbus Ave.
Beaverton, OR 97005
(503) 646-7933
Fax: (503) 641-4728
Garment labels and size tabs, pressure-sensitive, paper shipping and other types of labels.

D&G Sign and Label

P.O. Box DBZ-157
Northford, CT 06472-9973
(800) 356-9269, (203) 483-0491
Fax: (800) 824-4511
Specializes in identification tags. Products range from self-adhesive labels to metal tags.

Graphcomm Services

P.O. Box 220
Freeland, WA 98249
(360) 331-5668
Fax: (360) 331-3282
Custom labels and self-inking stamps. Also offers custom hang-tags and tagging equipment.

Interstate Label Co.

1715 E. Main St.
P.O. Box 1239
Freeland, WA 98249
(800) 426-3261, (360) 331-5550
Fax: (360) 331-3799
Labels in one to four colors. Products include mailing labels, laser labels, hot-stamped and embossed labels. Call for free catalog.

Sterling Name Tape Co.

P.O. Box 939
Winsted, CT 06098
(203) 379-5142
Fax: (203) 379-0394
Manufactures custom clothing labels in one or more ink colors from polysatin.

Promotional Items and Marketing Aids

The following companies offer a wide variety of custom-imprinted products. Contact each for a catalog to research the possibilities.

Amster Novelty Co., Inc.

101-21 101 St.
Ozone Park, NY 11416
(718) 835-7600
Fax: (718) 835-7666
Drawstring pouches, totes and other bags. Custom imprints with hot stamping, silkscreening and embroidery. Stitches fabrics to customer specifications.

Competitive Edge

3500 109th St.
Des Moines, IA 50322
(800) 458-3343, (515) 280-3343
Fax: (515) 288-3343
Offers a variety of items, including banners, imprinted pens and pencils, badges and pins, matches, napkins and a variety of garments. Can screen print products or embroider to customer specifications.

Convergence

1308 Continental Dr.
Abingdon, MD 21009-2340
(800) 433-1782
Fax: (410) 538-6121
Manufactures custom mouse pads and counter mats. Offers free sample kit.

Crestline Co., Inc.

Mt. Hope Ave.
P.O. Box 2027
Lewiston, ME 04241
(800) 221-7797, (207) 777-7075
Fax: (800) 242-8290
Offers hundreds of items, including badges, mugs, banners, key chains and pens.

Curtis Rand Industries

123 Townsend St., Ste. 360
San Francisco, CA 94107-1925
(800) 523-9909
Fax: (800) 523-3292
www.curtisrand.com
Sells custom-imprinted key tags, pens, mugs, golf caps and more. Will send free catalog.

Datalizer Slide Charts, Inc.
501 Westgate St.
Addison, IL 60101-4524
(630) 543-6000
Fax: (630) 543-1616
Manufactures custom slide charts. Will produce a
working custom sample free of charge.

Hayward Marketing
2369 Lincoln Ave.
Hayward, CA 94545
(510) 786-1132
Fax: (510) 786-1111
Umbrellas, hats, shirts, pens, mugs—you name it.
Hayward Marketing will also custom-imprint unique
items not included in its catalog.

Imageworks Manufacturing
49 South St.
Park Forest, IL 60466
(708) 503-1122
Fax: (708) 503-1133
www.imageworksmfg.com
Specializes in custom computer accessories, including
custom-imprinted mouse pads. Offers free catalog.

Jubilee Promotional Co.
94101A Watson Industrial Park
St. Louis, MO 63126-1522
(800) 851-1241
Fax: (314) 962-6657
www.donutbox.com
Specialty is custom-imprinted donut boxes. Answers
typical office question, "Who brought in the donuts?"
and encourages morning sales calls. Call for free
brochure.

Lapel Pin, Inc.
3609 Thousand Oaks Blvd., #222
Westlake Village, CA 91362
(800) 229-7467, (805) 374-1414
Fax: (805) 374-1417
www.lapelpin.com
Makes enamel pins from customer-furnished artwork.
Mail or fax art for free estimate.

LNS Enterprises
946 Hope St., Ste. 157
Stamford, CT 06907-2203
(800) 648-3770
Fax: (800) 348-3770
T-shirts and sweatshirts, leather and vinyl items, desk
accessories, mugs, executive gifts, gourmet gifts and
more.

LogoPromo
1295 Shaw Ave., #130
Clovis, CA 93612-3931
(209) 323-4500
Fax: (209) 323-9755
Manufactures temporary tattoos of company logo.
Available in a broad range of colors, including full-
color images. Minimum quantity is one thousand.
Prices start at $.05 each.

MartGuild
576 Industrial Pkwy.
P.O. Box 382
Chagrin Falls, OH 44022-0382
(800) 245-8978, (440) 247-8978
Fax: (440) 247-1107
Specializes in stamped metal products, including med-
als, key tags, jewelry, paperweights and belt buckles.
Offers free catalog.

Mouseworld
P.O. Box 640
Jensen Beach, FL 34958-0640
(561) 229-8131
Specializes in custom-imprinted mouse pads. No
minimums.

Nelson Marketing
P.O. Box 320
Oshkosh, WI 54902-0320
(800) 5-IMPRINT
Fax: (800) 355-5043
www.nelsonmarketing.com
Offers hats, mugs, tote bags, pens, desk accessories,
mugs, executive gifts and more. Will send free catalog.

Pacific Pin
3 W. Carrillo, Ste. 209
Santa Barbara, CA 93101
(888) 766-2111
Fax: (805) 882-2396
www.west.net/~pacpin
Lapel pins from your art. Prices start at $1 each. Can
quote a job in twenty-four hours.

PinSource
1233 Shelburne Rd.
Pierson House
South Burlington, VT 05403
(802) 863-8600
Fax: (802) 865-3777
www.pinsource.com
Custom-designed lapel pins in cloisonné and enamel.
Will send free catalog.

PromoMart

P.O. Box 190
Villanova, PA 19085-9622
www.promomart.com
On-line catalog is equipped with a product search engine that lets browsers view mouse pads, watches, T-shirts, jackets and many more products. Web site also lets users locate local consultants by keying in area codes.

Rainbow Symphony

6860 Canby Ave., Unit 120
Reseda, CA 91335
(818) 708-8400
Fax: (818) 708-8470
Specializes in custom imprinting of holographic novelties, including labels, foil-wrapped pens and pencils, glasses, holiday decorations, buttons, magnets, decals, party favors, window decorations, spinning tops and more. Services include in-house graphics and typesetting.

Screen Tech Design

2651 Cessna Dr.
Columbus, IN 47203
(812) 376-0310
Fax: (812) 379-4612
Offers custom-designed Lexan products, such as mouse pads, coasters and desk blotters.

Specialties Unlimited

1233 Shelburne Rd.
South Burlington, VT 05403
(800) 678-9288
Fax: (802) 865-3777
Advertising specialties, including paperweights and jewelry. Offers free catalog.

Successories, Inc.

919 Springer Dr.
Lombard, IL 60148
(800) 847-8144, (630) 629-9006
Fax: (630) 629-0090
Offers T-shirts, mugs, hats, award and recognition items in brass and crystal, plus other custom-imprinted products, including garments. Will send free catalog.

Sweet Impressions

27636 Avenue Scott, Bldg. E
Valencia, CA 91355-3969
(800) 373-8037, (805) 295-1600
Fax: (805) 295-5052
www.sweetimpressions.com
Makes chocolate coins imprinted with company logo, wrapped in gold or silver. Available in custom-printed boxes, tins or glassware. Also makes candy business cards. Minimum is 250 coins. Prices start at $.25 each plus plate charge of $22.00 on orders of less than 2,500.

Whirley Industries, Inc.

618 4th Ave.
P.O. Box 988
Warren, PA 16365-4923
(800) 825-5575
Fax: (814) 723-3245
Custom-imprinted thermal and car mugs.

White Knight Promotions

1602 Saxony Crescent
Gloucester, Ontario K1B 5K6
Canada
(613) 744-6145
Fax: (613) 744-7026
Carries a wide range of custom-imprinted items, including lapel pins, memo pads, shirts, hats, tote bags, key chains, mugs and desk accessories.

Badges and Emblems

Fawn Industries, Inc. (East Coast)

Hwy. 851
P.O. Box 230
New Park, PA 17352
(800) 388-3296, (717) 382-4855
Fax: (717) 382-4711

Fawn Industries, Inc. (West Coast)

1551 Stimson Rd.
P.O. Box 30727
Stockton, CA 95213
(800) 388-3296, (209) 234-0240
Fax: (209) 234-1944

Johnson's

1208 Brookland's Rd.
Dayton, OH 45409
(800) 388-3296, (717) 382-4855
Aviation wings and police, medical and other insignias manufactured from metal.

Recco Maid Embroidery Co.

4624 W. Cornelia Ave.
Chicago, IL 60641-3792
(773) 286-6333
Fax: (773) 286-0220

Project

This holiday gift of a watch features Los Angeles-based Shimo-kochi/Reeves's "Marketing Man" identity. The bold icon is part of the firm's brand program of which the watch is one of the latest in an entire line of items the firm has produced over the years. The watches were ordered from Lynx Marketing. Shimokochi/Reeves specified its watch model of choice and supplied the manufacturer with camera-ready artwork of the identity.

The watches were packaged in tins purchased from Paramount Can Company in La Miranda, California. Shimokochi/Reeves purchased the containers for about $.56 each. The tins with their snap-top lids, are sturdy, reusable containers used by the watches' recipients for a variety of purposes.

Shimokochi/Reeves carried the "Marketing Man" motif into the packaging of the watches, designing lid and box label graphics bearing a holiday message, which were printed on the studio's Canon Fiery printer. Staff members trimmed each label and affixed it to its tin lid as well as to corrugated shipping boxes. Each tin was lined with a piece of red corrugated paper before the watches were packaged for mailing.

For information on how to contact Lynx Marketing, see their listing below. For information on how to contact Paramount Can, see listing in chapter thirteen on page 154.

Shimokochi/Reeves created this holiday gift of a watch by purchasing watches with the firm's logo from a company that specializes in custom-imprinted watch faces. The watches were packaged in archival tins purchased from a can company.

Swiss Craft Embroidery Co., Inc.
1601 N. Natchez Ave., Dept. 95
Chicago, IL 60635
(800) 835-4666, (773) 622-4646
Fax: (773) 622-5308

Watches

The following companies offer watches with faces that can be custom-imprinted with supplied art.

Fashion Watch, Inc.
2580 Corporate Pl., #102-US10
Monterey Park, CA 91754
(800) 733-1332, (213) 881-9839
Fax: (213) 881-9819
Full-color logos and custom art in eight possible styles. Imprints can be applied to clock faces as well.

Great American Images
819 Cowan Rd.
Burlingame, CA 94010
(650) 697-2900
Fax: (650) 697-1730
Full-color logos and custom art in several styles.

Image Watches, Inc.
9095 Telstar Ave.
Elmonte, CA 91731-2809
(626) 312-2828
Fax: (626) 312-2851
Offers six different styles.

Infinity Watch Corp.
606 Monterey Pass Rd.
Monterey Park, CA 91754
(800) 313-8808, (213) 266-0998
Fax: (213) 266-1115
Can print simple designs or full color. Offers six different styles.

Lynx Marketing
9434 Old Katy Rd., #230
Houston, TX 77055
(713) 468-0018
Fax: (713) 468-1213
Offers several watch styles.

Perfect Time, Inc.
1422-28 S. Broadway, Dept. SD
Los Angeles, CA 90015
(800) 872-0392, (213) 746-3231
Fax: (213) 746-1169
www.perfectime.com

Manufactures wristwatches with faces imprinted with customer-furnished art. Styles start at $10.50. Call for free brochure.

Time Dimension, Inc.
9528 Rush St., #D
South El Monte, CA 91733
(800) 988-5646, (818) 279-7788
Fax: (818) 279-5870
In addition to watches, sells shirts, key chains and more.

Rubber Stamps

The following companies will manufacture rubber stamps to your specifications, including stamps with logos and images made from your artwork. In addition to stamps, most offer a variety of stamp pad colors and other stamp-related supplies.

Bizarro
P.O. Box 292
Greenville, RI 02828
(401) 231-8777
Fax: (401) 231-4770

Jackson Marking Products
Brownsville Rd.
Mt. Vernon, IL 62864
(800) 851-4945, (618) 242-1334

Jam Paper & Envelope
111 3rd Ave.
New York, NY 10003
(800) 8010-JAM, (212) 473-6666
Fax: (212) 473-7300

Name Brand
P.O. Box 34245
Potomac, MD 20827
(301) 299-3062
Fax: (301) 299-3063

A Stamp in the Hand Co.
20630 S. Leapwood Ave., Ste. B
Carson, CA 90746
(310) 329-8555
Fax: (310) 329-8985

Packaging

13

Sources for

Packaging Materials

and Related Services

Plastic, Vinyl and Cellophane Bags and Envelopes

Suppliers in this section differ in the type of packaging they offer as well as their ability to handle custom orders. Also check each listing carefully to see if printing capabilities are offered.

Action Bag Co.
501 N. Edgewood Ave.
Wood Dale, IL 60191
(630) 766-2881
Fax: (630) 766-3508
Ziploc and other plastic bags, cotton drawstring bags, shopping bags and more. Sells small quantities of unprinted bags (one thousand). Also does hot-stamp printing for larger orders (ten thousand minimum).

Bay West Plastics, Inc.
P.O. Box 334
West Springfield, MA 01090
(413) 731-8881
Fax: (413) 788-6065
Custom fabricators of heat-sealed vinyl pouches, envelopes and bags. Also has on-site screen printing capability.

Beltsville Plastic Products, Inc.
P.O. Box 98
Laurel, MD 20725
(800) 882-1022, (301) 953-2222
Fax: (301) 953-9462
Clear vinyl envelopes and sleeves for documents, photos and badges. Also makes zippered portfolios. Stock and custom designs hot stamped and silkscreened to your specifications.

Crystal-X Corp.
100 Pine St.
Darby, PA 19023
(800) 255-1160, (610) 586-3200
Fax: (610) 586-3832
Custom and stock boxes, totes, holders, folders, trays and bags.

D&E Vinyl Corp.
13524 Vintage Pl.
Chino, CA 91710
(909) 590-0502
Fax: (909) 591-7822
Custom fabrication of vinyl pouches, bags, binders and folders. Also offers screen printing, embossing and foil-stamp finishing.

Northeast Poly Bag Co.
2 Northeast Blvd.
P.O. Box 1460
Sterling, MA 01564
(800) 331-8420, (978) 422-3371
Fax: (800) 538-1139
Reclosable bags, mailing bags, poly bags, packing list envelopes and more.

Plastic BagMart
554 Haddon Ave.
Collingswood, NJ 08108
(609) 858-0800
Fax: (609) 854-6006
Clear and solid-colored plastic bags, including Ziploc. Offers hundreds of different sizes and styles. Doesn't handle printing. Minimum orders range depending on size and style.

The Plastic Bag Outlet
190 W. Passaic St.
Rochelle Park, NJ 07662
(201) 909-0011
Fax: (201) 909-0727
Plastic bags with handles, tote handle bags, garment bags and plastic gloves. Minimum order for custom-imprinted products is ten thousand.

Plastic Manufacturers, Inc.
3510-30 Scotts Ln., Bldg. #31
Philadelphia, PA 19129
(215) 438-1082
Fax: (215) 438-5560
Vinyl envelopes and sleeves. Will print, emboss or apply snaps, hangholes, adhesive backing, grommets and more. Available in clear vinyl and colors.

Sacket Co.
7249 Atoll Ave.
North Hollywood, CA 91605
(818) 764-0110
Fax: (818) 764-1305
Plastic and cellophane bags in over three hundred sizes. Can print up to four colors from customer-supplied art. Minimum $25 order required on unprinted bags. Minimums on printed bags vary.

The Tracies Co., Inc.
100 Cabot St.
Holyoke, MA 01240
(800) 441-7141, (413) 533-7141
Fax: (413) 536-0223
Clear vinyl envelopes for a variety of needs, including bank passbooks, shop envelopes and more. Can customize with hot stamping and screen printing.

Visual Horizons
180 Metro Park
Rochester, NY 14623
(800) 424-1011
Fax: (800) 424-5411
www.storesmart.com
Specializes in clear vinyl, adhesive-backed pockets in a variety of sizes. Smaller pockets accommodate business cards and slides. Other sizes available are suited for CD-ROMs, diskettes and more.

Cardboard and Paper Boxes

Acorn Paper Products
3686 E. Olympic Blvd.
Los Angeles, CA 90023
(213) 268-0507
Fax: (213) 262-8517
Manufactures printed corrugated boxes. Can print up to four colors.

A. Fleisig Sons
472 Broadway
New York, NY 10013-2620
(212) 226-7490
Fax: (212) 941-7840
Gift and mailing boxes. Also stocks display boxes with clear acetate windows. Sells plain and custom-printed boxes.

AGI, Inc.
6363 Sunset Blvd., #910
Los Angeles, CA 90028
(213) 937-0220
Fax: (213) 937-2710
Manufactures folding cartons and shopping bags. Specializes in music and video carton printing.

Doral Packaging Co.
315 W. Auburn Ave.
P.O. Box 98
Bellefontaine, OH 43311
(800) 241-6834, (937) 592-9785
Fax: (937) 592-1174
Sells plain and custom-printed gift and apparel boxes. Also offers paper and plastic bags.

Fidelity Direct
5601 International Pkwy.
P.O. Box 155
Minneapolis, MN 55440-0155
(800) 328-3034, (612) 536-6500
Fax: (800) 842-2725
Shipping boxes, mailing tubes and other types of mailers in hundreds of shapes and sizes. Minimum order ranges from fifteen to five hundred, depending on item. Does custom printing from furnished art.

Project

Canadian design firm Aartvark Communications has made a holiday tradition of sending its suppliers and clients a custom-made gift of its own design. Under the name Aartware, the firm sent this gift of its Aartware logo on a triangular-shaped, copper-plated lapel pin to over two hundred recipients. The pin was ordered from an Ottawa promotional specialties firm, White Knight Promotions, and packaged in a 4″ × 4″ box, purchased from Almar International, an Ontario-based manufacturer of custom wooden boxes. Almar gave the boxes a rustic look by burning the Aartware logo into each box lid with a heated die. Per unit cost was $2.50.

Before they were packaged, each pin was attached to a card bearing the firm's message, which Aartvark printed on its studio laser printer. To cushion the pins for shipping, Aartvark filled each box with potpourri.

For information on how to contact Almar International, see listing on page 154. For information on how to contact White Knight Promotions, see listing in chapter twelve, page 142.

As a holiday gift for clients and vendors, pins bearing Aartvark Communications' logo were packaged in archival wooden boxes.

First Packaging
2 Mid America Plaza, Ste. 800
Oakbrook Terrace, IL 60181
(630) 954-2319
Fax: (630) 665-9822
Corrugated boxes, folding cartons and mailers. Also sells Styrofoam and other mailing supplies.

The Friendly Chameleon
4438 Silverwood St.
Philadelphia, PA 19127
(800) 717-8242, (215) 487-3317
Fax: (215) 508-1690
Specializes in tree-free paper products made from hemp, flax and cotton. Carries gift boxes in a variety of sizes made from corrugated hemp. Also sells gift bags.

Packaging Un-Limited, Inc.
1121 W. Kentucky St.
Louisville, KY 40210
(800) 234-1833, (502) 584-4331
Fax: (502) 585-4955
Manufactures all types of cardboard boxes, including corrugated, gift, jewelry and hat. Also offers stock and custom-sized corrugated boxes, video mailers, book folders, mailing tubes and mailing supplies. Sells unprinted boxes or prints up to four colors on its products from customer-supplied art.

Polyline
1401 Estes Ave.
Elk Grove Village, IL 60007-5405
(847) 357-1266
Fax: (800) 816-3330, (847) 357-1264
Manufactures fiberboard containers and envelopes suitable for diskettes and CD-ROM discs. Also carries plastic jewel cases.

Premiere Packaging
1635 Commons Pkwy.
Macedon, NY 14502
(800) 831-7791
Fax: (800) 203-2703
Apparel, jewelry and gift boxes in a variety of colors and sizes. Will sell blanks or custom-imprint its products from furnished art. Minimum order is one thousand. Also sells bags.

Pritchard Packaging
6-52 Antares Dr.
Nepean, Ontario K2E 7Z1
Canada
(800) 224-1248, (613) 723-8989
Fax: (613) 723-0450
www.pritchard.com
Carries standard and unusual stock items, such as gift boxes and other types of paperboard and cardboard containers typically used in product packaging. Can also manufacture original designs from customer specifications. Also sells bags.

Paper Bags

AGI, Inc.
6363 Sunset Blvd., #910
Los Angeles, CA 90028
(213) 937-0220
Fax: (213) 937-2710
Manufactures folding cartons and shopping bags. Handles music and video carton printing.

Crystal Tissue
P.O. Box 340
Middletown, OH 45042
(513) 423-0731
Fax: (513) 423-0516
Offers shopping and merchandise bags preprinted with stock prints and patterns.

Doral Packaging Co.
315 W. Auburn Ave.
P.O. Box 98
Bellefontaine, OH 43311
(800) 241-6834, (937) 592-9785
Fax: (937) 592-1174
Sells plain and custom-printed merchandise and shopping bags. Also offers plastic bags.

Loose Ends
P.O. Box 20310
Keizer, OR 97307
(503) 390-7457
Fax: (503) 390-4724
www.loosend.com
Offers blank kraft bags in small quantities and bags printed with wildlife motifs. Also offers heavily textured handmade and corrugated papers and boxes in raffia and other nature-inspired products. Offers free catalog.

Packaging Un-Limited, Inc.
1121 W. Kentucky St.
Louisville, KY 40210
(800) 234-1833, (502) 584-4331
Fax: (502) 585-4955
Shopping bags with rope handles in matte and glossy finishes. Will print up to four colors from customer-supplied art or sell blank bags. Minimum quantity on unprinted bags is 250.

Premiere Packaging
1635 Commons Pkwy.
Macedon, NY 14502
(800) 831-7791
Fax: (800) 203-2703
White and natural Kraft shopping bags, high-gloss bags and groove-finished bags in a variety of colors. Also sells solid-color paper merchandise bags, paper bags preprinted in a variety of patterns and plastic bags. Will sell blanks, hot-stamp or print bags to customer specifications. Minimum order for bags is five hundred.

Pritchard Packaging
6-52 Antares Dr.
Nepean, Ontario K2E 7Z1
Canada
(800) 224-1248, (613) 723-8989
Fax: (613) 723-0450
www.pritchart.com
Carries stock packaging items, such as plain and moisture-barrier kraft bags, as well as unusual containers, such as bags made from corrugated stock. Can also manufacture original designs from customer specifications. Also sells boxes and other unusual paper and paperboard containers.

Wolf Paper & Twine
680 6th Ave.
New York, NY 10010-5183
(212) 675-4870
Fax: (212) 645-4976
Carries all kinds of paper bags.

Rigid Plastic Boxes

Alpack, Inc.
7 Overhill Rd.
Natick, MA 01760
(508) 653-9131
Fax: (508) 650-3696
Stock and custom boxes in a variety of shapes and sizes.

Althor Products
P.O. Box 640
Bethel, CT 06801
(800) 688-2693, (203) 830-6060
Fax: (203) 830-6064
Clear plastic boxes. Stock items include hinged, non-hinged square, rectangular and round. Also offers foam inserts, labels, vials and polybags. Small orders accepted.

Classic Line
5915 21st St.
Racine, WI 53406
(414) 554-4412
Fax: (414) 554-8370
Fully transparent, rigid-molded plastic boxes in a variety of shapes and sizes. Clear and colored plastic available as well as custom imprinting.

Project

If you've ever wondered how design firms come up with their studios' own brands of custom-labeled and packaged wines, it's not all that difficult.

Albuquerque-based Vaughn Wedeen Creative produced twelve cases of custom-labeled Santa's Private Reserve wine to give to its clients as a holiday gift. The firm first contacted a small winery in the Albuquerque area and ordered 144 unlabeled bottles of a particular vintage. Vaughn Wedeen had labels printed separately and affixed them to each of the bottles with spray adhesive (a tedious job made more agreeable by sampling some of the wine on hand).

To complete the package, the firm contacted Polyfoam Packers, a carton manufacturer that specializies in Styrofoam fitted boxes used for shipping glassware. Matching custom labels were then affixed to these boxes with spray adhesive before the wine was shipped to clients and vendors.

For information on how to contact Polyfoam Packers, see listing on page 156.

A holiday gift of wine became a studio brand when Vaughn Wedeen Creative customized unlabeled bottles with its own studio's label design.

Gary Plastic Packaging Corp.
770 Garrison Ave.
Bronx, NY 10474
(800) 221-8150, (718) 893-2200
Fax: (718) 378-2141
Offers over 350 stock sizes and shapes in rigid plastic boxes. Also does custom-designed plastic packaging and can customize stock boxes.

MTM Molded Products
3370 Obco Ct.
Dayton, OH 45414
(937) 890-7376
Fax: (937) 890-1747
Custom and stock rigid plastic boxes. Decorating and form inserts available. Sizes range from 2″ × 2″ × 1¼″ to 21″ × 9″ × 9″.

Pioneer Plastics
P.O. Box 6
Dixon, KY 42409
(800) 951-1551, (502) 639-9142
Fax: (502) 639-5882
Crystal clear boxes. Square, round and rectangular shapes with lids in a range of sizes.

Polyline
1401 Estes Ave.
Elk Grove Village, IL 60007-5405
(847) 357-1266
Fax: (800) 816-3330, (847) 357-1264

Manufactures hinged plastic containers suitable for diskettes and CD-ROM jewel cases. Also carries fiberboard mailers for discs and diskettes.

Plastic Bottles, Tubes, Boxes, Jars and Jugs

All-Pak Plastic Bottles
Corporate 1 West
1195 Washington Pike
Bridgeville, PA 15017
(800) 245-2283, (800) 245-2284, (412) 257-3000
Fax: (412) 257-3001
Wide range of stock sizes and shapes as well as custom molds. Also creates barrier bottles. Complete decorating service available.

Alpack, Inc.
7 Overhill Rd.
Natick, MA 01760
(508) 653-9131
Fax: (508) 650-3696
Stock and custom boxes. Also carries jars, vials, tubes, clamshells and carrying cases.

Alpha Plastics, Inc.
10315 Page Industrial Blvd.
St. Louis, MO 63132
(800) 421-4772, (314) 427-4300
Fax: (314) 427-5445

Specializes in FDA compliance for medical, pharmaceutical and food industries. Offers custom and stock bottle designs.

Altira, Inc.
3225 NW 112th St.
Miami, FL 33167
(305) 687-8074
Fax: (305) 688-8029
Custom bottle designs, including 3-D models and prototypes. Does silksceening, hot stamping, therimage and pad printing.

Bottlewerks, Inc.
9535 S. Cottage Grove Ave.
Chicago, IL 60628
(773) 978-5930
Fax: (773) 734-6395
A variety of container types in sizes two ounces to thirty-two ounces. Offers silkscreen, therimage and hot-stamp decorating.

Captive Plastics, Inc.
251 Circle Dr. N.
Piscataway, NJ 08854-0277
(732) 469-7900
Fax: (732) 356-9487
Stock and custom-designed containers. Provides caps and closures, flame treating, silkscreening and hot stamping, as well as pressure-sensitive and heat transfer labeling. Regional offices in New Jersey, Iowa and California.

Continental Glass & Plastics, Inc.
841 W. Cermak Rd.
Chicago, IL 60608
(800) 787-JARS, (312) 666-2050
Fax: (312) 243-3419
Offers a wide variety of bottles, tubes, vials and jars. Also provides closures, caps and sprayers as well as many kinds of decorating options, including pressure-sensitive labels. Printing options include flexography, foil-stamping, lacquer varnishes, letterpress and screen printing.

Countryside Products
411 N. Reynoldsburg-New Albany Rd.
P.O. Box 13256
Columbus, OH 43213
(614) 864-1700
Fax: (614) 864-0888
Stock containers ranging from two ounces to seven gallons. Also manufactures custom designs and provides screen printing and a wide range of closures. Regional offices in Louisville and Cincinnati.

Crawford Industries
1414 Crawford Dr.
P.O. Box 191
Crawfordsville, IN 47933
(800) 428-0840, (765) 362-6733
Fax: (800) 962-3343
Stock and custom polyethylene boxes for sales presentations, gift boxes and storage units. Screen printing, foil-stamping and debossing decorating offered.

Crown Packaging, Inc.
2345 W. Hubbard St.
Chicago, IL 60612-1490
(800) 621-4620, (312) 666-2000
Fax: (312) 666-1505
Stocks plastic bottles, jars, jugs and closures for immediate shipment.

Display Pack
1340 Monroe NW
Grand Rapids, MI 49505
(616) 451-3061
Fax: (616) 451-8907
Clear plastic blister packs and clamshells. Point-of-purchase trays. Also does custom thermoforming.

Flambeau Products
P.O. Box 97
Middlefield, OH 44062
(800) 457-5252, (440) 632-1631
Fax: (440) 632-1581
Clear plastic boxes with hinged and nonhinged lids. Also offers compartmentalized boxes. Available in stock and custom colors and sizes.

Freund Can Co.
167 W. 84th St.
Chicago, IL 60620-1298
(773) 224-4230
Fax: (773) 224-8812
Offers bottles, jars and jugs in a wide variety of styles and sizes.

InPac
1014 E. Algonquin Rd.
Schaumburg, IL 60173
(847) 776-9555
Fax: (847) 776-9593
Custom manufacturer of bottles, jars and other types of containers. Also makes closures and provides silkscreening and labeling. Makes prototypes and models.

Project

When the Bernhardt Fudyma Design Group (New York City) revamped its Web site, the firm wanted to herald its site redesign with a promotion, sent to current and prospective clients. The Web site's theme is based on interesting events that take place every month of the year, so the idea of incorporating this theme into a printed calendar was a natural.

What makes this calendar a standout is its format: a series of individual pages for each month packaged in a clear plastic case normally used for storing computer diskettes. The hinged case can be flipped in a way that displays the pages as a desk calendar for each month of the year. One side of each page is a photomontage from the Bernhardt Fudyma Web site. The opposite side displays that month's calendar.

"Hopefully, people will use it on their desk as a calendar, but it also serves as a reminder to visit our Web site," says firm principal Craig Bernhardt. "When you access the Web site, you can select a month and see what happened. Various events each month are linked to relevant examples of our firm's work."

The calendar was relatively inexpensive to produce. Individual pages were ganged onto excess trim from a client job (with the client's permission), so Bernhardt Fudyma paid only for the trimming and collating of the inserts. The plastic diskette cases and their mailers, purchased in a quantity of four hundred from Polyline, cost pennies each.

For information on how to contact Polyline, see listing on page 147.

The Bernhardt Fudyma Design Group used hinged plastic containers, normally used for computer diskettes, to house this calendar promotion.

Lee Container Corp.
Clinch Industrial Park
100 Chambers Blvd.
Homerville, GA 31634
(912) 487-3632
Fax: (912) 487-3631
Stock containers, including one- to two and a half-gallon rectangular and round bottles.

The Lerman Container Corp.
10 Great Hill Rd.
P.O. Box 979
Naugatuck, CT 06770
(203) 723-6681
Fax: (203) 723-6687
Offers custom design and an extensive line of stock containers as well as metal and plastic screw caps, dispensing caps, pumps and sprayers. Also does hot stamping, sleeve labeling, therimage, offset and silk-screen labeling. Specializes in tamper-evident packaging.

Mayfair Plastics
1500 E. 223rd St.
Carson, CA 90745
(800) 486-5428, (310) 952-8736
Fax: (800) 789-9976
Offers custom and stock designs in plastic containers. Decorating available on pressure-sensitive, sleeve and heat transfer labels.

Northwestern Bottle Co.
460 N. Lindbergh Blvd.
St. Louis, MO 63141
(800) 325-7782, (314) 569-3633
Fax: (314) 569-2772
Consultants for custom package design. Distributors in Atlanta, Boston, Chicago, Indianapolis, Kansas City, Los Angeles, Memphis, New Castle, Omaha, Orlando, Phoenix, St. Louis, San Francisco and Syracuse.

Package Supply & Equipment Co., Inc.
1931 Perimeter Rd.
Greenville, SC 29605
(864) 277-0900
Fax: (864) 277-0957
Bottles, jars, jugs and pails as well as all types of closures. Stock and custom designs available. Also screen prints on its products. Distribution centers in Atlanta, Charlotte, Nashville, Richmond, Orlando and Cincinnati.

Pan-Am Plastics
3555 S. Normal Ave.
Chicago, IL 60609
(773) 373-4200
Fax: (773) 373-2187
Stock and custom blow-molding containers in barrier-resin and high-density polyethylene plastic. Custom decorating as well as caps and closures also available.

PVC Container Corp.
400 Industrial Way W.
P.O. Box 597
Eatontown, NJ 07724
(732) 542-0060
Fax: (908) 542-7706
Stock bottle sizes ranging from 1 ounce to 64 ounces. Offers custom designs up to 128 ounces. In-house decorating options include silkscreening, hot stamping, heat transfer and pressure-sensitive labeling.

River Side Manufacturing
10390 Bermuda Ct.
Bullhead City, AZ 86440
(520) 768-1771
Fax: (520) 768-1770
Makes tubes, bottles, jars, cans and containers in a broad range of sizes. Also does labeling and screen printing on containers. Features low minimum runs.

Rosbro Plastics Co.
999 Main St.
Pawtucket, RI 02860
(401) 723-8400
Fax: (401) 725-3510
Manufactures custom-molded bottles, jars and jugs. Specializes in bottles from two to sixty-four ounces and widemouthed jars.

Sho-Me Container, Inc.
704 Pinder Ave.
Grinnell, IA 50112
(800) 394-7504, (515) 236-4798
Fax: (800) 959-0394
Offers stock plastic cans and jars with screw caps. Also offers in-house silkscreening.

Smith Container
260 Southfield Pkwy.
Forest Park, GA 30297-2520
(404) 363-1001
Fax: (404) 363-1011
Offers jugs, cans, bottles and jars as well as accompanying closures. District operations in Charlotte, Richmond, Memphis, Tampa, Orlando and Tulsa.

W. Braun Co.
300 N. Canal
Chicago, IL 60606
(312) 346-6500
Fax: (312) 346-9643
Offers a wide range of containers for cosmetic, over-the-counter household chemical, food and novelty industries. Custom and stock designs and closures.

Whink
1901 15th Ave., Dept. S1
Eldora, IA 50627
(800) 959-0873, (515) 858-2353
Fax: (515) 858-2485
Specializes in containers that meet FDA standards for food, medical and pharmaceutical industries. Offers screen printing, hot stamping and pressure-sensitive labeling.

Glass Containers

Allometrics, Inc.
P.O. Box 15825
Baton Rouge, LA 70895
(504) 272-4484
Fax: (504) 272-0844
Bottles, jugs and vials and closures. Can fill small orders.

All-Pak Plastic Bottles
Corporate 1 West
1195 Washington Pike
Bridgeville, PA 15017
(800) 245-2283, (800) 245-2284, (412) 257-3000
Fax: (412) 257-3001
Offers a wide range of stock sizes and shapes as well as custom molds. Also creates barrier bottles. Complete decorating service available.

Champion Container
180 Essex Ave.
Avenel, NJ 07001
(732) 636-6700
Fax: (732) 855-8663
Bottles and wide-mouthed jars in flint and amber.

Project

For the 1997/98 holiday season, Aartvark Communications came up with its own "designer blend" of coffee, sent to two hundred clients and vendors as a thank-you gift. The Canadian design firm's unique brand (a blend of several different coffee beans) was given the distinctive name of Big Dripper and packaged with a decidedly "antidesign" look in mind.

"Flaws in typography and registration were OK," says Stephen Hards, Aartvark staff writer and marketing manager. With this antiaesthetic in mind, Aartvark art director Jean-Luc Denat and junior designer Etienne Bessette, under the creative direction of senior designer Mario L'Écuyer, designed two package labels that combined the design firm's sense of humor with a purposely naive look. Aartvark's label designs were printed in-house on a color laser printer.

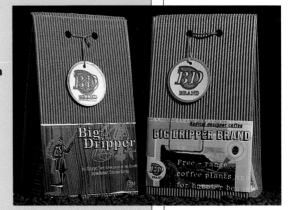

After Aartvark purchased the coffee beans from The Second Cup, an Ottawa-based coffee distributor, the design firm packaged the coffee in plastic-lined kraft paper bags with wire self-enclosures at the top to preserve freshness. The coffee bags were placed inside envelope-style, corrugated containers to which the designers affixed the Big Dripper labels. Both containers were purchased from Pritchard Packaging in Ottawa, Ontario.

To secure the top of each container and complete the antidesign look, Aartvark attached metal disc tags to each package, purchased from a local stationery store. Each tag was stamped twice, in red and black ink, with the same rubber stamp, bearing the BD monogram to give it a purposely out-of-register look. Aartvark personalized each package by writing each recipient's name on the opposite side of the tag.

For information on how to contact Pritchard Packaging, see listing on page 147.

Aartvark Communications made its own brand of "designer" coffee by printing labels on its studio printer and affixing them to corrugated containers.

Continental Glass & Plastics, Inc.

841 W. Cermak Rd.
Chicago, IL 60608
(800) 787-JARS, (312) 666-2050
Fax: (312) 243-3419
Offers a wide variety of bottles, tubes, vials and jars. Also provides closures, caps and sprayers as well as many kinds of decorating options, including pressure-sensitive labels. Printing options include flexography, foil-stamping, lacquer varnishes, letterpress and screen printing.

Crown Packaging, Inc.

2345 W. Hubbard St.
Chicago, IL 60612-1490
(800) 621-4620, (312) 666-2000
Fax: (312) 666-1505
Distributor of stock glass bottles, jars, jugs and closures. Products are available for immediate shipment.

InPac

1601 California
Rolling Meadows, IL 60008
(847) 776-9555
Fax: (708) 776-9593
Custom manufacturer of bottles, jars and other types of containers. Also makes closures and provides silk-screening and labeling. Makes prototypes and models.

The Lerman Container Corp.

10 Great Hill Rd.
P.O. Box 979
Naugatuck, CT 06770
(203) 723-6681
Fax: (203) 723-6687
Offers custom design and an extensive line of stock containers as well as metal and plastic screw caps, dispensing caps, pumps and sprayers. Also does hot stamping, sleeve labeling, therimage, offset and silkscreen labeling. Specializes in tamper-evident packaging.

Package Supply & Equipment Co., Inc.
1931 Perimeter Rd.
Greenville, SC 29605
(864) 277-0900
Fax: (864) 277-0957
Bottles, jars and jugs as well as all types of closures. Stock and custom designs available. Also screen prints on its products. Distribution centers in Atlanta, Charlotte, Nashville, Richmond, Orlando and Cincinnati.

Roth Glass Co.
171 Steuben St.
Pittsburgh, PA 15220
(412) 921-2095
Fax: (412) 921-8003
Manufactures glass medicine dropper assemblies; styles, lengths and diameters to client specifications.

Smith Container
260 Southfield Pkwy.
Forest Park, GA 30297-2520
(404) 363-1001
Fax: (404) 363-1011
Offers jugs, cans, bottles and jars as well as accompanying closures, including sprayers and pumps. District operations in Charlotte, Richmond, Memphis, Tampa, Orlando and Tulsa.

Metal Containers

American Aluminum Co.
230 Sheffield St.
Mountainside, NJ 07092
(908) 233-3500
Fax: (908) 233-3241
Manufactures seamless aluminum bottles and tamper-proof closures.

Freund Can Co.
155 W. 8th St.
Chicago, IL 60620-1298
(773) 224-4230
Fax: (773) 224-8812
Manufactures and distributes a variety of metal containers, such as pails, bottles, jars and seamless aluminum containers.

Package Supply & Equipment Co., Inc.
1931 Perimeter Rd.
Greenville, SC 29605
(864) 277-0900
Fax: (864) 277-0957
Bottles, jars, jugs and pails as well as all types of closures. Stock and custom designs available. Also screen prints on its products. Distribution centers in Atlanta, Charlotte, Nashville, Richmond, Orlando and Cincinnati.

Packaging Solutions
6835 W. Higgins Rd.
Chicago, IL 60656
(773) 792-3123
Fax: (773) 774-8188
Distributes extruded aluminum containers, imported from the United Kingdom.

Paramount Can Co.
16430 Thoebe Ave.
La Mirada, CA 90638
(714) 562-8410
Fax: (714) 562-8423
Manufactures and distributes a broad range of metal containers and enclosures, including pails, bottles and a variety of seamless aluminum containers.

Smith Container
260 Southfield Pkwy.
Forest Park, GA 30297-2520
(404) 363-1001
Fax: (404) 675-3739
www.fdp.com/smithcontainer
Distributes all types of metal containers and accompanying closures. District operations in Charlotte, Richmond, Memphis, Tampa, Orlando and Tulsa.

Wooden Boxes

Almar International
151 Viewbank Crescent
Oakville, Ontario L6L 1R3
Canada
(800) 646-8834, (905) 825-5700
Fax: (905) 827-9211
or
151 E. Roosevelt, Ste. 469
Lombard, IL 60148
Carries stock boxes with hinged and sliding lids. Also makes custom boxes and has produced designs that include a miniature coffin. Can burn logos and other designs into wood. Minimum quantity on custom orders is fifty.

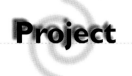

Project

This holiday promotion of gift tags in a can went to current and prospective clients of Design Horizons, Inc., as a combination gift and greeting for the 1997 holiday season. The design firm wanted to create something that would involve all of the designers in the firm. "When we've done promotions like this in the past, we've found that mass participation makes it successful," says DHI president Carl Miller. The gift tags follow previous holiday promotions that have included packaged gift wrap the firm's designers have created as well as its own "designer" line of holiday greeting cards.

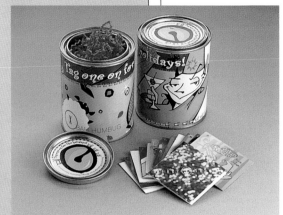

Gift tags in a can made a useful holiday gift for friends and clients of Design Horizons, Inc.

DHI designers came up with fifteen original gift tag designs that were ganged onto a single run and printed in four-color process on coated stock by Central Florida Press, a printer based in Orlando. The designers decided to package the gift tags in one-quart cans, normally used for paint, purchased from Atlanta-based Smith Container.

Designer Dean Sprague and illustrator Rob Schrab created holiday-themed designs for a wraparound label to go around each can as well as a coordinated lid label. The labels were printed by Randolph Street Press on crack-and-peel label stock. DHI staffers affixed the labels to each can and enclosed gift tags, a tape dispenser, scissors, and raffia (for tying the tags to gifts) before shipping.

Roughly three hundred of the promotions were assembled and sent to clients, prospective clients and studio friends of DHI, which has offices based in Vero Beach, Florida, as well as Chicago.

For information on how to contact Smith Container, see listing on page 154. For information on how to contact Randolph Street Press, see listing in chapter fourteen, page 165.

Loose Ends
P.O. Box 20310
Keizer, OR 97307
(503) 390-7457
Fax: (503) 390-4724
www.loosend.com
Offers an assortment of stock wooden boxes with sliding lids.

Other

Admore
24707 Wood Ct.
Macomb, MI 48042-5378
(800) 523-6673
Fax: (810) 949-8968
or

5300 Lindberg Ln.
Bell, CA 90201
(800) 338-5525
Fax: (800) 378-5525
Specializes in CD and diskette packaging as well as audio- and videotape packaging, portfolios and other boxes. Finishing techniques including foil-stamping, embossing, laminating and ultraviolet coating.

Andrew M. Martin Co., Inc.
16539 S. Main St.
Los Angeles, CA 90248
(800) 286-0460
Fax: (310) 323-2265
Specializes in pillow packs, polysqueeze tubes and pouch packs. Stock and custom designs. Handles manufacture and decorating.

Aspen Packaging
1200 St. Charles Rd.
Elgin, IL 60120
(800) 367-5493, (847) 608-2500
Fax: (847) 428-4600
Video packaging and mailers. Custom-imprinted from supplied art, film and digital files. Offers about fifty different styles and sizes. Order minimum is five hundred.

Compton Presentation Systems
68 Congress Cir. W.
Roselle, IL 60172
(800) 336-4940, (630) 539-2200
Fax: (630) 539-2209
Locating and printing on unusual products is a specialty. The company offers silkscreen printing, offset printing on vinyl, foil-stamping and embossing, holographs and more. Among the many jobs Compton has produced are product packaging, particularly CDs.

Corporate Image
1801 Thompson Ave.
Des Moines, IA 50316
(800) 247-8194
Fax: (888) 262-3839
Specializes in custom packaging for video- and audiocassettes, CD-ROM and diskette packaging and marketing kits.

Design Plastics
3550 N. Keystone Dr.
Omaha, NE 68134
(800) 491-0786, (402) 572-7177
Fax: (800) 881-0297, (402) 572-0500
Clear plastic blister packs and clamshells and packaging for compact discs. Also manufactures custom designs in plastic.

James Alexander Corp.
845 Rte. 94
Blairstown, NJ 07825
(908) 362-9266
Fax: (908) 362-5019
Specialists in custom packaging. Will work with designers to create packaging strategy that meets client objectives.

Package Works
1995 Broadway, 6th Fl.
New York, NY 10023
(212) 769-2552
Fax: (212) 769-3225
Works with designers to fashion custom packaging that encompasses a variety of package types, as well as printed packaging that incorporates clever folds and die cuts.

Polyfoam Packers
2320 Foster Ave.
Wheeling, IL 60090
(847) 398-0110
Fax: (847) 398-0653
Makes Styrofoam packaging suitable for shipping bottles, glassware and other fragile items.

Presskits
591 Providence Hwy.
Walpole, MA 02081
(800) 472-3497
Fax: (508) 668-2172
or
161 W. 61st St., #30A
New York, NY 10023
(212) 664-7686
Fax: (212) 541-4620
www.presskits.com
Produces custom media packaging, including video sleeves and CD-ROM packaging. Also prints pocket folders and portfolios.

Thibiant International
8601 Wilshire Blvd., Ste. 1100
Beverly Hills, CA 90211
(800) 375-7110, (310) 659-3347
Fax: (310) 659-4714
Specializes in packaging for skin care, hair care and fragrance industries.

Packaging Printers

Silkscreen Printing

These printers will print directly onto objects such as jars and bottles. Also check listings for plastic and glass containers. Many container manufacturers also offer container printing.

Alpha Plastics, Inc.
10315 Page Industrial Ct.
St. Louis, MO 63132
(800) 421-4772, (314) 427-4300
Fax: (314) 427-5445

Altira, Inc.
3225 NW 112th St.
Miami, FL 33167
(305) 687-8074
Fax: (305) 688-8029

Bottlewerks, Inc.
9535 S. Cottage Grove Ave.
Chicago, IL 60628
(773) 978-5930
Fax: (773) 734-6395

Empak
1501 Park Rd.
Chanhassen, MN 55317
(800) 341-4576, (612) 474-5282
Fax: (612) 949-1288

Imtran Industries, Inc.
25 Hale St.
Newburyport, MA 01950
(978) 462-2722
Fax: (978) 462-3113

Labels, Decals and Wrappers

The following printers offer a variety of printing techniques, including flexography, letterpress and silkscreen, as well as a wide range of label and decal types, shapes and sizes. In addition to label types mentioned, most also produce bar code labels. Don't overlook listings for plastic and glass containers. Many container manufacturers also offer label printing on labels that will fit their containers.

American Label
P.O. Box 342
Jefferson, MD 21755
(800) 438-3568, (301) 473-7491
Fax: (301) 473-7496
Tags, decals and labels. Also prints control panels and name badges. Screen printing on all types of surfaces, including Lexan, plastic, vinyl, foil and metal.

Andrews Decal Co., Inc.
6559 N. Avondale Ave.
Chicago, IL 60631-1521
(773) 775-1000
Fax: (312) 775-1001
Offers decals, nameplates, computer and pressure-sensitive labels. Flexography, letterpress and silkscreening available. Will print on a variety of materials.

Bay Area Labels
1980 Lundy Ave.
San Jose, CA 95131
(800) 229-5223, (408) 432-1980
Fax: (408) 434-6407
Decals and labels from Lexan, polyester, paper and other materials. Offers a variety of print applications, embossing, debossing and holograms. Also makes nameplates and membrane switches.

Bay Tech Label, Inc.
12177 28th St. N.
St. Petersburg, FL 33716
(800) 229-8321, (813) 223-7128
Fax: (813) 572-8345
Prints anywhere from one-color to four-color process. Laminating and varnishing also available.

Cummins Label Co.
2230 Glendening Dr.
Kalamazoo, MI 49001
(616) 345-3386
Fax: (616) 345-6657
Stock and custom-printed labels for many applications, including shipping and packaging. Offers letterpress, flexography and silkscreen printing. No minimum on orders placed.

Design Mark Industries
3 Kendrick Rd.
Wareham, MA 02571
(508) 295-9591
Fax: (508) 295-6752
Custom labels, decals and nameplates. Offers one- to four-color process, offset, flexographic and screen printing as well as hot stamping and embossing. District offices in Raleigh, North Carolina, and Philadelphia, Pennsylvania.

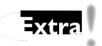

Bar Codes

Most product packaging requires a UPC (Universal Product Code)—the series of lines that is read by laser scanners at retail checkout counters. To find out how to obtain a code, contact the Uniform Code Council, 8163 Old Yankee Rd., Ste. J, Dayton, OH, (937) 435-3870.

Bar Code Pro 3.5 is a computer program that will let you print and import digital bar code graphics in formats compatible with Quark, PageMaker, Illustrator and other popular design and publishing programs. For more information, contact SNX, 692 10th St., Brooklyn, NY 11215, (718) 499-6293, Fax: (718) 768-3997, www.snx.com.

Flexo Transparent, Inc.
28 Wasson St.
Buffalo, NY 14210
(800) 33-FLEXO, (716) 825-7710
Fax: (716) 825-0139
Manufactures bottle sleeve labels. Stock and custom designs available.

Go Tape and Label, Inc.
19575 NE 10th Ave.
Miami, FL 33179
(800) 468-2731, (305) 652-8300
Fax: (305) 652-8306
Custom labels, tags and tape in all sizes and shapes. Offers one- to four-color process, silkscreening and hot stamping.

Grafstick Tape & Label
P.O. Box 3277
Framingham, MA 01701
(800) 537-6483
Fax: (508) 620-6229
Custom and preprinted labels in stock.

Identification Products Corp.
104 Silliman Ave.
P.O. Box 3276
Bridgeport, CT 06605
(800) 243-9888
Fax: (203) 334-5038
Custom labels on Lexan, foil, vinyl, Mylar and paper. Also makes aluminum nameplates.

Intermec Media Products
9290 LeSaint Dr.
Fairfield, OH 45014-5454
(513) 874-5882
Fax: (513) 874-8487
Bar code labels, tags and ribbons on thermal and thermal transfer papers, plastics and synthetics.

Label Quest
578 N. Michigan
Elmhurst, IL 60126
(800) 999-5301, (630) 833-9400
Fax: (630) 833-9421
Custom pressure-sensitive labels for packaging and other applications. Also offers mold decorating, heat transfers, rubdown products and five types of printing processes.

Labels and Decals, Inc.
300 Frontier Way
Bensenville, IL 60106
(800) 253-3225, (630) 227-0500
Fax: (630) 227-1016
Labels, nameplates and decals of all types and sizes. Printing applications include flexography, letterpress and silkscreening.

Nameplates for Industry, Inc.
213 Theodore Rice Blvd.
Industrial Park
New Bedford, MA 02745
(800) 999-8900, (508) 998-9021
Fax: (508) 995-0099
Offers labels, nameplates, decals and tags screen printed to client specifications. Call for free catalog and samples.

Precision Tape & Label, Inc.
P.O. Box 566
Uxbridge, MA 01569
(800) 225-7754, (508) 865-1157
Fax: (508) 865-1161
Custom-designed labels in up to six colors.

Reed-Rite Reliable Label Co.
1427 Center Circle Dr.
Downers Grove, IL 60515
(800) 323-7265, (630) 620-8100
Fax: (630) 620-8125
Decals, pressure-sensitive and static cling labels. Available on rolls and sheets. Offers hot stamping and foil labels.

Screenprint/Dow

271 Ballardvale St.
Wilmington, MA 01887
(781) 935-6395
Fax: (978) 658-2307
Nameplates, roll labels and control panels. Offers offset and screen printing, letterpress, hot stamping and flexography.

Seton Industries

P.O. Box 819
Branford, CT 06485
(800) 243-6624, (203) 488-8059
Fax: (203) 488-5973
Custom and stock labels, decals and nameplates on vinyl, polyester, paper, foil and metallic substrates. Call for free catalog and samples.

Techprint

137 Marsten St.
Lawrence, MA 01841
(800) 225-2538, (978) 975-1245
Fax: (978) 689-1888
Manufactures custom labels on rolls, on strips and as individual pieces. Offset and screen printing, flexography and hot stamping. Also offers nameplates, decals and other items.

Western Label Co., Inc.

5305 Alhambra Ave.
Los Angeles, CA 90032
(213) 225-2284
Fax: (213) 225-0740
Offers a wide range of labels, decals, tags and nameplates. Printing applications include flexography, letterpress, silkscreening, hot stamping and embossing. Offers up to twelve color printing.

Printing *and* Finishing *services*

CHAPTER 14

Sources for All Kinds

of Printing and Other

Finishing Techniques

Manufacturers of Ink and Ink Matching Systems

The following companies offer color mixing and swatch matching systems for printing inks. Each offers its own unique system and accompanying array of swatch books and other color matching aids. Some offer products that can be purchased off the shelf from local art and graphics supply stores.

Color Curve Systems, Inc.

Colwell Industries
200 6th St.
Ft. Wayne, IN 46808
(219) 424-5000
Fax: (219) 424-2710
www.colorcurve.com
Unique color matching system organizes ink colors by hue, value and level of saturation. Manufactures set of swatch books.

Pantone, Inc.

55 Knockerbocker Rd.
Moonachi, NJ 07074-9988
(800) 222-1149, (201) 935-5500
Fax: (201) 896-0242
www.pantone.com

Offers matching systems and swatch books covering a broad range of colors, including metallics. Also manufactures a number of color-related software products that aid in color matching on the computer.

Toyo

910 Sylvan Ave.
Englewood Cliffs, NJ 07632
(800) 227-8696, (201) 568-8660
Fax: (201) 569-2455
www.toyoinkus.com
Manufactures earth-friendly inks made from vegetable oils and natural pigments.

TRUMATCH, Inc.

25 W. 43rd St., Ste. 817
New York, NY 10036-7406
(800) TRU-9100, (212) 302-9100
Fax: (212) 302-0890, (212) 517-2237
www.trumatch.com
Digitally proportioned four-color matching system aids in creating exact four-color matches on the computer. Products include swatch books as well as Mac- and PC-compatible printing software.

Engravers by Region

Engraving is a special process of applying ink to paper that results in a raised surface and distinctive look for letterhead applications. These engravers are all members of the Engraved Stationery Manufacturers Association.

East

(CT, DC, DE, MA, MD, ME, NH, NJ, NY, PA, RI, VT)

All-State International
1-3 Commerce Dr.
Cranford, NJ 07016
(800) 222-0510, (908) 272-0800
Fax: (800) 634-5184

Anchor Engraving Co., Inc.
31-00 47th Ave.
Long Island City, NY 11101
(718) 784-7711
Fax: (718) 784-2683

Artcraft Co., Inc.
238 John Dietsch Blvd.
Attleboro Falls, MA 02763
(800) 659-4042, (508) 695-4042
Fax: (508) 699-6769

Bates, Jackson Engraving Co.
17-21 Elm St.
Buffalo, NY 14203
(716) 854-3000
Fax: (716) 847-1965

Blumberg Excelsior
62 White St.
New York, NY 10013
(800) 221-2972, (212) 431-7000
Fax: (212) 431-5111

Excelsior Process & Engraving
1466 Curran Hwy.
North Adams, MA 01247
(800) 551-8321, (413) 664-4321
Fax: (800) 526-9703

John O. Mooney Co.
9 Spruce St.
Pawling, NY 12564
(800) 431-2170, (914) 855-4456
Fax: (800) 724-1119

Lehman Brothers, Inc.
191 Foster St.
New Haven, CT 06511
(800) 343-3284, (203) 624-9911
Fax: (203) 624-0374

LS&G Image Dynamics
265 W. 40th St.
New York, NY 10018
(212) 302-9059
Fax: (212) 302-9173

P.E. Pascale & Co.
30-30 Northern Blvd.
Long Island City, NY 11101
(718) 706-1470
Fax: (718) 706-6201

Precise Corporate Printing
75 Front St.
Brooklyn, NY 11201
(800) 392-2496, (718) 243-9000
Fax: (718) 797-9637

Vose-Swain Engraving Co.
411 D St.
Boston, MA 02210
(617) 542-3711
Fax: (617) 482-4754

South

(AL, FL, GA, KY, LA, MS, NC, SC, TN, TX, VA, WV)

Blumberg-Excelsior, Inc.
P.O. Box 2122
Orlando, FL 32802
(800) 327-9220, (407) 299-8220
Fax: (407) 291-6912

Fine Arts Engraving Co.
9700 Chartwell St.
Dallas, TX 75243
(214) 553-1500
Fax: (214) 349-5266

Harper Engraving & Printing Co.
2485 Park Central Blvd.
Decatur, GA 30035
(800) 253-0250, (770) 593-9900
Fax: (770) 593-0974

PRINTED WITH SOY INK ™

Trademark of American Soybean Association

H.T. Hearn Engraving Co.
209 Regent Dr.
Winston-Salem, NC 27103
(910) 760-1467
Fax: (910) 760-3370

Ives Business Forms, Inc.
1009 Camp St.
New Orleans, LA 70130
(504) 561-8811
Fax: (504) 581-4837

Schmidt Engraving Co.
1124 Franklin Ave.
Waco, TX 76701
(254) 754-2361
Fax: (254) 753-1139

Midwest

(IA, IL, IN, MI, MN, MO, OH, WI)

Anderson Engraving
4201 E. 100 Ter.
Kansas City, MO 64141
(816) 761-9600
Fax: (816) 842-1649

Artistry Engraving & Embossing Co., Inc.
6000 N. Northwest Hwy.
Chicago, IL 60631
(773) 775-4888
Fax: (773) 775-0064

Fine Arts Engraving Co.
109 Shore Dr.
Burr Ridge, IL 60521
(630) 920-9300
Fax: (630) 920-1524

Harper Engraving & Printing Co.
2626 Fisher Rd.
Columbus, OH 43204
(800) 848-5196, (614) 276-0700
Fax: (614) 276-5557

Rose Engraving Co.
1435 Fuller SE
Grand Rapids, MI 49507
(616) 243-3108
Fax: (616) 243-7236

Shirley Engraving Co.
460 Virginia Ave.
Indianapolis, IN 46203
(317) 634-4084
Fax: (317) 685-2524

West

(CA, CO, KS, ND, NE, NV, SD, UT, WY)

APS Engravers & Lithographers
120 2nd St.
San Francisco, CA 94105
(415) 392-0979
Fax: (415) 392-0128

Burdge, Inc.
2151 Yates Ave.
Commerce, CA 90040-1900
(213) 722-2011
Fax: (213) 724-7901

The Ligature
3223 E. 46th St.
Los Angeles, CA 90058
(213) 585-2152
Fax: (213) 585-1737

Stuart F. Cooper Co.
1565 E. 23rd St.
Los Angeles, CA 90011
(800) 421-8703
Fax: (213) 747-3035

If you print a job with soy-based inks, the National Soy Ink Information Center licenses this trademark to those who use inks with soybean oil content on their printed pieces. This organization also offers information on the environmental advantages of using soy-based inks as well as other advice on eco-friendly printing. Contact the center at 4554 NW 114th St., Urbandale, IA 50322-5410, (800) 747-4275, Fax: (515) 251-8657, www.soyink.com.

Offset Lithographers by Region

These printers have all won recognition for graphic excellence and incorporating eco-friendly practices in their shops. In addition to setting the standard for excellence and responsibility in offset printing, they are also known for their ability to capably handle the most challenging printing jobs.

New England

(Canada, CT, MA, ME, NH, RI, VT)

Allied Printing Services, Inc.
579 Middle Turnpike W.
Manchester, CT 06040
(860) 643-1101
Fax: (860) 646-7954

C.J. Graphics
17 Noble St.
Toronto, Ontario M6K 2C7
Canada
(416) 588-0808
Fax: (416) 588-5015

Daniels Printing
40 Commercial St.
Everett, MA 02149
(617) 389-7900
Fax: (617) 389-5520

W.E. Andrews Co., Inc.
140 South Rd.
Bedford, MA 01720
(781) 275-0720
Fax: (781) 280-3131

Mid-Atlantic

(DC, DE, MD, NJ, NY, PA)

Dunmire Printing
820 12th St.
Altoona, PA 16602
(814) 944-7733
Fax: (814) 944-3463

Lincoln Graphics, Inc.
1670 Old Country Rd.
Plainview, NY 11803
(516) 293-7600
Fax: (516) 293-7608

L.P. Thebault Co.
249 Pomeroy Rd.
P.O. Box 169
Parsippany, NJ 07054
(973) 884-1300
Fax: (973) 884-0169

Old York Road Printing
406 Johnson St.
Jankintown, PA 19046
(215) 886-3300
Fax: (215) 886-5350

PCW100
15 Valley Rd.
Port Washington, NY 11050
(800) PCW-3117, (516) 767-8021
Fax: (516) 767-8034

Peake Printers, Inc.
2500 Schuster Dr.
Chervely, MD 20781
(301) 341-4600
Fax: (301) 341-1162

Penny Lane
230 Houston Ave.
Hempstead, NY 11550
(516) 486-4200
Fax: (516) 486-0649

In addition to conventional die-cut applications, such as packaging and pocket folders, HM Graphics also has the capability to print and construct 3-D design concepts, such as pop-ups. For more information, see their listing on page 165.

If you'd like more information on locating printers, acceptable trade practices and other printing-related issues, contact Printing Industries of America, a trade association with local offices in many major cities, or contact the organization at its national headquarters: 100 Daingerfield Rd., Alexandria, VA 22314-2888, (888) 272-3329, (703) 519-8100, Fax: (703) 548-3227.

Pomco Graphics, Inc.
4411-27 Whitaker Ave.
Philadelphia, PA 19120
(215) 455-9500
Fax: (215) 329-3223

Wheal-Grace Corp.
300 Ralph St.
P.O. Box 67
Belleville, NJ 07109
(201) 450-8100
Fax: (201) 450-5394
www.wheal-grace.com

Southeast

(AL, FL, GA, KY, MS, NC, SC, TN, VA, WV)

Cadmus
2750 Whitehall Park Dr.
Charlotte, NC 28273
(704) 583-6600
Fax: (704) 583-6666

Classic Graphics, Inc.
P.O. Box 560275
Charlotte, NC 28256-0275
(704) 597-9015
Fax: (704) 597-7041

Dickson's
1484 Atlanta Industrial Way
Atlanta, GA 30331
(800) 241-4811, (404) 696-9870
Fax: (404) 696-9923
www.dicksons.com

Fetter Printing Co.
700 Locust Ln.
Louisville, KY 40213
(502) 634-4771
Fax: (502) 634-3587

Gurtner Printing Co.
2033 Cook Dr.
Salem, VA 24153
(540) 772-7835
Fax: (540) 772-7792

The Hennegan Co.
7455 Empire Dr.
P.O. Box 6914
Florence, KY 41042
(606) 282-3600
Fax: (606) 282-3601

Josten's
2505 Empire Dr.
Winston-Salem, NC 27103
(910) 765-0070
Fax: (910) 659-9423

Progress Printing
P.O. Box 4575
Lynchburg, VA 24502
(804) 239-9213
Fax: (804) 237-1618

Williams Printing Co.
1240 Spring St. NW
Atlanta, GA 30309
(404) 875-6611
Fax: (404) 872-4025

Midwest

(IA, IL, IN, MI, MN, MO, OH, WI)

Berman Printing
1441 Western Ave.
Cincinnati, OH 45214
(513) 421-1600
Fax: (513) 421-2433

Central Printing Co.
2400 E. River Rd.
Dayton, OH 45439
(937) 276-8888
Fax: (937) 276-7728

Diversified Graphics
1700 Broadway
Minneapolis, MN 55413
(612) 331-1111
Fax: (612) 331-4079

The Etheridge Co.
2450 Oak Industrial Dr.
Grand Rapids, MI 49505
(616) 459-4418
Fax: (616) 459-6043

h.c. Johnson Press
P.O. Box 5566
Rockford, IL 61125
(815) 397-0800
Fax: (815) 397-9223

Project

When the creative professionals at New York City–based Siegel & Gale needed an idea for an invitation to an S.D. Warren–sponsored event at the AIGA National Conference in New Orleans, they took their lead from a campaign the agency developed for Strobe, S.D. Warren's latest paper line. To emphasize the brightness of Strobe's coated papers, the advertising agency featured sunglasses as a graphic element in the campaign. "We thought it would be cool to use sunglasses again and feature them in a three-panel, gate-fold configuration so people could actually pop them out and wear them," says designer Veronica Oh. Pop-out sunglasses became the focal point of the invitation along with the headline, "What the Brightest People in New Orleans Will Be Wearing."

Oh needed to print the invitation on Strobe Silk, the newest finish offered in the paper line. Initially she thought about using a four-color image until she became aware of a swatch book full of foil samples, including holographic patterns, supplied by the printer of the piece, Pomco Graphics. "Because Strobe is Warren's top-of-the-line paper, we thought this glamorous foil would be a good way to represent the grade," says Oh.

To provide a dramatic backdrop for the glittery foil sunglasses frame, Oh limited the color on the gate-folded invitation and its square enclosure to silver, black and red. The invitation and its enclosure were offset printed and the sunglasses die cut with a special perforation that allowed recipients to easily pop them out. Pomco Graphics did the printing, foil-stamping and other finishing aspects of the job, including the perforation.

Foil-stamping with silvery holographic foil gave glamour appeal to this invitation to an AIGA conference event.

For information on how to contact Pomco Graphics, see listing on page 164.

Hilltop Press, Inc.
624 E. Walnut St.
Indianapolis, IN 46204
(317) 634-4700
Fax: (317) 634-9682

HM Graphics, Inc.
P.O. Box 19901
Milwaukee, WI 53219
(414) 321-6600
Fax: (414) 546-8692

Refer to image on page 163.

Jefferson/Keeler
1234 S. Kings Hwy.
St. Louis, MO 63110
(314) 533-8087
Fax: (314) 533-2369

Print Craft, Inc.
315 5th Ave. NW
New Brighton, MN 55112
(612) 633-8122
Fax: (612) 633-1862

Randolph Street Press
1313 W. Randolph
Chicago, IL 60607
(312) 243-7878

Skokie Valley Reproductions
7400 N. Melvina St.
Niles, IL 60648
(847) 647-1131
Fax: (847) 647-2321

Unique Printers and Lithographers
5500 W. 31st St.
Cicero, IL 60804
(708) 656-8900
Fax: (708) 656-2176

Universal Lithographers
4415 S. Taylor Dr.
P.O. Box 181
Sheboygan, WI 53082-0181
(920) 452-3401
Fax: (920) 452-2348

Watt/Peterson, Inc.
15020 27th Ave. N.
Plymouth, MN 55447
(612) 553-1617
Fax: (612) 553-0956

Southwest

(AR, AZ, LA, NM, OK, TX)

Buchanan Printing
12400 Ford Rd.
Dallas, TX 75234
(972) 241-3311
Fax: (972) 406-6392

Heritage Press
8939 Premiere Row
Dallas, TX 75247
(214) 637-2700
Fax: (214) 637-2713

Imperial Litho/Graphics
210 S. 4th Ave.
Phoenix, AZ 85003
(602) 257-8500
Fax: (602) 495-2544

Williamson Printing Corp.
6700 Denton Dr.
Dallas, TX 75235
(214) 352-1122
Fax: (214) 352-1842

West

(CA, CO, KS, ND, NE, NV, SD, UT, WY)

Anderson Printing & Offset
855 Cahuenga Blvd.
Los Angeles, CA 90038
(213) 460-4115
Fax: (213) 460-6876

Color West Graphics
2720 Shannon
Santa Ana, CA 92704
(714) 979-9787
Fax: (714) 540-9701

Continental Graphics
8833 Complex Dr.
San Diego, CA 92123
(619) 292-6906
Fax: (619) 292-1325

Costello Brothers Lithographers
500 S. Palm Ave.
Alhambra, CA 91803-6681
(213) 283-6681
Fax: (213) 283-2094

The Dot Generator
10621-141 Calle Lee
Los Alamitos, CA 90720
(714) 952-0183
Fax: (714) 952-0870

George Rice & Sons
2001 N. Soto
Los Angeles, CA 90032
(213) 223-2020
Fax: (213) 223-3679

In to Ink
7888 Silverton Ave., Ste. C
San Diego, CA 92126
(619) 271-6363
Fax: (619) 271-1121

Simon Printing
2276 Mora St.
Mountain View, CA 94040
(650) 965-7170
Fax: (650) 965-7918

Project

When conceiving a design for Henry Weinhard's Brewery's promotional brochure, Duffy Design (Minneapolis) wanted to emphasize the heritage of the 168-year-old brewery. "There are a lot of brands out there that have a contrived history," notes designer Alan Colvin. "We wanted people to understand that this brand has a *real* history."

The brochure was directed to potential distributors of Henry Weinhard's beers as the brewery began to expand its venue from a Portland-based regional brewery to a national brand. In addition to relating the history of the brand, the brochure needed to contain information specific to each region's marketing plan.

Colvin and his colleagues at Duffy Design devised a brochure that tells the story of Henry Weinhard, who founded the brewery. The brochure cites the growth of his brewery in four pages. A pullout brand development plan, backed with a product description, gives marketing advice. The grommet-bound brochure also contains a pocket that can accommodate the brewery's individual media plan inserts.

To create a vintage look for the brochure, flyleaves were printed on Gilbert Gilclear, a translucent vellum that was flooded with ivory varnish to achieve the look of parchment. Enlargements of Weinhard's handwritten ledger sheet were overprinted on the flysheets as halftone screens.

This brochure presented several on-press challenges, including printing on industrial chipboard, all handled capably by Diversified Graphics.

The brochure's interior pages are printed on French Dur-o-tone butcher paper. But the rustic look of the cover was achieved by printing on industrial chipboard, mounted back-to-back. Diversified Graphics handled the challenge of printing the brochure's cover as well as its interior. The foil-stamp logo on the cover was done by Macintosh Embossing.

For information on how to contact Diversified Graphics, see page 164; for Macintosh Embossing, see page 174.

Northwest

(ID, MT, OR, WA)

Heath Printers

1617 Boylston Ave.
Seattle, WA 98122
(206) 323-3577
Fax: (206) 323-7960

Budget-Priced Four-Color Printing

These companies give optimum pricing on limited-run four-color printing. Most offer brochures, posters and postcards in stock sizes on house stock. A great idea for standard-sized jobs where four-color reproductions need to be made on a small-run basis and paper choice, custom finishes or press checks aren't an issue.

If you'd like a list of additional screen printers in your area or want more information on the screen printing industry, contact the SGIA (Screenprinting & Graphic Imaging Association) International, 10015 Main St., Fairfax, VA 22031-3489, (703) 385-1335, Fax: (703) 273-0469.

American Color Printing
8031 NW 14th St.
Miami, FL 33126
(800) 897-6175, (305) 599-8990
Fax: (305) 599-2334
Can handle everything from postcards to catalogs. Offers free catalog.

Copy Craft Printers, Inc.
4413 82nd St.
Lubbock, TX 79424
(800) 794-5594, (806) 794-7752
Fax: (806) 794-1305
Offers postcards, calendars, CD-inserts, envelopes, greeting cards and more. Offers free catalog.

Dynacolor Graphics
1182 NW 159th St.
Miami, FL 33169
(800) 624-8840
Fax: (305) 625-8929

The Great American Printing Co.
27102 Burbank
Foothill Ranch, CA 92610
(800) 440-2368
Fax: (800) 422-1378
Specializes in full-color business cards.

Imprint Color Graphics
4646 Western Ave.
Lisle, IL 60532-1543
(888) 783-8085, (630) 968-8080
Specializes in 8½″ × 11″ inserts and brochures.

MultiPrint
5555 W. Howard St.
Skokie, IL 60077-2621
(800) 858-9999
Brochures, postcards, posters and catalogs.

1800postcards
50 W. 23rd St., 6th Fl.
New York, NY 10010
(212) 473-5818
Fax: (212) 271-5506
www.1800postcards.com
Business is devoted exclusively to postcards. Also offers mailing service.

Paper Chase Printing, Inc.
7176 Sunset Blvd.
Hollywood, CA 90046
(800) 367-2737, (213) 874-2300
Fax: (213) 874-6583
Specializes in postcards.

Triangle/Expercolor
3737 Chase Ave.
Skokie, IL 60076-9958
(800) 766-6540
Fax: (847) 674-1230
Range of services includes postcards, brochures and catalogs. Minimum quantity is one thousand.

U.S. Press
P.O. Box 640
Valdosta, GA 31603-0640
(800) 227-7377
Fax: (912) 247-4405
Prints brochures. Offers free catalog.

Letterpress Printers

Letterpress printing offers antique typefaces, a unique debossed finish and a means of printing on handmade, industrial and other unusual papers that offset printers won't touch. The companies listed here not only specialize in letterpress printing, but it's the only kind of printing they offer. As a special breed, they not only bring rare expertise to the process, but also a high degree of craftsmanship and sensitivity to making the most of the aesthetic potential of this printing method.

Bloodroot Press
1404 Lutz Ave.
Ann Arbor, MI 48103
(734) 668-7436
Fax: (734) 668-7439

Bramkamp Printing Co., Inc.
800 Sycamore St.
Cincinnati, OH 45202
(513) 241-1865
Fax: (513) 241-4168

Claudia Laub Studio
7404 Beverly Blvd.
Los Angeles, CA 90036
(213) 931-1710
Fax: (213) 931-0126

Firefly Press
23 Village St.
Sommerville, MA 02143
(617) 625-7500
Fax: (617) 625-7500

Independent Project Press
40 Finley Dr.
P.O. Box 1033
Sedona, AZ 86336
(520) 204-1332
Fax: (520) 204-1332

Innerer Klang Press
50 Terminal St.
Charlestown, MA 02129
(617) 242-0689
Fax: (617) 242-0689

Julie Holcomb Printers
665 3rd St., Ste. 425
San Francisco, CA 94107
(415) 243-0530
Fax: (415) 243-3920

Mindanao Printing
1222 Hazel St. N.
St. Paul, MN 55119-4500
(612) 774-3768
Fax: (612) 771-9772

Purgatory Pie Press
19 Hudson St., #403
New York, NY 10013
(212) 274-8228
Fax: (212) 274-8228

Quintessence Working Press-Room Museum
356 Bunker Hill Mine Rd.
Amador City, CA 95601
(209) 267-5470

Red Star Printing
740 N. Franklin
Chicago, IL 60610
(312) 664-3871
Fax: (312) 664-8961

The Sun Hill Press
23 High St.
North Brookfield, MA 01535
(508) 867-7274
Fax: (508) 867-7274

Warwick Press
1 Cottage St.
Easthampton, MA 01027
(413) 527-5456
Fax: (413) 527-5456

Screen Printers

Silkscreen printing offers the opportunity to print on surfaces not possible with a press. You'll find listings for silkscreen printers who specialize in bottles and other packaging applications in chapter thirteen. Screen printers that specialize in garments can be found in chapter seven. Those that specialize in label printing can be found later in this chapter.

This listing includes screen printers offering a range of capability and attention to detail that makes them especially qualified to deal with the needs of advertising and graphic designers. They typically handle point-of-purchase, four-color work and are accustomed to meeting tight deadlines. All are members of the SGIA, an international association of silkscreen printers.

ABC Sign and Display
341 2nd Ave.
Des Moines, IA 50313
(515) 280-6868
Fax: (515) 280-1066

Advertising Display Co.
3939 Kearney St.
Denver, CO 80207
(303) 393-9000
Fax: (303) 393-8080

Albert Basse Associates
175 Campanelli Pkwy.
Stoughton, MA 02072
(781) 344-3555
Fax: (781) 344-3777

Champion Screen Printing
3901 Virginia Ave.
Cincinnati, OH 45227
(513) 271-3800
Fax: (513) 271-5963

Display Creations, Inc.
1970 Industrial Park Rd.
Brooklyn, NY 11207
(718) 257-2300
Fax: (718) 257-2558

Diversified Screen Printing
8B Union Hill Rd.
West Conshohockan, PA 19428
(610) 828-5444
Fax: (610) 828-7811

General Screen Printing
4520 W. Ohio Ave.
Tampa, FL 33614
(813) 875-0447
Fax: (813) 875-0647

Grady McCauley, Inc.
9260 Pleasantwood Ave. NW
North Canton, OH 44720
(330) 494-9444
Fax: (330) 494-9991

Graham Screen Print
12135 Valliant
San Antonio, TX 78216
(210) 348-0600
Fax: (210) 348-0603

Compton Presentation Systems specializes in printing on unusual surfaces, such as plastic and cloth, and finishing applications that require unusual closures and binding. For more information, see their listing on page 174.

In Store Media Corp.
510B Wharton Cir.
Atlanta, GA 30336
(404) 696-9200
Fax (404) 691-4522

Ivey-Seright International, Inc.
424 8th Ave. N.
Seattle, WA 98109
(206) 623-8113
Fax: (206) 467-6297

Miller-Zell, Inc.
4750 Frederick Dr. SW
Atlanta, GA 30336
(404) 691-7400
Fax: (404) 699-0006

Morrison & Burke, Inc.
5464 E. LaPalma Ave.
Anaheim, CA 92807
(714) 777-5000
Fax: (714) 777-5067

Pratt Poster Co., Inc.
3001 E. 30th St.
Indianapolis, IN 46218
(317) 924-3201
Fax: (317) 927-0653

Screen Tech Designs
2651 Cessna Dr.
Columbus, IN 47203
(812) 376-0310
Fax: (812) 379-4612

Semasys, Inc.
130 NE 50th St.
Oklahoma City, OK 73105
(405) 525-2335
Fax: (405) 525-3113

STM Graphics
8401 Chancellor Row
Dallas, TX 75247
(214) 631-6720
Fax: (214) 634-6297

Wise Graphics
300 E. Boundary Rd.
Chapin, SC 29036
(803) 345-5481
Fax: (803) 345-5512

Large-Scale Imaging and Graphics

The following companies offer enlargements of customer-supplied art and transparencies as well as customer-furnished computer files on disk. Process used depends on company and can include electrostatic, ink-jet and computerized airbrush. Large-scale imaging is used widely for billboards, vehicle graphics, display and other purposes. Prices vary according to the substrate and type of image. Check with each company to find out which process is most cost-efficient for your needs.

Ad Graphics

1711 Blount Rd., Ste. A
Pompano Beach, FL 33069
(800) 645-5740, (954) 974-9900
Fax: (954) 974-9925
Electrostatic printing on adhesive-backed vinyl. Can work from customer-furnished images, Mac- and PC-compatible files.

ALD Decal Manufacturing

435 Cleveland Ave. NW
Canton, OH 44702
(330) 453-2882
Fax: (330) 453-4313
Offers large-scale imaging on pressure-sensitive decals from translucent Scotchcal for backlit applications and Scotchlite reflective film. Works from customer-furnished art, photos and transparencies.

Belcom Corp.

3135 Madison
Bellwood, IL 60104
(708) 544-4499
Fax: (708) 544-5607
Ink-jet process that allows Belcom to print an image on virtually any substrate, including carpet.

Creative Color

235 W. 200 S.
Salt Lake City, UT 84101
(801) 355-4124
Fax: (801) 355-4152
Mural-sized prints and backlit transparencies. Also does mounting and laminating.

Digitable Dirigible

38 Vestry St.
New York, NY 10013
(212) 431-1925
Fax: (212) 431-1978
Electrostatic printing on paper. Can work with customer-furnished art as well as Mac-compatible computer files.

Gregory, Inc.

200 S. Regier St.
P.O. Box 410
Buhler, KS 67522
(800) 835-2221, (316) 543-6657
Fax: (800) 835-2221,
(316) 543-2690
Scotchprint graphics from supplied artwork, Mac and PC electronic files. Can print on paper, reflective, clear and transluscent substrates.

Joseph Merrit Co.

650 Franklin Ave.
Hartford, CT 06114
(800) 344-4477, (860) 296-2500
Fax: (860) 296-0414
Scotchprint imaging from transparencies, photos or digital files on adhesive-backed vinyl.

Lowen Color Graphics

1330 E. 4th St.
P.O. Box 1528
Hutchinson, KS 67504-1528
(800) 835-2365, (316) 663-2161
Fax: (316)663-1429
Utilizes Scotchprint technology. Available on opaque, reflective and translucent vinyl films.

Metromedia Technologies, Inc.

1320 N. Wilton Pl.
Los Angeles, CA 90028
(800) 999-4668
Fax: (800) 433-4668 (East Coast), (213) 856-6503
Manufactures Flex-Fleet graphics—a combination of acrylic paints on vinyl substrates suitable for applying imaging on trucks and other large vehicles.

Miratec Systems, Inc.

666 Transfer Rd.
St. Paul, MN 55114
(800) 336-1224, (612) 645-8440
Fax: (612) 645-8435
Scotchprint imaging from transparencies, photos or digital files.

NSP Corporate Graphics

475 N. Dean Rd.
Auburn, AL 36830
(800) 876-6002
Fax: (334) 821-6919
Large-scale imaging on a variety of substrates using the Scotchprint electrostatic system.

Onyx Graphics

6915 S. High Tech Dr.
Midvale, UT 84047
(800) 828-0723, (801) 568-9900
Fax: (801) 568-9911

Uses ink-jet process to print on high-gloss paper. Will laminate for increased durability.

Sungraf
325 W. Ansin Blvd.
Hallandale, FL 33009
(800) 327-1530, (954) 456-8500
Fax: (954) 454-2266
Digital airbrushed images in sizes up to sixteen feet high in unlimited lengths. Mac- and PC-compatible.

Vision Graphic Technologies, Inc.
3030 W. Directors Row
Salt Lake City, UT 84104
(800) 424-2483, (801) 973-8929
Fax: (801) 973-8944
Can produce all types of large-scale imaging from posters to billboards. Products include aerial banners and images up to forty feet. Also provides electrostatic imaging on a variety of substrates and can laminate prints for increased durability.

Laminating/Dry Mounting

These companies will laminate and dry mount items for portfolios and other types of presentations as well as menus, displays, counter cards and more.

Accuprint & Laminating of Cincinnati
329 Walnut St.
Cincinnati, OH 45202
(513) 651-1078
Fax: (513) 651-5624

Caulastics
5955 Mission St.
Daly City, CA 94014
(415) 585-9600
Fax: (415) 585-5209

Century Plus
2701 Girard NE
Albuquerque, NM 87107
(505) 888-2901
Fax: (505) 888-2902

Commercial Laminating Co.
3131 Chester Ave.
Cleveland, OH 44114
(216) 781-2434
Fax: (216) 781-9413

D&E Vinyl Corp.
13524 Vintage Pl.
Chino, CA 91710
(800) 929-2148, (909) 590-0502
Fax: (909) 591-7822

G2 Graphic Service, Inc.
5510 Cleon Ave.
North Hollywood, CA 91601
(213) 467-7828
Fax: (213) 469-0381

International Laminating
1712 Springfield St.
Dayton, OH 45403
(937) 254-8181
Fax: (937) 256-8813

Laminating Services Co.
7359 Varna Ave.
North Hollywood, CA 91605
(818) 982-9065
Fax: (818) 982-9065

Pavlik Laminating
3418 S. 48th St., #8
Phoenix, AZ 85040
(602) 968-4601
Fax: (602) 968-6422

Superior Reprographics
1925 5th Ave.
Seattle, WA 98101
(206) 443-6900
Fax: (206) 441-8390

Thermography

The raised surface of thermography is often thought of as an economical way of achieving the impression of engraving. You can order thermographed business cards from most commercial printers or quick-print outlets, which will typically send your work to a thermographer that specializes in business cards. But if you're looking for more unusual applications of thermography, contact these firms.

Ink Spot Litho
10715 Garvey Ave.
El Monte, CA 91733
(626) 443-1987
Fax: (626) 443-4326

Project

Instead of producing a standard capabilities brochure, Toronto-based Viva Dolan Communications and Design chose to use this hardcover book, designed to look like a child's primer, as the company's self-promotional brochure.

Let's Sell Ourselves! tells the firm's story by citing clients and accomplishments in a charming and unforgettable manner. The book's hardcover format and case binding provide an archival quality, making the book far more likely to be a "keeper" in the hands of its recipients than typical self-promotions.

Few designers think they can afford to publish a hardcover book, but the right suppliers made this concept viable for Viva Dolan. The book's four-color interior didn't involve any prepress color work; the illustrations were created on the computer, incorporating scans of client work done by Viva Dolan. Producing the job entirely from Viva Dolan's digital files eliminated the expense of any commercial prepress work. Printing was done by C.J. Graphics, a Toronto-based printer Viva Dolan works with frequently.

The book was bound by Anstey Book Binding, a company that specializes in fulfilling small runs of case-bound books, die cutting, hand-finishing and other special finishing applications that would normally be cost prohibitive in a small-run situation.

For the production of three hundred books, Viva Dolan paid a price comparable to what it would have cost to produce the same quantity of a four-color brochure on premium paper. The firm was able to have the job done at a discount because it frequently brings jobs to Anstey Book Binding and C.J. Graphics and credited both companies on the book's back cover.

For information on contacting C.J. Graphics, see listing on page 163; for Anstey Book Binding, see the listing below.

Viva Dolan Communications and Design was able to locate a small-run vendor that could produce a hardcover, case-bound capabilities brochure.

Winsted
917 SW 10th St.
Hallandale, NJ 33009
(305) 944-7862
Fax: (305) 454-9771

Embossing and Foil-Stamping

These companies have a reputation for meeting unusual challenges in foil-stamping and embossing.

Anstey Book Binding, Inc.
41 Hollinger Rd.
Toronto, Ontario M4B 3G4
Canada
(416) 757-9991
Fax: (416) 757-2040

Artistry Engraving & Embossing Co., Inc.
6000 N. Northwest Hwy.
Chicago, IL 60631
(773) 775-4888
Fax: (773) 775-0064

Bramkamp Printing Co., Inc.
800 Sycamore St.
Cincinnati, OH 45202
(513) 241-1865
Fax: (513) 241-4168

Capitol Hill Printing
1600 Sherman St.
Denver, CO 80203
(303) 832-2275
Fax: (303) 832-3645

Faust Printing
8656 Utica Ave., Ste. 100
Rancho Cucamonga, CA 91730
(909) 980-1577
Fax: (909) 989-9717

Gunther's Printing
16752 Millikan Ave.
Irvine, CA 92606
(714) 833-3500
Fax: (714) 833-3700

Knittel Engraving
5195 State Rte. 128
Miamitown, OH 45041
(513) 353-1315
Fax: (513) 353-4300

Macintosh Embossing
110 12th Ave. S.
Minneapolis, MN 55415
(612) 339-0901
Fax: (612) 339-9603

Finishing Specialists

Need a vendor that can source out materials such as leather, vinyl and linen? Or do you have a limited run of a case-bound book? These companies specialize in unusual printing and finishing techniques that go beyond the realm of traditional offset printing.

Admore
24707 Wood Ct.
Macomb, MI 48042-5378
(800) 523-6673
Fax: (810) 949-8968
or

5300 Lindberg Ln.
Bell, CA 90201
(800) 338-5525
Fax: (800) 378-5525
Specializes in presentation folders and inserts, CD and diskette packaging as well as audio- and videotape packaging. Also produces portfolios and other boxes. Finishing techniques include foil-stamping, embossing, laminating and ultraviolet coating.

Anstey Book Binding, Inc.
41 Hollinger Rd.
Toronto, Ontario M4B 364
Canada
(416) 757-9991
Fax: (416) 757-2040
Owned by a designer with a love for the fine craftsmanship associated with vintage printing and finishing techniques, Anstey Book Binding specializes in small runs of case-bound books, die cutting, hand-finishing and other special finishing applications that would normally be cost prohibitive in small-run situations. The company can do case binding, letterpress, foil-stamping, embossing, engraving and die cutting.

Compton Presentation Systems
68 Congress Cir. W.
Roselle, IL 60172
(800) 336-4940, (630) 539-2200
Fax: (630) 539-2209
Locating and printing on unusual substrates is Compton Presentation Systems' specialty. Compton has even done embossing on denim. The company offers silk-screen printing, offset printing on vinyl, foil-stamping and embossing, holographs and more. In addition to handling unusual printing and finishing applications, Compton also offers unusual bindings and closures, including posts, snaplocks, gold and silver corners, snaps and Velcro. Among the many jobs Compton has produced are products and product packaging, promotional pieces, training kits and binders.

Refer to image on page 170.

Corporate Image
1801 Thompson Ave.
Des Moines, IA 50316
(800) 247-8194
Fax: (888) 262-3839
Specializes in custom presentation packaging, including pocket folders, video- and audiocassettes, CD-ROM and diskette packaging and marketing kits.

Graphics3, Inc.

1400 Indiantown Rd.
P.O. Box 937
Jupiter, FL 33468-0937
(561) 746-6746
Fax: (561) 746-6922
www.graphics3inc.com

Specializes in rubber-band activated, 3-D greeting cards and calendars that pop up when opened. Wide choice of stock designs available. Offers free catalog.

Label, Decal, Nameplate and Tape Printers

The following printers offer a variety of printing techniques, including flexography, letterpress and silkscreen, as well as a wide range of label and decal types, shapes and sizes. In addition to label types mentioned, most also produce bar code labels.

American Label

P.O. Box 342
Jefferson, MD 21755
(800) 438-3568, (301) 473-7491
Fax: (301) 473-7496

Tags, decals and labels. Also prints control panels and name badges. Screen printing on all types of surfaces, including Lexan, plastic, vinyl, foil and metal.

American Nameplate

4501 S. Kildare Ave.
Chicago, IL 60632
(800) 878-6186, (773) 376-1400
Fax: (773) 376-2236

Custom metal labels and nameplates from aluminum, stainless steel and brass. Also makes labels of Mylar, vinyl and aluminum foil.

Andrews Decal Co., Inc.

6559 N. Avondale Ave.
Chicago, IL 60631-1521
(773) 775-1000
Fax: (312) 775-1001

Offers decals, nameplates, computer and pressure-sensitive labels. Flexography, letterpress and silk-screening available. Will print on a variety of materials.

Bay Area Labels

1980 Lundy Ave.
San Jose, CA 95131-1831
(800) 229-5223, (408) 432-1980
Fax: (408) 434-6407

Decals and labels from Lexan, polyester, paper and other materials. Offers a variety of print applications, embossing, debossing and holograms. Also makes nameplates and membrane switches.

Bay Tech Label, Inc.

12177 28th St. N.
St. Petersburg, FL 33716
(800) 229-8321, (813) 223-7128
Fax: (813) 572-8345

Prints anywhere from one-color to four-color process. Laminating and varnishing also available.

Cummins Label Co.

2230 Glendening Dr.
Kalamazoo, MI 49001
(616) 345-3386
Fax: (616) 345-6657

Stock and custom-printed labels for many applications, including shipping and packaging. Offers letterpress, flexography and silkscreen printing. No minimum on orders placed.

Design Mark Industries

3 Kendrick Rd.
Wareham, MA 02571
(508) 295-9591
Fax: (508) 295-6752

Custom labels, decals and nameplates. Offers one- to four-color process, offset, flexographic and screen printing as well as hot stamping and embossing. District offices in Raleigh, North Carolina, and Philadelphia, Pennsylvania.

Express Card and Label Co., Inc.

2012 NE Meriden Rd.
Topeka, KS 66608
(800) 862-9408, (913) 233-0369
Fax: (913) 233-2763

Custom labels, tags and coupons in up to eight colors. Multilayer constructions available.

Flexo Transparent, Inc.

28 Wasson St.
Buffalo, NY 14210
(800) 33-FLEXO, (716) 825-7710
Fax: (716) 825-0139

Manufactures bottle sleeve labels. Stock and custom designs available.

Go Tape and Label, Inc.
19575 NE 10th Ave.
Miami, FL 33179
(800) 468-2731, (305) 652-8300
Fax: (305) 652-8306
Custom labels, tags and tape in all sizes and shapes. Offers one- to four-color process, silkscreening and hot stamping.

Grafstick Tape & Label
P.O. Box 3277
Framingham, MA 01701
(800) 537-6483
Fax: (508) 620-6229
Custom and preprinted labels in stock.

Identification Products Corp.
104 Silliman Ave.
P.O. Box 3276
Bridgeport, CT 06605
(800) 243-9888
Fax: (203) 334-5038
Custom labels on Lexan, foil, vinyl, Mylar and paper. Also makes aluminum nameplates.

Intermec Media Products
9290 LeSaint Dr.
Fairfield, OH 45014-5454
(513) 874-5882
Fax: (513) 874-8487
Bar code labels, tags and ribbons on thermal and thermal transfer papers, plastics and synthetics.

Label Quest
578 N. Michigan
Elmhurst, IL 60126
(800) 999-5301, (630) 833-9400
Fax: (630) 833-9421
Custom pressure-sensitive labels for packaging and other applications. Also offers mold decorating, heat transfers, rubdown products and five types of printing processes.

Labels and Decals, Inc.
300 Frontier Way
Bensenville, IL 60106
(800) 253-3225, (630) 227-0500
Fax: (630) 227-1016
Labels, nameplates and decals of all types and sizes. Printing applications include flexography, letterpress and silkscreening.

Nameplates for Industry, Inc.
213 Theodore Rice Blvd.
Industrial Park
New Bedford, MA 02745
(800) 999-8900, (508) 998-9021
Fax: (508) 995-0099
Offers labels, nameplates, decals and tags, screen printed to client specifications. Call for free catalog and samples.

Precision Tape & Label, Inc.
P.O. Box 566
Uxbridge, MA 01569
(800) 225-7754, (508) 865-1157
Fax: (508) 865-1161
Custom-designed labels in up to six colors.

Reed-Rite Reliable Label Co.
1427 Center Circle Dr.
Downers Grove, IL 60515
(800) 323-7265, (630) 620-8100
Fax: (630) 620-8125
Decals, pressure-sensitive and static cling labels. Available on rolls and sheets. Offers hot stamping and foil labels.

Screenprint/Dow
271 Ballardvale St.
Wilmington, MA 01887
(781) 935-6395
Fax: (978) 658-2307
Nameplates, roll labels and control panels. Offers offset and screen printing, letterpress, hot stamping and flexography.

Seton Industries
P.O. Box 819
Branford, CT 06485
(800) 243-6624, (203) 488-8059
Fax: (203) 488-5973
Custom and stock labels, decals and nameplates on vinyl, polyester, paper, foil and metallic substrates. Call for free catalog and samples.

Star Label
9810 Ashton Rd.
Philadelphia, PA 19114
(800) 394-6900, (215) 677-STAR
Fax: (215) 673-2885, (215) 676-3292
Offers a wide range of labels, decals, tags and nameplates. Printing applications include flexography, letterpress, hot stamping and embossing. Offers up to twelve-color printing.

Techprint
137 Marsten St.
Lawrence, MA 01841
(800) 225-2538, (978) 975-1245
Fax: (978) 689-1888
Manufactures custom labels on rolls, strips and as individual pieces. Offset and screen printing, flexography and hot stamping. Also offers nameplates, decals and other items.

Envelope Converters

When producing envelopes or presentation folders from papers that don't come with stock envelopes or with color or graphics that bleed, these companies will convert preprinted printing papers and cover stocks into folded and glued final products.

Leader Cards, Inc.
P.O. Box 4607
Milwaukee, WI 53204
(800) 876-2273, (414) 645-5760
Fax: (414) 645-6826

National Envelope Corp.
207 Greenwood St.
Worcester, MA 01607
(800) 676-0226
Fax: (508) 798-9347
www.nationalenvelope.com
or
13871 Parks Steed Dr.
Earth City, MO 63045
(314) 291-2722
Fax: (314) 291-1036
or
14820 Don Julian Rd.
City of Industry, CA 91746
(800) 669-7696
Fax: (818) 968-6893
or
18221 Andover Park
West Tukwila, WA 98188
(800) 450-4420
Fax: (206) 575-8392

New York Envelope Co.
29-10 Hunterspoint Ave.
Long Island City, NY 11101
(800) 877-9551
Fax: (718) 361-3127

Old Colony Envelope Co.
70 Turnpike Industrial Rd.
Westfield, MA 01086
(800) 343-1273
Fax: (413) 572-3526

Williamhouse
245 5th Ave., Ste. 502
New York, NY 10016
(212) 689-8811
Fax: (212) 689-5989
or
1 Wedding Ln.
Scottdale, PA 15683
(800) 331-4640, (724) 887-5400
Fax: (724) 887-8077
or
6006 Superior Ct.
Morristown, TN 37814
(800) 654-5519
Fax: (800) 994-8077
or
3001 S. Hwy. 287
Corsicana, TX 75110
(800) 527-2422, (903) 872-5646
Fax: (903) 872-2666
or
14101 E. 33rd Pl.
Aurora, CO 80011
(303) 373-1780
Fax: (303) 371-7765
or
705 N. Baldwin Park Blvd.
City of Industry, CA 91746
(626) 369-4921
Fax: (626) 369-3532

Suppliers of Holography

These companies can do holographic imaging in a variety of applications, large and small.

AD 2000, Inc.
948 State St.
New Haven, CT 06511
(203) 624-6405
Fax: (203) 624-1780
http://ad2000.com/ad2000/
Offers a selection of over four hundred stock images widely used in advertising and promotion. Can handle a wide range of projects, including garment transfers, decorative applications, product printing and pressure-sensitive labels.

Bridgestone Graphic Technologies, Inc.
375 Howard Ave.
Bridgeport, CT 06605
(203) 366-1595
Fax: (203) 366-1667
Specializes in product authentication and tracking systems. Clients include 1966 Atlanta Centennial Olympic Games.

CFC Applied Holographics
500 State St.
Chicago Heights, IL 60411
(800) 323-3399
Fax: (708) 758-5989
Offers a full range of holographic services, including security applications and decorative foil patterns.

Crown Roll Leaf, Inc, and Holo-Grafx
91 Illinois Ave.
Paterson, NJ 07503
(973) 742-4000
Fax: (973) 742-0219
Can handle custom applications as well as holographs on pressure-sensitive labels. Sales offices in Illinois, California, Georgia, Toronto and Montreal.

Crystal Holographics
365 N. 600 W.
Logan, UT 84321
(801) 753-5775
Fax: (801) 753-5876
Specializes in mass production of photopolymer holograms. Can handle packaging and security projects as well as product applications.

Holographic Design Systems
1134 W. Washington Blvd.
Chicago, IL 60607
(312) 829-2292
Fax: (312) 829-9636
Offers a full range of holographic services, including display, packaging and other printing applications.

Rainbow Symphony
6860 Canby Ave., Unit 120
Reseda, CA 91335
(818) 708-8400
Fax: (818) 708-8470
Specializes in custom imprinting of holographic novelties, including labels, foil-wrapped pens and pencils, glasses, holiday decorations, buttons, magnets, decals, party favors and more. Services include in-house graphics and typesetting.

Prepress Software

Marzware Software
1805 E. Dyer Rd.
Santa Ana, CA 92705
(714) 756-5100
Fax: (714) 756-5108
www.marzware.com
Manufactures:
FlightCheck—Lets user verify, check and collect all files necessary before going to the printer or service bureau. Finds fonts, pictures and such.

Other

Bay Area Labels
1980 Lundy Ave.
San Jose, CA 95131
(800) 229-5223, (408) 432-1980
Fax: (408) 434-6407
Makes hologram labels.

Identicolor
720 White Plains Rd.
Scarsdale, NY 10583
(914) 472-6640
Fax: (914) 472-0954
Specializes in custom rubdown transfers. In addition to standard color rubdowns, company offers foil transfers and hologram transfers.

Lasercraft, Inc.
3300 Coffey Ln.
Santa Rosa, CA 95403
(800) 358-8296
Does laser cutting.

Pinwheel
50 Rte. 46 W., Ste. 201
Parsippany, NJ 07054
(973) 227-2000
Fax: (973) 227-3111
Specializes in comping packaging and other projects requiring short-run screen printing. Also makes custom rubdown transfers.

INDEX

INDEX OF COMPANY NAMES